E3 50

ALSO BY JONATHAN HARR

A Civil Action

THE

LOST

PAINTING

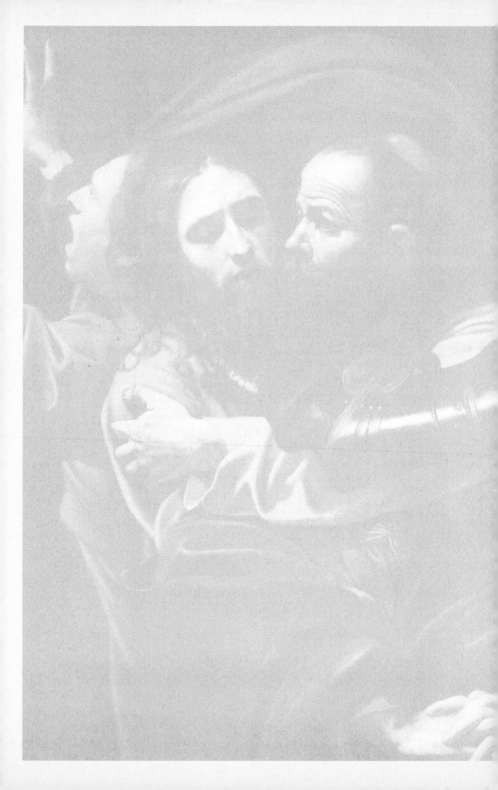

THE
LOST
PAINTING

JONATHAN
HARR

RANDOM HOUSE

NEW YORK

Published in the United States by Random House, an imprint
of The Random House Publishing Group, a division of
Random House, Inc., New York.

RANDOM HOUSE and colophon are registered trademarks of
Random House, Inc.

Title-page and part-title art: Caravaggio
(Michelangelo da Merisi), *The Taking of Christ,* 1602,
courtesy of the National Gallery of Ireland
and the Jesuit Community, who acknowledge
the generosity of the late Dr. Marie Lea-Wilson

ISBN 0-375-50801-5

Printed in the United States of America

For my father, Jack

CONTENTS

PART I

※

THE
ENGLISHMAN

THE ENGLISHMAN MOVES IN A SLOW BUT DELIBERATE SHUFFLE, knees slightly bent and feet splayed, as he crosses the piazza, heading in the direction of a restaurant named Da Fortunato. The year is 2001. The Englishman is ninety-one years old. He carries a cane, the old-fashioned kind, wooden with a hooked handle, although he does not always use it. The dome of his head, smooth as an eggshell, gleams pale in the bright midday Roman sun. He is dressed in his customary manner—a dark blue double-breasted suit, hand tailored on Savile Row more than thirty years ago, and a freshly starched white shirt with gold cuff links and a gold collar pin. His hearing is still sharp, his eyes clear and unclouded. He wears glasses, but then he has worn glasses ever since he was a child. The current pair are tortoiseshell and sit cockeyed on his face, the left earpiece broken at the joint. He has fashioned a temporary repair with tape. The lenses are smudged with his fingerprints.

Da Fortunato is located on a small street, in the shadow of the Pantheon. There are tables outside, shaded by a canopy of

umbrellas, but the Englishman prefers to eat inside. The owner hurries to greet him and addresses him as Sir Denis, using his English honorific. The waiters all call him Signore Mahon. He speaks to them in Italian with easy fluency, although with a distinct Etonian accent.

Sir Denis takes a single glass of red wine with lunch. A waiter recommends that he try the grilled porcini mushrooms with Tuscan olive oil and sea salt, and he agrees, smiling and clapping his hands together. "It's the season!" he says in a high, bright voice to the others at his table, his guests. "They are ever so good now!"

When in Rome he always eats at Da Fortunato, if not constrained by invitations to dine elsewhere. He is a man of regular habits. On his many visits to the city, he has always stayed at the Albergo del Senato, in the same corner room on the third floor, with a window that looks out over the great smoke-grayed marble portico of the Pantheon. Back home in London, he lives in the house in which he was born, a large redbrick Victorian townhouse in the quiet, orderly confines of Cadogan Square, in Belgravia. He was an only child. He has never married, and he has no direct heirs. His lovers—on this subject he is forever discreet—have long since died.

Around the table, the topic of conversation is an artist who lived four hundred years ago, named Michelangelo Merisi da Caravaggio. Sir Denis has studied, nose to the canvas, magnifying glass in hand, every known work by the artist. Since the death of his rival and nemesis, the great Italian art scholar Roberto Longhi, Sir Denis has been regarded as the world's foremost authority on Caravaggio. Nowadays, younger scholars

who claim the painter as their domain will challenge him on this point or that, as he himself had challenged Longhi many years ago. Even so, he is still paid handsome sums by collectors to render his opinion on the authenticity of disputed works. His verdict can mean a gain or loss of a small fortune for his clients.

To his great regret, Sir Denis tells his luncheon companions, he's never had the chance to own a painting by Caravaggio. For one thing, fewer than eighty authentic Caravaggios—some would argue no more than sixty—are known to exist. Several were destroyed during World War II, and others have simply vanished over the centuries. A genuine Caravaggio rarely comes on the market.

Sir Denis began buying the works of Baroque artists in the 1930s, when the ornate frames commanded higher prices at auction than the paintings themselves. Over the years he has amassed a virtual museum of seicento art in his house at Cadogan Square, seventy-nine masterpieces, works by Guercino, Guido Reni, the Carracci brothers, and Domenichino. He bought his last painting in 1964. By then, prices had begun to rise dramatically. After two centuries of disdain and neglect, the great tide of style had shifted, and before Sir Denis's eyes, the Italian Baroque had come back into fashion.

And no artist of that era has become more fashionable than Caravaggio. Any painting by him, even a small one, would be worth today many times the price of Sir Denis's finest Guercino. "A Caravaggio? Perhaps now as much as forty, fifty million English pounds," he says with a small shrug. "No one can say for certain."

He orders a bowl of wild strawberries for dessert. One of

his guests asks about the day, many years ago, when he went in search of a missing Caravaggio. Sir Denis smiles. The episode began, he recalls, with a disagreement with Roberto Longhi, who in 1951 had mounted the first exhibition in Milan of all known works by Caravaggio. Sir Denis, then forty-one years old and already known for his eye, spent several days at the exhibition studying the paintings. Among them was a picture of St. John the Baptist as a young boy, from the Roman collection of the Doria Pamphili family. No one had ever questioned its authenticity. But the more Sir Denis looked at the painting, the more doubtful he became. Later, in the files of the Archivio di Stato in Rome, he came across the trail of another version, one he thought more likely to be the original.

He went looking for it one day in the winter of 1952. Most likely it was morning, although he does not recall this with certainty. He walked from his hotel at a brisk pace—he used to walk briskly, he says—through the narrow, cobbled streets still in morning shadow, past ancient buildings with their umber-colored walls, stained and mottled by centuries of smoke and city grime, the shuttered windows flung open to catch the early sun. He would have worn a woolen overcoat against the damp Roman chill, and a hat, a felt fedora, he believes. He dressed back then as he dresses now—a starched white shirt with a high, old-fashioned collar, a tie, a double-breasted suit—although in those days he carried an umbrella instead of the cane.

His path took him through a maze of streets, many of which, in the years just after the war, still lacked street signs. He had no trouble finding his way. Even then he knew the streets of central Rome as well as he knew London's.

At the Capitoline Hill, he climbed the long stairway up to the piazza designed by Michelangelo. A friend named Carlo Pietrangeli, the director of the Capitoline Gallery, was waiting for him. They greeted each other in the English way, with handshakes. Sir Denis does not like being embraced, and throughout his many sojourns in Italy he has largely managed to avoid the customary greeting of a clasp and a kiss on both cheeks.

Pietrangeli told Sir Denis that he had finally managed to locate the object of his search in, of all places, the office of the mayor of Rome. Before that, the painting had hung for many years in the office of the inspector general of belle arti, in a medieval building on the Via del Portico d'Ottavia, in the Ghetto district of the city. The inspector general had regarded the painting merely as a decorative piece with a nice frame, of no particular value. The original, after all, was at the Doria Pamphili. After the war—Pietrangeli did not know the precise details—someone had moved it to the Palazzo Senatorio, and finally to the mayor's office.

Pietrangeli and Sir Denis crossed the piazza to the Palazzo Senatorio. The mayor's office lay at the end of a series of dark hallways and antechambers, a spacious room with a high ceiling and a small balcony that looked out over the ancient ruins of the Imperial Forum. There was no one in the office. Sir Denis spotted the painting hanging high on a wall.

He remembers standing beneath it, his head canted back, gazing intently up and comparing it in his mind with the one he had seen at Longhi's exhibition, the Doria Pamphili version. From his vantage point, several feet below the painting, it appeared almost identical in size and composition. It depicted a

naked boy, perhaps twelve years old, partly reclined, his body in profile, but his face turned to the viewer, a coy smile crossing his mouth. Most art historians thought Caravaggio had stolen the pose from Michelangelo, from a nude in the Sistine Chapel, and had made a ribald, irreverent parody of it.

From where he stood, Sir Denis could not make out the finer details. The surface of the canvas was dark, the image of the boy obscured by layers of dust and grime and yellowed varnish. But he could tell that the quality was superb. Then again, so was the quality of the Doria Pamphili painting.

He turned to Pietrangeli and exclaimed, "For goodness' sake, Carlo, we must get a closer look! We must get a ladder."

Waiting for the ladder to arrive, he paced impatiently in front of the painting, never taking his eyes off it. He thought he could discern some subtle differences between it and the Doria version. Here the boy's gaze caught the viewer directly, mockingly, whereas the eyes of the Doria boy seemed slightly averted, the smile distinctly less open. When a workman finally arrived with a ladder, Sir Denis clambered up and studied the canvas with his magnifying glass. The paint surface had the characteristic craquelure, the web of fine capillary-like cracks produced by the drying of the oil that contained the paint pigments. He saw some abrasion in the paint surface, particularly along the borders, where the canvas and the wooden stretcher behind it came into contact. In some areas, the ground, or preparatory layer, had become visible. He noted that the ground was dark reddish brown in color and roughly textured, as if sand had been mixed into it. This was precisely the type of ground that Caravaggio had often used.

He studied the face of the boy again, the eyes and mouth, areas difficult even for a great painter. This face, he concluded, was much livelier than the Doria version. Indeed, the entire work felt fresher and lighter in both color and execution. He detected the spark of invention and creativity in this painting, something a copyist could never achieve. By the time he climbed down the ladder he felt convinced that Caravaggio's hand had created this painting. As for the Doria version, it was possible, as some maintained, that Caravaggio himself had copied his own work, perhaps at the insistence of a wealthy patron. But Sir Denis was skeptical. He doubted that Caravaggio had ever known about the Doria painting.

At Da Fortunato, Sir Denis pauses after telling this story, and then he smiles. Longhi died years ago, and he'd never accepted the Capitoline version as the original. Longhi was not one to admit a mistake, says Sir Denis. That was the beginning—Sir Denis chuckles—of many disagreements and a long, contentious, and very satisfying feud.

The Englishman has had a hand in the search for several other lost paintings by Caravaggio. He mentions one in particular—it was called *The Taking of Christ*—that had been the object of both his and Longhi's desire. It had vanished without a trace more than two centuries ago. Like the *St. John,* many copies had turned up, all suggesting a masterpiece, but none worthy of attribution to Caravaggio. Longhi, near the end of his life, had come up with an important clue in the mystery of the painting's disappearance.

It had been a clever deduction on Longhi's part, Sir Denis tells his guests. But, poor fellow, he hadn't lived to solve the mystery.

The past held many secrets, and gave them up grudgingly. Sir Denis believed that a painting was like a window back into time, that with meticulous study he could peer into a work by Caravaggio and observe that moment, four hundred years ago, when the artist was in his studio, studying the model before him, mixing colors on his palette, putting brush to canvas. Sir Denis believed that by studying the work of an artist he could penetrate the depths of that man's mind. In the case of Caravaggio, it was the mind of a genius. A murderer and a madman, perhaps, but certainly a genius. And no copy, however good, could possibly reveal those depths. That would be like glimpsing a man's shadow and thinking you could know the man.

PART II

❦

THE ROMAN
GIRL

I

A LATE AFTERNOON IN FEBRUARY, THE SUN SLANTING LOW ACROSS
the rooftops of Rome. The year was 1989. From the door of the
Bibliotheca Hertziana on Via Gregoriana came Francesca Cap-
pelletti, carrying a canvas bag full of books, files, and notebooks
in one hand, and a large purse in the other. She was a graduate
student at the University of Rome, twenty-four years old, five
feet six inches tall, eyes dark brown, cheekbones high and prom-
inent. Her hair, thick and dark, fell to her shoulders. It had a
strange hue, the result of a recent visit to a beauty salon near
the Piazza Navona, where a hairdresser convinced her that red
highlights would make it look warmer. In fact, the highlights
made it look metallic, like brass. She wore no makeup, no ear-
rings, and only a single pearl ring on her left hand. Her chin had
a slight cleft, most noticeable in repose, although at the moment
she was decidedly not in repose.

She was late for an appointment. She had a long, rueful his-
tory of being late. As a consequence she'd perfected the art of
theatrical apology. The traffic of Rome was her most common

excuse, but she'd also invented stuck elevators, missing keys, broken heels, emotional crises, and illnesses in her family. Her apologies had a breathless, stricken sincerity, wide-eyed and imploring, which had rendered them acceptable time and again to friends and lovers.

This appointment was with a man named Giampaolo Correale. He had hired Francesca and several other art history students, friends of hers, to do research on some paintings at the Capitoline Gallery. Every few weeks, he would convene a meeting at his apartment to discuss their progress. Francesca wasn't always late for these meetings. And on those occasions when she had been, Correale had usually forgiven her with a wave of his hand. She had proven herself to be one of his more productive workers. All the same, he had a temperament that alarmed Francesca, capable of expansive good humor one moment and sudden fits of anger the next.

She rode her motorino, an old rust-stained blue Piaggio model, past the church of Trinità dei Monte and the Villa Medici, down the winding road to the Piazza del Popolo. She was a cautious but inexpert driver, despite eight years of experience. Her destination, Correale's apartment, was on Via Fracassini, a residential area of nineteenth-century buildings, small shops, and restaurants, a mile or so north of the city center. She calculated she would be about fifteen minutes late and began considering possible excuses. The truth—that she simply lost track of time while reading an essay on iconography—seemed somehow insufficient.

By the time she reached Correale's apartment, on the top

floor, breathless and hair in disarray, she presented the aspect of someone suitably distraught.

Correale opened the door. He was in his mid-forties, although he looked older, moderately overweight, mostly bald, with a closely trimmed beard going to gray. He had a stubby black cigar in hand. He peered at Francesca from over a pair of reading glasses. His eyes protruded slightly, like the eyes of a fish.

"Ah, Francesca has decided to join us after all!" Correale said for the benefit of the others in the room. His tone was ironic, but he was smiling.

No excuses were necessary. Francesca entered, murmuring only apologies.

The apartment was small, just two rooms, the air thickly wreathed with yellowish smoke from Correale's cigar. He smoked cigars incessantly. Francesca always left the meetings with a headache. Several unpacked cardboard boxes stood in a corner, stacked atop one another. A large bookcase was half filled with volumes, as if they had been hastily shoved into place. A sofa, a few chairs, several small paintings on the wall, and little else. It appeared as if Correale had just moved in, although he'd been living there for almost a year now, ever since his wife had left him. For the moment, at least, domesticity seemed to have little relevance for him.

There were three other women in the room. One, Francesca's age, was a fellow student from the university named Laura Testa. The other two were older, in their late thirties. One was an art historian who taught at the Istituto Centrale per il Restauro.

The other worked as a restorer of paintings and frescoes. She was plump and good-natured, with a quick, infectious laugh. She and Correale had just begun having an affair, which they sought to conceal but was obvious to everyone.

This small group had been working part-time for Correale for the past three months. His project was simple in concept but grand in ambition. He proposed to create a computer database for Italy's vast trove of art. He imagined an entry with scientific, technical, and historical information—"a complete medical record," he liked to call it—on every artifact from Roman antiquity to the modern era. He had persuaded a technology company named Italsiel to finance a pilot project as a test of this idea's commercial viability. The pilot phase had consisted of recording and cataloguing every known fact on some two hundred paintings at the Capitoline Gallery—a fraction of the gallery's collection but, as Correale pointed out, one had to begin somewhere.

Francesca and Laura had gotten detailed forms from Correale, thirty pages in length, to fill out on each of the two hundred paintings. The forms had looked complicated at first, but completing them had turned out to be merely tedious—"a fake complexity," Francesca once remarked. But Correale had paid well for each finished form, and Francesca and Laura had become adept at filling them in swiftly.

Now Correale had a new idea. The forms had their purpose, he said, puffing on his cigar, smoke rising in a nimbus over his head. But it was time to demonstrate just how this scientific approach to art would work. A case study, he called it. They would examine the two nearly identical St. John paintings attributed to

Caravaggio: the Doria Pamphili version and the one that Denis Mahon had found years ago in the mayor's office, now cleaned and hanging prominently in the Capitoline Gallery. Most art historians had come to accept the Capitoline as Caravaggio's original, but the one in the Doria still had its adherents. Not only Roberto Longhi but also Lionello Venturi, the other great Caravaggio scholar of the previous era, had steadfastly insisted on the Doria's authenticity. Venturi had once dismissed the Capitoline as a "weak copy."

Correale laid out his plan. They would investigate every possible aspect of the two paintings, a forensic investigation of the sort usually conducted at the scene of a murder. They would put the paintings under a microscope, both literally and figuratively, using X rays, infrared reflectography, and chemical and gas chromatograph analysis of the paints and the canvases. And they would also plot the history, the provenance, of the two paintings, collecting every reference they could find from the moment each had been created to the present day.

Correale assigned this task to Francesca and Laura. Other art historians had already done some of this work, but, Correale pointed out, there remained gaps in the early history of both paintings. Caravaggio scholars still argued, for example, about precisely when Caravaggio had painted the *St. John.* Not even Denis Mahon had managed to track down that information. Who knows? Correale said with a shrug. Maybe you'll discover something new.

To Francesca, it seemed that Correale regarded the provenance research as largely perfunctory. His real enthusiasm lay in the scientific and technical aspects of the work. But Francesca

liked her assignment. No more tedious forms to fill out. Just two paintings to concentrate on. A perfect job, in her imagination, was one in which she could spend her life in libraries studying art history, the eternal student.

Along the way, she would discover that, sometimes, when you go looking for one thing, you find another. And every now and then, your reward for persisting is that the other is better.

2

FRANCESCA SAW THE WORK OF CARAVAGGIO FOR THE FIRST TIME
when she was eleven years old. It was in the church of San Luigi
dei Francesi, just a short distance from the Piazza Navona. Her
father, an accountant who worked in a law office, used to take
her and her two sisters in hand on Sunday afternoons, the girls
dressed in churchgoing finery, for excursions around Rome.
They would set out to see the ancient ruins in the Forum or the
paintings and sculptures in one of the city's great galleries or
churches. Francesca, the oldest of the three, made a game of
these excursions, trying to match the paintings with the artists
before looking at the attributions. In time she came to know the
names of the masters of the Italian Renaissance and Baroque in
the way that schoolboys know the names and statistics of pro-
fessional soccer players.

Her first encounter with Caravaggio remained vivid, a pin-
prick of brilliant light in her memory. The three paintings
known as the Matthew cycle hung in the dim, shadowed regions
of the church, at the far end of the nave, in a recess known as the

Contarelli Chapel. It smelled of candle smoke and incense. A pale light filtered into the chapel through a small lunette window made nearly opaque by dust and grime. In Caravaggio's day, the flickering light of candles would have illuminated the chapel. When Francesca was a girl, illumination required a coin in a box. When the light came on, Francesca felt suddenly as if she were no longer in the church but in a theater. The three paintings seemed to breathe, to pulse with heat and life, capturing a moment in time like a scene glimpsed through a window. She stood with her hands on the smooth, cool marble railing of the chapel, transfixed by the depictions of Matthew's life. The most captivating to her was the one known as *The Calling of St. Matthew*— a scene in a Roman tavern of the sort that Caravaggio would have gone to, with wooden stools and a scarred wooden table, the sunlight from an opened door raking across an old stucco wall and settling on the tax collector who would become a saint.

Later, when she began to study art history seriously, Francesca learned that Caravaggio had painted his self-portrait among the figures in the background of *The Martyrdom of St. Matthew*. He had been twenty-nine then, but in the painting he looked older than that, bearded, brow furrowed, his mouth contorted in a grimace of dismay, his dark eyes filled with anguish. The Matthew paintings, his first public commission, brought him fame and wealth. Ten years later he would die alone, an outcast, in strange circumstances.

❧ 3 ❧

THE INVESTIGATION INTO THE ORIGINS OF THE TWO ST. JOHN
paintings occupied Francesca and Laura all that winter and
into the spring. They worked well together, even though they
worked in different ways. Correale, comparing the two, once said
of Francesca, "She is intelligent and intuitive, but like a nervous
racehorse." As for Laura, "She is methodical and scientific, more
like the mule that pulls the plow."

Laura was the first in her family to go to the university. She
was short and compactly built, and spoke with a heavy Roman
accent, a working-class accent that she made no effort to atten-
uate. Her manner was blunt and direct. The small gestures, the
feigned pleasantries that oil most social interactions, were for-
eign to her. "I try to be polite," she said of herself, "but even if I
don't say what I think, I cannot hide it."

They had both completed their undergraduate work at the
University of Rome with the highest honors. Each had her senior
thesis published in the prestigious scholarly art journal *Storia*

dell'Arte. They entered the graduate program, the specialization, as it is called, on the same day and took the same classes. They developed a friendship, but of the sort mostly limited to school and work.

They began their research at the national art library in the Piazza Venezia. They started with a book known informally as the bible of Caravaggio studies, compiled by an art historian named Mia Cinotti. It carried the subtitle *Tutte le Opere*—"All of the Works"—and its bibliography listed three thousand journal articles, monographs, and books on Caravaggio. In the section on the *St. John,* they read that most scholars believed Caravaggio had painted it between 1598 and 1601, although a few put the date as early as 1596. There were eleven known copies. Cinotti considered the Capitoline version discovered by Denis Mahon to be the authentic one, although she conceded that the Doria picture—the only important copy, by her lights—could possibly be a replica made by Caravaggio himself.

The earliest mention of the painting came from another artist, Giovanni Baglione, who had lived and worked in Rome at the same time as Caravaggio. The two men had been rivals and bitter enemies. Neither had anything good to say about the other. Thirty years after Caravaggio's death, Baglione published a series of short biographies of artists and sculptors in Rome. He recorded that Caravaggio—"a quarrelsome individual," whose "paintings were excessively praised by evil people"—had painted the *St. John* and two other pictures for a wealthy Roman collector named Ciriaco Mattei. One of those, as it happened, was the lost *Taking of Christ.* After Mattei's death, according to Cinotti, the *St. John* had a complicated history, passing through several

hands over the centuries before finally ending up at the Capitoline Gallery.

The history of the Doria *St. John* was at once much simpler and yet more mysterious. There was only a single known owner, the Doria Pamphili family. The picture had been in their possession since at least 1666, when it showed up for the first time in a family inventory, more than fifty years after Caravaggio's death. The painting's history before that date was unknown. Several scholars had attempted to track it back further, but nothing had come of their efforts.

Francesca and Laura talked it over. They decided to start with the Doria painting. Since less was known about its early history, it seemed to offer the greatest possibility to make a real discovery. And besides, the Doria Pamphili palazzo was just around the corner on Via del Corso, a five-minute walk from the library.

THE PALAZZO OCCUPIED AN ENTIRE CITY BLOCK. IT WAS A MASSIVE edifice of rusticated travertine and brick, soot-streaked and blackened by the incessant traffic on the Corso. At the center of the palazzo, visible through an entryway, the two young students saw a courtyard of orange and lemon trees and towering palms, a garden where barely a whisper of the city outside was audible. The Doria Pamphili family and its descendants had occupied this palazzo for almost four centuries. Their art gallery, with its collection of hundreds of paintings and sculptures, was open to the public.

The family's archive lay deep inside the palazzo. At the rear of the building, just off a narrow lane called Via della Gatta, Francesca and Laura entered a battered wooden door, climbed a flight of dimly lit marble stairs, and went past a warren of small, drab offices, the bureaucratic center of the family's once great holdings. A man behind a desk directed them down the hall to a pair of tall wooden doors.

The doors opened into a spacious room with a high, coffered ceiling, a terra-cotta floor, and windows overlooking another courtyard. In the center of the room there was a stout wooden table surrounded by bookshelves filled with hundreds of old leather-bound volumes and neatly labeled boxes. Through a partially opened door, Francesca could see into the heart of the archive, a long, narrow chamber lined with gray metal bookshelves that contained thousands more volumes.

The archivist who greeted them was a young Englishwoman, only a few years older than they, with long red hair gathered loosely behind her neck and a complexion as white as a porcelain doll. Her voice was soft, no more than a whisper. At first Francesca thought that this was how one should speak in the Doria Pamphili archive, even though there was no one else in the room. Later, when she happened to encounter the archivist on the street, Francesca realized that this was how the woman always spoke. "Like a ghost from another time," Francesca remarked.

The archivist explained in her whispery voice the organization of the documents. The earliest dated back to the eleventh century. The shelves contained aspects large and small of a

prominent family's passage through time—wills, contracts, and inventories; documents concerning banking, lawsuits, the arrangements of marriages, the purchase and sale of properties and goods.

Francesca and Laura asked to see the inventory of 1666 that contained the first mention of the Doria *St. John*. The archivist went on silent foot to retrieve it from the back room. She returned some moments later carrying a thick volume bound in worn, faded leather.

Seated at the table, they opened the book and leaned over it, their heads almost touching. The inventory had been drawn up at the death of the head of the household, one Camillo Pamphili, age forty-four, taken ill one day in July and dead the next from a fever of unknown origin. The notary had recorded Camillo's possessions on heavy paper of good quality. The edges had turned brown with age, and the tome gave off a stale, musty odor, but the pages were still cream-colored and unblemished.

They found the entry for the *St. John* on page 325, among a list of more than four hundred other paintings owned by Camillo Pamphili. There was no mistaking its description: "A painting of a young nude boy who caresses a sheep with white fleece, and with red below, with plants at his feet." The entry also described a frame decorated with a crosshatch pattern and small carved leaves, and recorded the size of the painting in palmi, an old Italian measure equal to eight and a half inches.

The entry did not name the artist, but that was not unusual. Many inventories failed to note the names of painters and sculptors, in part because artists had almost never signed their

works. Up until the Renaissance, they had been regarded merely as skilled tradesmen, practitioners of a manual craft, like shoemakers or potters. And even after they began to achieve individual recognition and ascend the social ladder—after Michelangelo, Leonardo, and Raphael—the idea of signing one's name to a work of art remained foreign, a practice that wouldn't fully take hold until the end of the nineteenth century.

Francesca and Laura began working their way back in time through earlier inventories and account books, hoping to find a citation that might reveal the source of the painting. Their visits to the archive settled into a routine. They came once or twice a week, usually together, after classes at the university. They rarely saw other researchers there, just the archivist, who would appear and disappear so silently they never heard her footsteps.

It took them hours to check the pages of a single inventory. Some of the old volumes had held up well over the years, but in others the ink had turned feathery brown on the brittle pages. They bent over the documents, trying to decipher the handwriting of notaries and bookkeepers, which was, it seemed, invariably small and difficult to puzzle out, with some entries in Latin and others in old Italian, full of abbreviations and curious spellings.

They found no mention of the painting in any of the inventories before 1666. They broadened their search. Camillo Pamphili had been an enthusiastic collector of art. He'd bought dozens of paintings from the estates of aging cardinals, minor nobility, and other collectors. They combed through account books, receipts, and sales documents, looking for some indication of how Camillo might have obtained the *St. John.* The trails

they followed branched out in bewildering complexity, full of detours and false leads.

When they grew discouraged, they reminded themselves that this painting had not simply materialized out of thin air. It had a history, if only that history could be known.

4

CORREALE CALLED FRANCESCA AND LAURA SEVERAL TIMES A WEEK, usually during the evening. His calls always began with an announcement of some new development. "Una cosa tremenda!" he would exclaim, and then go on at length about some scientific detail that researchers had discovered in an X ray of one or another of Caravaggio's paintings.

To Francesca, it never seemed like a "cosa tremenda." Even worse, Correale seemed to call just as she was walking out the door, or late at night when she was about to fall asleep. She'd hear in his voice the tone of someone who was settling in for an hour-long chat. She thought of him living alone in his tiny apartment with unpacked boxes, thinking about his wife, who was living with another man. He had a precarious air about him, Francesca once remarked, as if the ground beneath his feet had shifted. In moments of good cheer, he addressed her and Laura as "tesoro" and "cara," while at other moments, when something small happened to upset him, he'd fly into a fury, eyes bulging and hand smacking the table. He scared Francesca at those mo-

ments. She started avoiding his phone calls. Laura tolerated him better. She didn't hesitate to yell back at him. Once, when he called after midnight, she said in an angry voice: "Giampaolo! Don't you know what time it is? Don't you think I sleep?" He apologized, Laura told Francesca, but then he kept talking anyway and Laura didn't have the heart to hang up on him.

ONE WINTER AFTERNOON, ALONE IN THE DORIA PAMPHILI archive, Francesca came across a large collection of letters bound with string, written by Girolamo Pamphili, a cardinal who had died in 1610. He had lived in Rome during Caravaggio's day and he would have known of the painter's celebrity. His circle of acquaintances included men such as Ciriaco Mattei, the owner of the other *St. John,* and Cardinal Del Monte and Vincenzo Giustiniani, all of whom had bought paintings directly from Caravaggio. Francesca thought it might be worthwhile to read these letters.

Laura dismissed this idea as a waste of time, but Francesca decided to try anyway. She began at random, picking a letter out of the thick batch. And she succumbed to the delirium of the researcher. Girolamo's letters contained a portrait of Rome, detailed and domestic, lost to time. He wrote at length about buying a fancy new carriage, about the oppressive heat of the Roman summer and his plans to escape to his country villa, about dinner parties, church politics, and also about his health and hygiene. He fell ill in his early fifties—a problem with his bronchi and lungs, he wrote to a friend. Confined to bed, with

time on his hands, he described in detail his treatment, his diet, the periodic bleedings, the leeches applied to his skin to draw poisons out. And then his letters ended abruptly. The ailment, whatever it was, had killed him.

Francesca was captivated by this account of a life, but she found nothing relating to the painting and no mention of Caravaggio. Of course, she'd read only a small sampling of the letters. She realized that she could spend months sitting in the Pamphili archive reading. Perhaps she would find something important, but the chances were against it. And she didn't have months. Laura had been right—if she was trying to find the origins of the Doria painting, Francesca was wasting her time.

FRANCESCA, LIKE ALL STUDENTS OF ART HISTORY, KNEW THE broad outlines of Caravaggio's life. He had been resurrected from obscurity, in large part by Roberto Longhi, who had written in 1941 that Caravaggio was "one of the least known painters of Italian art." His eclipse occurred with astonishing rapidity. His realism had initially attracted many followers—the Caravaggisti, they were called—but the critics of his era found his paintings coarse and vulgar. They said that he did not understand the true essence of art and beauty, that he merely copied what he saw before him, that his work was no more than a "base imitation of nature." By the end of the seventeenth century, he was regarded as a minor painter of low repute. The years passed and few art connoisseurs bothered to take note of him. One who did, the nineteenth-century English critic John Ruskin, wrote in

disgust that Caravaggio fed "upon horror and ugliness, and filthiness of sin."

When Longhi put together his Caravaggio exhibition in Milan in 1951, many of the visitors, art historians among them, knew little or nothing about the artist. His paintings had long been consigned to the back rooms and storage bins of galleries and museums.

And then, in the years since that exhibition, Caravaggio scholarship suddenly, miraculously, blossomed into an industry. His rebirth into the world of art was swift, the mirror image of his disappearance three centuries earlier. Nowadays, it seemed to Francesca, almost every art historian with an interest in the seicento had a Caravaggio article in the works, and museums everywhere wanted to put on a Caravaggio exhibition, even if they had only one or two of his paintings. She called it "the Caravaggio disease." Sometimes she feared she would also be infected by it.

The accounts of much of his life remained sketchy. He arrived in Rome in 1592, in the late summer, or perhaps early autumn. He was twenty-one years old. He had come to Rome from Milan. Most likely he had walked, keeping company with wayfarers who banded together for protection against robbers. He entered the city's ancient walls through the Porta del Popolo, and from there he made his way to the Campo Marzio, the most densely populated district of the city. It was then, as it is now, a crowded district of narrow, winding lanes and shadowed passageways, opening every so often onto a sunlit piazza. The larger streets, the Via del Corso and the Via di Ripetta, were paved with cobbles, but most others were unpaved, dusty in summer, muddy

in winter. There were beggars and alms-seekers at every turn, fortune-tellers, jugglers, minstrels, prostitutes, street urchins, pilgrims, postulants, and, of course, priests in their black robes, and the endless cacophony of voices in dozens of dialects and languages. It was a city of odors, ripe and foul, chamber pots emptied every morning from windows overlooking the streets, in the marketplaces discarded vegetables and fruit rotting in piles on the ground, stray dogs scavenging around the butchers' stalls and the fishmongers' markets for offal amid the blood and flies.

It was said by the painter Giovanni Baglione that Caravaggio had found his first lodgings in Rome with another painter known as Lorenzo the Sicilian, who "had a shop full of crude works." Another account, by a doctor named Giulio Mancini, who also knew Caravaggio, said that he was given a room by one Pandolfo Pucci, master of the house for a relative of the former pope. He was ill-treated by Pucci, according to Mancini, made to do "unpleasant work" and given only greens to eat at every meal. To pay for his cramped attic room and miserable board, Caravaggio had to make copies of devotional figures, the sort of art that sold for a few scudi in stalls along the streets and in the Piazza Navona. At one point in those early years, an innkeeper named Tarquino gave Caravaggio a room. In payment Caravaggio painted the innkeeper's portrait, although that painting is now lost. During his first three years in Rome, he lived in as many as ten different places. He was exceedingly poor, reported Mancini, his clothing little more than rags. He lived on the bleak margins of the art world, selling his paintings in the street, along with hundreds of other young artists who had come to Rome to make their fortunes.

Francesca found herself enchanted by the brief moments, like scenes in a darkly lit play, that had emerged about Caravaggio's life. The most detailed and vivid of these came out of the voluminous records of old police reports.

There was, for example, an inquiry into an incident that occurred one Tuesday night in July 1597. It was notable for the fact that it constituted the first known physical description of Caravaggio.

Around sunset, shortly after eight o'clock, a dealer in paintings and secondhand goods named Constantino Spata was at work in his shop next to the church of San Luigi dei Francesi. He had already eaten dinner with his family—his wife and four children lived above the shop, in cramped quarters—when Caravaggio and another painter, Prospero Orsi, stopped by. Spata had sold a few paintings by Caravaggio for small sums of money. They were going out to eat, Caravaggio told Spata, and invited the shopkeeper to join them. Spata decided to accompany them to a nearby tavern, the Osteria della Lupa—the Tavern of the Wolf—just off Via della Scrofa. Some hours later, on returning to Spata's shop, the three men heard cries of alarm and saw a man racing in their direction. The streets were dark and Spata— or so he claimed in an interview before a magistrate—could not identify the man. A short distance farther on, they came across a black cloak lying on the ground, evidently the property of the fleeing man. Caravaggio bent down to pick it up. He had recognized the man and told the others he would return the cloak to him.

In the piazza of the church of Sant'Agostino, a two-minute walk from Spata's shop, Caravaggio banged on the door of a bar-

bershop. It was closed at that hour, but a light showed from within. Barbers of that era served as surgeons, and this barber, Luca by name, had once treated Caravaggio for a wound he'd gotten in a fight with a stablehand. Caravaggio knew the fleeing man as the barber's apprentice, and he handed over the cloak.

The barber Luca was summoned by the magistrate. In his testimony, Luca described Caravaggio in this way: a young man, around twenty or twenty-five, with a thin black beard, stocky in build, with black eyes, heavy brows, and thick unruly hair. He went about usually dressed in black, said Luca, his appearance disordered, with worn stockings and a threadbare cloak.

The precise nature of the incident—evidently it involved an assault or a vendetta—remains unknown, buried in the archives, or perhaps never pursued any further by the authorities. Caravaggio was apparently never called to testify. But to Francesca the police report captured a moment in time—a dark summer night on the streets of Rome—in the same way that Caravaggio's paintings seemed to arrest time. And to art historians, especially those afflicted with the Caravaggio disease, the details were precious. The testimony of Luca the barber, apart from his description of Caravaggio, also put a name to Constantino Spata, the dealer in paintings and secondhand goods who had sold at least two of Caravaggio's paintings in the days when he was living in poverty.

Spata, as it turned out, played a pivotal role in Caravaggio's fortunes. His shop was directly across the street from a great palazzo occupied by Cardinal Francesco Del Monte, then forty-four years old and a connoisseur of art. Passing by Spata's shop, the cardinal caught sight of a painting depicting a street scene in

Rome: two card hustlers cheating a naïve, well-dressed young man. It was a painting unlike any the cardinal had seen before— strikingly naturalistic, with a lucidity of color and light that stood out from the customary mannered scenes of saints and angels and billowing clouds. Del Monte bought that painting, which became known as *The Cardsharps,* for a few scudi. On another visit to Spata's shop, the cardinal bought a second painting, this one showing a young woman, a Gypsy fortune-teller, reading the palm of a smug, well-dressed Roman youth, smiling sweetly as she caresses his hand and steals his ring.

The details of the first meeting between Cardinal Del Monte and Caravaggio are lost to the past. Possibly the cardinal arranged the meeting through Spata; or perhaps Caravaggio, alerted to Del Monte's interest, arranged to be in Spata's shop when the cardinal came by. Caravaggio was then twenty-five years old, still living an itinerant existence, still near destitution. However the meeting occurred, it ended with Cardinal Del Monte offering Caravaggio room and board in his palazzo and freedom to paint.

And so it happened that Caravaggio, through his friend Spata, chanced upon the best of circumstances for an artist—he found a wealthy and appreciative patron who could advance his career by introducing him to other wealthy collectors. Caravaggio lived in Del Monte's palazzo for nearly four years. During that time he rose from obscurity to fame. Del Monte used his influence to get Caravaggio his first public commission, for the St. Matthew paintings in San Luigi dei Francesi, the paintings that Francesca had seen as a child.

5

It was the end of March and the meetings at Correale's apartment began to grow more frequent. He would summon Francesca and Laura and the rest of his small staff every week or so. The group was growing in size. Correale was in the midst of arranging some scientific tests on the two *St. Johns,* and now he brought in for briefings the technicians who would conduct those tests. There was detailed talk of X-ray machines and infrared cameras, of chemical analysis of paint fragments, of microscopic examination of the fabrics of the two canvases. Correale, of course, planned to be in attendance throughout. Francesca had rarely seen him in such a good mood. He rubbed his hands together in delight at the prospect of these tests, as if he were about to sit down to a banquet table.

The technical talk bored Francesca. She and Laura had spent weeks in the archive, and they had finally come up with a tentative answer to the origins of the Doria *St. John.* They made their report to Correale at the end of the meeting, after the technicians had departed. They had tracked down a group of twenty-

seven unnamed paintings purchased by Camillo Pamphili from an elderly cardinal in financial difficulty. They'd gone to the Archivio di Stato to examine the cardinal's papers, and they found that he had sold a painting of St. John. Almost certainly Camillo had been the buyer. The painting was attributed to a talented Spaniard named Jusepe de Ribera, who had studied in Rome as a youth and had adopted Caravaggio's distinctive style. Ribera was a good painter, good enough to have made a faithful copy of the original *St. John.*

Correale listened, nodding from time to time, and filling the air in the small apartment with smoke from his cigar. "And what about the Capitoline painting?" he asked when they'd finished.

They had been working on that, they told him. The first owner, Ciriaco Mattei, had lived in a grand palazzo, one of four Mattei palazzi, on the edge of the Ghetto district, not far from the Capitoline Hill. Francesca and Laura had gone there—it was still known in Rome as the Isola Mattei, the Mattei Island—only to learn that there was no Mattei archive there. Nor were there any Mattei documents in the Archivio di Stato.

But they did have a lead, they told Correale. They'd come across an article by a German scholar, published more than twenty years earlier, about the construction of the last Mattei palazzo, built during Caravaggio's day. On the first page of the article, in a footnote, the German had thanked Her Excellency Principessa Donna Giulia Antici-Mattei for having "so generously made available" the family archive in the town of Recanati.

Recanati was a small and ancient hill town, little more than a village, located on the Adriatic coast, in the region known as Le Marche. Laura had called the Department of Culture for Le

Marche, but no one there knew about a Mattei archive. She'd also called the city hall in Recanati, and gotten the same answer. Then they had tried to find the German scholar, but they'd had no luck. They didn't even know if she was still alive.

Correale pondered this. They could, of course, just go to Recanati and ask around, he suggested. It was small enough that they might find somebody who would know about an archive.

Francesca and Laura had considered doing that. But there was no guarantee that the archive was still there. The German had seen it, but that had been more than two decades ago. And getting to Recanati was not easy. There were no direct trains, and by car it was a trip of many hours across the Apennine Mountains.

<center>❧</center>

AT HOME ONE MORNING, FRANCESCA DID SOMETHING BOTH OBVIous and ingenious. She got out the Rome telephone book and looked up the name Mattei. The listings filled four pages. She ran her finger down the columns, looking for Giulia Antici-Mattei, and stopped at a listing for Guido Antici-Mattei.

A woman, elderly by the sound of her voice, answered the telephone.

Francesca asked if she could speak to the prince, Guido Mattei.

The woman gasped. Francesca imagined her hand fluttering to her chest. The prince had been dead for forty years, said the woman. She was his daughter, the Marchesa, Annamaria Antici-Mattei.

Amazing, thought Francesca. After forty years the family had not changed the telephone listing. Francesca expressed her regrets, apologized for her intrusion, and then said she was looking for the Mattei archive. Did the Marchesa know by chance anything about it?

The old lady was immediately suspicious. "Who are you?" she asked.

Francesca explained that she and a colleague were doing research on a painting by Caravaggio, a painting that the Mattei family had once owned.

The Marchesa spoke dismissively. "A German woman visited the archives some years ago. She wrote an article that contains everything. And another German has also come there, doing some research. You won't find anything new. The Germans already did everything."

Yes, replied Francesca, she had read the article. But perhaps there was something more in the archive that the Germans had overlooked, especially concerning this one painting. Would it be possible to visit the archive, just briefly?

"No, no, no," said the Marchesa, her voice querulous and high-pitched. "Impossible, completely impossible. It is all in Recanati, too far away. And I would have to be present, you understand. I cannot let just anyone rummage around among those papers. And besides, the Germans have already seen everything."

And with that the Marchesa said a firm good-bye.

Francesca felt the sort of frustration a child might feel peering through a store window at a coveted doll. The Mattei archive, unlike the Doria Pamphili, was virgin territory, explored only by a couple of scholars, and many years ago at that. It was

precisely the sort of place where she and Laura might have a real chance of finding something original and important.

That evening Francesca called Laura and recounted her conversation with the old lady. Laura, of course, favored the direct, blunt approach. They should call the Marchesa back. They should implore her to let them see the archive.

"It's no use," said Francesca. "The woman has made up her mind. Calling her again won't change that. It will just annoy her."

They had no choice, it seemed, but to go back to the libraries and through the motions of research, citing documents by other historians, who had in turn cited earlier historians and all the familiar old travel guides and early biographers of Caravaggio.

<hr>

THE NEXT MORNING, RIDING HER MOTORINO INTO THE CITY, Francesca found herself thinking about a friend from high school named Stefano Aluffi. He was himself descended from a family of minor nobility—he could claim the title of count, although he never used it—and he had a passion for Roman history and genealogy. He was tall and blond, and carried himself, on first acquaintance, with an Old World courtliness. He kept in contact with many of the old nobility, friends of his parents, and their descendants, who were his own contemporaries. He maintained, only half jokingly, that no household was complete without the *Albo d'Oro*—the "Gold Register" of Italian nobility.

Francesca recalled that Stefano had once introduced her, at some party or another, to a striking young woman whose name was Sabina. She and Sabina had talked, just briefly, in the way

one does at parties, and Francesca had never seen her again. But she recalled now—why hadn't she thought of this earlier?—that Stefano had said Sabina was related to the Mattei family of the famous Isola Mattei.

Nowadays Francesca and Stefano might run into each other once a month or so, at the occasional dinners and parties of mutual friends. But a few years ago, when Stefano had arrived at the University of Rome to study art history, they'd spent a lot of time together. He had come to her for help. Like most new students, he'd gotten lost in the crowds and endless bureaucracy of the place. Francesca became his "spiritual adviser," as he later put it. They had taken many of the same classes, they had studied together at her house, and she tutored him well enough to enable him to graduate.

Francesca called Stefano and asked him about the Mattei family. Was Sabina in fact related to the same family that had owned the palazzi in the Ghetto? Stefano, who kept track of these things, said Sabina was the niece of the Marchesa, Annamaria Antici-Mattei.

Francesca explained that she wanted to see the Mattei archive and Annamaria had refused permission. Could Stefano ask Sabina to intercede on her behalf? Talk to her aunt and assure the old lady that she, Francesca, was not making a frivolous request, that she was a serious scholar?

A few days later Stefano called Francesca back. Sabina had talked to her aunt. He thought that she had convinced the old lady to let Francesca into the archive. He suggested that Francesca try calling the Marchesa again.

This time the Marchesa sounded more welcoming. Her

niece, of whom she was quite fond, had vouched for them. Why had Francesca not mentioned that she knew Sabina? But she warned Francesca again that the research would be a waste of time, and that they could stay only a day or two. The archive was kept in an old palazzo, the last of the family's once great holdings. The Marchesa used it as a summer house. It had no heating and was empty most of the year. The Marchesa said she would go to Recanati in late April, after Easter, to open up the palazzo. They could come then, if they liked.

"CHE BRAVA!" CORREALE SAID EXUBERANTLY WHEN LAURA TOLD him they had found the Mattei archive at last. He grew annoyed, though, when Laura said they couldn't get into the archive until the end of April. That was a month away. Couldn't they convince the Marchesa to let them see it sooner?

Francesca refused to ask the Marchesa again. She was afraid the old lady would grow irritated and withdraw her permission. Correale got upset, but in the end he could only resign himself to the wait.

6

The Bibliotheca Hertziana occupied three buildings on Via Gregoriana, at the top of the Spanish Steps. The oldest of the buildings dated back four hundred years. Inside the library, the rooms were connected by a network of dark passageways and staircases that twisted and turned in labyrinthine complexity. The library, privately run by a German institution, was devoted solely to the study of art and architecture, particularly the Renaissance and Baroque. Entry was gained by permit only, and the grant of permits was strictly controlled. The Hertziana was the domain of scholars with credentials, not of students.

Francesca managed, after many applications and pleas, to get a temporary pass to the library, good for fifteen days. It was her second such pass, and her most valued possession.

She had a favorite place in the library, a long wooden table, scarred from years of use, on the third floor amid the shelves of books, in a pool of lamplight. At the far end of the table, the afternoon sun came in through tall French doors, which opened onto a balcony where a tangle of overgrown roses and vines grew

from cracked terra-cotta vases. From this spot, Francesca looked out the French doors to the sprawl of Rome below, the tiled rooftops and church domes, and in the distance, in the blue haze across the Tiber River, the great dome of St. Peter's. She could almost see the top of the building where she had been born, at the foot of the Spanish Steps, in a fifth-floor apartment overlooking the Via dei Condotti. In the days before that street had turned completely to glitter and commerce, before Gucci, Valentino, and Versace, Francesca's mother would go out to buy fruit and vegetables at the stalls on Via Bocca de Leone and come face-to-face with Sophia Loren and Alberto Moravia.

The Bibliotheca Hertziana stayed open until nine o'clock every night, and Francesca rarely left before then. At her table, she collected dozens of articles and monographs about Caravaggio and began reading through them. Many offered nothing particularly new or interesting, just the background noise of art scholars going about the business of advancing their opinions or disputing the opinions of their colleagues. Sometimes in an article, a real piece of information—an actual fact, a date, a contract—would emerge from the vast tangled swamps of archives. Then it would be scrutinized and interpreted by the confraternity of Caravaggio scholars, and if it withstood examination, it would assume its place in the assembled landscape of Caravaggio's life.

That landscape was a mere patchwork of moments. Only recently, for example, had scholars discovered that Caravaggio had been born in 1571 and not 1573, as they had long assumed. It was known from documents found in Milan, near his birthplace in the town of Caravaggio, that he had been apprenticed at the age

of thirteen to a painter of minor consequence named Simone Peterzano. No one knew whether he'd finished that apprenticeship, or why he'd left Milan to come to Rome. He could read and write—an inventory of his possessions taken at the time of his eviction from a house in the Campo Marzio listed a dozen books, although none of the titles—but not a single letter or document written by him had survived. Only the police records captured a few moments with the sort of immediacy and detail that Caravaggio himself had captured in his paintings. There was the afternoon of April 24, 1604, when he flung an earthen plate of cooked artichokes in the face of a waiter named Pietro de Fosaccia at the Osteria del Moro. Or the night of November 18, when he was stopped by the police near the Piazza del Popolo for carrying a sword and dagger and, after presenting a permit for the arms, told the police, "Ti ho in culo," "Shove it up your ass." On the evening of July 29, 1605, he struck a young lawyer named Mariano Pasqualone with his sword in the Piazza Navona. The lawyer, wounded in the head, told the police that he and Caravaggio had argued the day before over a girl named Lena who worked as a model for the painter—"She is Michelangelo's girl," the lawyer said.

From her table on the third floor of the Hertziana, Francesca could look out the French doors and see the places where these events and a dozen others in the police reports had occurred. The layout of the streets and piazzas of central Rome remained more or less the same today as four hundred years ago. Yet for all these details, pieced together like a mosaic to construct a narrative of his life, Caravaggio himself remained unknown, an enigma.

✄ 7 ✄

FRANCESCA BORROWED HER SISTER SILVIA'S CAR FOR THE TRIP TO
Recanati. Silvia had just bought the car used, a type known as an
A 112. It was tiny, with a forty-three-horsepower engine that
coughed and shuddered when Francesca shifted gears. The
bumper was loose and there were rust spots on the fenders,
which had once been blue but had faded to gray. Through a hole
in the floorboards, Francesca could see the pavement passing
beneath her feet.

She left home on an April morning, a week after Easter. In
Rome, the day was sparkling and the skies a deep blue, the tem-
perature sweetly springlike. Francesca drove through crowded
streets to the apartment where Laura lived with her mother and
brother in the south of the city, near Via Marconi. Francesca was
not, as she herself readily admitted, a skillful driver. She drove
slowly, not out of caution but because of distraction: her mind
was forever wandering to issues more interesting to her than
driving. Motorists behind her would honk their horns and ges-

ticulate angrily as they passed her. She always looked mysti-
fied—large eyes opened wide—at their ire.

Laura put her overnight bag in the backseat and they set off,
their spirits high, laughing and looking forward to an adventure.
Within a few minutes, however, Laura began to get worried. It
seemed that Francesca had no idea where she was going. She
made one wrong turn, and then another. Laura began giving di-
rections. When Francesca reached into the backseat to retrieve
a book she wanted to show Laura, talking all the while, the car
veered toward the sidewalk. Laura gasped. She could endure it
no longer.

"Listen, Francesca," she said, "I think it would be better if I
drove."

Francesca happily agreed.

In Laura's capable hands, they left Rome without incident,
heading north on the Via Salaria, following the ancient Roman
route toward the Adriatic. The trip to Recanati would take
them over the Apennine Mountains, the spine of Italy, to the
Adriatic Sea. In little more than an hour they reached the
foothills. Ahead of them lay snowcapped peaks, shrouded in
mist. A chilly breeze came up through the holes in the floor-
boards. The car's tiny engine rattled, the gears made grinding
sounds. As the grades grew steeper, traffic on the two-lane road
began to back up behind them. Laura pulled over to the right, to
the edge of the pavement, and they climbed in slow motion.
Laura said they might have to get out and push the car to the top.
Francesca looked worried, but Laura laughed.

Cresting a long rise, they could see off to their right the great

peak of Gran Sasso—the Big Stone, the highest of the Apennines. On the descent, the car gathered momentum. Laura discovered that the brakes were not much better than the engine, but the road was wide and the curves gentle, and Laura liked speed. In the far distance, they saw the dark blue horizontal line of the Adriatic, dividing sky and earth. At the coast, at the small town of Giulanova, they turned left and drove north along the shoreline to Ancona. The day was so clear and bright that they could see the faint outlines of the Dalmatian coast across the Adriatic.

THEY ARRIVED AT RECANATI SHORTLY AFTER TWO IN THE AFTERnoon. The town was eight miles inland from the coast, built a millennium ago on a hilltop. The little car struggled up the winding road, past groves of olives, in the shadow of an ancient defensive wall, crumbling in places, that still encircled the town. As they climbed, the countryside spread out before them like a storybook land—the Adriatic to the east, the Apennines to the west, and neighboring towns shimmering in the sunlight on their own hilltops, rising from the undulating plains below.

They entered the town through the remains of an old gate and drove down a narrow street paved in cobbles. They had made reservations at La Ginestra, a hotel named after a famous poem by the nineteenth-century writer Giacomo Leopardi. They went down Via Leopardi and past the central piazza of the town, Piazza Leopardi, which was of course dominated by a bronze statue of Leopardi. The poet, who had died young—he

was partially blind and suffered a spinal deformity that had bent him nearly double—had repeatedly tried to escape the place of his birth. He regarded it as a virtual prison. Now he was permanently entombed there. The town was small enough that they didn't bother to ask directions. It's the sort of place, remarked Laura, where everybody knows if you bought a new scarf, or how many lovers your mother had.

The hotel was run by a family, the same family that had run it for generations. From a door in the rear emerged a middle-aged woman, smiling and wiping her hands on an apron. All twenty-eight rooms had been occupied over Easter with tourists, said the woman. Now Francesca and Laura were the only guests. There was a small breakfast room, each table with a pink tablecloth and a vase of flowers, and windows looking out onto a garden. The sitting room had an upright piano and a TV. It looked as if it was used more by the family as their living room than by paying guests. Children's drawings and schoolbooks and homework papers were spread on the desk. Correale had agreed to pay the bill—forty-five dollars a night—for a single room with two beds.

The woman gave them directions to the Palazzo Antici-Mattei. "Just a short walk," she said. Everything in Recanati was just a short walk away. Turn right outside the hotel, go past the bar Il Diamante, past the church of San Vito, and then right again on Via Antici. They couldn't miss it.

They set off promptly, encountering only a few people, mostly elderly, on the street. A breeze from the sea made the air feel cooler in Recanati than in Rome, and they wore their jackets. In five minutes they reached the palazzo, at number 5 Via

Antici. It was three stories high, built of brick and covered by an old stucco finish that had fallen away in places, stained with streaks of rust and moss. The large wooden door had been painted green, but the paint was cracked and peeling now, as were the closed, sagging shutters along the row of windows on the upper floor.

Laura rang the bell. They stepped back and composed themselves, wanting to present a pleasing aspect to the old woman. A minute passed, and then another. Laura rang the bell again. They could hear it sounding distantly inside the building, but no one came to the door. Francesca peered through the heavy iron grating that covered the ground-floor windows, but she could see nothing. Once again they rang the bell, and this time Laura made a few heavy thuds of her fist on the door. Nothing.

"What should we do?" asked Francesca, gazing around.

Another, smaller door fifteen feet away seemed to be part of the building. They decided to knock there. They heard voices and movement inside, and at last an old woman, bent over a cane, hair gray and wispy, appeared. She was wrapped in several sweaters and wore two pairs of glasses, one atop the other, which had the effect of greatly magnifying her eyes. She was missing several teeth. She peered up at them suspiciously.

"We have an appointment to visit the Marchesa," Laura said. "But no one seems to be home next door."

"Yes, yes," said the old woman, "the Marchesa is there." She told them to wait and disappeared into the darkness of the room. A moment later she returned with a large key in her hand. When the Marchesa was away in Rome, she explained, she and her husband took care of the palazzo.

She led Francesca and Laura a few paces down the street to the green door, moving with surprising speed and agility on her cane. They followed her into the entryway. In front of them a large courtyard with a few small lemon and fig trees lay open to the sky. In another era, it would have been a gracious setting, but now it had a dilapidated, untended look, with a pile of dead leaves blown into a corner, weeds sprouting here and there from cracks in the tiled floor. They stood in the entryway while the old woman went in search of the Marchesa. They could hear her high, raspy call—"Maria! Maria!"—fading down one of the corridors, and then silence.

"One old lady in search of another," Laura whispered to Francesca.

A few minutes later they heard voices coming toward them and the stumping of the old custodian's cane on the tiled floor. Then two women appeared side by side. To Francesca, they seemed to be about the same age, but they were a study in contrasts. The Marchesa was tall and thin, her carriage erect, and she wore a colorful spring dress, a bit out of style perhaps, but still elegant. Her face was long and narrow, her eyes deep blue, blond hair turning to gray, cut short and neatly coiffed. There was something about her appearance that put Francesca in mind of British aristocracy, of the way, Francesca imagined, that Agatha Christie might have looked. Except, of course, the Marchesa's ancestry was Roman as far back as anyone could trace.

The Marchesa greeted them politely but with reserve. Francesca felt a momentary impulse to curtsy. She introduced herself and Laura, and the Marchesa held out a frail, trembling hand. On closer encounter, the Marchesa showed her age. Her face

was deeply lined, and her lipstick, thickly and inexpertly applied, had smudged at the corners of her mouth and the margins of her narrow lips.

"So," said the Marchesa, "you have come to see the archive? Now, what is it that you are searching for? What is the subject?"

They explained—the origins of Caravaggio's painting of St. John, once owned by the Marchesa's ancestor Ciriaco Mattei. Francesca had already explained this to the Marchesa some weeks ago on the telephone, but she did not seem to remember.

"Well, since you are here," the Marchesa said, "I will let you enter. But in my opinion, it will be a waste of time. This German woman has already gone through everything. We have become friends. She has seen everything and done everything."

The Marchesa led the way to the archive, down a flight of stone stairs to the cellar. They entered a large rectangular room, dimly illuminated by the daylight that filtered through two rectangular windows high on the opposite wall. There was no glass in the windows; they were covered only by a rusted iron grating and opened directly at street level. The Marchesa turned on a light—a single bare bulb suspended from the high ceiling. At the center of the room there was a long wooden table, squarely placed under the light of the bare bulb. Several opened cardboard boxes sat on the table, along with a few large leather-bound volumes and folders containing loose sheets of paper. Many more boxes sat on the brick floor. Along the walls, the Marchesa had installed—recently, by the looks of it—gray metal shelves to hold the archives.

Francesca thought of the Doria Pamphili archive, with its

high ceilings, shaded lamps, and tiled floors. This place felt damp and smelled musty, the odor of decay.

The Marchesa lit a cigarette. She was, Francesca and Laura would soon learn, an inveterate smoker. For the last few years, she told them, she had occupied herself with reorganizing the archives according to a new scheme she had discussed with the German woman. "Un grande impegno"—"a big undertaking"— the Marchesa remarked, gazing at the hundreds of volumes and folios on the gray metal shelves.

She opened a small notebook and asked them to sign their names. "Now, what is it you are looking for?" she asked again. And again Francesca explained. They would start with the inventories of the 1600s, and then try to find the account books.

The Marchesa donned a long white cotton shift that buttoned up the middle, the sort of coat a doctor might wear, and a pair of cotton gloves. "To protect myself from the dust," she explained. Indeed, the room was dusty. In the weak shafts of sunlight from the small windows, Francesca could see motes of dust, and the table was covered with a fine grit blown in from the street.

Francesca's eyes went to the leather-bound volumes on the steel shelves. Most were identified with labels on their spines, the legacy of an archival organization created in the early nineteenth century, when the documents were still housed in the family palazzo in Rome. But that organization had been turned topsy-turvy with the transport of everything to Recanati. Francesca ran her hand along the books. She felt as if she were touching history.

The Marchesa directed them to a collection of inventories

from the early 1600s. Most of these were contained in bound volumes, but a few were simply loose, in boxes that opened much like books. The first inventory, from 1603, concerned the possessions of Girolamo, the second of the three Mattei brothers. He had been a cardinal, an able administrator who had directed the city's Department of Streets and then the Department of Prisons. Some scholars believed that he had been Caravaggio's patron, and not Ciriaco. But his inventory recorded only eighteen paintings at the time of his death at age fifty-six, and these were devotional images of little consequence. It was clear to Francesca and Laura that Cardinal Girolamo Mattei had little interest in art.

The second and third inventories, dated 1604 and 1613, belonged to Asdrubale, Ciriaco's younger brother. Both had been compiled during his lifetime, at Asdrubale's request, by his maggiordomo, who oversaw the operations of the palazzo. They were bound in leather and much lengthier than Girolamo's. Asdrubale had built his own palazzo, a grand and imposing edifice, next to that of his two brothers, and had spent a fortune furnishing and decorating it. The German scholar had already examined Asdrubale's inventories at great length. Francesca and Laura leafed through them quickly and put them aside.

It was the inventory of the oldest brother, Ciriaco, that they most wanted to see. He had died in 1614, at the age of seventy-two, an advanced age in that day. He had left his entire estate to his son, Giovanni Battista. But it wasn't until two years later, on December 4, 1616, that the son ordered an inventory of his own possessions and those he'd inherited from his father. The volume that contained this inventory was also bound; it ran some

one hundred and fifty pages, on heavy paper. It had the name "Giovan Battista Mattei" on the cover, but it had somehow escaped the old filing system by which the archive had been organized. Francesca and Laura realized that they were the first to lay hands on it in decades.

They sat at the table, shoulder to shoulder under the solitary lightbulb, and opened the book. It was organized by category— furniture, statuary, books, jewelry, rugs and tapestries, silverware, carriages and horses, property of every conceivable sort. The list of paintings began on page twenty-one. The handwriting, by a notary named Ludovico Carletti, was bold and clear, the ink as fresh-looking as if it had been applied a week ago. Laura moved her finger down the list of paintings, reading each aloud in a soft voice. The Marchesa sat at the far end of the long wooden table, smoking a cigarette and casting an inquisitive eye at the two young women.

At the bottom of the page, Laura's finger stopped. They read the line together: "A painting of San Gio. Battista with his lamb by the hand of Caravaggio, with a frame decorated in gold."

Francesca let out a small cry of delight. They had found it, the earliest mention of the painting to come to light.

They began whispering excitedly together. At the end of the table, the Marchesa looked up sharply. "What is going on?" she demanded. "What have you found?"

Francesca felt compelled, for some reason she herself could not explain, to diminish the importance of their discovery. "Oh," she replied to the Marchesa, "it is just a word in the inventory that we didn't understand."

"Ah," said the Marchesa, nodding her head. She puffed on a

cigarette and went back to her work. She had three files opened in front of her and shifted papers with her white-gloved hands from one file into another. Occasionally she made a comment. "I found something concerning the building of the palazzo," she said. "Is that something you are looking for?"

"No, it isn't," Francesca replied.

And the Marchesa said, in consternation, "I really don't understand what it is you are looking for. What is the subject?" Every half hour, it seemed, the Marchesa asked them the same question, and they gave the same answer.

Francesca watched the Marchesa out of the corner of her eye. The old lady picked up a yellowed card, an index of the documents contained in one file, studied it for a moment, and then ripped it in half.

"Interesting, this work of yours," Francesca said. "May I ask what is it you are doing exactly?"

The Marchesa explained that she was changing the archive from its old chronological system. She was more interested in the people in her family than in a simple chronology. Consequently, she was organizing the documents so that those pertaining to a particular person—Ciriaco, for example—would all be gathered in one place. "After this, it will be much easier to find everything," she said.

"Ah, I see," said Francesca.

Francesca and Laura talked in low voices between themselves. Watching the Marchesa at work, Laura whispered, was like watching someone clean house by throwing things out the window—plates and silverware, pots and pans—as if that were completely normal.

They went back to the inventory. Ciriaco Mattei had owned, according to the earliest sources, at least three paintings by Caravaggio, and perhaps more. On the next page, midway down, they saw Caravaggio's name again, this time for the painting called *La Presa di Giesu Cristo*—*The Taking of Christ*—the painting that had been missing for hundreds of years. Francesca and Laura had both seen photographs of the many copies of the painting, and they'd read articles by Roberto Longhi, who had been obsessed with finding it. The inventory described the picture as having a black frame decorated with gold, and a red drapery with silk cords that had been used to cover it.

They had been in the archive only two hours and they had already found two important entries concerning Caravaggio. They had conclusive proof now that Ciriaco had owned both the *St. John* and *The Taking of Christ*. If they achieved nothing else, they could consider their trip a success. But they hoped to trace both paintings back even further. The Mattei brothers had kept careful account of their expenditures. The German scholar Gerda Panofsky-Soergel had found Asdrubale's *libri dei conti*, account books, and had published hundreds of items dealing with the cost of constructing his new palazzo. And yet no one, it seemed, had ever looked through Ciriaco's account books.

They found three of Ciriaco's leather-bound account books, each about two hundred pages long, on the same shelf as the inventories. Written on the cover of the first book were the words "Rincontro di Cevole dal 1594 al 1604"—"Account of Expenses from 1594 to 1604." The second one, similarly labeled, covered the next seven years, up to 1612. The last one contained only two years of expenditures, the last two years of Ciriaco's life.

They opened the first account book. Every page, front and back, was densely covered with entries in black ink. The writing was small, but the hand was neat and orderly, and it was consistently the same hand throughout. On the far right of each page they saw a column of numbers, and at the bottom, under a heavy line, a total of that page's expenditures.

Ciriaco would have had a bookkeeper, a computista, to keep a record of daily expenses for running the palazzo, for the purchase of food and wine, for payments to merchants and employees. But this book did not contain these sorts of mundane entries. It appeared to record mostly works of art—statues, paintings, frescoes—as well as improvements Ciriaco had made to his palazzo and his garden.

It took Francesca and Laura time to decipher the handwriting. The entries were full of abbreviations, a sort of informal shorthand, and words spelled in the old manner, the English equivalent of reading Shakespeare. They noticed a distinctly personal phrasing in some of the entries—"thirty scudi paid on my behalf to Franco the sculptor for the price of a statue bought for my garden." It dawned on them that a bookkeeper hadn't kept this account, that Ciriaco himself must have written out these entries. To Francesca, they acquired a sudden and beguiling intimacy. She ran her finger across the handwriting, touching the ink on the page.

Ciriaco had been a diligent accountant. He had noted payments as small as eight scudi and as large as two thousand. In an era when it cost forty-five scudi to rent a house for a year in the Campo Marzio, he had spent astonishing sums—thousands of scudi every year—on his passion for art.

He could afford it. The Mattei fortune was built on vast agricultural holdings in the Roman countryside, on vineyards, olive groves, wheat fields, and especially cattle, and these had made the family fabulously rich. Ciriaco's ancestors had a talent for prospering even when times were bad. After the Spanish sacked Rome in 1527, when all was chaos and uncertainty and thousands of people fled the city, the Mattei clan bought up property at a fraction of its value. By the time of Ciriaco's birth, in 1542, the family was perhaps the richest in Rome, with a household staff to manage its affairs that numbered more than three hundred, second in size only to that of the papal court.

Francesca and Laura scanned quickly through the entries for the first years. The light coming in the small windows overhead faded to dusk, and their eyes burned with the effort of reading the tiny handwriting by the light of the single overhead bulb. The Marchesa, meanwhile, had grown more loquacious as the afternoon passed. Francesca, trying to be polite, turned her attention to the old woman while Laura continued to read. The Marchesa was smoking a cigarette and reminiscing, talking about her childhood in the palazzo in Rome, the elegant dinner parties and concerts, the tables set with the finest crystal and silver, the beautiful rooms with gilded ceilings and frescoes on the walls, the staff of twenty servants. It had all ended, the Marchesa recalled, her voice turning brittle, on a day in 1933, when she was twelve years old. Her mother told her one evening, just before her bedtime, that they would leave the palazzo the next day and move to an apartment on Via del Plebiscito, into a building owned by their friends the Doria Pamphili family.

A strange coincidence, thought Francesca, that the two fam-

ilies should be linked by friendship as well as the twin St. John paintings.

"Imagine," the Marchesa said to Francesca, "from one day to the next, without any warning, my life had changed completely."

Her family had brought with them only their clothes and a few personal items. All of the paintings, the statues, the furniture, the tapestries and rugs—everything that had belonged to the Mattei family for generations—all of that they left behind. Of course, at the age of twelve, she had not understood how this could have happened. Her parents spoke only vaguely of debts. It was only later that the Marchesa learned the details of how her father, Prince Guido, had gambled away everything in card games. He'd lost what remained of the family's patrimony in a final game with a count named Pierluigi Donini Ferretti.

The ruin of the family's fortune was not the fault of the Marchesa's father alone. The decline had begun much earlier, in the generations after Ciriaco's death, a common story of folly and indolence, of great wealth sapping the ambition and industry of those born into it. But it was also the consequence of events beyond the control of Ciriaco's descendants. Napoleon's army had swept through northern Italy in 1798 and occupied Rome. To pay for the army's keep, Napoleon's administrators had levied punitive taxes on the Roman nobility. The Mattei family had been forced to sell many of their possessions, among them the paintings by Caravaggio, Guido Reni, Antiveduto Grammatica, Lorenzo Lotto, Valentin de Boulogne, and Francesco Bassano. They'd had to borrow money at usurious rates, and then sell even more of their patrimony to pay the moneylenders. They had survived

that period, much diminished, up until the Marchesa's father started losing at the card table.

By the time the Marchesa had told her story, it was dark outside and the cellar had grown chilly. The Marchesa seemed dispirited. Francesca and Laura decided it was time to leave for the night. The Marchesa accompanied them up the stone steps to the front door. They asked her permission to return the next morning, and the Marchesa, looking sad and distracted, merely assented with a nod.

8

THAT EVENING, FRANCESCA AND LAURA ATE IN A RESTAURANT next to the hotel, sitting before windows that looked out over the countryside toward the Adriatic. They knew Correale would be pleased with the citation of the *St. John* in Ciriaco's inventory. Laura had a feeling that tomorrow they might find something even better in the account books: the actual date and record of payment. It was just a matter of time and persistence. It was a good thing they had gotten to the archive now, Laura said. The Marchesa was turning it upside down. No one would be able to find a thing after she finished her work. And, besides, there was always the risk that she might set the entire palazzo aflame. She was so absentminded she might leave a smoldering cigarette in a cellar full of old paper.

The Marchesa greeted them at the door the next morning, in distinctly better spirits. She offered them coffee; she seemed to want to chat, especially with Francesca, as if this were a social call. Francesca felt inclined to humor her, but Laura said they really should get to work on Ciriaco's account books. The Marchesa,

suddenly looking a bit out of sorts, accompanied them down to the cellar.

She fixed them with a stern look as she donned her white gloves. "Now, tell me," she said, "what is it exactly that you are looking for? What is the subject?"

They opened the account book to the place where Laura had left off the previous night, on the page that marked the start of the year 1600. It was at the end of that year, or perhaps in the spring of 1601—no one knew for certain—that Caravaggio left Del Monte's palazzo and took up residence with Ciriaco Mattei. The parting with Del Monte had been amicable. Caravaggio saw him again several times and relied on him when he got into trouble with the law.

In Ciriaco's household, as in Del Monte's, Caravaggio would have lived on the third floor of the palazzo. He would have had a room to himself, one large enough to use as a studio, rather than sharing cramped quarters with other servants. His circumstances had vastly improved. He lived under the protection of a powerful and wealthy patron, he received free room and board, and Ciriaco would have paid him the going rate for his paintings. Furthermore, Caravaggio was free to paint for others, not just for Ciriaco. By then, his fee was the highest of any painter in Rome. After the success of two public commissions, in the churches of Santa Maria del Popolo and San Luigi dei Francesi, his work was in great demand. He was twenty-eight years old, and the talk of Rome.

Francesca and Laura worked their way through the entries for 1600, but found nothing concerning Caravaggio. Laura grew momentarily excited when she found a reference to a "Mich'

Angelo pittore." But it was for work in the garden, and for only ten scudi. Caravaggio commanded much higher sums.

They went slowly and carefully through the year 1601, but again found nothing. By then, Caravaggio certainly was living in Ciriaco's palazzo. They each began to feel a sense of resignation, although they said nothing of it to each other, as the possibility grew that they might not come across anything more significant than they'd already found.

Francesca had gotten up from her chair when she heard Laura softly exclaim, "Ecco!"

The date was January 7, 1602, and Ciriaco had written in a clear, unmistakable hand the name "Michel Angelo da Caravaggio pittore." The payment was one hundred fifty scudi for the painting of—and here they had difficulty deciphering Ciriaco's handwriting. It seemed to say, "for the painting of N.S. in," and then two words that were unclear. One of them looked as if it began with a "p"—could it be "padrone," meaning master or owner? The "N.S." probably meant "Nostro Signore," a common reference to Christ.

The Marchesa, her attention attracted by their excitement, looked on with curiosity. "You've found something interesting?" she asked.

"Possibly," replied Francesca, "but there are some words we don't quite understand."

They each copied out the entry in their notebooks as precisely as they could, mimicking Ciriaco's handwriting for the words they couldn't decipher. The entry was four lines long, a record of payment to Caravaggio that no one had seen since the moment Ciriaco wrote it almost four centuries ago. Almost cer-

tainly it referred to the painting known as *The Supper at Emmaus*, which Baglione had seen in Ciriaco's palazzo. It now hung in London, in the National Gallery.

Two pages later—it took Francesca and Laura half an hour of reading to get there—they found another payment to Caravaggio. The date was June 26, 1602, and the sum was sixty scudi, but this time Ciriaco did not specify the reason for the payment. Could it have been for the *St. John*? Sixty scudi seemed a rather small sum for Caravaggio, but the *St. John,* after all, depicted just a single figure.

They worked quickly, skimming through the entries, occasionally sharing a glance with each other. Now they knew for certain that Ciriaco had been a diligent bookkeeper and that they would find the other payments to Caravaggio. Such a find was the grail for all art historians, the closest one could come to the past creation of a work of art.

The next payment came at the beginning of the year 1603, on January 2. And this time they understood immediately which painting Ciriaco had bought. One hundred and twenty-five scudi "for a painting with its frame of Christ taken in the garden."

"*La Presa di Cristo,*" murmured Francesca.

The Marchesa looked over with inquiring eyes.

"Another painting by Caravaggio," explained Francesca.

"Now, is that the one you're looking for?" asked the Marchesa.

"Not exactly," replied Francesca. "It's been lost for many years."

"Ah," said the Marchesa, narrowing her eyes. "What happened to it?"

"No one knows for certain. Several people have looked for it, but they haven't found it."

"Such a pity that we have lost everything," said the Marchesa in a dolorous voice.

Francesca and Laura had found three payments, and Baglione had written that Ciriaco had owned three paintings by Caravaggio. And perhaps Ciriaco had bought even more. Baglione said that Ciriaco had owned *The Incredulity of St. Thomas*—a painting now in the Bildergalerie in Potsdam, Germany—but they'd found no reference to it in any of the inventories. They pressed on. Several pages later they saw Caravaggio's name again, a payment of twenty-five scudi. A small sum, given the other payments, and a little mystifying. Ciriaco once again did not specify what he had paid Caravaggio for.

By now it was early afternoon. They had not taken a break for coffee or for lunch, but neither of them felt hungry. They read through another year of payments—1604—hoping to find more, but not expecting it. By that year, Caravaggio had left Ciriaco Mattei's palazzo. They went back to the first payment and slowly checked through the entries again to make sure they had overlooked nothing about the *St. John*.

Laura was not completely satisfied. She felt troubled at not having found a specific mention of the painting. Correale will not be happy, she told Francesca.

Francesca was not much concerned about Correale. They had found enough to set the world of Caravaggio scholars—those with the Caravaggio disease—into a frenzy. And the payment of sixty scudi without mention of a painting was, in all probability, for the *St. John*.

The archive was almost too good to leave, a trove of discoveries waiting to be made. But it was almost four o'clock in the afternoon and they decided to return to Rome with what they'd already discovered. They would have to come back, and that meant convincing the Marchesa, but Francesca sensed that the old woman liked her. And the Marchesa's trust in them seemed to have grown. She'd spent part of that day upstairs, apparently feeling it wasn't necessary to monitor them.

They were just about to leave when Francesca, holding Ciriaco's account book, paused for a moment. "I think we should hide it," she whispered to Laura. "There are three hundred other books the same size. If the Marchesa changes the number, it will take us hours to find it again."

The Marchesa had several piles of books on the table and on top of boxes on the floor, work that she'd already completed. Francesca slid the book into the bottom of one of those piles. The Marchesa had been working in the archive for years, and she'd made slow progress. Francesca figured there was a good chance those piles would remain untouched until she and Laura returned.

9

THEY ARRIVED BACK IN ROME AROUND MIDNIGHT. ON THE RIDE home, they discussed what they should do with their findings. They would, of course, call Correale tomorrow morning. Francesca suggested they also talk to Maurizio Calvesi, their professor at the university. He had been head of the art history department for many years and was just then finishing a book on Caravaggio. Francesca thought he would want to have these dates and records of payment.

Francesca's mind kept returning to the payment for *The Taking of Christ*. She recalled sitting in the Bibliotheca Hertziana just before the trip to Recanati and reading in the art journal *Paragone* a brief article by Roberto Longhi, only three pages long. It had attracted her attention because Longhi had commented on Gerda Panofsky-Soergel's research at the Mattei archive.

Francesca remembered the article clearly, partly because of the disdain with which Longhi had treated the German scholar. Age had not mellowed his acid temperament. It had irritated him that Panofsky-Soergel had gotten access to an archive

which had been, he wrote, "long precluded to Italian scholars." It apparently further irritated him that she was a woman. He kept referring to her as the "kind lady," and the "illustrious woman," although he clearly meant neither. Worst of all, Longhi implied, Panofsky-Soergel had no idea what she was looking at, and she had compounded her ignorance by making no attempt to understand what she had uncovered.

Francesca recalled that Longhi had made a particularly interesting deduction from one of the documents that Panofsky-Soergel had found in the Mattei archive. The document was dated February 1, 1802, and it concerned the sale of six Mattei paintings to a rich Scotsman named William Hamilton Nisbet. The first painting on the list was called *The Imprisonment of Christ,* and it was attributed to one "Gherardo della Notte"—Gerard of the Night. Longhi recognized this as the Roman nickname of Gerard van Honthorst, a Dutch artist who had come to Rome in 1612, two years after Caravaggio's death. Honthorst had stayed in Rome for eight years, earning a living by imitating the style— a shadowy scene illuminated by a single light—that Caravaggio had made famous.

The attribution of this painting to Honthorst had struck Longhi as curious. For one thing, he knew of no Honthorst painting of that subject, and he had a vast and encyclopedic memory for art. But Caravaggio, wrote Longhi, had painted just such a work for Ciriaco Mattei. Longhi had never seen the original—the painting, he pointed out, had been lost long ago. But he knew it almost as well as if he had seen it. He'd read a detailed description of the painting written in 1672 by an art critic named Giovan Pietro Bellori. A description so lucid, so precise,

Longhi wrote, "that it would enable me to recognize the painting at first sight, were fortune to allow me to encounter it."

Pietro Bellori had seen Caravaggio's original more than three centuries earlier, in the Mattei palazzo. "Judas lays his hand on the shoulder of the Lord after the kiss," Bellori had written, "and a soldier in full armor extends his arm and his ironclad hand to the chest of the Lord who stands patiently and humbly with his arms crossed before him; behind, St. John is seen fleeing with outstretched arms." Bellori had criticized Caravaggio for his "excessive naturalism," yet he had admired the realistic touches in this painting: "Caravaggio even imitated the rust on the armor of the soldier whose head is covered by a helmet so that only his profile can be seen; behind him, a lantern is raised and one can distinguish two more heads of armed men."

Longhi had read that description while just a boy and it had stayed vividly in his mind ever since. He had recognized a copy of the painting—"weak and lifeless," he called it—at the shop of a dealer in antiques named Tass in London, on Brompton Road. That was in the 1930s, when Longhi had been forty years old. Since then he had come across several other copies, but even the best of them did not possess the spark, the vitality, that he knew he would see when he finally came across the original. Back then, he expected it would turn up in his lifetime.

Francesca imagined Longhi reading Gerda Panofsky-Soergel's article. He had written his critique of her in 1969, when he was seventy-nine years old, and he had died the next year. From everything Francesca had heard about him, he had been a thoroughly unpleasant man, given to grudges and malicious comments about colleagues. But he was a brilliant scholar. In his

later years, thought Francesca, he'd probably given up hope of finding Caravaggio's original picture. And then, by chance, he had come across that single line about the sale of a painting by Honthorst to a Scotsman. His pulse must have quickened. Was it not possible, Longhi speculated in his critique of Panofsky-Soergel, that the painting had been mislabeled? And that the Scotsman, Hamilton Nisbet, had actually purchased the lost painting by Caravaggio? In which case, Longhi surmised, the original *Taking of Christ* was likely somewhere in the British Isles, possibly still in the unwitting possession of Hamilton Nisbet's descendants, or perhaps hanging in obscurity in some small parish church.

To Francesca, this inspired deduction was a perfect illustration of Longhi's genius as an art historian. From the smallest of clues—one line in a two-hundred-year-old document—he had started to unravel, without moving from his chair, the mystery of a missing Caravaggio.

Or so it seemed. Twenty years had passed since Longhi had written that brief article, and no one had found the painting yet. It was possible, thought Francesca, that Longhi had been wrong, that Hamilton Nisbet had bought some other painting, not the one by Caravaggio. But Longhi clearly hadn't thought so. And, of course, he'd found fault with Panofsky-Soergel for not having made the same deduction.

IN ROME THE NEXT MORNING, LAURA CALLED CORREALE AND TOLD him they'd had some success in Recanati.

"Lauretta cara!" he exclaimed over the telephone. "Tell me all about it."

Laura gave him a report of the payments to Caravaggio. Correale wanted to arrange a meeting at his apartment that evening so they could inform Rosalia Varoli-Piazza, the art historian working on the project, of their findings.

At home, Francesca prepared herself to call Professor Calvesi at his office at the University of Rome. She felt shy about calling him. He was a renowned and widely published scholar, regarded in his world with respect and, as with all people who wield influence and power, with fear. Among students, he comported himself with an icy detachment that warned against intrusion. He was Francesca's thesis adviser—in name, at least. She'd met him face-to-face only a few times, always briefly, and always in the company of others. On one of those occasions she'd had to seek his approval for the subject of her undergraduate thesis. A younger professor had escorted her into Calvesi's office, where Francesca had stammered out a few words, heart beating in her throat. Calvesi had approved her project with a perfunctory nod. Later, when they passed each other in the hall and she smiled at him, his look told her that he could not quite place her.

Francesca rehearsed a brief account of the Recanati payments, took a few deep breaths, and dialed the number. The telephone rang in his office for two minutes, but no one responded. She looked up his home number, dialed again, and this time got an answering machine. But as she began to leave a message, a series of beeps cut her off. Either the machine was full or it was broken. That afternoon, she tried again, with the same result.

Later that day she met Laura at the library in the Piazza

Venezia. Laura suggested they check on the prices Caravaggio had been paid for other paintings, to see how they corresponded to Ciriaco's payments. They looked up a contract Caravaggio had signed on September 24, 1600—a contract found by Denis Mahon in the Archivio di Stato—in which Caravaggio agreed to paint two pictures for a wealthy Vatican official in a chapel in the church of Santa Maria del Popolo. The patron, one Tiberio Cerasi, had stipulated a painting depicting the martyrdom of St. Peter and another of the conversion of Paul. The contract called for Caravaggio to deliver the paintings within eight months for a payment of four hundred scudi for both pictures. Each measured about ten palmi by six, or seven feet by five and a half.

This seemed to accord with the one hundred twenty-five scudi that Ciriaco had paid for *The Taking of Christ,* and the one hundred fifty scudi for *The Supper at Emmaus.* The price of a painting was often based on its size, and both Mattei paintings, measuring around eight palmi by six, were smaller than the ones in Santa Maria del Popolo.

The *St. John* owned by Ciriaco was the smallest of the three, and it depicted just a single figure. To Francesca and Laura, it seemed reasonable to infer that Ciriaco's payment of sixty scudi for an unspecified work might have been for the *St. John.* Perhaps even the second payment of twenty-five scudi was also for that painting.

✄ IO ✄

CORREALE GREETED FRANCESCA AND LAURA AT THE DOOR OF HIS
apartment on Via Fracassini with open arms and a big smile.

"My dear girls!" he exclaimed. "You've found something im-
portant for me! I want to hear all about it."

The living room of Correale's apartment had now become a
library dedicated to Caravaggio. Books and articles on the painter
covered every surface. The smoke from Correale's cigars already
hung thickly in the air. Both the art historian Rosalia Varoli and
Paola Sannucci, the restorer, awaited the report from Recanati.

Correale wanted to know all the details about the archive
and the Marchesa. Francesca and Laura took turns telling him,
and he laughed and clapped his hands and swore delightedly.
Rosalia Varoli understood immediately the importance of the
payments and the dates. These findings, she said, would create a
huge stir in the art world. For years scholars had been debating
and disagreeing about the precise dates of Caravaggio's early
paintings, and now they had indisputable evidence for at least
two of them, *The Taking of Christ* and *The Supper at Emmaus*.

Correale, however, grew a little perturbed. "So, then," he said, "there was no specific payment for the *St. John*?"

"We couldn't find anything in Ciriaco's account book," said Laura.

"Are you certain?" asked Correale. "Could you have missed it?"

"Well, it's possible, but I don't think we did. We looked carefully."

"But in this basement with such terrible lighting! And you were there for such a short time!"

"We need to go back. There are many other things to look at, but we wanted to show you what we'd found as soon as possible."

"Of course, of course!" exclaimed Correale. "You did an excellent job, but we have to check again to make certain."

They discussed the two payments of sixty and twenty-five scudi that Ciriaco had made to Caravaggio without specifying the reason. Rosalia Varoli speculated that one of the sums—the twenty-five scudi—might have been for the *St. John,* and the sixty scudi for another unknown painting, perhaps *The Incredulity of St. Thomas,* which Baglione claimed that Ciriaco had owned. Correale acknowledged this possibility. A pity that history could not be more precise. He would have preferred to have an explicit citation for the *St. John.*

But he was only mildly disappointed, and he quickly got over it. The discoveries in the Recanati archive, he understood, had become the most important aspect of his *St. John* project. "Che colpo tremendo!" he exclaimed at the end of the evening, beaming at the two young women. "I didn't expect that you would find something this important."

And then Correale said, "Of course, we must keep this ab-

solutely secret. No one else must know about it until the exhibition. It will come as a revelation!"

Both Francesca and Laura thought at that instant about Professor Calvesi. They hadn't yet spoken to Calvesi, and neither was about to mention just then their efforts to contact the professor.

After they left Correale's apartment that night, they discussed the dilemma.

"I still think we ought to tell Calvesi," said Francesca.

"Correale will be furious if he finds out," replied Laura.

"But Calvesi is our professor; we owe it to him. And he's writing his book about Caravaggio—he should have this information. Correale will see that we had an obligation." Francesca paused for a moment, and then added: "I don't think Correale will be that angry."

"I think he will."

⤳ II ⟿

Francesca made another attempt to get in touch with Calvesi. She called his house, and this time the message machine worked. She spoke to the machine, trying to keep her message brief. The moment she uttered Caravaggio's name in connection with the Recanati payments, she heard the phone at the other end being picked up and Calvesi's voice.

"Payments to Caravaggio?" Calvesi said.

"Yes," replied Francesca. "I thought you'd want to know."

"Who is this, please?" Calvesi asked her.

Francesca explained: one of his graduate students.

"Ah, yes, Francesca! Of course," said Calvesi. "Certainly I want to know about this. You must come over as soon as possible. This afternoon?"

Francesca and Laura met in the Campo dei Fiori half an hour before their appointment with Calvesi. He lived nearby, on the Via dei Pettinari, an ancient narrow street that dated back to the days of the Roman empire. They both felt nervous about

seeing the professor. They calmed themselves by eating gelato and rehearsing their presentation.

At the door, Calvesi greeted them with a brief smile and remembered both of their names. He was in his early sixties, white hair neatly trimmed, dressed in a cardigan and corduroy pants. At the university he always wore professorial tweeds and carried himself with an air of stern preoccupation. But now, at the door to his house, he seemed to Francesca much less forbidding, perhaps even a little self-conscious.

He led them into his apartment. They would talk in his library, he told them. They followed him through a series of rooms, spacious and well-appointed, with subdued lighting, Oriental rugs, and an abundance of art, almost all of it contemporary paintings and sculptures. He and his wife had lived in this apartment for more than thirty years, he told them. The library was large, two stories in height, with a modern wooden staircase that went up to a mezzanine. The shelves extended from floor to ceiling, all neatly ordered, a collection of tens of thousands of books and journals that the professor had amassed in his long career as an art historian.

Calvesi was not given to small talk, and this made him seem aloof. In her anxiety, Francesca tended to talk, making comments about his collection of art, about the library—stupidly, she thought later, as if she were chattering at a cocktail party, as if she were playing the role, as a boyfriend had once accused her, of the dumb blonde, although she was neither blond nor dumb. For her part, Laura adopted a strategy of respectful silence.

In the library, Calvesi sat in a large leather chair and directed the two young women to the couch. He crossed his arms

and cleared his throat. At that moment, Francesca realized—
she couldn't say exactly what it was that brought her to this
realization—that Calvesi was not deliberately aloof, but rather
shy. Perhaps it was the way he'd cleared his throat, or the move-
ment of his eyes, which never quite met hers. It shocked her mo-
mentarily to think that a man of his stature, of his achievements,
could actually be shy.

They told him briefly about Correale's *St. John* project and
how that had led them to the Recanati archive. Calvesi listened
attentively, nodding now and then, and when they described the
account books of Ciriaco, Francesca could see his interest
sharpen. He made no interruption, but leaned forward in his
chair. They brought out their notes to show him the entries they
had copied, and he took them in hand and studied them carefully.

"This," he said slowly, "is a very important discovery. It puts
everything about these years of Caravaggio into focus. Now we
have a chronology that is indisputable."

As he talked about the significance of the entries and the
dates, he stood and began pacing, growing flushed and more ex-
cited than Francesca had ever seen him. He was in the grip,
thought Francesca, of the Caravaggio disease. She and Laura
were smiling broadly, happy that they had made their professor so
happy.

Calvesi told them he was in the final stages of correcting the
page proofs of his book about Caravaggio, called *Le realtà del Ca-
ravaggio.* It was too late, he said, to insert this information in the
body of the text, but he wanted to mention it in the introduc-
tion. Of course, he would give them full credit for the discovery.

And then he said they must publish these findings, the pay-

ments and the dates, in a responsible journal such as *Storia dell'Arte* as soon as possible.

Laura said, "Well, Correale has asked us to keep it secret until the *St. John* exhibition."

Calvesi shook his head. "If other people know about this, there will be talk, rumors. It's inevitable. Once you find something like this, it is impossible to keep quiet. Someone else might publish it first and take the credit. It has happened to me before."

They resisted, but not for long. Calvesi convinced them it was not just in their own interests, but in the interest of art history. "Correale should not ask such a thing of you. It is too important for him to keep for his own purposes."

By the end of the meeting, Calvesi had helped them decide on a strategy. They would publish first in a monthly art journal, *Art e Dossier,* a brief article dealing only with the two named paintings, *The Taking of Christ* and *The Supper at Emmaus.* They wouldn't mention the *St. John,* which was Correale's primary interest. After the exhibition, they would work on a longer, more thorough essay for *Storia dell'Arte,* which came out only four times a year.

Calvesi walked them to the door and congratulated them warmly. They promised to keep in touch with him and to inform him of any new discoveries when they returned to the Recanati archive.

They left Calvesi's apartment and walked together down Via dei Pettinari to the Tiber River, to the Ponte Sisto. It was dusk in Rome. Overhead the swallows of spring circled and pirouetted high in the sky and the last rays of the sun bathed the church

domes of the city in a golden light. They both felt excited by Calvesi's reaction. In the small and insular world that mattered to art historians, they really had achieved something. Neither of them felt like telling Correale that they had talked to Professor Calvesi. They would delay that moment of reckoning until it was absolutely unavoidable.

✃ 12 ✃

Francesca arrived at the Doria Pamphili palazzo on a Monday morning in late April, a day when the picture gallery was closed to the public. Correale had arranged for the technical examination of the Doria *St. John* on that day, and he wanted all of his staff present. Two weeks earlier he had subjected the Capitoline painting, the presumed original by Caravaggio, to its examination. Francesca and Laura had been in Recanati and had missed that event. Francesca hadn't minded. She didn't find the scientific side of art history—paint analysis and X rays—very interesting.

By the time she walked in, the Doria painting had already been taken down from its customary place and moved to a table in a large room just off the main gallery. The windows in the room were shuttered, the corners in shadow. A weak light came from the chandelier overhead. Technicians wearing white lab coats brought in various pieces of equipment, including a portable X-ray machine and a device the size of a handheld video camera that would scan the painting with infrared light.

They set up powerful lamps on portable metal stands around the table. All in all, the scene looked like a makeshift operating room.

Correale, dressed for the occasion in coat and tie, moved about briskly and with an air of authority, smoking his small cigars and issuing a steady stream of commentary and observations as he watched the technicians prepare their equipment. Paola Sannucci, the restorer working for Correale, was examining the painting through a large magnifying lens on a metal stand. Correale would pause now and then in his officiating to peer through the magnifying lens. After watching the examination of the Capitoline painting, he had acquired enough knowledge of the scientific jargon to sound like an expert even though without the real experts, the technicians, he would have been lost.

The Doria painting had been shorn of its frame. It lay on a soft white cloth draped over a table. To Francesca, it had the aspect of a creature of advanced age and in grave health. At this angle, the paint surface seemed lusterless and appeared worn. The tacking edges of the painting, where the raw, unpainted canvas was nailed to the stout wooden stretcher, were concealed by strips of dark wood, apparently applied long ago to ensure a tight fit within the frame. The original canvas, whether by Caravaggio or not, was almost four hundred years old, and the fabric itself was not readily visible, even from the back of the painting. Age and the effects of gravity would have caused it to sag on the stretcher, distorting the surface of the picture. To remedy this, a second, newer canvas had been glued to the back of the original—a process called relining—during a restoration performed thirty years ago.

Close up, Francesca could see the damage caused by time. Over its entire surface the picture had lost many tiny particles of paint, mere pinpricks—puntinature, Paola Sannucci called them—not discernible from a normal viewing distance. These particles had fallen at nearly regular intervals, at the intersections where the threads of the canvas, the warp and the weft, crossed each other and formed small nodules. The canvas had been cheap, made of poor-quality hemp and carelessly woven. Still, Caravaggio might have used just such a canvas. He had once painted a picture on a bedsheet. Another time, after he'd left the Mattei palazzo and was living alone in a small house off the Via della Scrofa, he had spread a half-finished canvas on a kitchen table and dined off the back of it.

The earlier examination of the Capitoline *St. John* had revealed it to be in much better shape than the Doria, in large part because the Capitoline canvas was of higher quality, more tightly woven with linen threads of uniform diameter.

The technical examination lasted the entire day, and for long periods Francesca and Laura had nothing to do but observe. The portable X-ray machine could capture only a small portion of the painting, and the technicians had to keep repositioning the machine, sixteen times in all, to get a composite of the entire picture. Francesca wandered in and out of the room and tried to dream up an excuse for leaving early.

Correale had a particular interest—an obsession, one could call it—with finding incised lines in Caravaggio's paintings. Few other Baroque painters had made these types of lines, scored with the butt end of a brush into the wet undercoat, and no one had made them in quite the same way as Caravaggio. He painted

from life, from models sitting before him, and most art historians believed that he didn't make preliminary drawings. In this, he had departed from a long-established tradition by which painters made detailed studies before applying brush to canvas. The scored lines, it was surmised, had served as a guide for positioning his models. In the finished paintings, the lines were sometimes visible to the naked eye, usually at a certain angle, in a raking light. Not every one of his paintings revealed signs of these marks. But to Caravaggio experts, their presence was almost as good as the artist's signature.

Two weeks earlier, during the examination of the Capitoline *St. John*, Correale had hoped to find incised lines, and thus add to the proof that it was Caravaggio's original. He and Paola Sannucci and the technicians had scrutinized every inch of the painting, but in the end they had not found a scoring mark. True, there were a few faint ridges on the borders of the boy's figure, and for a while Correale maintained that these *could* be scoring marks, but everyone else interpreted them merely as brushstrokes in wet paint, places where Caravaggio had defined the boy's flesh against the dark background.

But evidence of a different kind had emerged from beneath the surface of the Capitoline version, and it seemed to confirm the painting's authenticity. The X rays and the infrared images had revealed a ghostly image—a pentimento—at the precise point where the boy's arm and the curved horn of the ram intersected. The artist had painted the arm first, and then had painted the ram's horn over the finished arm. This constituted a clear sign that the painting was the authentic one. A copyist, following the outlines of an original painting, would not have

bothered to paint the arm and then paint the horn over it. The infrared images also revealed other pentimenti, in the folds and drapery of the red and white cloths, and in the foliage in the dark background. These were false starts and adjustments that no copyist would have needed to make.

So Correale had come to accept the Capitoline as the original even before the technical examination of the Doria version. All the same, the paintings were so strikingly similar—the outline of one placed atop the other matched in almost every contour—that it seemed necessary to examine the Doria picture as fully as the Capitoline. But how, Correale wondered, could anyone make such a near perfect copy?

This question interested Francesca, too. She thought of all the copies Roberto Longhi had found of the lost *Taking of Christ*. None of them had been good enough for Longhi to mistake for the original. Yet the Doria *St. John* had fooled him completely.

Paola Sannucci offered an answer, based on a technique described in a seventeenth-century manual on painting. A copyist, she explained, would take a piece of paper large enough to cover the original painting, and grease it well with walnut oil, which would make it translucent. The copyist would lay the greased paper on top of the original and trace the outlines with charcoal or a soft pencil. Once he had a complete tracing, he would lightly sprinkle the reverse side of the greased paper with charcoal or some other black powder, and place the paper on a fresh canvas already primed with the ground. He would then go over the traced outlines with a stylus and transfer them precisely to the new canvas. Then, of course, he had to possess the talent to replicate Caravaggio's colors, the sense of volume and the play of

light, a task more difficult than the mechanical act of tracing contours.

Obviously the Doria copyist would have needed both skill and unfettered access to the original painting, and this would have meant seeking the approval of Ciriaco Mattei. Francesca wondered whether the Recanati archives might contain some document, or perhaps just a notation buried among the thousands of entries, authorizing the making of a copy. It was possible that Ciriaco had commissioned the copy himself, as a gift to a powerful friend such as Cardinal Savelli's father, who might have admired the original. One more thing, thought Francesca, to search for when she and Laura returned to Recanati.

It was mid-afternoon when Francesca finally invented an appointment and got away from the Doria Pamphili. By then, the technical work was drawing to a close. Some items, such as a chemical analysis of the paint, would require laboratory work and specialized equipment. Whether Caravaggio himself had copied his own painting remained unresolved, a matter still left to speculation. If the paint proved to be the same used by Caravaggio in the Capitoline *St. John,* it would support that hypothesis. But by now, none of the investigators still believed that Caravaggio had touched this canvas, or even seen it. He had only made two known copies of his own paintings, and neither was a literal and precise copy, as this one was. It seemed unlikely that an artist of his skills and temperament, who had plenty of commissions, would spend time laboriously making an exact copy of his own work.

13

FRANCESCA AND LAURA BEGAN MAKING PLANS FOR ANOTHER TRIP to Recanati. They had a long list of items to look for, and they expected to spend several more days in the basement archive. That depended, of course, on the Marchesa's good graces. It fell to Francesca to make the telephone call and ask permission for another visit.

The Marchesa seemed pleased to hear from her. Francesca spent the first twenty minutes asking after the Marchesa's health, the state of her garden, her nieces and nephews. Finally she brought up the subject of the archive. Had the Marchesa made progress in her new system of ordering the past? Ah, not much, the old lady replied, family matters had occupied her. Would the Marchesa mind terribly if Francesca came for another visit to the archive?

"Oh, you may come and look around," replied the Marchesa. "Now, tell me," she added, "what is it you're looking for?"

THEY STARTED THE TRIP ON A MONDAY MORNING IN JUNE. LAURA drove her own car this time, an old Fiat Uno, which climbed the Apennines only slightly faster than the one Francesca had borrowed from her sister. By late afternoon, they had checked in to the Hotel La Ginestra, the same room as before, with two small beds. Notebooks in hand, they set out for the Mattei palazzo.

A young woman in her thirties answered the door. In the background Francesca and Laura could hear the voices of children. A moment later the Marchesa appeared, in a long summer dress, red lipstick still smudged at the corners of her mouth. She held out a fluttering hand in greeting and introduced Francesca and Laura to her daughter-in-law. The family had come from Rome for a stay in the country, and the Marchesa, smiling and in good humor, was clearly delighted to have her relations around her.

She led Francesca and Laura down the stone steps to the archive. It appeared unchanged from the time they'd last seen it a month before. The same bare bulb and stale, damp fungal odor of stone and earth, the same opened boxes of documents and stacks of volumes on the floor, the same piles of folders and books on the table. An ashtray full of the Marchesa's cigarette butts, each with the crimson mark of her lipstick, lay on the table where Francesca last remembered it.

The Marchesa donned her white coat and cotton gloves and took her customary seat at the head of the table. While she opened folders and held up old documents to scrutinize them, Francesca went over to the stack of volumes piled on top of a box on the floor, in the corner of the archive, where she'd hidden Ciriaco's account book. It was still there, untouched.

They began where they'd left off, going through Ciriaco's account book to see whether they had missed an entry concerning the *St. John.* By the end of the day, they concluded that they had overlooked nothing. Correale would have to content himself with the record of two smaller payments that Ciriaco had made to Caravaggio for unspecified works. Clearly at least one of those payments must have been for the Capitoline *St. John.*

Their research for Correale was nearly complete. The painting's voyage across nearly four centuries of time was documented thoroughly enough to satisfy almost any art historian. The *St. John* had remained in the Mattei family for only twenty-two years, until 1624, before passing on to other hands. The rest of the archive would contain nothing more about the painting.

Even so, Francesca and Laura had no thought of leaving Recanati. They knew that they were at the doorstep of an even more intriguing narrative—the story of the lost painting by Caravaggio. Had the Scotsman Hamilton Nisbet really bought the original *Taking of Christ,* as Longhi had speculated? And if so, how had the painting come to be attributed to a minor Dutch painter named Honthorst? The archive might reveal the answer to that.

They spent the end of the day gathering together all the family's inventories and account books from among the hundreds of volumes. They cleared a place on the table and arranged them chronologically, always under the curious eye of the Marchesa. That night they ate dinner at the same small restaurant near the hotel, this time on a terrace looking out toward the Adriatic, a soft summer breeze coming from the sea. Afterward they walked around the town, joining residents and the few tourists in the

evening passeggiata—the promenade—traditional in small cities all over Italy.

<p style="text-align:center">⊘</p>

THE NEXT MORNING, DOWN IN THE CELLAR WITH THE MARCHESA, they started going through more inventories. They knew the earliest ones quite well now, up to the death of Ciriaco's son, Giovanni Battista, in 1624.

Of the paintings Caravaggio had made for Ciriaco Mattei, *The Taking of Christ* had remained longest with the family. Ciriaco had given *The Supper at Emmaus,* probably in exchange for a favor, to his powerful friend Scipione Borghese, an avid art collector and also nephew to the Pope. And in his will, Giovanni Battista had left the *St. John* to Caravaggio's first patron, Cardinal Del Monte. But Giovanni Battista had specified that his cousin Paolo, the son of Asdrubale, should receive *The Taking of Christ.*

Francesca and Laura came across their first surprise late that morning, in an inventory of 1676. Along with *The Taking of Christ,* duly noted as by the hand of Caravaggio, they saw, several pages further on, an entry that read "Copia della presa di Giesu nell'orto del Caravaggio": "Copy of *The Taking of Christ in the Garden* by Caravaggio." The entry supplied no other details about the copy, no measurements, no description of the frame.

The next inventory, some fifty years later, cited the original by Caravaggio, and also the copy, this time as "by a disciple" of Caravaggio.

A day later they stumbled across more information about the copy, in the account books of Asdrubale, Ciriaco's younger

brother: a payment of twelve scudi made in September 1626 to one Giovanni di Attili, a painter. The entry explicitly stated that Attili was being paid to make a copy of Caravaggio's *Taking of Christ.* Asdrubale must have greatly admired the painting. He'd had the copy made soon after the death of his nephew Giovanni Battista. Perhaps he had been disappointed not to have the original, to see it go to his son instead of himself.

Neither Francesca nor Laura had ever heard of Giovanni di Attili. He was a painter unknown to history, his life and death a mystery. But as a copyist he must have had the necessary skill to get the commission from Asdrubale. Perhaps he had also been commissioned to make the Doria Pamphili copy of the *St. John.* It would please Correale to find such a citation and clear up the murky origins of that painting.

Caravaggio was one of the most copied of all painters, and *The Taking of Christ* was, as Roberto Longhi had discovered, one of the most frequently copied works. Most were of low quality, like the one Longhi had found in London in the 1930s. But one very good version had surfaced in Odessa, Russia. A Russian art historian had published photographs of that painting more than thirty years earlier, back in 1956, advancing it as the original. A Russian count had acquired it in Paris sometime before 1870, but its earlier history was largely unknown. Longhi and other Caravaggio experts had studied the photographs. All had agreed that it was a very good painting. A few had even embraced it as the original. But without inspecting it "nose to the canvas," as Denis Mahon would say, most Caravaggio scholars were not willing to make a definitive judgment one way or the other. And it was difficult to inspect close up. The trip was long and com-

plicated, requiring visa negotiations with the Soviet authorities and then several connecting flights to Odessa.

Longhi, for one, had remained unconvinced by the Odessa version. He believed until his death that the original was probably somewhere in Scotland, masquerading as a Honthorst. If that was true, and the Odessa version really was just a very good copy, good enough to give some experts pause, then it might be the work of Giovanni di Attili. Like the copyist of the Doria *St. John,* Di Attili had enjoyed unfettered access to the original.

LAURA AND FRANCESCA WORKED IN THE DARK ARCHIVE FOR three days, glimpsing the summer sun from the small grated windows above their heads. The Marchesa kept them company, and when she grew weary, she would summon the elderly housekeeper who always wore two heavy sweaters even on the warmest days. Sometimes the Marchesa would send down her daughter-in-law, who would chat with them and leaf in desultory fashion through one of the volumes.

By the third day Francesca began to yearn for the sun. She felt she had grown pale and sickly-looking after so much time in the clammy cellar. She had plans to attend the wedding of a friend in Rome the following week and she knew that a young man she'd met the previous fall would also be there. She'd had a brief fling with him. She didn't want to have another, but all the same, for reasons of vanity, she thought a few hours at the beach, under the Adriatic sun, would make her look better.

She tried to convince Laura to go with her. Laura wasn't in-

terested in the beach. Francesca explained her ulterior motive and the young man.

Laura said, "I thought you and Luciano were together."

Luciano was a boy Francesca had known since her first year in high school, when they were both fourteen years old. Laura had never met Luciano, but she'd heard Francesca talk about him. He was in England, studying philosophy at Oxford. The previous year, Francesca had spent time with him in London, when she'd had a two-month grant to study at the Warburg Institute. They'd had a romance, which had grown complicated because Francesca didn't take it seriously, but Luciano did.

"Everyone seems to think we're together," replied Francesca. "But it's not really so. He's more of a really good friend."

"Oh," said Laura. "I thought it was more than that."

Laura still wouldn't go to the beach. But they did agree to take some time off and visit the town of Loreto, a few miles away, to see the famous basilica. It was said that Caravaggio had gone there once. He had later painted a picture of the Madonna of Loreto for a chapel in the church of Sant'Agostino near the Piazza Navona. Baglione and others had criticized it as lacking in decorum because it depicted the dirty feet of the pilgrims kneeling in front of Mary.

THEY FOLLOWED *THE TAKING OF CHRIST* THROUGH ONE INVENtory after another. The language varied slightly—in some places the painting was called *The Taking of Christ in the Garden,* in others *The Capture of Christ,* and in yet another *Christ Betrayed by Judas*—

but it was always attributed to Caravaggio. Most entries also mentioned its size—eight palmi by six—and its black frame decorated with gold filigree.

The first alteration in this description came in 1753, when the painting was recorded as measuring only six palmi by seven. By then, the *Taking* had been moved twice to new locations in the palazzo. Possibly the inventorist had made a mistake in the measurement. Or perhaps the picture had been cut down slightly to fit its new quarters.

Near the end of the 1753 inventory, they found an entry for a "large painting" called *The Betrayal by Judas.* It hung upstairs, in a room in the family's private apartments. Was this the copy by Giovanni di Attili? It seemed so, but there was no way for Francesca and Laura to know for certain, since the entry contained no other details and no measurements, merely a valuation of less than two scudi.

It is in the nature of such inventories, performed over two centuries and by different hands, to vary in style and detail. For the most part, however, each new Mattei inventorist appeared to have consulted the work of his predecessors. But when Francesca and Laura began examining the inventory of 1793, they found themselves confronted with a new and completely strange landscape, a collection that bore only a faint resemblance to the Mattei galleries. It was here that they saw the attribution for *The Taking of Christ* suddenly change, after almost two hundred years, from Caravaggio to Gherardo della Notte. Moreover, the painting was said to measure "6 palmi riquad.ti"—it was now recorded as square instead of rectangular.

The particulars of the Caravaggio painting—if, indeed, it

was still the same painting by Caravaggio—were not the only details scrambled in this inventory. Many other works had new attributions, new measurements, different titles. It was a tossed salad of an inventory, jumbled and confused, and utterly untrustworthy.

Before long, Francesca and Laura discovered how this had happened. In the archive, they came across a guidebook called *An Instructive Itinerary of Rome,* published seven years before the 1793 inventory. Written by one Giuseppe Vasi, it was replete with errors, the same sorts of errors that later infected the inventory, among them the attribution of *The Taking of Christ* to Honthorst. The family was in decline. The inventorist they hired was either incompetent or lazy. He had clearly relied on Vasi's guidebook alone, perpetuating one confusion after another.

Another guidebook of that era, by a German named Von Ramdohr, took note of the mistaken attribution to Honthorst. Von Ramdohr had no doubts about who had painted the picture. "Judas betrays Christ with his kiss, by Caravaggio," wrote Von Ramdohr, adding, "Others say it is by Honthorst, which is less likely."

So Longhi's intuition appeared to have been correct. The Scotsman Hamilton Nisbet had bought Caravaggio's *Taking of Christ,* believing it was by Honthorst. But what had happened to the copy, which had disappeared from the records? In an inventory so confused, could the original have been mistaken for the copy? There was simply no way to tell.

Francesca and Laura spent another full day in the archives, wading through more inventories and account books. Each no-

ticed that the other had dark circles under her eyes from the poor light and eyestrain. Their hands felt cramped from hours of copying entries into their notebooks, their backs ached from bending over the old volumes.

They left Recanati on the afternoon of the fourth day, their notebooks full. In Rome the next evening, they went together to see Correale. He had a new task for them. The exhibition catalogue would contain several essays on the history, iconography, and technical investigations of the two *St. John* paintings. Correale had planned at first to incorporate their findings into the essay by Rosalia Varoli-Piazza on the paintings' histories. But now, with the smile of someone bestowing an award, he told them that they should write a separate essay on the archive and their findings.

This pleased Francesca and Laura. They had made the discoveries, and they deserved the credit for them, not just a footnote in someone else's article. But they had already made a commitment to write a short article for *Art e Dossier*. They had not yet told Correale about that.

❧ 14 ❧

THE REST OF THE SUMMER PASSED QUICKLY. FRANCESCA ATTENDED
her friend's wedding and saw the young man she knew at the re-
ception. They smiled and flirted, which was all she had wanted.
She and Laura divided up the task of writing the essay for Cor-
reale. Each worked on her own. They saw each other infre-
quently, meeting only a few times at the library to coordinate
their efforts and review what each other had written. It was a
good time to work, the season of tourists, the time of year when
most Romans made plans to leave the city, when shops and
restaurants shuttered their doors in the August heat.

Francesca was also busy planning for another trip to London
in September. She had won a second research grant, this time
for a year, to the Warburg Institute, part of the University of
London's School of Advanced Study.

The Warburg was familiar ground to her. Luciano had con-
vinced her to come the previous year. He'd described the li-
braries at the universities in England, open until late at night
and on weekends, where you could wander from floor to floor

and take down whatever books interested you. He told her about how he'd spent the entire night in a library at Oxford, eating in the cafeteria and studying and writing until the sun rose. They were both accustomed to the national library in Rome, always crowded, closed on weekends, where you could request only two books at a time and then had to wait, sometimes for hours, for a bored civil servant to fetch them. Compared with that, Luciano told Francesca, "England is like arriving in paradise."

ON THAT FIRST TRIP A YEAR EARLIER, FRANCESCA HAD ARRANGED to rent a room in London with another student. But those plans had fallen through at the last minute, and she'd arrived having no place to stay. Luciano was in Oxford, an hour away by train. She called him, and he gave her the name of a friend in London. One friend led to another, until finally Francesca had the address of a large house on Sloane Square, in Chelsea. She'd been told that the owner, a young Italian named Roberto Pesenti, often took in boarders.

Bags in hand, Francesca rang at the door of the house on Sloane Square, but no one answered. A sign tacked to the door informed her that there was a key under the mat. She opened the door and wandered in. In the dining room, she encountered a small, irate-looking woman wearing an apron and vigorously vacuuming a rug littered with crumbs. On the table was a tub containing the remains of a sangria—wine dregs and rotting fruit. The woman, evidently the maid, looked up at Francesca. Smiling politely, Francesca asked in English if Roberto Pesenti

was present. The woman's eyes narrowed at Roberto's name, she brought up a wagging finger and spoke rapidly and with obvious disapproval in a language that Francesca recognized as Portuguese. Francesca tried Italian, to no avail. The maid went back to vacuuming. Francesca looked around the house—three floors, wide hallways, impressive staircase, many bedrooms, and a plethora of nooks and crannies. Francesca found a small room, no bigger than a closet, with a narrow bed. It was the only bedroom that seemed unoccupied.

The house, it turned out, had an ever-changing cast of residents. Many were Italians, but at any given time there might also be Spaniards, Swiss, French, Swedes, Germans, and Americans. People came and went. The cooking was communal, big dinner parties routine. In the course of her first day there, Francesca met several of the residents, all young, mostly graduate students. Roberto, she learned, was himself studying finance and working at Goldman Sachs. No one seemed to know precisely where he had gone. Spain, someone thought. He often took business trips, she was told.

The room with the narrow bed was too small for Francesca to work in, so she installed her books and files on a credenza in the now spotless dining room. She used the dining room table as her desk.

The next morning she found her way to the Warburg Institute. She was greeted by a member of the staff and given a tour of the facilities, something that would never have happened in the milling, chaotic halls of the University of Rome. In the library, order and quiet reigned, the study areas seemed vast, and everything was available to her for the asking. She looked

around in amazement. For someone who loved libraries, it was, as Luciano had promised her, a type of paradise.

Late that afternoon, back at the house on Sloane Square, Francesca was at the dining room table working when she heard someone come in the front door. Behind her she heard a voice ask in English, "Excuse me, but do we know each other?"

Francesca turned and saw a man a few years older than she, small in stature, sparrow-like with a narrow face and thin, dun-colored hair. He was dressed in a dark blue business suit. She replied in English, heavily accented, saying her name and that she had just recently arrived. Immediately the man spoke to her in fluent Italian, with a Milanese accent. It was Roberto Pesenti. He looked a bit perplexed, perhaps even exasperated, as she explained her circumstances, that she just needed a place to stay briefly until she found other lodgings.

He asked what she was studying.

Art history, she replied, at the Warburg Institute.

His eyes lit up. He had just taken an art history course at Christie's, the auction house. He'd wanted to study art, but his family thought he should get a background in finance. Most of his friends worked in investment banks or were studying to become lawyers.

Francesca went out to dinner that night with Roberto and another resident of the house, a young man from Naples. Roberto explained that he was on a campaign to curb the chaos in the house. The Portuguese maid had given him a lecture. But he told Francesca she could stay until she found another place. They talked about art and the Warburg Institute and nightlife in London, a subject the man from Naples seemed to know a lot

about. Roberto spoke English with near fluency and could mimic the refined diction of the upper class. He told Francesca that he'd known immediately she was from Rome because of her strong accent. She frowned, a little offended. Most Italians considered Roman accents coarse and uncultured, the equivalent of a Cockney accent in Britain. The man from Naples said, with genuine surprise in his voice, "Oh, really? I thought she was from Tuscany." Tuscan accents are viewed as elegant, the purest form of Italian. Francesca clapped her hands with delight and laughed at Roberto, who laughed along with her. She realized he had been teasing her.

ON WEEKENDS LUCIANO TOOK THE TRAIN IN FROM OXFORD TO see Francesca. During the week, they talked often on the telephone, long conversations about life, art, and philosophy. She found it easy to talk with him, "about anything and everything," she once said. When he came to London, they went out to dinners, to movies, to parties, often in the company of other Italians and foreigners.

Luciano had once told Francesca that he'd fallen in love with her when they were in high school, the moment he'd laid eyes on her, on their first day at the Liceo Lucrezio Caro. She'd dismissed that with a roll of her eyes as romantic exaggeration, but he insisted that it was true. He had been too shy ever to ask her out, too shy that first year to say anything to her. He came from a rural district north of Rome where his father had a medical practice, an area of agricultural fields alternating with large,

bleak concrete apartment blocks known as dormitorios. As a teenager, he'd been tall and skinny, with elbows and knees that sometimes felt as if they didn't belong to his body. He wore glasses and he dressed differently from his classmates, in clothes that looked, Francesca would later say, as if they had been bought by his mother.

Francesca had been the best student at the liceo, winning one academic prize after another. She had been invited to compete for a position in the Scuola Normale Superiore in Pisa, the most prestigious university in Italy. But her scholastic achievements embarrassed her and she did her best to conceal them. Her boyfriend back then rode a motorcycle, wore the right clothes, was handsome, outgoing, athletic, and in constant danger of failing at school. Luciano said that Francesca was the smartest person he'd ever met, but his classmates had widely regarded him as the school genius for the way he challenged the received wisdom of their textbooks and their professors.

They'd gone their separate ways at the University of Rome. They found their own paths through the chaos of the university, through the milling crowds of students and the interminable lines, the lecture halls and libraries so packed that every chair, windowsill, and bit of floor space was occupied by a warm body. The university, the second largest in the world after Cairo's, offered no orientation, no advisers, counselors, or tutors to guide students. It was, Luciano once remarked, "a true Darwinian context—only the fittest survive."

And then one day, after three years, Luciano called Francesca. Would she mind giving his younger brother some advice on courses and professors? At the end of the conversation,

they agreed to meet for dinner with some of their old acquaintances.

They began seeing each other more often, always in the company of other friends. Their relationship was chaste, involving nothing more than the customary kiss on the cheek in greeting. They were friends, not lovers.

That changed during Francesca's first stay in London. One night, she and Luciano went to a dinner party at the apartment of another Italian studying in England. They both knew everyone there. It was a night like any other. Luciano tended to be quiet at such gatherings, Francesca talkative. Luciano, by his own admission, had little talent for the idle, good-humored chatter of dinner parties. Francesca, on the other hand, moved with ease from one person to another, full of gaiety and laughter, able to make each conversation seem personal. At the end of the evening, they walked out together. On the street, they fell into a deep discussion and walked for several blocks. Finally they arrived at the house on Sloane Square. Francesca paused and turned to face Luciano. It was late, and the street was silent and dark. She looked intently at him, eyes serious, as he talked. He noticed a change in her demeanor and saw that her gaze had grown soft and expectant. He looked down at his shoes, and mumbled that it was late, he should be on his way. She blinked and looked at him quizzically. "Yes, of course. I'll see you soon," she said, and turned to go up the steps.

Luciano told himself that he was a fool. She had expected him to kiss her. Or at least, he thought that was what she expected. He had wanted to kiss her; he should have kissed her.

But what if he'd read the situation wrong? If he had kissed her and she had not expected it, it might ruin a friendship.

The following night they again met with a group of friends. After dinner at a restaurant, they again walked together to the house on Sloane Square. They did not get far before Francesca stopped abruptly and turned to Luciano. She leaned forward and kissed him full on the mouth. She pulled back and smiled at him. "I had to kiss you," she said with a laugh, "because last night you should have kissed me."

"Yes," he said, "but it seems that I never do the obvious thing."

They spent that night together. To Francesca it was not an event of great consequence. She still considered Luciano her friend, not her lover. "I've just never thought of him in that way, as a possible boyfriend," she'd said to Laura and others.

For Luciano, it was different. Not long after, he told Francesca that he had been in love with her since high school. Francesca claimed she didn't really believe him, even when she heard him say this to others. She made light of it. "You only think you love me," she told him. "You just don't want to take the time away from your books to find anyone else."

But in time she came to understand that he was serious. "I was not being honest with him," she said later. "I knew that for him it was different. But I pretended that I didn't know. I pretended that it was just friendship when I knew that it was something more for him."

He'd say to her, "Okay, you're not in love with me now, but you will be. I'm persistent."

FOR HER SECOND TRIP TO LONDON, FRANCESCA FOUND A BASE-
ment apartment near King's and Fulham roads. The Sloane
Square house had been too distracting for serious study. And
this time Francesca was coming with a Roman friend, Caterina,
who also had a research grant in London. They had known each
other since their first years as undergraduates at La Sapienza,
the University of Rome. Apart from an interest in art history,
they shared the same sense of humor and, being roughly the
same size, they also shared their clothes. Neither had a propen-
sity for neatness. They were, in short, ideal roommates.

The apartment was small and dark, but efficiently orga-
nized, far enough from the noise and tumult of central London
and yet convenient to the Warburg. It was, Francesca told Lu-
ciano, ideal for her purposes.

She made a second home of the Warburg's vast library. She
usually arrived late morning—she was a late riser, eyes soft and
occluded with sleep and dreams until almost noon—and stayed
among the books at her favorite table until long after nightfall.
She was working on several projects at once, fulfilling her obli-
gations for the Warburg grant, still writing the unfinished essay
for Correale, and pursuing the fate of the Mattei paintings.

Between projects, she looked for information on William
Hamilton Nisbet and his art collection. Her first efforts, search-
ing under the family name, yielded no interesting results. She
changed tactics and began searching for catalogues of Scottish
exhibitions in which Hamilton Nisbet's collection might have
appeared. The earliest listing was for a catalogue entitled *Old*

Masters and Scottish National Portraits, published in 1884 in Edinburgh. She went into the stacks to retrieve the catalogue. Standing there, book in hand, she flipped through the pages. It contained an introductory essay about the exhibition and lists of paintings and their attributions, but no reproductions. She scanned the long list of paintings and her eye lit on the name Honthorst. The painting, now called *The Betrayal of Christ,* had been lent to the exhibition by one Miss Constance Nisbet Hamilton. Curious, she thought, that the name had been inverted, but it could only be the same painting that William Hamilton Nisbet—Constance's great-grandfather—had bought in Rome from the Mattei family.

Francesca went back to the library index and made a list of other catalogues. She collected the books from the stacks and brought them back to her reading table. One was called *Pictures for Scotland: The National Gallery of Scotland and Its Collection.* This was not an exhibition catalogue, but rather a history of the National Gallery of Scotland's collection. She turned to the index and looked under Honthorst. Nothing. Nor anything by Caravaggio. Then the name Serodine caught her attention, the painting called *Tribute Money.* Hamilton Nisbet had bought just such a painting from the Matteis, although, like the one by Caravaggio, it had also been misattributed, in this case to Rubens. Francesca flipped to the indicated page and saw the Serodine painting reproduced, the size of a postcard, in black and white. The legend above it read: "Bought as by Rubens from the Palazzo Mattei by William Hamilton Nisbet in 1802."

In the accompanying text, Francesca read that the painting had come to the National Gallery of Scotland in 1921 as part of

a bequest of twenty-eight paintings from Mary Georgina Constance Nisbet Hamilton Ogilvy, the last of William Hamilton Nisbet's direct heirs. The gallery also had another picture from the Mattei family, a small painting from Francesco Bassano's studio called *The Adoration of the Shepherds.* But the National Gallery had rejected, for whatever reason, the other three Mattei paintings—including *The Taking of Christ*—that Hamilton Nisbet had bought in Rome. They had gone up for auction at a place called Dowell's, in Edinburgh, in 1921. One of them, *Christ Disputing with the Doctors,* by Antiveduto Grammatica, had been found in 1956, hanging in a Scottish presbytery in Cowdenheath.

The only Mattei painting still unaccounted for was *The Taking of Christ.* The National Gallery had let what would become the single most valuable painting of the group slip through its hands. Francesca thought that the writer of the essay—his name was Hugh Brigstocke, and he was the assistant keeper of the gallery—had done his homework well. He had read Longhi's 1969 article in *Paragone* and he knew that the *Taking,* sold as a Honthorst, was most likely the missing Caravaggio. In footnotes, Brigstocke had listed his sources and included the portfolio numbers of the Hamilton Nisbet papers in the Scottish Record Office.

So what had happened at the auction at Dowell's on April 16, 1921? Surely an auction house kept records of its sales, thought Francesca. Who had bought *The Taking of Christ?*

Francesca presumed that Brigstocke had checked the records at the auction house, although he made no mention of them. Most likely he'd arrived at a dead end. She looked up the publication date of the book—1972, eighteen years earlier. She wondered whether

Brigstocke still worked at the National Gallery of Scotland. Was he even alive? She wanted to speak to him. She also wanted to go to Edinburgh, to Dowell's auction house, and follow the document trail herself. Perhaps, she thought, she could entice Luciano into coming with her.

⁂

LUCIANO SHOWED FRANCESCA AROUND OXFORD AND TRIED TO convince her that she should move to England. The Italian educational system, he told her, was a type of Mafia, a national scandal. He knew at first hand. He had applied to doctoral programs in philosophy in Rome, Florence, Bologna, Venice, Milan, and Turin. Each admitted only three students a year. He'd taken the oral and written exams, traveling by train and staying in cheap hotel rooms with other applicants, people in their thirties and forties who had applied time and again and never gotten a place. Admission depended on knowing someone, on having a rich father who could pull strings, or on being the protégé—or the sycophant—of an important professor. Luciano had no connections. Time and again he'd been rejected.

It was a different story in England, where he applied to Oxford, Cambridge, St. Andrews, and the University of Warwick. All accepted him. "You shouldn't be wasting your time in Italy," he told Francesca. "You should come to England."

She knew he was right about Italy. But she had a talent for making connections. She actually liked going to the openings of new exhibits and academic conferences, where she was learning to make her presence gently known, to use charm and flattery on

important art historians and powerful professors, nodding seriously at their observations and laughing at their witticisms, often putting a hand softly on their arms. Luciano called it "fare marchette"—using feminine wiles instead of her native intelligence to get ahead.

He devoted himself to her while she was in London, always ready to help, always caring and attentive. There were moments when she thought that maybe this was love after all, even if she didn't feel the sort of passion she'd experienced in other romances. It is a rare thing, she thought, to have a friendship like this, so maybe it is love. And then she'd catch herself and think, No, I think it's a mistake. It's because I am in London, far from my family and other friends. It's like being in vitro.

Perhaps the trouble was just the dreary skies of London, but the crispness and precision of the Warburg also began to weigh on her. She was one of only a few fellows, and the staff was cheerful and helpful. Too helpful, it sometimes felt to her. "I couldn't go look at a picture without someone asking—always very nicely—why I wanted to see it. And I might not even know why I wanted to see it, just an idea that I had that I was too shy to express."

Luciano didn't seem to miss Rome at all. Francesca told him that he must have been switched at birth, that he really was an Englishman who by accident had grown up in Italy.

She, on the other hand, found herself hungering for Rome, for the colors of the old buildings and the narrow, crowded streets, the small noisy cafés where Romans would stand shoulder to shoulder at the bar drinking espresso and talking, a tight nest of bodies, the warmth and humidity of humanity. Coming

down a narrow, winding street in the Campo Marzio, Via dei Portoghesi, in the dark shadows and dampness from the buildings on either side, she would round a corner and suddenly see a burst of sunlight illuminating the façade of a building, the ocher walls turned to gold by the sun. She realized that she could not imagine living anywhere else in the world.

15

In Rome, meanwhile, Laura began investigating what had happened to the six Mattei paintings after Hamilton Nisbet had bought them. The Scotsman would have needed authorization from the papal authorities to take the paintings out of Rome. The export license, usually granted as a matter of course, should contain a list of the paintings and their attributions along with the sum Hamilton Nisbet had paid for each.

Laura went one morning to the Archivio di Stato on Corso del Rinascimento. In the catalogue she found the section called Esportazioni, Exportations, of art and antiquities. The records were contained in filing case number 14. The individual export licenses were not listed. Laura expected that the file would be vast, containing hundreds, perhaps thousands of export requests made by rich travelers on the Grand Tour.

At the desk, she submitted a request for the case and then began a long wait for the clerk to retrieve it. When it finally arrived, late in the afternoon, Laura saw that it was indeed immense, almost too thick for her to put her arms around. But

inside the case were individual files with dates. She thumbed through them, a century of export licenses, until she found file number 300, with individual pieces of paper dated between 1801 and 1802. She took that file to a table in the reading room and began leafing through the pages. There was no standard form for requesting an export license, so each request was unique.

She went through dozens of pages, quickly scanning each for the name Mattei or Hamilton Nisbet. Near the end, with only a few documents remaining, she began to think that perhaps the license didn't exist. It was possible that Hamilton Nisbet had smuggled the paintings out of Rome, perhaps because he had anticipated problems, or perhaps simply to avoid taxes.

She went back to the beginning of 1802 and studied each document more carefully. Her eye stopped on one that began with the name of Patrizio Moir—Patrick Moir, certainly an Englishman. It was a single page, dated February 8, 1802, and it contained a short list of paintings that Moir said he wanted to send to England. The third in that list was described as "Jesus betrayed by Judas, in the Flemish style," with a size of seven palmi by five and a price of one hundred fifty scudi. It corresponded in subject and size to *The Taking of Christ*. The descriptions of the other paintings—among them *Christ Disputing with the Doctors* and *Christ with the Samaritan*—matched the five additional paintings that Hamilton Nisbet had purchased from Giuseppe Mattei.

Laura knew that she had found the correct export license, even though the document mentioned neither Hamilton Nisbet nor Mattei. But who was Patrizio Moir? Most likely an agent for Hamilton Nisbet, Laura surmised, one of many Englishmen

who lived in Rome and offered their services as cicerones to their wealthy countrymen on the Grand Tour.

The sales document from the Recanati archive had not listed the prices that Hamilton Nisbet had paid for the six paintings. But Moir, in order to obtain the export license, had to give a monetary value for each painting. He described each painting as being "in the style of," or "in the school of," making it seem as if they were copies, or works by unknown, unimportant painters. The total price for all six came to only five hundred twenty-five scudi. Laura suspected that Moir had understated what Hamilton Nisbet had actually paid. Moir was probably experienced at this sort of transaction. The less consequential the paintings, the easier it was to get them out of the country, and the lower the export duties. Moir had probably saved his client a substantial sum in taxes.

The bottom of the export license had a seal of authorization stamped into red wax, just above the signature of the assessor of fine arts and antiquities. Interesting, thought Laura, how expeditiously this license had been granted. It had taken Moir only a week from the time of Hamilton Nisbet's purchase to secure the license. Perhaps the bureaucracy had worked with greater efficiency back then. More likely, she thought, Moir had bribed the officials in the export office.

❧ 16 ❧

FRANCESCA RETURNED TO ROME IN DECEMBER FOR THE CHRIST-
mas holidays. Within a few days, she and Laura completed the
article for *Art e Dossier* that Professor Calvesi had urged them to
write. It was scheduled for publication in February. They would
have to tell Correale soon.

As it happened, the timing of the publication could not
have been worse. The article would come out just as Correale
planned to present the results of the *St. John* project at a sympo-
sium of experts at the Capitoline Gallery.

Now that the moment was near, Francesca wasn't so confi-
dent that Correale would take the news well.

"Do you think he'll be angry?" she asked Laura again.

"You know what he's like," replied Laura. "But we have to tell
him. If we don't, he'll find out anyway."

They kept putting off the chore. They had plenty to do.
They had to finish the essay for Correale and check all the foot-
notes, which numbered more than a hundred. Francesca had the
additional burden of writing the brief biography of Caravaggio

that Correale had requested. She had started it but had not gotten very far. She knew that it would not take her long to write, a few evenings of hard work, and for that reason she never seemed to get around to it.

Meanwhile, Correale was busy organizing the details for the *St. John* symposium. He oversaw the editing of all the essays for the catalogue and occupied himself with writing invitations to the most highly regarded Caravaggio experts. He planned the event meticulously, down to the order in which the scholars would speak and the seating arrangements for the lunch that would follow. These were delicate matters. Several of the scholars were touchy and easily offended, and others had ongoing feuds. Correale hoped to avoid any unpleasantness.

In mid-January Francesca and Laura finally concluded that they could wait no longer, they had to tell Correale about Professor Calvesi and the *Art e Dossier* article. Correale had scheduled a meeting at his apartment. Francesca and Laura decided that they should wait until the end of the meeting, when the others had gone and they were alone with Correale.

That evening several people crowded into Correale's apartment. He was in fine form, orchestrating the discussion, delighting in the plans for the symposium. Francesca and Laura sat silent most of the time, listening to the others talk. As usual, Correale's interest lay with the technical people. The meeting dragged on. Francesca kept looking at her watch. One or two people had already left. Just after eight o'clock she whispered to Laura that she also had to leave, she had a dinner engagement, she hadn't thought the meeting would go on so long.

Laura looked at her with astonishment. "What about telling Correale?" she whispered back to Francesca.

"We can tell him another time," Francesca said. She clasped Laura's hand. "Sorry, but I really must go."

With that, Francesca stood up, made her apologies, and said she had another appointment. Going out the door, she cast a last glance at Laura, a look of regret.

Laura knew that Correale's temper frightened Francesca. They'd both seen him grow red in the face, throw papers and swear vilely. His angry moments were unpredictable and usually short-lived, but Francesca had always looked terrorized afterward. Laura understood that she had left tonight because her courage had deserted her.

Laura decided to tell Correale herself. If she waited for Francesca, they would never get around to telling him. When everyone else had finally gone, Laura rose from the sofa as if to depart, but paused and said to Correale, as if it were an afterthought, "Listen, Giampaolo, there's something you should know about."

"Tell me, Lauretta cara," said Correale.

Laura explained that they had gone to see Calvesi and told him about the Caravaggio payments. She could see Correale start to get angry, eyes narrow, puffing rapidly on one of his small cigars. He seemed about to say something, but Laura continued talking. Calvesi had told them they should publish this information, that they had an obligation as art historians to publish, and of course they had felt obliged to listen to their professor, head of the art history department. And so, Laura concluded, they had written an article for *Art e Dossier*.

✣

CORREALE REMEMBERED THE EVENT DIFFERENTLY. IN HIS RECOL-
lection, Laura told him about discussing the Recanati findings
with Calvesi, but not about the article in *Art e Dossier.* Correale
found out about that only after it had been published, from a
friend who called to say he had just seen the article in the latest
edition at a newsstand. Correale at first did not believe his
friend. Impossible, he said. Then he ran out to the newsstand
and bought a copy for himself. He stood on the street, staring at
it in disbelief. The cover of the magazine had a close-up repro-
duction of a Caravaggio painting, *Martha and Mary Magdalene,* and
the words "New Dates for the Mattei Paintings." He flipped
through the magazine, came to the photos of two of the Mattei
Caravaggios, *The Supper at Emmaus* and *The Taking of Christ,* the
Odessa version. The article was short, barely two pages long.
Scanning it with furious eyes, Correale saw that it did not men-
tion him or his project. "The insult of the insult," said Correale
later. At the very least, he should have gotten credit for initiating
the research. The article referred only in passing to the *St. John.*
But it contained the essential facts about the Recanati discover-
ies, discoveries that Correale had wanted to reveal to the world.

Whatever the truth of the matter, there is no dispute con-
cerning his call to Francesca. The moment she picked up the re-
ceiver, she heard Correale's voice swearing without pause, an
incessant stream of epithets, each more inventive than the last.
Francesca held the phone away from her ear, but she couldn't
mistake the words. Once, twice, she tried to explain—they'd had
to tell Calvesi, she began—but she never got any further than

that. After what felt like a long while to Francesca, Correale's energy seemed to flag. She made another effort to explain, but he interrupted her. Because they had betrayed him in such a way, he said, he would never again speak to her or Laura. They were beneath contempt. And then he hung up.

Later, in calmer moments, Correale would say that he understood why they had gone to Calvesi. He was their professor; they looked to him for approval, the way, thought Correale, a child would look to his mother. He was angry that they had spoken to Calvesi, but if they had asked his permission, he would have given it to them. But he could never forgive the article in *Art e Dossier*. "A knife in the back," as he put it.

17

CORREALE KEPT HIS WORD. HE DID NOT SPEAK TO EITHER Francesca or Laura again. A few last editing questions about their article in the symposium catalogue were communicated to them by someone else on the project. They received their invitations to the symposium in the mail. It was scheduled for February 27 at the Capitoline Gallery.

Correale had set up an impressive panel of Caravaggio scholars to make presentations. Francesca recognized all the names, luminaries in the world of art history such as Denis Mahon, Mina Gregori, Keith Christiansen from the Metropolitan in New York, Luigi Spezzaferro, Christoph Frommel, and of course Calvesi. Except for Calvesi, she had not met any of them.

Neither she nor Laura intended to miss the symposium, despite Correale's wrath. It was, after all, their discoveries in the Recanati archive that made the event truly noteworthy for other Caravaggio scholars. Francesca wanted to make a good appearance. She tried a different hairdresser and bought her-

self a new outfit—a lavender skirt and matching jacket, a flow-
ery silk foulard, and a pair of magenta heels.

She rode her old Piaggio motorino to the Capitoline Gallery,
skirt hiked to her thighs, hair blowing in the wind. She arrived
half an hour late for the opening of the symposium, but this time
her tardiness was deliberate. She felt apprehensive at the pros-
pect of encountering Correale. She had decided to avoid the
mingling and casual chatting among acquaintances that always
occurred at the beginning of such affairs. And then there would
be the formalities, the welcome by the director of the Capitoline
and by Correale and the introductory speeches by two execu-
tives from Italsiel, the software company that had financed the
St. John project. She didn't mind missing those, either.

Nearing the grand hall of the Capitoline Gallery, she saw
that the symposium had attracted a large audience. People stood
near the entry, holding their winter coats in their arms. She
wended her way through the crowd. All of the folding chairs,
some two hundred of them, were occupied. She found a place
among others standing in the back along the gallery walls. At the
other end of the hall, the two *St. Johns*, bathed in light, were dis-
played side by side behind velvet ropes, like identical twins with
only slight variations in their features. The Doria version looked
darker, the colors less vibrant, next to the luminous Capitoline
painting.

Correale was at the podium, looking plump and formal in a
dark suit and tie, his reading glasses low on his nose. She heard
him speaking about Italsiel's new system of gathering scientific
and technical information on works of art. Francesca scanned

the crowd for familiar faces. Laura, ever punctual, had arrived in time to get a seat in the middle of the hall. Here and there among the crowd she spotted others she knew, professors and fellow students at the university. In the front row she noticed Calvesi, and she recognized nearby the fat, bejowled form of another Caravaggio scholar, Luigi Spezzaferro.

Correale had finished his speech and the director of the Capitoline had risen to introduce Denis Mahon. Francesca watched the elderly Englishman rise from the front row and move cautiously to the podium, cane in one hand and a sheaf of papers in the other. He adjusted his glasses, fussed with his papers, and peered out at the crowd. The hall grew quiet. Francesca did not know precisely how old Sir Denis was—in his early eighties, she'd heard. Everyone remarked on his age, and in the same breath on his astuteness of mind. He looked elfin to Francesca, his eyes bright and a small smile, almost mischievous, playing across his face.

His voice surprised her—its high, almost feminine register, without the watery quaver of old age. He spoke in Italian, flawlessly, with a British accent that Francesca found delightful. He noted that everyone was gathered here on this day because of his discovery, almost forty years ago, of the *St. John* hanging high on the wall of the mayor's office, at a time when everyone else thought the original painting was at the Doria Pamphili. He said this without seeming to brag, even though his age and accomplishments would have allowed him that indulgence. He had a few barbs for what he called the "old barons" of the art world— Longhi and Lionello Venturi, both long dead—who had never openly acknowledged the authenticity of the Capitoline *St. John*.

Francesca had imagined Mahon would give a short, unre-markable speech, the sort one often heard at such events. But he spoke at length, and midway through she saw how clear and sharp his mind had remained. The problem, he said, lay in the two payments of sixty and twenty-five scudi by Ciriaco Mattei for unspecified work to Caravaggio. The payments for *The Supper at Emmaus* and *The Taking of Christ,* said Mahon, seemed to accord well enough with Caravaggio's other known fees, although per-haps one hundred twenty-five scudi for the *Taking* was a trifle low. But to assume that Ciriaco had paid only sixty scudi for *The Incredulity of St. Thomas*—of which the Mattei archive contained no mention—and a mere twenty-five scudi for the *St. John* made no sense at all. Both payments were, said Mahon, "by a wide margin, too little."

Mahon proposed a different schedule of payments. He thought the Mattei family had probably never owned *The In-credulity of St. Thomas,* and that Baglione had erred in saying they had. He himself had never seen Baglione's original handwritten manuscript in the Vatican library. Some young scholar might want to check the manuscript against the published versions. Perhaps there had been a transcription error, repeated through the centuries, in the printing of the book.

And then he suggested that it made more sense to regard the first payment of sixty scudi as being for the *St. John,* not *The In-credulity of St. Thomas.* The second, smaller sum of twenty-five scudi might represent an additional payment for the *St. John,* or perhaps an advance for *The Taking of Christ.*

Mahon had challenged, in the same way Longhi might have, the conclusions in Correale's symposium catalogue. He had ad-

vanced a new set of conclusions that, once articulated, seemed far more likely to be accurate.

Standing among the tightly packed listeners at the back of the hall, Francesca listened with half an ear as one after another of the scholars spoke, displaying their erudition. Some argued that Caravaggio had made preparatory drawings for his paintings; others disagreed. Some speculated that he'd had a bottega of sorts, a commercial workshop, which had produced authorized copies of his works, such as the Doria *St. John,* although no evidence for a workshop had ever turned up. The meeting went on for three hours. It grew warm in the hall. People shifted in their seats.

During a break in the proceedings, Francesca made her way up through the crowd to the front, where the eminent art historians were gathered, surrounded by others. She saw Laura standing near Calvesi and went up to them. Correale stood nearby, talking to someone she didn't know. Their eyes met for a moment, and he looked away.

Luigi Spezzaferro, bespectacled, face flushed, wearing a billowing suit coat that bore traces of recent meals, bellied his way up to her. "Francesca Cappelletti?" he said, voice loud and heavy with a Roman accent. "Congratulations on your work. You should have come to me first, of course. I could have helped you with the bibliography: it would have been much better. You did pretty well, but you don't know enough yet."

A few minutes later, Francesca and Laura found themselves introduced to Denis Mahon. "Marvelous work," he said to them with a warm smile. "I really must compliment you both. It is so important to have these dates."

Francesca could feel herself blush, at once shy and proud.

Then Sir Denis said to them, "I wonder if you might have time tomorrow to lunch with me? There are some other matters I would like to ask you about."

Francesca was taken aback by this invitation. She wondered if she'd understood correctly.

Laura said, "Yes, of course, it would be our pleasure."

Francesca, nodding vigorously, stammered a simple assent.

"Tomorrow at one, let us say? I will meet you at the Hotel Senato."

18

THE INVITATION BOTH EXCITED AND UNNERVED FRANCESCA. IT
was as if a grandmaster in chess had taken note of her talent and
invited her to play a game. She was afraid of making a foolish
mistake.

She met Laura the next day in front of the Albergo del Sen-
ato, in the Piazza della Rotunda. They had both arrived early;
this was one appointment for which even Francesca would never
have been late. Denis Mahon was himself early. In the hotel
lobby they saw him sitting in an armchair, hands resting on his
cane. He wore a heavy coat against the February chill. He
seemed lost in thought, staring straight ahead.

They went over to him. He looked up, as if startled, and then
smiled and said, "Ah, che piacere!" and rose slowly from the
chair. He addressed them in the formal manner, shaking each
woman's hand in turn. They walked out of the hotel, Francesca
on one side of the old man, Laura on the other, and went across
the piazza toward Da Fortunato.

Inside the door, the manager greeted Sir Denis with a beam-

ing smile and helped take the heavy coat off his shoulders. Photographs of Da Fortunato's more famous clientele—actors, politicians, writers—hung in the entryway. Francesca saw a black-and-white photo of Mahon in a pin-striped suit, looking up at the camera with a grin, seated at a table with another man. Sir Denis paused briefly to cast an eye at the display of fresh fish on ice—sea bass, oysters, squid, shrimp with their carapaces intact. He seemed to lift his nose to catch the aromas in the air and rubbed his hands together. A man who liked to eat.

The manager escorted them to a table in the front room, near a window facing the street. Francesca had a tendency to chatter when she felt nervous, but that habit deserted her now. Both she and Laura sat solemnly, awkwardly, hands in their laps, too shy even to open the napkins until Mahon made a move. He seemed to realize their discomfort. He congratulated them again on their research. He asked about the Recanati archive, how they had tracked it down, how long they had spent there. He drew them out with ease and deftness, asking their opinions on various matters concerning the Mattei family and Caravaggio. Did it seem possible to them that Ciriaco had actually owned *The Incredulity of St. Thomas* by Caravaggio, as Baglione had written? It might be worthwhile, he suggested, for one of them to perform the research he'd suggested and check Baglione's original manuscript. It might contain some clues, a note in the margin perhaps.

The dishes arrived as they talked—for the Englishman, an antipasto of mixed seafood marinated in olive oil and lemon juice, followed by medallion of veal with lemon and capers and a plate of spinach repassato, cooked with garlic and oil. He ate

slowly, but with obvious pleasure, commenting on the excellence of the seafood, the tenderness of the veal. Laura ordered a simple plate of pasta and Francesca just a salad with ruchetta and Parmigiano. She took only a few bites and moved the rest around on her plate, listening intently to Mahon's every word. It seemed surreal to her, this lunch with Denis Mahon asking them questions, wanting to hear their opinions, as if he regarded them as his peers.

It was apparent that he had read their essay with great care. Not even the smallest item in the footnotes had escaped his notice. In addition to the dates, he told them, they had verified Longhi's suspicion that Hamilton Nisbet had bought the original *Taking of Christ* in 1802. And that meant that the Odessa version had to be a copy. It had turned up in Paris in the 1870s, while Hamilton Nisbet's heirs still had possession of the original.

Francesca mentioned that she had come across the essay by Hugh Brigstocke concerning the Hamilton Nisbet collection.

"Hugh Brigstocke?" said Mahon. "Yes, I know him. He has left the Scottish National Gallery. He's at Sotheby's now, in charge of cataloguing Old Masters."

"Brigstocke had written that *The Taking of Christ* went up for auction in 1921," continued Francesca. "What happened to it after that?"

Mahon said he was certain that Brigstocke had checked the records of the auction house, but had come up empty-handed. He gave Francesca an appraising look. He asked how she had happened to come across the essay.

"At the Warburg Institute," she replied. She had a scholar-

ship to study there for a year. She was, in fact, returning to London the next day.

"You know," said Mahon, "I think you ought to talk to Brigstocke when you get back to London."

"I'd like to talk to him," said Francesca. "But I felt reluctant to call him without an introduction. I thought he might be offended by a student asking him questions."

Mahon smiled. "You can tell him that I told you to call. By the way, where are you staying in London?"

"Radcliffe Road, near King's Road and Fulham," Francesca said.

"How lovely!" said Mahon. "We are neighbors! I live in Belgravia, in Cadogan Square. You must stop by for a visit and see my paintings. Here, let me give you my telephone number." He called to the waiter to bring him a pen and a piece of paper and jotted down his number. He gave her the pen and asked that she write down hers.

Francesca couldn't imagine actually summoning the courage to call Mahon. He's just being kind, she told herself, he doesn't really expect me to call.

Only later did it occur to her that she'd probably misunderstood. He hadn't given her his number out of kindness, and he wasn't taking a personal interest in her and her career. Sir Denis's true interest in life was art. That was his chessboard, Francesca realized, and all his moves had significance. He'd given her his number because he thought that perhaps she might come across something else of interest to him. And if she did, he wanted to be the first one to hear about it.

❧ 19 ❧

FRANCESCA RETURNED TO LONDON AND TOOK UP HER STUDIES AT the Warburg. In a spare moment, she looked up an address for the Ogilvy family in Scotland, the descendants of Constance Nisbet Hamilton, the last of the direct line of William Hamilton Nisbet. She wrote a letter asking for information about their collection of paintings, and inquiring whether, by chance, they could shed any light on the fate of *The Taking of Christ* by Honthorst. Luciano, in London for a weekend, corrected her English grammar. She tried calling Hugh Brigstocke at Sotheby's. She got as far as a secretary and left a message. Several days passed without a response.

One evening, after a day at the Warburg library, she was washing her hair in the bathroom when she heard the telephone ring. Her roommate, Caterina, answered. A moment later Caterina appeared at the door and said, "It's Denis Mahon; he wants to speak with you."

Francesca stared at her. "Are you joking?" she said.

Caterina shook her head.

Francesca wrapped a towel around herself and went to the telephone.

The Englishman said brightly in his high voice, "I hope I am not disturbing you."

"Oh no," said Francesca, hair dripping on her shoulders. "Not at all."

Mahon asked whether she had spoken to Brigstocke yet.

Francesca said that she had called Sotheby's and left a message, but she had not heard back.

Mahon said he would give her Brigstocke's home number. He would call Brigstocke himself, he added, and tell him to expect a call from Francesca. Mahon seemed in the mood to chat for a while. A seventeenth-century painting, a battle scene, had just come up for auction. Mahon felt certain it was by Poussin, a Baroque artist about whom he had written more than a dozen monographs. Others had raised questions about this attribution. Would Francesca, when she returned to Rome, mind checking a few documents in the Vatican library concerning this painting?

Francesca, clutching the towel around her, damp strands of hair on her shoulders, said she would be delighted to help.

Mahon spoke on for a while about Poussin. Francesca tried to call to mind paintings and dates, tried to think of intelligent comments to make on the subject of Poussin, on the old theoretical debate concerning line and color that had divided him and Rubens. For almost an hour she stood half naked and cold, trying to find a way to end the conversation without giving offense.

It was Mahon who finally brought the talk to a close, expressing his pleasure at chatting with her and making her promise to let him know if she happened to find anything interesting.

The next evening Francesca called Hugh Brigstocke at his home. Their conversation was brief. He was polite, but Francesca had the impression that he didn't like receiving phone calls about business at home, even if they had originated from Denis Mahon. She explained that she was interested in paintings Hamilton Nisbet had acquired in Rome. Brigstocke said he didn't think he would be much help to her on that subject. Francesca told him briefly about her work in the Recanati archive. Might she come to see him at Sotheby's? With some reluctance, it seemed to Francesca, he gave her an appointment for the following week.

※

On a wet, gray afternoon, Francesca caught the bus on King's Road and rode in to Piccadilly. Caterina came with her to keep her company. At the door of Sotheby's on New Bond Street, Caterina wished her luck and they parted.

The receptionist directed Francesca to the third floor. A young woman met her at the elevator and escorted her down several long corridors to Brigstocke's office. The place seemed busy, people walking here and there with sheaves of papers in their hands, all apparently on urgent business. Brigstocke rose from behind his desk to greet her. He was a handsome man in his late forties, with a heavy, craggy face. Francesca took a seat in

front of the desk. She wondered whether he spoke Italian—her English was still imperfect—but she was reluctant to ask.

He spoke to her in English. "So you know Denis Mahon?" he said.

"Not well," she replied honestly, explaining that she had just met him a few weeks ago in Rome.

"He latches on to young scholars," said Brigstocke. "He likes to have them in tow. He'll come in and out of your life when you're doing something that interests him."

Brigstocke said this in a way that Francesca interpreted as dismissive. She was just another young scholar to Mahon, and to Brigstocke as well.

"He'll call you at all hours to talk," continued Brigstocke. "It's an obsession with him."

A woman poked her head in the door and asked Brigstocke a question that Francesca didn't understand. Brigstocke said he would be free in a minute. And at that moment the phone on his desk rang. Francesca looked around the office as he spoke. His desk was piled with catalogues and files. Several paintings, old but not recognizable to Francesca, leaned against the wall.

Brigstocke hung up the phone and apologized to Francesca. "Now, what can I do for you?"

"The Mattei paintings that Hamilton Nisbet had bought in 1802," began Francesca.

"Ah, yes," said Brigstocke. "Denis mentioned that you're interested in them."

"Only one of them is still missing, *The Taking of Christ*," said Francesca. The research she and Laura had done in Recanati had

shown to a near certainty that it was the lost painting by Caravaggio. Brigstocke seemed to grow more interested when she talked about finding the inventory in which the attribution had changed to Honthorst.

"Well," said Brigstocke, "I looked into it. It was sold in 1921 at Dowell's auction house in Edinburgh. I found the Dowell's catalogue, but it had been put together by someone uneducated, someone who either didn't know or didn't care what he was doing." Brigstocke fished around among the files on his desk and drew forth several pages, which he handed to Francesca. "This is from the auction catalogue," he said. "Denis thought you'd want to see it."

It was dated Saturday, April 16, 1921, and contained a list of paintings. On the seventh page of the catalogue, midway down, Francesca saw the words "After Gerard Honthorst. The Betrayal of Christ." Just below it was another of the six Mattei paintings, *Christ and the Woman of Samaria,* with the attribution "After Lodovico Caracci." This was a painting actually by Alessandro Turchi that had been found in a collection in New York.

"There's no record of who bought any of these paintings," Brigstocke told Francesca. "And Dowell's doesn't exist anymore. It was bought in 1970 by another auctioneer, Charles Phillips & Sons."

"Perhaps the heirs of Constance Nisbet Hamilton would know something more?" asked Francesca.

Brigstocke said he had contacted the family. They knew nothing. "Maybe it'll turn up someday. I hope so, but many paintings have been destroyed."

Francesca said she planned to go to Edinburgh and see what she could find. Did he have any suggestions for her?

Brigstocke gave her a level gaze. "You look like the sort of person who won't be discouraged," he said. It didn't sound to Francesca as if he meant it as a compliment. But he smiled at her as he rose from his chair to signal the end of the interview.

20

It was May in England, the days warmer and sunny, the tulips in riotous bloom in Hyde Park. Francesca received a reply, formal and brief, from her letter to the Ogilvy family, the distant descendants of William Hamilton Nisbet. As Brigstocke had already told her, the family had no information about the paintings that had gone up for auction seventy years ago. The letter suggested that Francesca direct her efforts to the archives of the National Portrait Gallery in Edinburgh.

Francesca told Luciano about her plan to go to Edinburgh, and he offered to go with her. They were both busy with their studies, Francesca writing a paper on the iconography of Renaissance depictions of mythology and studying for an exam in medieval art. They decided to go at the end of the school term, in June. Francesca found a small, inexpensive hotel, family-run with only a dozen rooms but in the center of the city. With the help of a guidebook, she planned her itinerary, circling on a street map of Edinburgh the National Gallery, the National Portrait Gallery, the National Library, the Scottish Record Office,

and the location on George Street of what had once been Dowell's auction house.

On a Sunday in late June, they set off in Luciano's car. For Luciano, this was purely a vacation, an opportunity to be alone with Francesca for the next few days. And she also regarded it as a vacation, even if she had brought along a suitcase heavy with art history books for the exam she would have to take back in Rome. She told herself not to expect too much from this trip. She didn't really think that she would find the painting, but she did hope to find something, some clue, that would take her a step further.

They spent four days in Edinburgh, in the small hotel with bow windows and pink steps located just behind the National Portrait Gallery. The old center of the city reminded Francesca of an anglicized Rome—narrow cobbled streets, eighteenth-century buildings, the ruins of an ancient castle on a hill overlooking the city—but Edinburgh was well-ordered and clean, with traffic that actually obeyed the rules.

Luciano accompanied her on her rounds. First to the National Gallery, where a heavyset Scottish woman with thick spectacles narrowed her eyes in puzzlement at Francesca's accent. Finally the woman took in hand the photocopy of the page from the Dowell's catalogue that Francesca had gotten from Brigstocke. She held it close to her nose, scrutinized it, turned it this way and that, disappeared for twenty minutes, and came back empty-handed. She suggested that Francesca try the archives at the National Portrait Gallery or the Scottish Record Office.

At the Scottish Record Office, another bespectacled, middle-aged woman cocked her head at Francesca's accent. Francesca

finally made herself understood, and then spent an hour in fruitless search for documents from Dowell's. She did find a thick folder on Hamilton Nisbet, his forebears and his heirs. She leafed through the pages, taking notes on Hamilton Nisbet's life. He had been enormously wealthy, as rich as the Mattei family in Ciriaco's day. He'd owned three grand estates on vast tracts of land in East Lothian, east of Edinburgh. His primary residence had been Biel House, a sixty-six-room mansion where, according to an inventory, *The Taking of Christ* by Honthorst had hung in the dining room. All very interesting, thought Francesca, but nothing in the folder revealed what had happened to the painting after the auction.

Her last stop of the day was the archive at the National Portrait Gallery, and it was there, with Luciano patiently at her shoulder, that Francesca came across dozens of old catalogues from Dowell's. Her heart quickened when she saw the one dated Saturday, April 16, 1921, the date of the Hamilton Nisbet auction. The title page read: "Catalogue of a Collection of Valuable Pictures in Oil and Water-colour Removed from the Mansion-House of Biel, East Lothian." There were several copies of the catalogue, all identical except for one that had been annotated with a list of figures, handwritten in the margins next to each painting. The sum next to *The Betrayal of Christ,* by Gerard Honthorst, was noted as £8-8-0—eight guineas. Francesca did not know the precise value of eight guineas in 1921, but it seemed like a paltry sum. Luciano guessed it would be no more than fifty English pounds in current value.

Francesca searched the entire Dowell's folder, looking for records of sale, some accounting of the disposition of the paint-

ings, of who had bought them. Nothing. She felt a sudden sadness, like a wave of fatigue. She put her head in her hands.

"Eight guineas," she murmured to Luciano. Had the painting actually sold at that price? Or had the auctioneer merely noted in the margin the reserve prices for the paintings? One way or the other, the sum of eight guineas was a measure of how time had eclipsed Caravaggio's fame. She remembered the opening of Longhi's famous essay "Ultimi Studi sul Caravaggio e la Sua Cerchia," written some fifty years earlier: Longhi said that by 1900 Caravaggio had become one of the least-known painters in Italian art.

The next morning Francesca and Luciano walked over to 18 George Street, the former site of Dowell's, now owned by Charles Phillips & Sons. The building, several stories tall and constructed of stone with a pinkish hue, dated from the turn of the century and had spacious windows on the ground floor through which one could see a display of paintings and antique vases.

Francesca approached a young woman seated behind a desk. Using her best English diction, she asked whether, by chance, Charles Phillips & Sons had kept any old records from Dowell's.

The girl tilted her head in perplexity, either at the substance of the question or, more likely, thought Francesca, at her accent. She told Francesca to wait a minute and went to summon help. A moment later, she returned with an older woman. More frowning and tilting heads. Finally they understood the words "Dowell's" and "documents."

The older woman shook her head and smiled merrily. "Dear me, those old records, we wouldn't keep them. Maybe some of

them went to the archive at the Record Office or the National Gallery, but I imagine they've been burned."

"Nothing at all?" said Francesca. "You are certain?"

"Oh yes, quite certain," said the woman, still amused.

On the sidewalk outside the building, Francesca turned to stare at the gallery. "No records," she said to Luciano, her voice tinged with bitterness. "You always tell me how precise and orderly this country is. In Italy, at least, they keep every piece of paper, every document, going back five hundred years!"

Francesca had tracked the painting over three hundred and twenty years. During that time empires had risen and fallen, wars had been fought, fortunes had been made and lost, plagues, famines, floods, and droughts had ravaged lands. A mere seventy years ago, on a Saturday afternoon in April, the painting had been here in this building, and then it had simply disappeared. It was not unreasonable to think that it might have perished. It was, after all, a mere piece of cloth, measuring four feet by five.

IT WAS THE FIRST DAY OF JULY WHEN FRANCESCA AND LUCIANO left Edinburgh. Just one month later, across the Irish Sea, the chronicle of the lost painting by Caravaggio was about to take a new turn.

PART III

❦

THE
RESTORER

❧ I ❧

THE NATIONAL GALLERY OF IRELAND STANDS NEAR THE CENTER of Dublin, directly across from the large green expanse of Merrion Square, with its paved walkways, flower beds, and copses of neatly pruned trees. From Merrion Square, the gallery presents a stolid, institutional aspect—it is a heavy gray stone edifice with a squat portico and four blocky columns. On the gallery's roof, barely visible from the street, there is a curious structure of wood and glass. It is clearly a late addition, boxy and utilitarian, bearing no architectural relationship to the gallery's nineteenth-century Georgian façade. Some gallery employees refer to it as the penthouse.

The penthouse has long been the domain of the gallery's two restorers, the studio where they cleaned and repaired old and damaged paintings. It was accessible by means of a freight elevator, but the restorers usually climbed up an old marble spiral staircase that led to a dark landing and a stout metal door. Its interior was luminous, even on cloudy days, with light filtering in through an expanse of large windows high up on three of the

walls. The concrete floor was stained by years of paint splatters. The room was spacious. In it stood a broad table, also paint-stained, three sturdy easels, a binocular microscope mounted on a wheeled tripod, and several powerful lamps. In one corner, a tall metal cabinet held jars and tins of solvents, varnishes, lacquers, and oils. A smaller wooden cabinet with wide, shallow drawers, the sort of cabinet one might have seen in a dentist's office years ago, contained dozens of small tubes of restorers' paint, fine-tipped brushes, and an assortment of stainless-steel implements. Paintings in various states of distress—flaking, torn, cracked, infected with the white bloom of fungus—stood propped against the walls. One, a portrait of an English nobleman, had a triangular rip in the center, two inches on either side, a wound produced when a security guard backed into a camera on a tripod. Another, a small sixteenth-century Italian panel of the Madonna, lay on the table, its surface mottled and blackened by an early, inept restoration.

It was August 1990. Sergio Benedetti had worked in the restoration studio at the National Gallery for the past thirteen years, along with Andrew O'Connor, the gallery's chief restorer. Benedetti was then forty-seven years old. He was married and had two children. He had a steady, if low-paying, job, but for some time now he'd found himself growing discontented with his professional lot in life. He had felt that he was destined to achieve something important, to make himself known in the art world, and yet the years had come and gone without presenting him any clear opportunities. At times he felt that life in Ireland was akin to exile, in a land on the far periphery of the art world. He missed Italy, often acutely. He had begun his career there,

restoring paintings and frescoes, but the bureaucracy, the end-
less delays in getting paid, and the constant need to seek out
work had finally defeated him.

To supplement his salary at the National Gallery, Benedetti
took in freelance work from time to time, by an understanding
he had worked out with the gallery's director. The gallery also
had a policy of opening its doors every Thursday morning to
offer free assessments on the merits of sundry objects of art
carted in by the public. Very little of value turned up, but Ben-
edetti enjoyed these mornings and the diversion they provided
from his routine.

On this particular Thursday morning in August, Benedetti
had an appointment to look at some paintings outside the
gallery. The appointment had been arranged by the gallery's new
assistant director, Brian Kennedy. An acquaintance of Kennedy's,
the rector at the St. Ignatius Residence, where fourteen Jesuit
priests lived, had inquired several months ago about the possi-
bility of having some paintings cleaned. At the time, Kennedy
had been busy with the details of his new job. He'd put the mat-
ter off until just recently, when the rector called again to re-
mind him.

The Jesuit residence was situated at 35 Lower Leeson Street,
a ten-minute walk from the gallery. Benedetti and Kennedy set
out in late morning, the day sunny and warm. Walking side by
side, they presented a study in contrasts—Kennedy in a dark
suit, tall and lanky, in his late twenties, with horn-rimmed glasses
and a birdlike face, and Benedetti in corduroy pants and cotton
shirt, shorter and much stouter, his features growing heavy with
middle age. Kennedy had a youthful, energetic manner. He was

smart and ambitious, and yet affable, while Benedetti tended to brood. For all their differences, Benedetti liked the young man's company.

On their way to Leeson Street, Kennedy mentioned that he'd visited the Jesuit residence in the past. The rector, Father Noel Barber, edited a scholarly journal for which Kennedy had written several articles. He recalled that the residence had half a dozen paintings, works with religious themes. "Some dark copies of Old Masters," he told Benedetti, "the sort of thing you find in lots of Irish religious houses. They have one hanging in the parlor that I think might be quite good."

They walked past St. Stephen's Green and turned onto Lower Leeson Street, a quiet, well-kept thoroughfare lined with old Georgian row houses in brick and stone, each four stories tall. The door of 35 Lower Leeson Street was painted bright blue and lace curtains hung in the windows. Father Noel Barber greeted Benedetti and Kennedy and welcomed them in. He explained that they were in the midst of cleaning and refurbishing the house—pulling up old carpeting, polishing the floors, and painting the walls. They had taken down all the paintings and moved them to the library on the second floor. He led the way up the stairs.

The library was a large book-lined room overlooking the street. Benedetti saw seven or eight paintings of varying sizes propped up against the bookcases. His eyes were drawn immediately to the largest one, in an ornate gilt frame. He stared at it for a long moment, and then forced himself to look away to the other paintings. He knelt before each, his eyes registering the details, but his mind remained with the large painting in the gilt frame. He saw several early twentieth-century Irish paintings of

little consequence, and an Italian work, possibly sixteenth century but provincial and clumsily executed. All rubbish, he thought to himself. He made no comment. Behind him, he heard Kennedy and Father Barber talking.

Finally he turned his attention to the large painting. It was dark, the entire surface obscured by a film of dust, grease, and soot. The varnish had turned a yellowish brown, giving the flesh tones in the faces and hands a tobacco-like hue. The robe worn by Christ had turned the color of dead leaves, although Benedetti's eye told him that beneath the dirt and varnish it was probably a coral red. He could see that the canvas had gone a little slack in the frame. He judged that it had not been cleaned or relined in more than a century.

He came close to the painting, squatting on his haunches before it, his face inches from the surface. It was definitely a seventeenth-century work, he thought. The craquelure, the network of fine hairline cracks, was just what he would expect in a painting almost four centuries old. All in all, the picture appeared to be in rather good shape. He could see only a few areas where the paint surface had cupped slightly and flaked, the worst on the right edge of the canvas, on the back of the second soldier. But the most important areas, around the hands and faces, seemed free of damage.

He examined the features of Christ and of Judas, the eyes and ears, and the details of the hands. Could it possibly be? he asked himself. He reached out and touched the surface lightly with the pads of his fingers, feeling the texture of the paint, the slight give of the canvas. If it is not by him, Benedetti thought, it is the best possible copy.

Benedetti stood and turned to Kennedy and Father Barber, who had fallen silent and were observing him. "Of all the paintings," Benedetti said, keeping his voice neutral, "this one is definitely the best. To understand it better, we should take it back to the gallery for cleaning and restoration. If you care," he added with a shrug.

Father Barber responded with a smile. "Oh, yes," he said. "We've always thought it to be the best work in the house."

"A good second-division work," added Kennedy with a nod.

The painting, said Father Barber, had hung for many years in the dining room, which had a high ceiling, an old coal-burning fireplace, and large windows looking out on the back garden. More recently, the Jesuits had moved it to the front parlor.

Benedetti said he would make the arrangements to pick up the painting. The restoration process, he told Father Barber, would normally take around three to four months for a painting of this size. But he also had his regular obligations at the gallery, so it would no doubt take longer.

"How long do you estimate?" asked Father Barber.

"Possibly six months or eight months," said Benedetti. "I can't say for certain. I think it should be relined first, before I can start cleaning. I'll know better then."

Father Barber, a small, trim man in his mid-fifties with lively, intelligent eyes, seemed curious about the restoration process. He asked Benedetti several questions, to which Benedetti responded politely but briefly. None of the other paintings in the residence was mentioned, nor was there any discussion of a fee for Benedetti's work. A fee was the furthest thing from Benedetti's mind at that moment. His only thought was to get this

painting into the restoration studio so that he could examine it at length and in detail.

On the way back to the gallery, Brian Kennedy noticed a change in Benedetti's demeanor. The restorer hadn't uttered a word since they'd left the Jesuit residence, and he was walking at a fast and determined pace.

"Sergio, what's up?" Kennedy asked.

"The picture is possibly much more important than they think," replied Benedetti.

"Why? What do you think it is?"

"I think it might be by Caravaggio."

"You must be joking," said Kennedy, although he could see that Benedetti was in no joking mood. Kennedy had a doctorate in art history, but his areas of concentration were twentieth-century Irish art and arts policy. He had worked at the Ministry of Fine Arts before coming to the National Gallery. He understood the import of what Benedetti had just suggested. It seemed quite preposterous to him.

"Well," said Kennedy, "I guess we should talk to Raymond straightaway."

2

RAYMOND WAS RAYMOND KEAVENEY, THE DIRECTOR OF THE National Gallery of Ireland. Benedetti had known him for eleven years, ever since Keaveney had arrived at the gallery as an unpaid trainee curator. Benedetti had been in Ireland for just two years, and he barely spoke English. Keaveney had studied art history in Rome, and to Benedetti's relief, he spoke Italian, so they could converse in the restorer's native language.

Keaveney had risen through the gallery's small ranks to become director a year and a half ago. Now he occupied a spacious second-floor office furnished with dark, heavy antiques. He was a wiry man with sharp features and a crest of wavy gray hair that grew long over his ears and collar. He tended to get excited easily. He reminded some gallery employees of a rooster.

Keaveney was seated at his desk when Benedetti and Kennedy appeared at the door. Kennedy told him about their visit that morning to the Jesuit residence. He wasted no time getting to the point. "Sergio thinks one of the paintings might be by Caravaggio."

Keaveney looked startled. "Are you serious?" he asked Benedetti.

"It is either by him, or it is the best copy of his painting," replied Benedetti.

Keaveney was deeply skeptical. He had learned to respect Benedetti's professional judgment, and he could see that Benedetti was agitated, in a state of excitement that Keaveney had rarely seen before. But to stumble across a Caravaggio in your own backyard—in Dublin, of all places—seemed wildly improbable.

Benedetti described the painting to Keaveney. He said he had immediately recognized the subject—the betrayal of Christ by Judas. Such a painting was known to have been lost for many years, Benedetti explained, although many copies had turned up. There was one in Odessa that some art historians thought might be the original, although most regarded it as a very good copy. The quality of the one in the Jesuit residence appeared equally good. "I think it could be the original," he told Keaveney. "I want to get it into the studio as soon as possible, to study it more closely."

"Of course," said Keveaney, who was himself anxious to take a look at the painting. "But how in the world did the Jesuits get it?"

Kennedy replied that they hadn't asked the Jesuits that question yet. In fact, apart from the three of them, no one else knew of Benedetti's suspicion.

"We should keep it that way, for the time being," said Keaveney, now pacing back and forth, trying to order his thoughts. "Not even other gallery personnel should know. Let's go slow

and not get ahead of ourselves. We don't want to make fools of ourselves."

Benedetti hurried out to make arrangements to transport the painting from Lower Leeson Street to the gallery. The painting was too big to carry back, too big even to fit in the trunk of his car, and the gallery did not have a vehicle of its own. Benedetti would have to lease the van of an art dealer with whom the gallery regularly did business.

Keaveney shut the door to his office and conferred alone with Kennedy. "What's your honest opinion?" he asked Kennedy.

"It all seems so unlikely," said Kennedy. "I've seen the painting before—it was hanging in the parlor—and so have a lot of other people, some of them very knowledgeable about art. It's not as if it just came out of somebody's attic."

"But if Sergio is right," mused Keaveney, "the implications are staggering. There will be dealers from London and New York with their wallets wide open. It'll be a circus!" He drew a deep breath. "The most important thing is that we get this right and don't embarrass the gallery. We must keep it absolutely quiet until we are sure of ourselves."

That evening, Keaveney tried to keep calm by telling himself that surely Benedetti was mistaken. After all, the restorer had said that many copies of the same painting existed. No doubt this was just another copy. They would proceed on that assumption.

But Keaveney's mind kept racing back to the possibility that the picture was genuine. A stroke of incredible fortune, he thought, to find a painting like that! One that would put the National Gallery of Ireland on the map! And also an incredible

burden. The gallery was ill equipped to handle a discovery of such magnitude. The professional staff numbered fewer than a dozen, including the bookkeeper, the photographer, and a part-time public relations person. One entire section of the gallery had been closed down because of chronic leaks in the roof. A larger and richer museum could assign a team of scholars to conduct a thorough investigation into the painting's provenance, and another team of technicians to carry out the scientific tests. How could the National Gallery of Ireland possibly manage it all alone?

❧ 3 ❧

BENEDETTI LEARNED THAT THE VAN BELONGING TO THE ART dealer was in use, unavailable to the gallery until the following week. The restorer resigned himself to the wait. The weekend seemed interminable. His mood shifted feverishly from elation to doubt to anxiety. One moment he was certain he had found the lost original by Caravaggio; the next moment he thought he couldn't be that lucky, it was just another copy. In his mind, he played over and over again the image he'd retained of the painting, like a lottery winner obsessively examining his ticket. He longed to see it again, to take it into his possession, to study it alone and in peace.

His greatest anxiety, one that kept him turning restlessly in bed at night, was that the painting would disappear just at the moment it was in his grasp. He imagined Father Barber calling in another restorer, or an art historian, for a second opinion. Or some antiquarian visiting the Jesuit residence and offering to buy it. In the morning light, Benedetti told himself these

thoughts were irrational, the painting wouldn't vanish in a mere four days, but in his darkest hours his fears beset him anew.

When Benedetti had first arrived in Ireland, it had crossed his mind that he might, with luck and vigilance, happen upon a valuable discovery. He knew that an endless stream of antiquities, sculptures, and especially Renaissance and Baroque paintings had flowed into the British Isles during the eighteenth century, sent back by wealthy young aristocrats on the Grand Tour. Families and fortunes had risen and fallen over the past two centuries, and many of the collections had been dispersed. Some had gone to museums, others had gone up for auction, and a few worthy pieces of art had simply disappeared. The Italian Baroque, in particular, had fallen out of favor, denigrated by critics like John Ruskin, who had written that a work by Guercino was "partly despicable, partly disgusting, partly ridiculous," a fair summary of his entire view of the era.

By the time Benedetti arrived in Dublin, the Baroque had already begun coming back into fashion. The paintings had acquired a new luster and value. Museums were spending large sums of money, sometimes millions of dollars, to obtain them. Every year or so, it seemed to Benedetti, he would read in newspapers and art journals about another remarkable discovery.

Benedetti had not expected to enrich himself personally by discovering an important painting. But he had hoped he might advance his career by publishing such a find in a prestigious art journal. Yet the years had passed, and he had found nothing of note. Perhaps, he thought, if he had ended up in England or Scotland or Wales, he would have had a better chance. He hadn't

realized just how poor Ireland had been—almost like a third world country just a decade ago, he once remarked to an Italian friend.

For twenty-five years he had tended to torn canvases and cracked panels, to cupping, flaking, peeling, and alligatoring paint. He had learned his trade at the Istituto Centrale per il Restauro in Rome, which admitted only twelve students every year. In Italy, restorers were looked upon as skilled tradesmen. Art historians, on the other hand, were regarded as professionals, on the same social level as doctors and lawyers and university professors. Benedetti had aspired to study first archaeology, and then later art history, but he had become a restorer out of necessity. He couldn't afford the years of schooling and postgraduate studies, and then the uncertain job prospects that faced a newly graduated art historian.

He had lived in Rome but had traveled all over Italy, from Sicily to Genoa, restoring frescoes and oil paintings. He had spent months in Assisi, working with a team of other restorers on the Giotto frescoes on the ceiling of the cathedral of San Francesco. He had worked on hundreds of paintings, masterpieces from the sixteenth and seventeenth centuries, although he had never laid his hands on a Michelangelo, a Raphael, or a Caravaggio.

In Rome, he often ate at a trattoria called Mario's, in the Piazza Madonna dei Monti, a short distance from the Istituto Centrale. A liter carafe of red wine cost one hundred sixty lire, the equivalent of fifty cents, a plate of spaghetti one hundred twenty-five lire, a steak three hundred lire. Mario's wife did the cooking. The place was furnished simply, with large, sturdy

wooden tables and chairs, and white tablecloths washed only once a week, but covered with butcher paper to keep them clean. The décor consisted of a Peroni beer calendar on the whitewashed wall. Mario kept the door open until three in the morning. The trattoria was always crowded, loud, and convivial, always with a card game of scopa going on. Mario's attracted students and professors from the institute, sitting eight to ten to a table, and then, as word spread about the late-night discussions and debates concerning art, a few famous art historians began dropping by. At Mario's on an evening in 1968, Benedetti met Denis Mahon, then in his late fifties, dressed in his usual dark doublebreasted Savile Row suit and surrounded by acolytes. The topic was Caravaggio. Benedetti entered into the discourse. Mahon seemed to take note of the young restorer's scope of knowledge.

Benedetti had, in fact, read just about everything there was to read concerning Caravaggio. His hero back then was Roberto Longhi, the master of Caravaggio studies. Mahon came in a close second. Most art historians tend to adopt a particular artist and make a career of studying him. Benedetti, the amateur, had adopted Caravaggio.

Mario's trattoria was not the sort of place Denis Mahon visited regularly, but after meeting the Englishman there, Benedetti made an effort to keep in contact with him. When there was an exhibition opening in Rome or Bologna or Florence that he knew Mahon would attend, Benedetti would try to go. At conferences where Mahon spoke, he came to listen and stayed afterward to make his presence known. Mahon remembered his name and always seemed pleased to see him. Most important, Mahon always spoke to him as an equal.

☙❧

THE MORNING DAWNED CLEAR AND BRIGHT ON THE DAY BENEDETTI had arranged to pick up the painting. He felt thankful for the sunny day. In Ireland, there was always the possibility of rain, and he had not wanted to transport this painting in a downpour.

He and two art handlers from the gallery, members of what was called the Working Party, rode in the art dealer's van to the Jesuit residence. Father Barber escorted them upstairs to the library. The Working Party had brought along a roll of heavy plastic bubble wrap to protect the painting during the move. Benedetti's nerves were on edge, but he wanted to betray no emotion. He and Father Barber chatted, Benedetti keeping his voice casual, as they watched the gallery men prepare the painting for its move.

The Working Party carried the wrapped painting downstairs and installed it in the van, strapping it into place so that it wouldn't shift during the short ride to the gallery. No mention was made by Father Barber or Benedetti of a receipt or a document attesting to the terms of the transaction. Normally Benedetti or one of the Working Party would have written out such a document, describing among other things the condition of the painting. But given Brian Kennedy's relationship with Father Barber, and the unspoken agreement that the cleaning and restoration would be carried out at no cost to the Jesuits, it seemed that trust and one's word were sufficient.

Up in the penthouse studio, Benedetti had begun removing the plastic wrapping from the painting when Raymond Keaveney appeared at the door. Like Benedetti, Keaveney had spent

a difficult weekend, weighing the advantages and problems of having a lost Caravaggio on his hands. His field of study had been sixteenth-century Roman frescoes: the high Renaissance and the Mannerists. He had seen many paintings by Caravaggio in the churches and galleries of Rome, but as he gazed at this one, he admitted to himself he would not have recognized it as a Caravaggio. He stared at it, chin cupped in the palm of his hand. He thought the face of Christ and the way in which Christ's hands were clasped looked somewhat awkward for a master-piece. The details, of course, were hard to make out through the yellow film of grime and old varnish. But Keaveney's first reaction was one of grave doubt. He compressed his lips and shook his head slightly. To Benedetti, he said, "Ahh, I'm not so sure about this one, Sergio."

Benedetti, looking upon the painting for the first time in good light, was experiencing precisely the opposite reaction. The painting was as good as he'd remembered. At least as good, he thought, as the photographs he'd seen of the Odessa version. He forced himself to be skeptical, but he couldn't help feeling that he was in the presence of the master.

He noticed just then, for the first time, the wooden plaque attached to the frame at the bottom of the painting. It was itself dirty, the words barely legible. He gently wiped away some of the grime. The plaque read, in neat precise lettering, "The Betrayal of Christ," and beneath that appeared the name Gerard Hont-horst. In smaller lettering, in parentheses, was written "Gherardo della Notte."

4

THAT AFTERNOON BENEDETTI SET ABOUT PREPARING FOR THE OP-
erations he would perform on the painting. He covered the large
table in the center of the studio with a white cloth and laid the
painting in its frame facedown on the cloth. The back of the
canvas was stained here and there and had turned brown and
brittle with age. The canvas was attached to an old, heavy
wooden stretcher, which in turn had been fitted into the frame
and secured by a series of thin, headless brads. The brads, now
rusty, had been hammered into the soft wood of the frame and
bent over the stretcher to keep the painting in place. It was an
old framing method. Nowadays Benedetti would use stainless-
steel spring clips to attach a painting to its frame.

He removed the brads with a pair of pliers and lifted the
wooden stretcher out of the frame. He saw immediately that the
picture had been relined at least once before. The previous re-
storer had glued another canvas onto the back of the original
one and, in the process, had trimmed the old tacking edges of
the seventeenth-century canvas to within a quarter inch of the

painted surface. Benedetti judged that the relining canvas was itself now more than a hundred years old. It had held up remarkably well, but the effects of gravity and repeated expansions and contractions from humidity were causing it to sag, if only slightly, on the stretcher.

Benedetti had known from the outset that he would have to reline the picture with a fresh canvas. Relining served several functions. In the first place, it provided a strong new support for the old canvas; next, the glue used in relining would penetrate the back of the picture and aid in securing any minute fragments of paint that had cupped or lifted over the years. On this painting, that damage was limited, confined mostly to the far right side, the dark areas on the shoulder and back of the second soldier. Considering the picture's age, its state of health was, all in all, remarkably good.

Gallery procedure required that before anything was done to the painting, it be photographed in its original state. Benedetti called down to the basement lab of Michael Olohan, the gallery photographer, to notify him that the painting was ready. It was Olohan's job to make a detailed visual record of each step in the restoration process of all the gallery's works of art.

Olohan took the painting down to his lab in the freight elevator and set it up on a metal easel. He was in his mid-thirties and had worked for the gallery for half a dozen years. He had photographed hundreds of paintings. He'd seen others emerge from under clouded layers of equally heavy grime. "It's like looking at a woman through a window that hasn't been washed in a hundred years, all streaked with dirt and dust," he once re-

marked. "You can tell it's a woman, but you can't tell much else. Then you wash the window and you see her shape and form, and you see that she is young and lovely."

Brian Kennedy had already alerted Olohan to the arrival of the Jesuits' picture, although he had not mentioned that it might be a Caravaggio. He had told the photographer only that he wanted a particularly thorough documentation of the painting. Olohan assumed that this was because the picture belonged to the Jesuits and not to the gallery. Olohan took photographs of both the front and back of the painting, and then several close-ups of the most important parts, the faces and hands. He made notes of the camera settings and the lighting, so that each successive series of photographs would be taken under the same conditions.

He did not recognize the painting as a composition by Caravaggio, but he did think, as he later put it, that it was "a remarkably fine work." He looked forward to watching the colors and shapes come back to life as Benedetti cleaned it.

IN THE RESTORATION STUDIO, BENEDETTI EXAMINED THE FRAME. It appeared to be late eighteenth century or early nineteenth century, gilded and well made. Along the sight edges, that part of the frame closest to the picture, ran a finely carved beading, like a string of pearls, although several of them had broken off. The frame, Benedetti thought, could prove valuable in tracing the provenance of the painting.

But it was the attribution to Honthorst that interested

Benedetti most. He had read long ago, in his student days, Bellori's account of Caravaggio's life, and he'd recognized this painting the moment he saw it as the one described by Bellori. He'd also read Longhi's essay about *The Taking of Christ* and its many copies, although the details were not fresh in his mind. But the name Honthorst—he could not quite put his finger on it, it lurked just outside his memory, yet he knew he had once come across something concerning the Dutch artist and Caravaggio.

The thought no sooner occurred to him than he remembered the context. A short article by Longhi, just a note really, buried inside an issue of *Paragone,* and one paragraph in that note in which Longhi had surmised that a painting attributed to Honthorst was in reality by Caravaggio.

At home, Benedetti had a large collection of books and art journals, including a complete set of *Paragone* issues dating back to his student days. His memory told him that the painting Longhi had written about was *The Taking of Christ,* and that it had been sold to an Englishman as a painting by Honthorst. If that was true, if his memory had not betrayed him, then Benedetti knew he had his first real lead in tracing the painting's provenance.

It took him only a few minutes that evening to find the correct issue of *Paragone,* with Longhi's acerbic three-page note about the German scholar Gerda Panofsky-Soergel and her research in the Mattei archive. The reference to *The Taking of Christ* was brief—a single long sentence on the third page, a mere digression. But Benedetti saw that he had remembered correctly. All of a sudden, it did not seem so preposterous that this particular painting should end up in Dublin, just a short journey across the Irish Sea from Scotland. Benedetti resolved to make

that journey himself as soon as possible, his first stop in piecing together the painting's history.

※

AT THE GALLERY THE NEXT MORNING, BENEDETTI SHOWED RAY-mond Keaveney and Brian Kennedy the article by Longhi. He could see in the director's eyes the skepticism of yesterday begin to waver.

The obvious step was for Kennedy to ask the Jesuits how they had gotten the painting. But the mere act of posing such a question might raise in Father Barber's mind questions of his own. Keaveney didn't want Kennedy to be in the position of having to answer those questions yet. It was too early, he argued.

Benedetti would proceed with restoring the painting and, at the same time, conduct an investigation into its provenance. Father Barber didn't expect to have it back for at least six months, and they could probably delay even longer, if necessary. Until they had proof—documentation of the painting's voyage through time—they would continue to keep the matter a secret even from other gallery employees.

5

ANDREW O'CONNOR WAS THE GALLERY'S SENIOR RESTORER AND, in name at least, Benedetti's boss, although in practice he had always treated Benedetti as his equal. They shared the penthouse studio, often working side by side on different paintings, and occasionally even on the same painting. O'Connor was one of the few gallery employees who knew from the beginning that Benedetti suspected this *Taking of Christ* might be the lost original by Caravaggio.

O'Connor and Benedetti had first met more than twenty years ago at Mario's trattoria in Rome, when O'Connor was studying at the Istituto Centrale per il Restauro. Benedetti had by then graduated and gone into business for himself, and from time to time he'd hired O'Connor to help him out. Back then, O'Connor was poor, barely able to make ends meet. Benedetti had always paid him generously, often more than the sum they had agreed upon. When O'Connor took sick and lay abed in his attic room for a week, unable to negotiate the five flights of stairs, Benedetti took care of him, bringing him soup and medi-

cine, mopping his feverish brow, and arranging for a doctor to come and see him. At a St. Patrick's Day party at the Irish embassy in Rome, O'Connor introduced Benedetti to the woman who would become his wife, and then he served as Benedetti's best man.

They had stayed in touch after O'Connor left Rome and returned to Ireland. One day, years later, O'Connor received a letter from Benedetti saying that he'd reached the end of his string, he couldn't tolerate the bureaucracy in Italy, and he didn't know where to turn. O'Connor told him to come to Ireland. As it happened, the other restorer at the gallery had just quit and gone off to Australia. The job didn't pay much, but at least it paid steadily, and they could find outside work. "It's my last chance," Benedetti wrote back.

O'Connor had arranged an interview for Benedetti with James White, then the director of the gallery. White spoke no Italian, and Benedetti spoke no English. O'Connor offered to sit in on the interview and translate. White replied that O'Connor's presence would be inappropriate. O'Connor often wondered how Benedetti managed to get through that interview.

Up in the penthouse studio, O'Connor studied *The Taking of Christ.* From what he could see, beneath the dirt and varnish, the quality of this painting appeared quite good. But O'Connor had cleaned hundreds, perhaps thousands of paintings. Every now and then he'd get excited about one of them. He'd see the qualities rather than the faults. And then one day he'd come in and stare at the painting and say to himself, It doesn't look as good as it did yesterday. What was I thinking, anyhow?

For the time being, O'Connor preferred to remain skeptical.

But the painting interested him. He wanted to work on it, to get a feel for the artist.

O'Connor recalls that within a few days of the painting's arrival, Benedetti began cleaning one or two small areas, only a couple of inches square, on the periphery of the picture. This test cleaning determines which combination of solvents will work best to remove the dirt, grease, and varnish, and how the paint surface will react. In the language of restorers, the process is called "opening a window" on the painting.

Since it was Benedetti's project, O'Connor felt compelled to ask if he might work on it. Benedetti assented. O'Connor selected a dark area at the bottom, near the robe of Christ. He used cotton swabs and began with distilled water, barely dampening the swab, to remove the superficial dirt. Occasionally he wet a swab in his mouth. Saliva contains enzymes and is often effective at removing dirt and some oils. In Italy he'd seen restorers clean paintings with small pellets of fresh bread. The process of cleaning old paintings has a long history, not all of it illustrious. In previous eras, paintings had been variously scrubbed with soap and water, caustic soda, wood ash, and lye; many had been damaged irreparably. An older restorer once described paintings to O'Connor as breathing, half-organic entities. "It's a good thing they can't cry," this restorer said, "otherwise you would go to museums and have to put your fingers in your ears."

Looking at the Jesuits' painting, O'Connor judged that it had survived earlier cleanings rather well. The paint surface was largely intact. O'Connor had seen all types of cracks in the brittle surfaces of paintings—spoke cracks, spiral cracks, garland

cracks, flame cracks, net cracks, grid cracks. They were all signs of damage of one sort or another. But this one had only the characteristic and inevitable craquelure of old age, something no restorer could remedy even if he wanted to.

After half a dozen swabs, O'Connor had cleared away the initial layer of dirt. The window, a few inches square, was still just barely opened. He had reached a more resistant layer of microscopic particles bound by oils, grease, perhaps even some tars from tobacco smoke, a common contaminant in privately owned paintings. In the case of this one, which had hung in the Jesuit dining room, coal dust and smoke from the fireplace had probably been bound into the mixture.

From experience, O'Connor knew which solvents worked best at removing this layer. He preferred acetone because it evaporated so quickly that it remained only briefly on the paint surface. He also used white spirits and alcohol. Often he would mix several solvents. At the Istituto Centrale, he had learned a dozen different recipes. One of the most common was called 3A—acetone, alcohol, and acqua (water), in equal parts.

He began with a dilute solution of acetone, increasing the strength as he went on. The film of dirt and oil came away, and then the yellowed varnish. Within the confines of the small window, he began to glimpse the depth and intensity of the colors in the original paint. Under the microscope at low power, he could see the clear contours of the brushstrokes. If this picture was in fact by Caravaggio, O'Connor knew that he had come as close to the hand of the master as anyone could.

DURING THE NEXT FEW WEEKS, O'CONNOR WATCHED AS MORE OF
the painting began to emerge in ever larger windows made by
Benedetti. He began to notice that Benedetti was coming in to
work at odd hours, times when O'Connor wasn't around. To
O'Connor, it seemed that Benedetti was avoiding him, that he
wanted to work alone; he had the distinct sensation that Ben-
edetti had become strangely possessive about the painting. In
Benedetti's absence, it sat on its easel, covered by a green felt
cloth.

One day, about three weeks after the painting's arrival,
O'Connor and Benedetti crossed paths in the studio. Benedetti
was staring at the painting. He stood with his arms crossed, his
eyes narrowed in concentration, his mouth compressed into a
frown.

"Look at the arm of Judas," Benedetti said to O'Connor.
"What do you think?"

O'Connor studied the painting. "What are you getting at?"
he asked.

"It seems too short, doesn't it?" said Benedetti.

It did. A subtle error of proportion, not immediately evi-
dent in the context of the entire painting.

"It looks like he painted the shoulder and then didn't have
enough room for the arm," said Benedetti.

O'Connor understood that Benedetti was wrestling with his
doubts.

"Well," said Benedetti finally, "he wasn't a perfect anatomist.
He made other errors like this. In *The Supper at Emmaus,* the apos-
tle's hand is too large."

BENEDETTI DID EXPERIENCE A FLEETING MOMENT OF DOUBT AFTER he'd had the painting for about a month. Looking back on it, he couldn't recall with precision why he'd felt that way. It had not been the arm of Judas, or any specific aspect of the painting itself. In fact, just the opposite. If anything, that spasm of doubt had afflicted him because everything seemed to be going too perfectly. He simply couldn't credit his own good fortune.

As he opened larger windows and stripped away layers of dirt and varnish, he became more and more certain that the painting really could only be by Caravaggio's hand. Apart from the quality of the brushwork, the speed and assurance with which Caravaggio had painted, Benedetti had come across several telltale pentimenti, errors of the sort that a copyist would not likely make. The most significant, visible to the naked eye, was on the head of Judas. Benedetti had found it only because the painting had been cleaned too harshly in the past. Two centimeters above Judas' ear, Benedetti saw the ghostly image of another ear. Caravaggio had painted from live models directly onto the canvas, without making preliminary drawings. He'd probably started his compositions with the face, perhaps the ear, of a central figure. This pentimento supported just such a hypothesis. Clearly Caravaggio had second thoughts and painted over the first ear, but an earlier cleaning had abraded that layer of pigment.

Benedetti discovered other small pentimenti, also visible to the naked eye, such as the belt on the soldier at the center of the

picture, which Caravaggio had enlarged to fit the brass buckle that he'd already painted. And the restorer had found one of Caravaggio's characteristic touches, scoring marks that the painter had made with the butt end of his brush in the wet ground to define the lances that the soldiers carried.

6

BENEDETTI HAD A SMALL OFFICE, NO BIGGER THAN A CLOSET, ON
the third floor of the gallery. The furniture consisted of a wooden
desk that faced a single round window with a view of Merrion
Square, a chair, a bookcase, and a four-drawer filing cabinet. He
cleared out one of those drawers and began assembling a dossier
on *The Taking of Christ*. In one file, he kept detailed notes on the
restoration process and his observations on the state of the
painting. He also started several other files—on Hamilton Nis-
bet, on the Mattei family, on Caravaggio. He gathered together
all of his books and articles on Caravaggio and arranged them in
the bookcase. When he was not working upstairs in the studio,
he came to his office and started filling his files with notes.

He knew that Caravaggio had made at least three, and per-
haps four, paintings for the Mattei family. One of those, he be-
lieved, was upstairs in the restoration studio. The second one,
The Supper at Emmaus, was at the British National Gallery in Lon-
don. Benedetti had seen that picture several times, the painting
with the apostle's hand that was too big. On his next trip to

London he would study it again, this time with an eye to detecting stylistic and technical similarities between it and *The Taking of Christ*.

He'd also seen the third painting—the young *St. John* at the Capitoline Gallery in Rome. On his last trip to Italy, only six months before, he'd bought a copy of the *St. John* symposium catalogue published by Correale. Now he went back to that catalogue and studied it with new interest, scrutinizing the photographs in the technical section. There were several close-ups of the canvas that Caravaggio had used to paint the *St. John*. To Benedetti's eye, that canvas, made of heavy hemp, eight to nine threads per centimeter, seemed identical to the canvas of *The Taking of Christ*. The painter had probably cut both canvases from the same long roll. The catalogue also contained a detailed chemical and spectrographic analysis of the pigments that Caravaggio had used. It would be useful, thought Benedetti, to compare those pigments with those in *The Taking of Christ*, but the gallery didn't have the scientific instruments to make such analyses.

He turned to the essay by Francesca Cappelletti and Laura Testa on the history of the *St. John* and the Mattei archive. He began reading it closely, taking notes. He knew the names of many art historians who had written about Caravaggio, but he did not recognize either of these writers. They had somehow managed to get into the Mattei archive in Recanati, which Longhi had complained, twenty years earlier, was closed to Italian scholars. The essay contained only two paragraphs about *The Taking of Christ*, most importantly the date and sum of Ciriaco's payment to Caravaggio. Benedetti wanted to see those docu-

ments for himself, and to see what else the archive might tell him about *The Taking of Christ*. He would have to make a trip to Recanati.

Benedetti knew that Caravaggio had lived in Ciriaco Mattei's palazzo for around two years. He had probably left, going out to live on his own, shortly after January 2, 1603, the date of Ciriaco's last payment, which had been for *The Taking of Christ*. He had managed to stay out of trouble with the law for most of those two years. And he had been very productive, painting more than half a dozen works in addition to those for Ciriaco.

ONE OF CARAVAGGIO'S REGULAR MODELS HAD BEEN A YOUNG woman named Fillide Melandroni. He posed her as St. Catherine of Alexandria for a painting that Cardinal Del Monte had owned. She was seventeen, perhaps eighteen years old when Caravaggio first painted her. She had full lips, a milky complexion, and abundant blond hair, which she wore up, with ringlets cascading down the side of her face and neck. In her eyes—dark, lively, slightly mocking—one could see intelligence, wit, and also a fiery temperament. She made her living as a high-class prostitute, a courtesan. Her official lover was a Florentine man of letters named Giulio Strozzi, middle-aged, rich, with connections to the Church. He bought her jewels, and gowns of silk embroidered with gold thread. She had Caravaggio paint her portrait for Strozzi, although Strozzi allowed her to keep the painting in her own house.

Her unofficial lovers were many, and perhaps Caravaggio

was among them. Another was a young man in his early twenties named Ranuccio Tomassoni, whom Caravaggio knew and disliked. Ranuccio was the youngest of six brothers, several of them former soldiers who had fought in Flanders and Croatia during the French Wars. They ruled their neighborhood in Campo Marzio with violence and impunity; even the police would back away from a confrontation with them.

Fillide's relationship with Ranuccio was tempestuous. Early one morning in December 1600, she went to his house in the Piazza della Rotunda, facing the Pantheon. A man named Antonio stood by the fire, warming himself. He later recounted the events of that morning to a magistrate. Fillide ran past him, according to Antonio, up the stairs to the bedroom of Ranuccio. Antonio followed. Ranuccio was still in bed, and beside him was a prostitute named Prudenza. Fillide started screaming at Prudenza, "You filthy whore, here you are!" She ran to a table and picked up a knife, and then rushed at Prudenza, shrieking, "I am going to cut you from here to there, you slut!" Antonio quickly wrested the knife from her, but Fillide went at Prudenza with her fists and grabbed her by the hair. "She pulled a lot of hair out," Antonio testified. Ranuccio managed to separate them, and Fillide, still yelling oaths and threats at Prudenza, finally departed.

Fillide had not finished with Prudenza. Later that day, she and a friend, another prostitute called Tella, came to the house where Prudenza lived with her mother. They forced their way in, pushing aside Prudenza's mother. Fillide, knife in hand, again came at Prudenza, trying to cut her in the face. Prudenza put her arm up in defense and received a gash on her wrist. Fillide man-

aged to inflict a small cut just above Prudenza's mouth, and then she left, screaming that she would be back to cut up her face properly.

Scholars have not yet found Fillide's testimony concerning the dispute, nor the ultimate disposition of the case. In the years that followed, however, Fillide maintained her connections with Ranuccio Tomassoni and his family. She acquired a house on Via Borgognona, next door to Ranuccio's older brother Giovan Francesco. She never married, but she grew wealthy as a courtesan and continued her relationship with Giulio Strozzi, who persisted in trying to wed her. She died in 1618, at age thirty-seven. In her will, written three years before her death, she stipulated that Caravaggio's portrait of her be returned to Strozzi. But by then, Strozzi had also died.

Caravaggio had stopped using Fillide as a model by the time he moved out of Ciriaco Mattei's palazzo, in 1603. He soon took up with a new woman from the Piazza Navona, elegant and dark-haired, whose name was Lena. She first appeared as the Madonna of Loreto in a large altarpiece for the church of San Agostino, near the Piazza Navona. Less than a year later, he used her again for the *Madonna with St. Anne.* In the middle of that year, a young notary named Mariano Pasqualone began courting Lena. Caravaggio encountered Pasqualone one night in July on the Via del Corso, and they had a heated exchange about Lena. Two days later, shortly after dusk, Caravaggio came up behind Pasqualone, who was strolling with another man in the Piazza Navona. With his sword, he hit Pasqualone on the back of the head, knocking him to the ground, and then he fled into the dark. Still bleeding from the gash in the head, Pasqualone gave a statement to the

clerk of the criminal court. "I didn't see who wounded me, but I never had a problem with anyone except the said Michelangelo. A few nights ago he and I had words on the Corso on account of a girl called Lena. . . . She is Michelangelo's girl."

Caravaggio immediately left Rome to avoid arrest. He had been living at the time in a small house in the Campo Marzio, in a narrow street called the Vicolo San Biagio. In spite of his fame, he lived a spare and disorderly existence. He wore his clothes, by one account, until they "had fallen into rags," and was "very negligent of personal cleanliness." He fell six months behind on his rent, even though a single painting by him commanded a sum large enough to pay for two full years. The details of his domestic life are known because his landlady, Prudenza Bruna, went to court seeking the unpaid rent after Caravaggio suddenly disappeared. In addition, she stated that Caravaggio had put a large hole in the ceiling on the second floor, where he had his studio. As compensation, the court gave her a mandate to seize his belongings. A clerk made an inventory of those—a sorry list of dilapidated furniture, a few utensils and plates, some torn clothes, a dozen unnamed books, two large unpainted canvases, a wooden easel, and an assortment of props that he used in his paintings, among them mirrors, vases, swords and daggers, and some cheap jewelry.

He was absent from Rome for almost a month; some said he'd gone to Genoa. He returned at the end of August after working out an agreement with Pasqualone to drop the criminal complaint in exchange for a formal—and rather abject—statement of apology. On his return, he learned that his landlady had seized his belongings. He was furious. He came at midnight to

the landlady's house and hurled stones at her windows, breaking the wooden shutters. She lodged another complaint.

His work was in great demand and yet his behavior was growing increasingly erratic. One report from a Flemish painter who was in Rome in 1604 described his comportment this way: "After a fortnight's work, he will swagger about for a month or two with his sword at his side and a servant following him, from one ball court to the next, ever ready to engage in a fight or argument, with the result that it is most difficult to get along with him."

Three months after his attack on Pasqualone, Caravaggio was himself assaulted and seriously wounded. A clerk of the criminal court came to interview him while he was recuperating at the house of a friend named Andrea Rufetti near the Piazza Colonna. The clerk noted that Caravaggio was in bed and had wounds on his throat and left ear, which were covered with dressings. The clerk asked who had attacked him. Caravaggio replied, "I wounded myself with my sword when I fell on the stairs."

The clerk, obviously skeptical, asked for details. Caravaggio said, "I don't know where it happened, and no one else was present."

The clerk pressed him. Caravaggio responded: "I can say no more."

During his recovery, Caravaggio began with his second Lena painting, the *Madonna with St. Anne.* It was a prestigious commission, intended for display in a chapel at St. Peter's, and especially important to Caravaggio because, in spite of his popularity, he had suffered several professional setbacks. Two months before

his attack on Pasqualone, he had delivered a painting of the death of the Virgin, a huge altarpiece measuring twelve feet by eight, to the church of Santa Maria della Scala in Trastevere. The church rejected it outright, although it was later bought by the Duke of Mantua and ultimately would end up in the Louvre. Caravaggio had depicted Mary stretched out on a table, head canted to the side, arm flung out, face and body swollen in death. He had depicted "the corpse of an ordinary woman," said one of his critics. And that woman, the model for Mary, was a known prostitute, also known to be Caravaggio's lover. "Some filthy whore from the slums," wrote the physician Giulio Mancini, who had once treated the painter for an illness.

Caravaggio finished the second Lena painting in March 1606, while still at the house of his friend Rufetti. It went on display at the chapel in St. Peter's in April. Within the month, it was taken down. The Church never offered an official reason for its removal, but Caravaggio's critics maintained that the cardinals had found it offensive. Lena looked too voluptuous to be the Madonna, her breasts swelling from the top of her low-cut gown. And her son, Jesus, depicted as a four-year-old boy, was too overtly naked, his genitals in full view.

It was his second rejection within the span of a year. Caravaggio took to the streets with his friends, his mood foul. For two months, he didn't work. He drank and spent time at the ball courts, an open dusty expanse near the Via della Pallacorda, playing and wagering on a racquet game similar to tennis. In late May, he encountered Ranuccio Tomassoni, Fillide's onetime lover, in the Piazza San Lorenzo in Lucina. The details of that encounter were not recorded, but it is known that the words ex-

changed were heated. The two men had known each other for six or seven years, since the time they had both been involved with Fillide. Some historians have suggested that she might have been at the center of their enmity. The contemporary reports all stated that Caravaggio owed Tomassoni ten scudi for a wager over a ball game. Perhaps that was true, but their mutual hostility had origins—women, slights, and insults—that went back much further.

Two days after their argument, on the afternoon of May 28, a Sunday, Caravaggio and three of his friends came through the Piazza San Lorenzo on their way to the ball courts at Via della Pallacorda. All were armed with swords. The piazza was the Tomassoni clan's territory, the site of the house where their patriarch had lived for many years and where the brothers had all grown up. Caravaggio's passage through the piazza, armed and with friends, was a deliberate provocation. And Ranuccio Tomassoni reacted by arming himself and following Caravaggio to the ball courts in the company of his older brother, Giovan Francesco, and the two brothers of Ranuccio's wife, both with reputations for violence.

On that afternoon at Via della Pallacorda, the confrontation was not with racquets and balls, but taunts and epithets. It ended with swords. Some accounts suggest that Caravaggio and Ranuccio Tomassoni faced off against each other, with their friends looking on from the sidelines. Others describe a general mêlée. The fight, according to one description, went on for a long time, but in the case of two men going at each other with swords, muscle fatigue and exhaustion would have set in within several minutes. Tomassoni, then twenty-seven and the younger

man by almost a decade, fell to the ground—perhaps in retreat, as one account reported, or perhaps from a misstep. Caravaggio stood over him and aimed a thrust at his genitals, intending not to kill but to humiliate, possibly even to emasculate. His sword caught Tomassoni in the upper thigh, severing the femoral artery.

As Tomassoni lay on the ground, blood jetting from his wound, his brother attacked Caravaggio, cutting him deeply with his sword in the head and neck. And by now the fighting was general. Caravaggio's friend Petronio Troppa, a soldier from Bologna known as the Captain, came to his aid. Tomassoni's two brothers-in-law joined in. The Captain was wounded in the left arm, the thigh, and the foot. Caravaggio, bleeding copiously from his head wound, fled to safety. The Tomassoni clan carried Ranuccio back to the house in the Piazza San Lorenzo.

Ranuccio Tomassoni died there, supposedly after making a last confession, although a severed artery wouldn't have permitted time for confession. He was buried the next morning in the Pantheon. His brother and his two brothers-in-law fled Rome to avoid arrest. The authorities began searching that evening for Caravaggio, but his immediate whereabouts were unknown. He might have sought refuge with Del Monte, whose residence was nearby. Two of his friends also left the city. Only the Captain from Bologna, owing to the serious wounds in his left leg and foot, was unable to escape arrest. He was apprehended and jailed in the Tor di Nona, where the barber who operated on him reported removing seven pieces of bone from the wound in his arm and judged his survival unlikely.

Caravaggio escaped from Rome sometime within the following two days. He went by horseback, or possibly by carriage,

assisted by friends. His injuries prevented him from traveling alone. He was a hunted man. Within the Papal State, his crime carried a bando capitale, a death sentence that anyone could enforce without fear of prosecution. And he also knew, to a certainty, that the Tomassoni brothers would be seeking their own revenge.

His destination was first reported to be Florence, some thought perhaps Modena. Both were wrong. He went to the south, to the Alban Hills. He would never again see the city of Rome.

⊰ 7 ⊱

RELINING A PAINTING IS NOT A DECISION THAT A RESTORER MAKES lightly. It is the equivalent of cardiac surgery, a delicate and invasive procedure that subjects a painting already weakened by age to great stresses.

All restorers who have been around for any length of time have seen relining disasters and have heard about others. Michael Olohan, the gallery photographer, once watched another restorer glue on a relining canvas with an iron that turned out to be too hot. The restorer lifted the picture off the table and discovered that most of the paint surface had become detached from the canvas and fused to the top of the table.

Benedetti, however, was a skilled restorer and had performed this operation many times without mishap. This painting had become the most important of his career, and he approached the procedure with great care. Relining would occupy him for several days.

His first task was to protect the picture's surface by facing it with tissue paper. On the electric hotplate in the restoration

studio, he mixed up a pot of glue, following a basic recipe he had learned years ago at the Istituto Centrale per il Restauro—a quantity of pellets of colla forte made with rabbit-skin glue, an equal quantity of water, a tablespoon of white vinegar, a pungent drop of purified ox bile, and a dollop of molasses to give the mixture elasticity. There were many such recipes, some consisting of fish glue instead of rabbit, some calling for an ox skull, which contained large amounts of collagen. And there were, of course, modern mixtures containing synthetic resin adhesives that one could buy prepackaged. Benedetti had tried some of them, but he preferred making his own glue according to the old recipes.

To the basic mixture, Benedetti stirred in more water until the glue became very dilute and ran off his whisk like a thin syrup. He left it to cool, using the time to cut up large squares of tissue paper. When the glue was just tepid, he dipped a wide brush into the pot and spread a thin layer on top of the painting, and then applied one of the sheets of tissue paper, brushing more glue over the tissue. The paper functioned as a temporary protective layer and prevented the loss of any paint flakes during the stress of relining. Benedetti repeated this process until he had covered the entire surface of the painting, and left it overnight to dry.

The next morning he took the painting off its wooden stretcher by removing the old, rusty broad-headed nails around the tacking edge of the canvas. When the picture was free of the stretcher, he turned it facedown, with its tissue covering, onto the soft cloth that covered the table. The painting was particularly vulnerable in this state, just a loose piece of canvas without

the rigid support of the stretcher. He began detaching the old lining. It was brittle and tore easily into long strips, two to three inches wide, which Benedetti pulled away with relative ease, as if skinning a carcass. The paste glue used by the previous restorer more than a hundred years earlier turned to a grainy powder as he separated the two canvases. Only occasionally did he have to resort to using a scalpel.

Once he had removed the old lining, he brushed away the powdery residue of its glue and then used a flat wooden scraper to detach any particles that still adhered. It was vitally important to have a smooth and flat surface on which to attach the lining. Any small lumps between the lining and the original canvas would distort the painted surface.

The back of the original canvas had turned dark brown with age. Like the canvas used in the *St. John* of the Capitoline, it was made of a single sheet of good-quality hemp, without any seams or tears or knots in the weave.

On the following day, Benedetti would begin the last and most arduous stage of the procedure—attaching a fresh lining to the back of the old canvas.

THERE IS MUCH DISPUTE ABOUT WHAT HAPPENED NEXT. FOR Benedetti, restoring *The Taking of Christ* was the greatest moment in his professional career, and to this day he adamantly denies that he had any problem relining the painting. O'Connor and others at the gallery, however, tell a very different story. According to them, he came close to ruining the painting.

O'Connor recalls that the gallery had run out of the loose-weave canvas common to Italian paintings. Ordering another roll from Italy and having it shipped to Dublin would take several weeks. But there was, standing in a corner of the restoration studio, a tall roll of Irish linen canvas. The usual practice called for using a lining similar to the original canvas. The Irish linen, however, was of high quality, densely woven and durable. O'Connor remembers that Benedetti elected to use the Irish canvas rather than wait for the Italian to arrive.

In O'Connor's account of events, Benedetti cut a large sheet from the roll, several inches longer and wider than the original canvas, so that he'd have ample room for the tacking edges. He fixed the borders of the Irish canvas securely in an expandable metal frame called a Rigamonte stretcher, developed by an Italian especially for use in relining. In a large pot, he cooked up some more glue from his basic recipe. This time he thickened it with quantities of flour, adding water until it had a gruel-like consistency. He added more molasses for greater elasticity. When the glue had cooled, he brought the pot to the table and spread it on the back of *The Taking of Christ,* using a wooden spatula with shallow notches in it.

As there are modern adhesives, so there are also modern methods of relining. These require large and expensive instruments such as heat tables and low-pressure tables, which create partial vacuums to seal one canvas to another. The gallery had a rudimentary heat table, but Benedetti again preferred the old way, which had been tested over the centuries. He felt he had more control when he was touching the painting directly.

Benedetti placed the new lining, taut in the Rigamonte

stretcher, on the back of the old painting. Then, with a wooden squeegee, and occasionally with the palms of his hands, he pressed the lining firmly into the glue, beginning in the center and working his way out to the edges, forcing the excess glue out from between the two canvases.

When Benedetti had removed as much glue as possible, he took the painting off the table and set the Rigamonte stretcher on end so that air could circulate around it and the water in the glue would begin to evaporate. This stage could take anywhere from a few hours to a day, depending on the temperature and humidity. In Italy, at the Istituto Centrale, they taught students to test the rate of evaporation by putting the palms of their hands on the back of the relining canvas. When it felt just barely damp to the touch, that was the time to apply heat and pressure to create a strong bond between the canvases. Knowing the right moment was a matter of experience and judgment.

Ironing is the final act in relining. It bonds the two canvases together and serves to flatten and secure particles of paint that have cupped and lifted from the picture surface. The process horrifies those uninitiated in the secrets of restoration. In the hands of someone unskilled, it can ruin a painting, as Olohan had seen with his own eyes. Too much heat, too heavy a hand, and the paint surface under the tissue paper can scorch or even melt.

The studio had several heavy irons made especially for relining. The newer ones had temperature controls. Both Benedetti and O'Connor believed their readings were unreliable. They preferred using the oldest of the irons, shaped like a tailor's iron, heated by electricity and weighing around twelve pounds. It had

a cracked wooden handle and a rusted, paint-splotched base, but a clean, smooth ironing surface, and it generated a constant temperature.

⋅✕⋅

THE DAY AFTER BENEDETTI RELINED THE PAINTING, MICHAEL Olohan came up to the studio from his basement lab. Having taken detailed, close-up photographs of the painting at each stage of the restoration process, he had gotten to know it intimately—every square inch of it, he liked to say. And by now he'd also heard the rumor that it might be a Caravaggio. He was hoping that it was, for Benedetti's sake as much as the gallery's. "For an Italian restorer to discover a Caravaggio, that's like having your number come up at the biggest lotto drawing of the century," Olohan said.

In the restoration studio, Olohan saw the painting sitting on the easel. He recalled that Benedetti had taken off the tissue facing. Olohan could not believe his eyes. In his words, "There were areas that had hairline cracks, like a sheet of ice that has started to melt, a flash of cracks all over it. I was shocked. I couldn't believe it."

Benedetti was not in the studio. Olohan went looking for Andrew O'Connor. When he found O'Connor, he said, "Andrew! What the hell has happened to the picture?"

O'Connor had already spoken to Benedetti, who had been terse. The problem, O'Connor said, had been caused by the Irish canvas. Because it was densely woven, it did not absorb the glue at the same rate as the old Italian canvas. It had not dried

properly and had contracted, pulling with it the Italian canvas and raising ridges, small corrugations, in the paint surface. Along those corrugations, the paint layer had cracked and lifted.

O'Connor had the impression that Benedetti wanted no advice and no help in solving the problem. He thought Benedetti had looked concerned, but not alarmed, and certainly not panicked.

Olohan saw Benedetti the next day. The dark look on the restorer's face kept Olohan from saying anything about the painting. It wasn't his place, thought the photographer, and besides, there was nothing to say. Olohan felt bad for Benedetti. He had seen Benedetti successfully reline paintings much more difficult than *The Taking of Christ,* on one occasion a painting so large it took up the entire floor of the restoration studio.

O'Connor knew how much this painting meant to Benedetti. Their relationship, once so close, had changed in recent years. The distance between them had grown even wider around the time *The Taking of Christ* had arrived at the gallery. Yet O'Connor thought he understood what Benedetti must be going through. He had damaged the very thing that he had come to care most about. "I could imagine his unhappiness inside," O'Connor said.

THE FEW PEOPLE AT THE GALLERY WHO KNEW WHAT HAD HAP-pened did not discuss it in Benedetti's presence, and he never brought up the issue himself. O'Connor, in the studio every day, left Benedetti to his own devices. They did not speak much anymore.

The painting sat on an easel, covered by the baize blanket. O'Connor assumed that Benedetti was taking his time to consider possible remedies. In fact, there was no reason to hurry, since the damage had been done and it wouldn't grow any worse.

One possibility was to remove the Irish canvas and line the painting with an Italian canvas. But this would once again subject the picture to the stresses of relining. O'Connor remembered that Benedetti tried to solve the problem by ironing out the Irish canvas, and to some extent, that worked, reducing the dimensions of the cracks in the painting. But it didn't work well enough. The painting would have to be relined again.

8

Awaiting arrival of the Italian canvas, Benedetti took a trip to Edinburgh. He retraced the steps that Francesca had taken only a few months earlier, although he was unaware of this. If the clerks at the Scottish Record Office, the archivist at the National Portrait Gallery, or the middle-aged bespectacled woman at the old Dowell's auction house thought it peculiar that yet another Italian was asking for information on William Hamilton Nisbet, none of them told Benedetti so.

At the National Portrait Gallery, he found the 1921 auction catalogue that Francesca had seen, with the handwritten annotation of eight guineas next to *The Taking of Christ*. To Benedetti's eye, it looked as if the auctioneer had jotted down in the margin of the catalogue the reserve prices for each of the paintings, the minimum prices at which Dowell's would sell the paintings. The sums looked too uniform to be sale prices. He couldn't be certain of this, of course, but he thought it possible that the painting had failed to sell, even at eight guineas, and the auction house had retained it.

At the Scottish Record Office, he pored through the box of files containing the assorted papers of the Hamilton Nisbet family. He came up with two valuable documents in Italian, receipts that Duke Giuseppe Mattei had signed acknowledging payment for six paintings, among them *The Taking of Christ* by Honthorst.

Benedetti began assembling a portrait of Hamilton Nisbet, although it was a vague and indistinct portrait. He had studied at Eton, served in the 3rd Dragoon Guards, and had briefly been a member of Parliament. He had twice taken the Grand Tour to Italy, but he had left no diaries or journals that Benedetti could find, no personal commentary that would give flesh to the man.

Benedetti's most important discovery happened at the National Gallery of Scotland. There, he saw the two Mattei paintings—one by the studio of Francesco Bassano, the other by Serodine—that the gallery had acquired in 1921, after the death of Hamilton Nisbet's last direct descendant. Both paintings had carved, gilded frames like the one on *The Taking of Christ*. The frames were identical, down to the pearl sight moldings.

Benedetti had not doubted that the painting in Dublin had come from Hamilton Nisbet's collection. The mistaken attribution to Honthorst, perpetuated over two hundred years, had been sufficient for him. But now, he had something more. The frames provided physical proof of a direct link to Hamilton Nisbet, and the documentary trail linked Hamilton Nisbet to the Mattei family.

RAYMOND KEAVENEY HAD BECOME A BELIEVER. THE DIRECTOR was by now convinced that Benedetti had found the lost painting by Caravaggio. The documentary evidence and Benedetti's discoveries in Scotland all fit together as neatly as the pieces of a jigsaw puzzle.

Keaveney now began worrying about the future. He doubted the Jesuits could afford to keep the painting. It would cost a huge sum to insure, and the Jesuit residence, with people coming in and out all the time, lacked the security to keep an object of such value. They would probably have to sell it. And that was Keaveney's greatest fear. He knew there would be no lack of ready buyers. Once the Jesuits knew the truth about the painting's origins, his task would be to persuade them to keep it in Ireland as part of the country's national patrimony. He hoped he could persuade them to leave it at the National Gallery of Ireland on a permanent loan: where it would be safe, where others could see it, and where it would add luster to the gallery's reputation.

All of this presumed, of course, that the Jesuits actually owned the painting. That was Keaveney's other worry. He did not yet know how they had happened to acquire it, whether they had purchased it or someone had given it to them. If it had been a gift, it was always possible that the owner, or some heir of the owner, might emerge to claim it, once its true value was known. Given the amount of money at stake—tens of millions, certainly— the issue of ownership could turn into a legal nightmare, one that might take years to resolve.

Keaveney and Brian Kennedy had decided that Kennedy would keep in touch with Father Barber. He would stop by the

Jesuit residence every so often and let the priest know how the restoration was proceeding. Kennedy had no desire to lie to Father Barber. But he would tell him only what they knew for certain.

In his first report, a few months after Benedetti had taken the painting, Kennedy informed Father Barber that the restoration was proceeding more slowly than they had anticipated, but that the painting was "a fairly good" Italian work.

Father Barber looked concerned. "Italian?" he said. "Does that mean that it is not a genuine Honthorst after all?"

"Oh, no, no," replied Kennedy. "Honthorst worked in Rome, and if it is by him, it was almost certainly painted while he was there. We're looking into that aspect."

Father Barber appeared relieved.

On Kennedy's next visit, some months later, he informed Father Barber that the painting was a *very* good Italian painting. "In the manner of Caravaggio," Kennedy added.

Father Barber was pleased to hear this. He asked how the restoration was coming along.

"Oh, it's coming along quite well now," replied Kennedy. "There was a problem at the beginning because Sergio didn't have the right type of canvas for relining it."

"I see," said Father Barber.

"It is going to take longer than we thought," explained Kennedy. "Sergio has a lot of work to do for the gallery. We have an exhibition of fifty-four paintings that are traveling to America this summer, and he must put those works in order."

"Ah," said Father Barber.

Back at the gallery, Kennedy met with Keaveney and

Benedetti. Father Barber was a reasonable and patient man, Kennedy said, but perhaps it was time they invited him over to see his painting. After all, they'd had possession of it for almost a year now.

Keaveney saw no harm in this.

⚜

BENEDETTI HAD RELINED THE PAINTING WITH A FRESH ITALIAN-woven canvas. The process had gone without incident, and the cracks caused by the earlier relining were barely detectable to the uninformed eye. O'Connor, of course, could see them, but even another restorer, one with no knowledge of what had happened, would likely attribute them to age. And the average viewer, looking at the painting in the gallery, would never notice them.

By the time Father Barber visited the studio, Benedetti had also finished cleaning away the brown haze of dust and grime. The colors and details had emerged with a vivid luminosity.

Father Barber stared at the painting as if seeing it for the first time. "I hadn't realized," he murmured, "just how different it would look. It really is quite beautiful, isn't it?"

Everyone nodded assent.

The painting, Benedetti explained to Father Barber, was ready for in-fill and retouching, the final and most time-consuming stages of restoration. He had removed all the work of the previous restorer, revealing many small lacunae, spots of missing paint fragments that showed starkly here and there, down to the original ground on the picture. Most were no larger than the size of a

thumbtack, and some were much smaller. The majority were scattered on the right side of the picture, where the damage had been most severe. Benedetti explained that he would have to fill all those lacunae with thin layers of a putty-like substance to bring the gaps level with the paint surface. And then he could begin retouching, mixing paints made in Italy especially for restoration. They were varnish-based, which meant that they dried quickly and were easy to remove.

Father Barber followed all of this with intense interest. He had many questions, about the use of solvents and why they hadn't also dissolved the paint, about the substance Benedetti would use to fill the lacunae, about matching the colors for retouching. Benedetti answered patiently.

Father Barber had understood from the beginning that the process would be long and meticulous, but now he had a new appreciation of just how long and meticulous. He also understood that Benedetti could work on the painting only part-time, and that the traveling exhibition to America would occupy him for some months to come.

9

THE NATIONAL GALLERY OF IRELAND POSSESSED A SINGLE PAINTING by Rembrandt, done in 1647, called *The Rest on the Flight to Egypt.* It was a small and dark painting, a landscape at night, which the gallery had always promoted as one of its main attractions. "Our grandest prize," Raymond Keaveney called it.

Keaveney had gotten a telephone call some months earlier from Neil MacGregor, the director of the National Gallery in London. MacGregor wanted to borrow the little Rembrandt for an exhibition. Could Keaveney make it available?

Requests of this sort are routine between gallery directors, although they often involve considerable bargaining. To Keaveney, it was important to maintain good relations with the British gallery, which was much larger and far richer than its Irish sister. London, for example, owned twenty Rembrandts. Keaveney told MacGregor that they could work something out, although as MacGregor surely knew, the painting was the Irish Gallery's most important work. How long would London want to keep it?

Nine months, replied MacGregor.

Nine months? repeated Keaveney.

A big and important exhibition, explained MacGregor, paintings, etchings, and drawings that would travel to Berlin and Amsterdam.

Keaveney was in a quandary. He wanted to accommodate London, but to have the Rembrandt gone for so long would be painful. On the other hand, he knew he could ask MacGregor for something in return, for reciprocity, but what?

Keaveney made a trip to London, where he wandered around the National Gallery, gazing at its many masterpieces, considering what he might like to have in place of the Rembrandt.

He paused in the vast gallery of Italian Baroque paintings. Denis Mahon owned half a dozen pictures in this gallery, all by Guercino and Guido Reni. All were on long-term loan, although Sir Denis had made it clear that someday the National Gallery would own them outright. The room also contained three paintings by Caravaggio. One, *Boy Bitten by a Lizard,* was a small work, done in the early days when Caravaggio was selling his paintings on the street. The second, dark and melancholic, was *Salome Receives the Head of John the Baptist.* Caravaggio had painted it in 1607 in Naples, where he'd fled after the death of Ranuccio Tomassoni. And the third was *The Supper at Emmaus.*

Keaveney stood in front of the Caravaggio pictures. Of course! he thought suddenly. The answer was staring him directly in the face. *The Supper at Emmaus*! Caravaggio had painted it for Ciriaco Mattei one year before *The Taking of Christ.* The two paintings were similar in size and format, both horizontal with half-length figures. If London would agree to lend it, Benedetti could compare them side by side.

Back in Dublin, Keaveney told Benedetti and Brian Kennedy about his idea. They would use the *Supper* as the centerpiece of a small exhibition of their own, the followers of Caravaggio, the Caravaggisti, as they were known. From their own holdings they could select fifteen or so Caravaggisti paintings to display— a Gentileschi, a Ribera, one by Mattia Preti, and some other minor artists.

The idea for a Caravaggisti show was, as Brian Kennedy observed, something of "a ruse," but it also had obvious appeal, given the growing fame of Caravaggio. Benedetti suggested they might even try to get the *St. John* from the Capitoline Gallery. Then they would have all three of the Mattei paintings together, in one place, to compare. The results of such a comparison might prove quite valuable. Apart from the brushwork, Benedetti could examine the original canvases and compare the weave and the threads. It was possible that Caravaggio had cut the canvases for all the Mattei paintings from the same long roll.

It would, of course, create a sensation in the art world if they also unveiled *The Taking of Christ* at the same time. But that was much too risky. Even if Benedetti didn't doubt the painting's authenticity, they still had to assemble a complete dossier, irrefutable proof, and solicit confirmation from renowned experts like Denis Mahon.

Keaveney called Neil MacGregor to propose the trade. He could hear the hesitation in MacGregor's voice. "Uh, let me look into that," MacGregor said. And then: "Have you considered anything else?"

The Supper at Emmaus was much more famous, and much bigger, than the little Rembrandt. London had lent it out only once

before, to the Metropolitan Museum in New York for a huge and carefully planned exhibition. Keaveney was asking for one of the great prizes of the British National Gallery.

In the weeks that followed, Keaveney had several discussions with London. They tried to persuade him to choose something else. He persisted. London, always polite, never directly told him no, and Keaveney took this as a positive sign.

Benedetti had meanwhile called Rome. He described the Caravaggisti show and asked if they would consider lending the *St. John*. Rome was more direct than London. They said no.

❧ 10 ❧

It was October 1991. More than a year had passed since Benedetti had taken the painting from the Jesuit residence. He had accompanied the gallery's paintings to America, and then he took a short vacation in Italy, to see relatives in Florence. While there, he decided to attend an exhibition of Guercino's paintings in Bologna. He'd heard that Denis Mahon had written the exhibition catalogue and had lent several of his own Guercinos to show.

The train ride from Florence to Bologna took only an hour and a half. At the Museo Nazionale, Benedetti wandered around among the tourists looking at the paintings. The show had opened some days earlier, and on this weekday afternoon it was not particularly crowded.

Benedetti came into a large room and saw, sitting alone on a wooden bench, his back to him, the figure of Denis Mahon. The Englishman wore his habitual dark blue suit, and Benedetti could tell, even from behind, that he was tired, his shoulders slumped.

Benedetti had not expected to see Mahon at the exhibition, this many days after the opening. He went over to the bench and sat down beside Mahon, who was resting with his hands atop his wooden cane. Mahon looked up, as if emerging from a reverie. "Ah, Sergio!" he said softly. "What a surprise to see you."

They spoke in Italian. Benedetti asked after Mahon's health—he calculated that the Englishman was now around eighty-two years old. They hadn't seen each other in six or seven years. Sir Denis replied that he was in fine form, just a bit tired after the inauguration of the exhibit, several speeches, and an endless round of dinners.

Benedetti complimented him on the exhibit and the catalogue.

"Yes, it's all come out rather well, I think," said Mahon.

They chatted for a few minutes, Benedetti all the while debating internally whether this was the right time to tell Sir Denis about *The Taking of Christ*. He had planned to tell him at some point. He knew that the Englishman's opinion of the painting would be essential to establishing its authenticity in the world of Caravaggio scholars. He wanted Sir Denis to give his blessing to the picture, but he had not anticipated seeing him in Bologna. He had imagined a meeting with Mahon for which he would come well prepared, with photographs, detailed close-ups, a file of documentation.

But he couldn't resist. The chance meeting was simply too propitious. He looked around to make sure they were alone in the room, and said to Mahon, in a low voice, "I think I might have found *The Taking of Christ*."

"Caravaggio?" Sir Denis exclaimed, looking up with sharp eyes.

Benedetti nodded.

"You're not really serious, are you?" said Mahon, with a slight smile.

"I am serious," said Benedetti. "I'm certain it is the original."

Mahon grinned broadly and banged his cane three times on the ground, the sound reverberating in the empty gallery. "Where the devil did you find it?"

"You won't believe it," replied Benedetti. "In a religious house in Dublin."

He explained how he had come across the picture in the Jesuit residence, the attribution to Honthorst, and his efforts to trace the provenance.

"I'll send you photos as soon as I get back to Dublin," Benedetti said. "I'm hoping you'll come up to see it when you have the chance."

"Oh, yes, I must, I must!" exclaimed Mahon. "You ought to speak to Francesca Cappelletti," he added. "She has been working in the Mattei archive. I'll give you her number."

Yes, said Benedetti, he knew her name from the *St. John* publication and the article in *Storia dell'Arte*. He would like to speak to her, and he also hoped to go to Recanati himself.

Sir Denis seemed rejuvenated by Benedetti's news. He raised himself from the bench and said, "Let's look at some pictures."

As they walked around the gallery, Benedetti told Sir Denis about Raymond Keaveney's efforts to persuade the British National Gallery to ship *The Supper at Emmaus* to Dublin. "We want

to put the pictures side by side to compare them. We're having some problems with London."

Sir Denis looked thoughtful. He sat on the board of trustees of the National Gallery, and every loan request had to be approved by the board. He said to Benedetti, "Send me the photos and let me take a look at them. I'll see what I can do about London."

◦ｄ II ◦ｄ

A YEAR AND A HALF HAD PASSED SINCE THE SUMMER WHEN Francesca had gone to Edinburgh with Luciano. In that time, both she and Laura had been awarded their master's degrees, with high honors. Calvesi had asked them to teach a seminar to second-year students at the university on the collections of Mattei, Del Monte, and Giustiniani. They both took the exams, oral and written, for admission to the doctoral program at the University of Rome. Of the several hundred applicants each year, only three were admitted. Francesca, on her first try, was among those; Laura was not. She resigned herself to trying again next year.

Every now and then Francesca heard from Denis Mahon, who called for long chats. Occasionally he asked her to look up documents for him in the Archivio di Stato or the Vatican library. She did so willingly.

The Bibliotheca Hertziana granted her a long-term admittance pass. She spent most afternoons there, studying at her favorite spot, the long wooden table on the third floor with the view over the rooftops of Rome.

When friends asked her what she had found on the trip to Edinburgh, Francesca told them she had run into a dead end. She'd say that she believed the painting was there, somewhere in Scotland. She did not want to believe it had been destroyed.

It seemed that everyone she encountered, even the most casual acquaintances at the university, knew about her search for the lost Caravaggio. At first, she answered seriously, but then she grew bored explaining the details. Still looking for the Caravaggio? someone she barely knew would ask in a jesting way, and she would roll her eyes. She grew weary of it all. She kept saying she hadn't really expected to find it, and this was, in its way, true. Looking back on that time, she realized that finding the picture would have been a miracle. Perhaps she had been a little naïve, she thought. But she didn't regret making the effort. It would have bothered her, a pebble in her shoe, if she had not at least tried.

Then one evening, Francesca got a telephone call from a man who asked in English, "May I speak with Francesca Cappelletti?"

Francesca replied in English. "This is Francesca."

The man seemed hesitant. "I hope I am not disturbing you, but are you the young woman who was looking for the painting by Caravaggio?"

"Yes," said Francesca. "Why do you ask?"

"The painting that was owned by the Scotsman Hamilton Nisbet?"

Again Francesca said yes, her curiosity growing. The caller had a refined, upper-class English accent, slightly pompous; he sounded as if he was in his thirties or early forties, and his

voice sounded vaguely familiar. "Have we met before?" she asked.

"No, no, we haven't," said the man, "but I've heard about your search for the painting."

"Ah, yes?" said Francesca.

Again the man hesitated. "Well," he said, "I was having tea at the Warburg Institute, you see. And I happened to hear a conversation concerning this painting. It seems, well . . . it seems that there is a good possibility it might turn up shortly."

"Do you mean someone has found it?" said Francesca, voice rising.

"Well," said the man, "I am not at liberty to say much. There are other people involved. It is all very confidential, you see."

"My God!" exclaimed Francesca. "How wonderful! How exciting! Can you at least tell me where it was found?"

"I'm afraid I really am not free to say—"

Francesca heard a strange noise at the other end of the line, like someone muffling a sneeze. She listened, perplexed. And in an instant she understood that it was someone stifling laughter. "Who is this?" she demanded angrily.

The laughter erupted in gales, and she then knew that her caller was Roberto Pesenti, the friend who had put her up in the Sloane Square house in London. "Roberto? Is that you?" she said in Italian.

More laughter. The sort of laughter that causes tears to flow.

"Roberto, sei tu!" Francesca screamed into the telephone. "Bastardo, cretino, idiota!"

Through his laughter, Roberto said, "Francesca, I'm sorry, but it's just so funny! I had you absolutely convinced!"

"It's not funny!" said Francesca, but her anger began to wane, and Roberto's laughter infected her. She kept calling him a bastardo, but by then she was laughing, too.

It wasn't quite so funny when she learned that Roberto had told the story of his call, with embellishments, to some of their mutual friends. She tried to be good-humored about it, but she began to grow exasperated the third or fourth time it came up.

✦

IN THE FALL OF 1991, FRANCESCA RETURNED TO LONDON, AGAIN to the Warburg, but this time for only a two-week visit. She and Luciano kept constant company. He told her he wanted to marry her. She'd heard this before, but she'd always dismissed it with a laugh and teased Luciano about being too involved in his work to find someone better suited to him. But this time he would not be put off. This time he was serious.

Francesca couldn't bring herself to tell him no. She said she was undecided.

"That's okay," said Luciano, "but I won't give up."

While in London, Francesca saw Denis Mahon, who brought up the subject of Caravaggio. "Who knows when the next one will be found?" he remarked with a twinkle in his eye. Francesca looked at him expectantly, but he just smiled. "I have a feeling something will turn up soon," he said.

When Francesca returned to Rome, she reported this con-

versation to Laura. "It was very strange," Francesca said. "I think he knows something."

"Knows what?" asked Laura.

"He wouldn't say, and it didn't feel proper for me to ask. But I had a feeling he was talking about *The Taking of Christ*."

Laura shrugged. "We'll see."

ONE EVENING THAT AUTUMN, FRANCESCA ARRIVED HOME FROM the Bibliotheca Hertziana and her mother said she'd had a phone call. Some man—her mother couldn't recall his name—who wanted to speak to Francesca. He hadn't left a telephone number, and her mother remembered only that he said he was from the Scottish Academy. Strangely, though, remarked her mother, he spoke Italian very well, with a slight Florentine accent.

The Scottish Academy? mused Francesca. It had been a year and a half since she'd been to Scotland. And the man spoke Italian well? The thought crossed her mind that it might be another prank by Roberto.

The man called again later that week. This time Francesca was at home. Her mother passed her the telephone.

The first words the man uttered were "I am looking for you because I think you are interested in *The Taking of Christ* by Caravaggio. I am interested in it, too."

Francesca said, "Who am I speaking to, please?"

The man said his name was Sergio Benedetti. He worked as a restorer of paintings at the National Gallery of Ireland, in Dublin.

Francesca was dubious. "You are not from the Scottish Academy?" she asked.

"No," said the man, in a voice that sounded puzzled. "Why do you ask?"

"Never mind," said Francesca, realizing that her mother was perfectly capable of confusing Ireland with Scotland, and a gallery with an academy. "How can I help you?"

"Excuse me," said the man, "but may I ask how old you are? Are you married?"

"What kind of question is that?" asked Francesca, voice rising.

"You sound rather young," said the man. "I thought you would be older. Who was the woman who answered the telephone?"

"Who are you?" demanded Francesca. She was close to hanging up. "What do you want from me? Did Roberto put you up to this?"

"Roberto?" said the man. "No, no, I got your telephone number from Denis Mahon. He suggested that I call you."

"From Denis Mahon?" said Francesca, still wary.

"It concerns your research in the Mattei archive in Recanati," continued the man who called himself Benedetti. He had read Francesca's article about the Mattei Caravaggios in *Storia dell'Arte,* he said, and wanted to speak with her about it, especially the information concerning *The Taking of Christ.* He mentioned several details from the inventories, particularly those documents where the attribution had changed from Caravaggio to Honthorst. "I'm coming to Rome soon," he said. "I hope to go to Recanati to see the archive with my own eyes."

"That won't be possible," Francesca said. "The palazzo in Recanati is closed during the winter."

"Are you certain?" he said. "A pity. In any case, I would like to meet with you and discuss your article at greater length. I assure you it's something you'll find interesting. But I must ask you not to tell anyone about this. It's at a very delicate stage."

Francesca was still not wholly convinced, but her curiosity was growing. She apologized for her angry reaction. "I've gotten other phone calls," she explained.

Benedetti said he would get in touch with her when he got to Rome, in a week or so, and they would arrange a place to meet. He asked her again not to mention his call to anyone.

Francesca's first impulse on hanging up the phone was to dial Denis Mahon's number in London and find out whether Benedetti was indeed who he claimed to be. He had been very secretive and had actually told her nothing at all. And asking her how old she was and if she were married—those were not the sort of questions one would expect from another art historian.

She called Sir Denis, who picked up, as usual, after the first ring. They exchanged pleasantries, and then Francesca said she'd just gotten a strange call from someone named Sergio Benedetti. Did Sir Denis know him?

Oh, yes, said Mahon. He had known Sergio for many years. And yes, he had given Benedetti her telephone number. He didn't think Francesca would mind. "It's possibly quite interesting," he said.

Mahon was obviously being discreet. Francesca understood that he was not telling her all he knew, and Francesca knew not to press further. But by now she was very curious.

At the Hertziana the next afternoon, idling away her time, she looked up Benedetti's name to see if he had published anything about Caravaggio or the seicento. She searched the index, but came up empty-handed. If Benedetti had any expertise beyond restoration, he had kept it to himself.

☙

SEVERAL WEEKS LATER, FRANCESCA HEARD FROM BENEDETTI AGAIN. He called one morning to say that he was in Rome, staying at the apartment of friends near the Piazza del Popolo. He hoped Francesca could stop by that afternoon.

Francesca asked if she should also bring Laura Testa.

"No," said Benedetti. "The fewer people, the better."

Okay, Francesca thought to herself, let's see what happens.

The woman who answered the door greeted Francesca with a warm smile. She was in her thirties and seemed vaguely familiar. "Finally we meet," said the woman. "I always see you in the hallways at the university." Now Francesca placed her: an instructor of Byzantine art at the university. She brought Francesca into the living room, a spacious apartment with a view over the trees of Lungotevere, and introduced her to her husband, an archaeologist at the Vatican, and to Benedetti.

Benedetti rose to shake her hand. He wore a neatly pressed shirt and gray slacks. Francesca estimated that he was in his late forties, stout and heavy in the face, a little taller than she, with thick brown hair that was turning gray at the temples. In his youth he might have been handsome, thought Francesca,

but his eyes had a dark, preoccupied look. With a smile that didn't seem quite genuine, he said, "You are younger than I expected."

Francesca smiled back. She was still just a student, she explained.

On the table before him, Benedetti had photocopies of the *Storia dell'Arte* article and the essay that she and Laura had written for the *St. John* symposium. Francesca could see that both were extensively underlined and had notes scribbled in the margins.

Benedetti, taking the articles in hand, wanted to know if she had more information about the Mattei archive, specifically information concerning *The Taking of Christ* that she and Laura had not yet published.

"Plenty of information about the Mattei collection," replied Francesca, "but nothing more about *The Taking of Christ*." She mentioned that she had gone to Edinburgh in an effort to trace the painting, but she'd run into a dead end with the sale at Dowell's auction house.

Benedetti nodded. He had gone to Dowell's, too, he said.

"So," said Francesca, "have you found the painting?"

"I can't say at this point," he replied, shaking his head slowly. "There's a lot of work to do yet. And I have to ask you again not to say anything about this to anyone."

Francesca understood then that he had a painting. Whether it was the original, or yet another of the many copies, remained to be seen. She had a dozen questions to ask, foremost among them where he'd found this painting. But it was obvi-

ous that Benedetti had come not to answer questions but to ask them.

For the next hour, he went through the *Storia dell'Arte* article line by line, footnote by footnote, asking her for details and clarification. He wanted to know what the archive looked like, how the documents were organized, what Annamaria Antici-Mattei was like as a person.

He laughed coldly at Francesca's description of the old building in Recanati. Did she know, he asked, how they had lost the palazzo in Rome? Gambling, he had heard. Did she know any of the details? These old Roman families, he said, they'd all gone soft. Even the Doria Pamphili, they couldn't even produce children anymore, the descendants were all bastards!

Francesca felt offended. She had grown fond of the old Marchesa. She didn't like to hear him making such comments at her expense.

Francesca couldn't put her finger on a precise comment or any factual error that Benedetti had made, but some of his remarks gave her the impression that he lacked something basic, a broader context, perhaps, of art history. That impression, she realized, might have grown out of his manner to her. He made several remarks—"You, of course, wouldn't know this"; "This is beyond your scope"—that made her bristle, although she merely nodded and smiled diffidently. Perhaps he was just reacting to her youth, she thought. Or perhaps it was a sign of his own insecurity. Denis Mahon, whose knowledge of art history was beyond dispute, had never condescended to her this way.

As Francesca put on her coat to leave, Benedetti said he

would be in touch soon. And he warned her again not to speak to anyone about his inquiries.

He was, thought Francesca, the sort of man who, if you asked him, "How are you today?" would say, "Fine, fine. But don't tell anybody."

12

Raymond Keaveney finally had good news from London. The British National Gallery had relented and agreed to lend *The Supper at Emmaus*. Perhaps it had been Keaveney's persistence, or perhaps Denis Mahon had spoken to Neil MacGregor. No one knew for certain. Whatever had happened, the painting was coming to Dublin for a month. It would arrive in mid-February.

That left only a short time to assemble a show, to write an exhibition catalogue, and to prepare and hang the paintings. Benedetti had already chosen the fifteen Caravaggisti pictures for display. It was a small exhibition of decidedly minor works, except for *The Supper at Emmaus*. Outside of Ireland, the show wouldn't attract the slightest attention, but it still required considerable work in the next three months.

Benedetti had wanted to write the exhibition catalogue, his first professional attempt at curating an entire show, and Keaveney had agreed to let him. "But you won't let me down on restoration, right, Sergio?" Keaveney said.

"Always two jobs instead of one," Benedetti later commented, his voice bitter, outside of Keaveney's hearing.

The catalogue required Benedetti to write fifteen short essays, one on each of the paintings, as well as a longer introductory piece. He was well prepared. He knew the paintings well and had a dossier on each. He worked on weekends and late into the night. Upstairs in the restoration studio, *The Taking of Christ* stood on an easel, covered by the baize blanket. He had no time to work on it.

He'd sent Olohan's photos of the painting to Denis Mahon, who had reacted with measured enthusiasm. Mahon said he would come to Dublin in March, at the end of the Caravaggisti show, to take a close look at the painting.

By mid-February, the paintings were hanging in place, the catalogue printed. Benedetti awaited the arrival of *The Supper at Emmaus*. The British were bringing it to Dublin by truck, with an escort of attendants.

On the day the truck pulled up to the gallery's entrance, Benedetti and Brian Kennedy came down to see the unloading of the painting. The British workers, joined by the gallery's Working Party, wheeled out a large plywood crate on a dolly. The crate seemed unusually heavy. Once inside the gallery, they had to carry it up the long curved flight of stairs to the exhibition room on the second floor. It took ten men, struggling and swearing, to carry the crate up the stairs. Benedetti and Kennedy looked on in consternation. The Working Party began to disassemble the crate, which had been screwed together and sealed with rubber gaskets against moisture. When the plywood

came away, Benedetti and Kennedy saw the painting inside the crate, sitting on foam-cushioned supports. It was encased in glass.

"What is this?" asked Benedetti.

Protective glass, bulletproof, said a British worker.

Benedetti was astonished.

Kennedy felt like laughing. "Incredible!" he said. "Does everybody in London think there are bombs going off up here?"

The chief of the Working Party went off to get brackets strong enough to support the painting on the wall. Lifting and mounting the picture in its thick glass case once again required a team of people. Benedetti and Kennedy looked on, along with Keaveney, who had come to join them.

"It's insulting," said Benedetti. "They don't show it under glass in London."

Benedetti wouldn't be able to examine the painting as he had expected to do. He couldn't move it upstairs to the studio, where he could study it closely, under the same conditions and lighting as the *Taking*. He couldn't look at the tacking edges and see if the canvas matched the one used for the *Taking*. The British, without intending it, had thwarted him.

ON AN AVERAGE WEEKDAY, THE GALLERY RARELY HAD MORE THAN fifty visitors, and often fewer than that. You could wander the spacious rooms in silence and near solitude.

The Caravaggisti exhibition, assembled in a few short months, with little funding and almost no money for advertising, opened

on February 19, 1992. From the beginning, it drew two thousand people a day. The guards, the cloakroom attendants, the clerks in the small bookstore were all overwhelmed. Keaveney came down to the entrance and stood nervously by, watching the throngs march in, holding his breath as the gallery teetered on the edge of chaos. "It was really scary," he said of that time.

The show ran for one month, and its success provided Keaveney with a vivid testament to the power of Caravaggio's name. He could only imagine what might have happened if the painting in the studio upstairs, under the baize blanket—a long-lost Caravaggio—had also been on display.

The most important visitor arrived the day after the exhibition closed. Sir Denis was escorted up to Keaveney's office, where Benedetti had set up *The Taking of Christ* on a sturdy easel.

Sir Denis stood before the painting, leaning on his cane, eyes moving quickly. After a minute or so, he shuffled forward and examined first one area and then another with his nose only a few inches from the canvas. Benedetti moved up with him. He directed Sir Denis's attention to the pentimenti at the ear of Judas and the belt buckle. Sir Denis nodded but said nothing.

A moment later, he turned to Benedetti. He extended his hand and said, "Congratulations, Sergio."

13

Sir Denis returned home to London and called Neil MacGregor at the British National Gallery. He told MacGregor that he had just seen with his own eyes the lost *Taking of Christ*. "It looks like the real McCoy," Mahon said.

MacGregor was delighted. He congratulated Sir Denis, and added that he hoped London would have a chance to display it soon.

Sir Denis told MacGregor that he would have the opportunity to see the painting for himself in the near future, provided he would grant a favor. Sir Denis wanted the British gallery's scientific department to examine *The Taking of Christ*—high-quality photos, X rays, infrared, and pigment analysis. "The sort of thing you would do for one of your own paintings," said Sir Denis.

London had one of the most advanced scientific departments in the art world, but London rarely worked on paintings that were not part of its own collection. In this instance, however, MacGregor agreed without hesitation.

∘✕∘

AT DAWN ONE MORNING IN MAY, SIX WEEKS AFTER THE Caravaggisti show, Benedetti loaded the *Taking* into a large rental truck with air-cushion suspension and set out with a driver for London. Keaveney had to persuade the Irish government to indemnify the gallery against damage or loss of the painting with a thirty-million-pound insurance policy. He and Kennedy and Benedetti had planned the voyage with the utmost secrecy. Apart from the three of them, no one in Ireland knew the precise date of Benedetti's departure.

The driver had recommended going up to Belfast and taking the ferry from there across the Irish Sea. Benedetti didn't like the idea of carrying the painting through Belfast, but the driver convinced him they would save time because of better roads.

The painting remained in London for only four days, and Benedetti stayed by its side most of that time. The science and restoration departments employed fifteen people full-time and occupied a spacious suite of rooms, along with a huge skylit studio, at the back of the gallery. In the science labs, Benedetti saw a vast array of gleaming machinery and electronic equipment, microscopes, spectroscopes, computer monitors, and beakers of chemicals. He watched as a young woman detached a dozen minuscule fragments from the borders of lacunae in the painting and carried the fragments to a machine that embedded each one in a small block of resin. On a television monitor attached to a microscope, the fragments appeared like landscapes of an alien terrain, jumbled strata of brightly colored boulders and crystals of green, yellow, vermilion, and ocher.

The head of the science department, an organic chemist named Ashok Roy, interpreted the findings. He had taken pigment samples from *The Supper at Emmaus* to compare with *The Taking of Christ*. The chemical composition of the paints in both pictures was similar. Caravaggio had bought his pigments— lead-tin yellow, malachite, red lake, bone black, green earth—at the store of a druggist, perhaps the one near the church of San Luigi dei Francesi. They came either in rough form, in blocks and large granules, or already ground to powder by mortar and pestle. He had mixed the pigments with walnut oil, the most common binding agent of the day. Nothing in the composition of the paints suggested that *The Taking of Christ* had been painted by anyone other than Caravaggio. But that did not prove he had.

One aspect about the *Taking* did strike Ashok Roy as unusual. The priming layer, the ground, had been applied irregularly, thickly in some parts, thinly in others, and it had a gritty texture. That was typical of Caravaggio, but Roy found the composition of this particular ground strange—"bizarre" was the word he used. It contained reds and yellows and large grains of green earth, a pigment composed of iron and magnesium. Grounds usually contained lead-based pigments and calcium, which dry quickly. Green earth dries slowly. This primer looked to Roy like a "palette-scraping" ground—the painter had simply recycled leftover paints from his palette board to make the priming layer.

⁂

IN THE ROME OF CARAVAGGIO'S DAY, NEWS TRAVELED LARGELY BY word of mouth, although both printed and handwritten notices,

called avvisi, were also posted from time to time in various piaz-
zas. One such avviso appeared on October 24, 1609. It read:
"From Naples there is news that Caravaggio, the celebrated
painter, has been killed, while others say badly disfigured."

Two weeks later, Giulio Mancini, the doctor who had once
treated Caravaggio, wrote to his brother in Siena with more in-
formation. "It is said that Michelangelo da Caravaggio has been
assaulted by four men in Naples, and they fear that he has been
slashed. If true, it would be a shame and disturbing to all. God
grant that it is not true."

Caravaggio was a regular customer at the Osteria del Cer-
riglio, a large tavern in the Carità district of Naples. The osteria,
three stories tall and built around a courtyard with a fountain,
was renowned for its food and wine, and also for the allure of
the prostitutes in the upstairs rooms overlooking the courtyard.

He was assaulted on the night of October 20, in the steep
and narrow street leading to the osteria's door. The men who at-
tacked him apparently did not intend to kill him, but to cut his
face and disfigure him. Baglione, the biographer who knew Ca-
ravaggio best, wrote that "he was so severely slashed in the face
that he was almost unrecognizable." The identities of his attack-
ers remain unknown, although art historians have speculated at
length on the reason for the assault. Caravaggio did not lack for
enemies.

It had been more than three years since he fled Rome after
the death of Ranuccio Tomassoni. In those years he had wan-
dered southern Italy, from Naples to Malta, then to Syracuse,
Messina, and Palermo in Sicily, before again returning to Naples.
His reputation as an artist had preceded him. He had been wel-

comed wherever he went. He painted prodigiously and swiftly, large public commissions for churches and smaller works for wealthy patrons who knew of his fame and clamored for his works. In Naples, for the church of Pio Monte della Misericordia, he painted a huge canvas depicting the Seven Acts of Mercy, for which he was paid four hundred ducats. In Malta, *The Beheading of John the Baptist,* measuring seventeen by twelve feet. In Syracuse, for the church of Santa Lucia, *The Burial of St. Lucy.* In Messina, two more large works: *The Raising of Lazarus* and, for the Capuchin church, *The Adoration of the Shepherds,* for which he was paid a thousand scudi, the highest fee he'd ever received.

His paintings had changed in mood and tenor, and he had changed his methods, too. He painted sparely and quickly, without the finish of the Roman days, but with greater drama and a stark intensity. He often depicted scenes of violent death in settings that were dark, shadowed, and cavernous. He occasionally used himself as a model, as he had in Rome. One of his last paintings, *David with the Head of Goliath,* shows the boy David gazing in melancholy at the decapitated head of Goliath, which he holds aloft by a fistful of black unruly hair. In death, the opened eyes of Goliath—Caravaggio's self-portrait—seem fixed inwardly in horror, mouth agape, blood dripping from the severed neck. It was as if Caravaggio knew his fate.

He had stayed for a full year in Malta, and had been accepted into the Order of the Knights of Malta, a high tribute that normally required a substantial payment. Caravaggio paid in paintings. For a few short months he enjoyed the rich life of a nobleman and the respect accorded a member of the order. And then he fought with a fellow cavaliere, a grievous crime in that

strict and hierarchical society. He was imprisoned briefly, but managed to escape and flee to Sicily. The documents of the order record that he was expelled "like a foul and diseased limb." And now the Knights of Malta and the cavaliere with whom he'd fought were also seeking justice from him.

He had plenty of money and was famous, but he still lived under the bando capitale, the sentence of death. He was a hunted man with a bounty on his head. He had powerful allies in Rome, among them Cardinal Scipione Borghese, nephew to the Pope, and Cardinal Ferdinand Gonzaga, who were working to get him a pardon. But his mental state was growing more and more unbalanced.

In Sicily he was described by those who met him as "deranged" and "mad." He lived in constant fear, sleeping fully dressed with a dagger always by his side.

He left Sicily for reasons unknown and returned to Naples, perhaps because he'd heard that a papal pardon was in the offing, or maybe because he was just trying to keep ahead of his pursuers. To return to Rome, he needed not just the pardon but also a formal pact of peace with the Tomassoni family. Ranuccio's two cousins and his older brother, Giovan Francesco, had all been allowed to return after a three-year exile. Some art historians speculate that they were the men who had attacked Caravaggio at the Osteria del Cerriglio, exacting their price for the peace by disfiguring the painter's face. Others think it likely that the Knights of Malta and the offended cavaliere had caught up with Caravaggio in Naples. And it was always possible that Caravaggio, in his deranged and paranoid state, had simply offended someone else altogether, someone heretofore uninvolved in his past.

It took him months to recover from the attack. His face was by now badly scarred from three separate woundings. But he did not stop painting. In Naples, in a period of eight months, he produced half a dozen works, some destined as gifts for those in Rome who were pressing for his clemency. Others were commissioned works for churches, such as *The Resurrection of Christ* and *St. Francis Receiving the Stigmata,* both paintings now lost.

Around the beginning of July 1610, Caravaggio boarded a small two-masted transport ship, a felucca, and sailed up the coast. He had heard from his protectors in Rome that Pope Paul V would soon sign a pardon. He carried with him a bundle of belongings and two rolled-up paintings. The felucca's northernmost destination was Porto Ercole, a fortress city on a spit of land sixty miles north of Rome, but it made several stops along the way. Caravaggio intended to debark at a small customs port near the mouth of the Tiber and make his way upriver to Rome.

Two days after leaving Naples, the felucca put in at a coastal fortress in the small village of Palo, just north of the Tiber. The captain of the garrison summoned Caravaggio, who was forced to leave the ship without his belongings. According to one account, the captain had mistaken Caravaggio for someone else, for another cavaliere whom he had been told to detain. It is likely that Caravaggio reacted to the captain as he usually did to those in uniform, with rudeness and insults. Whatever the reason, the captain put Caravaggio in the garrison jail for two days and released him only after he had paid a substantial penalty, a hundred scudi according to one account.

The felucca, with a schedule to keep, had gone on to Porto Ercole, where its cargo had been unloaded. Out of jail, the

painter, in a fury, decided to make for Porto Ercole and his possessions, among which was a painting of St. John promised to Scipione Borghese for his intervention with the Pope. It was a long journey by foot under the summer sun, nearly sixty miles of dunes and coastal marshes, with only a few fishing villages along the way and the ever-present risk of bandits. Rome was closer, but Caravaggio apparently decided he couldn't return to the city without his possessions and without bearing tributes for his benefactors.

Baglione, his rival, wrote: "In desperation, he started out along the beach under the fierce heat of the July sun trying to catch sight of the vessel that carried his belongings. Finally he came to a place where he was put to bed with a raging fever; and so, without the aid of God or man, in a few days he died, just as miserably as he had lived."

He died on July 18, 1610, at the age of thirty-nine, in an infirmary in Porto Ercole. Most scholars assume that he died of malaria contracted in the mosquito-infested marshes. But the incubation period for malaria is at least eight days, and more commonly a month or longer. He more likely died of dysentery and dehydration, his constitution still weak from his wounds.

Word of his death reached Rome ten days after he died, on July 28. By then the Pope had already granted his pardon.

14

DENIS MAHON, AGAIN IN BOLOGNA, BOARDED THE TRAIN FOR Rome, en route to yet another Caravaggio conference. It was May 1992. An Italian colleague had mounted an exhibition at the Palazzo Ruspoli, on the Via del Corso, of twenty paintings by Caravaggio, each with detailed technical analyses, X rays, and infrared photographs. The exhibition was entitled "How Masterpieces Are Born."

At Termini, Rome's train station, Sir Denis was met by an acquaintance, a journalist named Fabio Isman from the Roman daily *Il Messaggero*. Isman had known Mahon for ten years, since he had started covering arts and culture for the newspaper. He carried Sir Denis's bags to his car.

On the way to the conference, Sir Denis and Isman discussed one of the paintings in the exhibition, *The Lute Player,* which Mahon had recently played a role in authenticating. Isman said to Mahon, "So, when is the next Caravaggio going to turn up?"

Sir Denis laughed. "Oh, I just saw one a few weeks ago."

Isman was startled. He had just been making conversation. "Seriously?" he said to Mahon. "Where?"

"I really can't say any more," replied Mahon. "It's not my painting."

Isman pressed for more information, but Sir Denis only smiled enigmatically and remained resolutely silent on the matter.

The conference, a one-day affair, bustled with many famous Caravaggio scholars. There was Mina Gregori, who had put together the exhibition, and Maurizio Marini, Luigi Spezzaferro, and Maurizio Calvesi. From America had come Keith Christiansen; from Germany, Christoph Frommel and Erich Schleier.

Fabio Isman circulated among the crowd, going from one expert to the next as they chatted in small groups. "Have you heard about the new Caravaggio?" he would ask. He was rewarded with surprised looks and puzzled queries. "What new Caravaggio?" he heard time and again.

Isman did not doubt that Mahon had told him the truth, that a lost Caravaggio had recently turned up. Mahon was not the type to make such a remark in jest. But no one else seemed to know anything about it. Very strange, thought Isman.

And then, in making his rounds, he encountered Claudio Strinati, the minister of arts and culture for Rome. Isman had known Strinati for many years and considered him a friend. They chatted for a moment. Isman said: "I heard from Denis Mahon that a new Caravaggio has turned up. Do you know anything about it?"

Strinati laughed. "There's always a new Caravaggio turning up," he said. "Except that most of them aren't actually Caravaggios."

"Yes," said Isman, "but in this case Denis said he'd seen it himself."

"Well, then," said Strinati with a shrug, "I guess there really must be a new Caravaggio."

Isman saw in Strinati's eyes a look of amusement. His demeanor told Isman that the minister must, in fact, know something about this new painting; otherwise he wouldn't have responded so casually to such news. "You do know about it, don't you?" said Isman.

Strinati smiled, and said: "I really can't tell you anything."

Isman took out one of his calling cards. "Just do me a favor," he said, pressing the card into Strinati's hand. "Give this to the person who has the painting. Tell him I want to speak to him. Tell him to call me anytime."

Strinati took the card. "Okay. But no promises, you understand."

AS IT HAPPENED, SERGIO BENEDETTI WAS ALSO AT THE CONFERENCE. He knew most of the celebrated Caravaggio scholars, and many of them knew him, but only as a restorer and enthusiastic amateur scholar. He had not been invited to speak. He sat in the audience, listening to the presentations. It would never have occurred to anyone that he might have been invited to speak. But the day would soon come when he would enter the ranks of the experts, and his opinions would be sought after, just as theirs were now. He had in his briefcase, by his side, a series of pho-

tographs of *The Taking of Christ*. He comported himself with the serene assurance of a man who possessed a superior knowledge.

Among the hundred or more people at the conference, only two, apart from Denis Mahon and Benedetti himself, knew about the painting. One was Mina Gregori, the organizer of the conference, and the other was Claudio Strinati, whom Benedetti had known since the days of Mario's trattoria.

At the end of the conference, as people stood and gathered their belongings, Strinati came up to Benedetti. He handed the restorer the card that Fabio Isman had given him. "He's a reporter for *Il Messaggero*," Strinati explained. "Apparently Denis let something slip. But he doesn't know anything beyond the rumor that a painting has been found."

Benedetti took the card and put it in his jacket pocket. He had never met Fabio Isman, and he certainly had no intention of calling a journalist.

WHILE HE WAS IN ROME, BENEDETTI GOT IN TOUCH WITH Francesca again. They arranged to meet late one afternoon at the Bibliotheca Hertziana. This time Benedetti had no objection to having Laura present. He had a variety of questions, some concerning the export license for the Mattei paintings that she had found in the Archivio di Stato.

They met in a small, well-lit room on the third floor of the library. The Germans who ran the Hertziana were strict about maintaining silence, a rule that Francesca was often reprimanded

for violating. This third-floor room, with two scuffed brown leather couches and several tattered upholstered chairs, was the only place in the library where conversation was tolerated. But it had the disadvantage of serving as a corridor for people going to the periodical room.

Benedetti greeted Laura in a manner that she found brusque: a perfunctory handshake and no hint of a smile. She thought he carried himself with an air of self-importance that verged on conceit. He spoke in a low voice and would fall silent when someone happened to pass through the room. Laura found it annoying at first, and then amusing. She exchanged a glance with Francesca, who merely lifted her shoulders and smiled.

Benedetti asked Laura for details about the export license. She told him that the license had listed the prices that Hamilton Nisbet had paid for the six paintings—a total of five hundred twenty-five scudi—prices that she had doubted. Benedetti nodded. She'd been right to doubt them. He'd found a document in the Scottish Record Office, a receipt signed by Duke Giuseppe Mattei, with a price of two thousand three hundred scudi. Hamilton Nisbet's agent, Patrick Moir, had grossly understated the cost of the paintings to avoid paying customs duties. Perhaps Moir had been acting on behalf of his employer, or perhaps in his own interests, and had simply pocketed part of the export fee.

From his briefcase, Benedetti took out several photos and color transparencies of *The Taking of Christ*. He showed Francesca and Laura close-ups of parts of the painting, including the ghostly second ear of Judas, visible through the thin layer of overpainting. As they studied the photos, Benedetti glanced around constantly,

making sure that no one else was looking on or could overhear them.

The photos convinced Francesca that Benedetti really did have the original *Taking of Christ* by Caravaggio. Laura was more skeptical. She asked Benedetti where he'd found the painting, and he replied vaguely, mentioning only a "religious house" in Dublin. She asked if he'd discovered what had happened at Dowell's auction house in Edinburgh. Benedetti said, "I can't give you any details now."

Later, after Benedetti put the photos back into his briefcase and departed, Francesca said to Laura, "So, what do you think?"

Laura had been put off by Benedetti's haughty manner. "He didn't tell us much. What's the point in being so mysterious about it all? He acts like he's Roberto Longhi."

"But about the painting?" said Francesca.

"I think it could be the real one," said Laura with a shrug. "Not that it necessarily is."

15

FOR WEEKS AFTER THE CONFERENCE, FABIO ISMAN WAITED IN HIS office at *Il Messaggero* for news of the latest Caravaggio discovery. None arrived. He wrote other articles about other exhibitions and other artists, but in his spare time he always returned to the mysterious new Caravaggio.

Finally, he decided to call Denis Mahon in London and try to ferret out additional details. Sir Denis confirmed that a painting existed, but he would divulge nothing more.

Isman called one Caravaggio scholar after another. They all denied knowing about the painting, but Isman wasn't sure they were telling him the truth. He began trying a new tactic. "Congratulations!" he'd exclaim on his next call. "I hear you're the one who's found the new Caravaggio."

"Ah, I wish I had," said Maurizio Marini.

To a person, all denied any knowledge. Isman refined his technique. When he called Mina Gregori, with whom he'd already spoken once and gotten nowhere, he said to her, "I hear

this new painting is an early 'profano,' like *The Lute Player* or the *Bacchus*."

"Oh no," said Mina Gregori, "it's a religious one. A painting we've been waiting for a long time."

She would tell him no more, but he had learned a few important details. A religious painting, one that was apparently well-known. There were only half a dozen Caravaggios that fit such a description.

He put in a call to Keith Christiansen at the Metropolitan Museum in New York. Christiansen and Sir Denis were quite close. The *Lute Player* that Mahon had authenticated in Paris had been acquired by the Metropolitan. Perhaps, thought Isman, the Metropolitan was involved in acquiring this new Caravaggio.

Christiansen confirmed that he had heard about the painting, but the Metropolitan had no stake in it. It had been found, Christiansen said, by someone unknown in the world of Caravaggio studies. "It's nobody you'd expect," he told Isman.

And so Isman made a list of lesser-known Caravaggio experts and began calling them. All to no avail.

He pondered the few facts he had managed to gather. A well-known religious painting, missing for a long time. If it was well-known, there were probably copies of it.

His mind kept circling the problem. He stayed abreast of developments in the art world and subscribed to all the most important journals. He recalled having seen the article in *Storia dell'Arte* about the Caravaggio paintings in the Mattei collection.

And with that recollection, Isman had a sudden inspiration. Could it be that the painting was *The Taking of Christ*? He could

not be certain, of course, but it seemed to fit with the few par-
ticulars he had learned.

He quickly located that issue of *Storia dell'Arte*. He saw that
the article had been written by two women, Francesca Cappel-
letti and Laura Testa, whose names he did not recognize. Might
they have found the painting? He decided that was improbable.
According to their article, *The Taking of Christ* had left Italy for
Scotland in 1802, and had gone missing after the auction in Ed-
inburgh in 1921. Most likely it was still somewhere in the British
Isles.

He concentrated his efforts on Great Britain, looking through
journals and catalogues for some clue. He came across the cata-
logue of a small and curious exhibition—"Caravaggio and His
Followers"—that had taken place in Dublin. Very odd, Isman
thought, a Caravaggio show with no Caravaggios except for *The
Supper at Emmaus,* which Dublin had somehow managed to get on
loan from London. He leafed through the catalogue. The cura-
tor, he noticed, had been one Sergio Benedetti, obviously an
Italian. Isman looked in the index of Maurizio Marini's com-
pendious volume on Caravaggio. Marini had listed the author of
every article written on Caravaggio. Benedetti's name was not
among them. Benedetti was unknown in the world of Caravaggio
scholarship. That fit with what Keith Christiansen had told him:
"It's nobody you would expect."

On the Friday before Easter Sunday—Good Friday—Isman
picked up the telephone and called the National Gallery of Ire-
land. Ten months had passed since he'd first heard from Denis
Mahon that a lost Caravaggio had been found. He asked to
speak to Sergio Benedetti. When Benedetti picked up the line,

Isman said, as he had said to so many others, "Congratulations! I hear that you've found the lost Caravaggio."

"Cazzo!" exclaimed Benedetti in surprise. "How did you find that out?"

Isman was equally astonished to discover that he had guessed right. "So it's true?" he said to Benedetti. "You've got *The Taking of Christ*?"

"Who told you about it?" asked Benedetti.

Isman could hardly believe his luck. He'd also guessed right about the painting. "No one told me," he said to Benedetti. "It was an educated guess. So where did you find it?"

"I can't tell you that now," said Benedetti. "This is still top secret."

"Not anymore, it isn't," said Isman with a laugh.

Benedetti said, "I'm writing an article for publication in *The Burlington Magazine* in September. We'll have a press conference before the exhibition and I'll tell you everything then. But you can't publish until then."

"Oh, no," said Isman. "I'm publishing this tomorrow. It'll be on the front page. Can you send me a photograph of the painting?"

"Absolutely not!" said Benedetti.

⚜

FABIO ISMAN DID NOT, IN FACT, PUBLISH THE NEXT DAY. HE LACKED a significant piece of information—where Benedetti had found the painting. That, and a photograph.

But Isman was not about to hold back a story of this impor-

tance on such details. His article appeared on Tuesday morning, four days after he'd contacted Benedetti. It was indeed on the front page of *Il Messaggero,* under the headline "A Lost Caravaggio Returns." The newspaper used a photo of the Odessa painting, duly noted as such, in place of the Dublin original.

✴ 16 ✴

IMMEDIATELY AFTER HIS CONVERSATION WITH ISMAN, BENEDETTI notified Brian Kennedy that word of the painting had gotten out. The problem was urgent. The Jesuits did not yet know the full truth about the painting, and Kennedy did not want them to learn from the newspapers.

Kennedy tried to get in touch with Father Barber. He discovered that the priest was away for the Easter weekend, on a silent retreat at a monastery, and not expected back until Tuesday. Kennedy left word that he had called, and then he considered driving to the monastery and slipping a note under Father Barber's door. "If he thinks it's important enough, maybe he'll come out," Kennedy said. But in the end, he decided not to interrupt the priest's meditations. "At least we know he's not reading any newspapers," reasoned Kennedy.

On Tuesday morning, Kennedy told Father Barber that he needed to talk to him right away. Ten minutes later, after a fast walk from the gallery, Kennedy appeared at the Jesuits' door. He

said to Father Barber, "You better sit down, Noel. I've got some news that you can't take standing up."

They sat in the front parlor on the old, worn couches. On the wall above them was the large empty space where *The Taking of Christ* had once hung. Kennedy got straight to the point. The painting was almost certainly by Caravaggio. There could be little doubt of it. They had the proof, not just in the painting's quality, but in the documents.

"By Jove!" exclaimed Noel Barber, clapping his hands together. "That's wonderful news!"

Kennedy explained the implications, starting with the value of the painting—perhaps as much as thirty-five million pounds—and the clamor its announcement would cause in the art world. He warned the priest that there would be a media onslaught beginning within the next few days. And of course, the Jesuits would have to decide what to do with the painting. They would have plenty of offers from museums and wealthy collectors. But first the gallery would like to display it for a time, in exchange for the restoration work that Benedetti had performed. After that, the decision was up to Father Barber and the Jesuit community.

At first Father Barber looked a little shocked by this news. And then, once he had absorbed it, he made no effort to conceal his enthusiasm. He expressed his delight freely. "He couldn't contain himself," Kennedy later reported to Raymond Keaveney. "He was nearly floating."

One other matter, Kennedy said to Father Barber. In order to have a full history, a complete provenance of the painting,

they would have to know how the Jesuits had happened to ac-
quire it.

Father Barber reflected on this for a moment. He told
Kennedy it had been given to Father Tom Finlay, one of the
priests who had lived in the house, by a woman whom Father
Finlay had counseled many years ago. At least, that was what Fa-
ther Barber had heard from an elderly resident of the house.
The woman's name was Dr. Marie Lea-Wilson. She had been a
pediatrician of some distinction in Dublin. She had died more
than twenty years earlier.

Do you know if she has any heirs? asked Kennedy.

Father Barber didn't know.

IT FELL TO BENEDETTI TO TIE UP THE LOOSE ENDS OF THE PROVE-
nance. He came by the Jesuit residence to interview Father Bar-
ber and examine whatever records the Jesuits had concerning
the painting. By now, Father Barber had made inquiries of his
own. He confirmed that the painting had been a gift by Marie
Lea-Wilson to Father Finlay, who had been a professor of polit-
ical economy at University College Dublin. As far as anyone
could determine, she had given him the painting sometime in
the early 1930s.

That, at least, was the institutional memory as handed
down by the elderly Jesuit priests at the residence. Father Bar-
ber had searched the files for some declaration of the gift and its
precise date, but had come up empty.

Benedetti was amazed. The Society of Jesus, known for its intellectual rigor, didn't keep careful records? "A shameful situation," the restorer later remarked, with some petulance. "Religious archives in Italy, they record everything. Not here in Ireland. They are a peculiar people."

Benedetti began an investigation into the life of Marie Lea-Wilson. He stopped first at the probate court to look at her will. Dr. Lea-Wilson had died in 1971, at the age of eighty-three. She'd never had children. She had lived for fifty years in a large old Georgian house on Upper Fitzwilliam Street, a short walk from the Jesuit residence. In her first will, she had left much of her estate to a longtime housekeeper named Bridget. While hospitalized, however, she'd apparently had a change of heart. She had another will drawn up that cut Bridget out entirely. That will stipulated that her estate be divided among a number of charities, principally the Children's Hospital in Dublin, where she had practiced medicine for more than forty years.

Benedetti tried to track down the housekeeper Bridget. All he found was a death certificate. It was clear to him that Dr. Lea-Wilson had no heirs who could lay claim to the painting. It belonged to the Jesuits.

But how had Marie Lea-Wilson gotten the painting in the first place? It had gone up for auction at Dowell's in Edinburgh in 1921, and the Jesuits had acquired it from her at some point in the early 1930s. That left a gap of ten or more years in the painting's life.

Benedetti set out to learn everything he could about Marie Lea-Wilson. She had been born Marie Monica Eugene Ryan in

1888 to a well-to-do Catholic family in Charleville, County Cork. Her father had been a solicitor, and she too had studied law. At the age of twenty-five, she married an Englishman, a Protestant, named Captain Percival Lea-Wilson, then twenty-seven and a district inspector of the Royal Irish Constabulary in Gorey. At the outbreak of the Easter Rebellion, two years after their wedding, Captain Lea-Wilson was given charge of a group of Irish Republican prisoners. He humiliated them, forcing some to strip naked in the rain and lie facedown in the mud. The IRA vowed vengeance. Captain Lea-Wilson knew that he was a marked man. He took to drink. Four years later, on the morning of June 16, 1920, he was shot and killed on the road in front of his home as he went to get the newspaper.

Marie Lea-Wilson descended into a prolonged period of mourning. Some years after her husband's death, she met Father Thomas Finlay, who offered her spiritual guidance, solace, and practical advice. She began studying medicine at Trinity College and was awarded her degree in 1928. She was then forty years old, and one of the few female doctors in Dublin.

At the National Children's Hospital on Harcourt Street, Benedetti got a fuller picture of Dr. Lea-Wilson from nurses and staff people who had worked with her. She was, according to one nurse who had known her since the 1950s, "a small, shrunken woman," with white hair that had a yellow streak running up the middle. She smoked cigarettes continuously—"Continuously!" the elderly nurse emphasized. She dressed in dark Victorian-like clothes, in skirts that descended to her ankles. On the front of her long black coat she had pinned row upon row of religious

medals, and more medals adorned the front of her blouse. She made annual pilgrimages to the shrine of Fatima in Portugal and had gone several times to the Vatican. In those days, she was the only female doctor in the hospital, devoutly Catholic in a profession dominated by Protestant men. She would arrive at the hospital in a car driven by Bridget the housekeeper who, it seemed, had a compulsion to drive in reverse. "We would all roar laughing at the way Bridget drove," recalled another nurse. Marie Lea-Wilson held clinics three mornings a week and would see children without a referral letter. Her manner was severe and autocratic. She would sit on a chair, smoking and dispensing advice, always with one of her little dogs, of which she had many, in her lap. "She did have a great feeling for the poor," said another woman who had known her. "In a bit of a strange way," she added.

Benedetti scrutinized Dr. Lea-Wilson's university records, hoping he could find some link to Edinburgh, which was a world-renowned center for medical study. But he could find no evidence that she had ever studied there.

He came away knowing a great deal about the life of Marie Lea-Wilson, but he could find no clue in that odd and eccentric life about the thing that mattered to him most. How had she gotten the painting? Had she bought it for eight guineas at Dowell's? Or had she chanced upon it in the shop of some antiques dealer in Edinburgh? Or perhaps even a dealer in Ireland? There was no way to trace its passage across the Irish Sea. In those days, Ireland had been part of the British empire, and no export license had been required to move goods out of Scotland.

It frustrated Benedetti. The painting was almost four cen-

turies old, and he could track its precise whereabouts, down even to the rooms in which it had hung, for all but ten of those years. He could find no way to penetrate the veil of that decade. He would have liked a complete accounting, but the one he had was good enough. Much better, in fact, than for most masterpieces.

❧ 17 ❧

WHILE BENEDETTI INVESTIGATED THE LIFE OF MARIE LEA-
Wilson, the Jesuits of Ireland debated the fate of the painting.
They agreed that an object of such value could no longer be kept
at the Lower Leeson Street residence. A few among them ar-
gued that it should be sold. They could use the money to endow
the order's St. Vincent de Paul Society, the largest charity in Ire-
land. Or to build a new school, for which the order was at that
moment trying to raise money. Unemployment in Ireland was at
19 percent. How, in good conscience, asked some of the fathers,
could they ask for donations from Irish citizens when they had a
painting worth thirty million pounds or more?

This was a compelling argument. At the National Gallery,
Brian Kennedy and Raymond Keaveney understood its logic
and feared its outcome. But others among the Jesuits—Father
Barber foremost among them—insisted that it should stay in
Ireland. "The country would turn on us in anger if we sold it
off," said Father Barber.

And so there arose a suggestion that the Irish government

purchase the painting—at a handsome price, of course, although certainly much less than the J. Paul Getty Museum in Los Angeles might have paid.

That solution also didn't appeal to Father Barber. He mustered new arguments. He maintained that, absent any documents attesting to Marie Lea-Wilson's intentions, the painting should be regarded as a deposit "in trust." By this reasoning, the Jesuits were not in a position to sell it or to give it away. "We received it freely, not to flog it in the marketplace," he said. "We should make it freely available."

Father Barber kept Brian Kennedy informed of the debate, and Kennedy in turn passed on what he heard to Benedetti and Raymond Keaveney. Finally Father Barber called and said the society had arrived at a decision. They asked to have a meeting at the gallery.

Father Barber arrived with the Provincial, the head of the Society of Jesus in Ireland. Benedetti had set up the painting, now fully cleaned and retouched and glowing under a fresh coat of varnish, on an easel in a third-floor conference room. The Provincial, seeing it for the first time, paused to admire it, and Benedetti pointed out to him several interesting aspects, such as the self-portrait of Caravaggio and the pentimento of Judas' ear.

They took their seats around the table, Benedetti next to Kennedy and Keaveney on one side, Father Barber and the Provincial on the other.

The Provincial announced the decision. The Jesuits would retain ownership of the painting. They would, however, make it available to the National Gallery of Ireland, where it would reside, on an "indefinite loan." A Jesuit lawyer would work out the

arrangements and terms, but in practice this meant that the gallery would have full possession of the painting.

There were smiles, handshakes, and expressions of gratitude all around. Kennedy had already gotten a pretty clear idea from Father Barber of this outcome and, short of an outright gift, he and Keaveney could not have hoped for more. In truth, the debate among the Jesuits had never been very heated. Father Barber, as head of the Lower Leeson Street residence, had quickly prevailed.

The Jesuit lawyer later worked out the conditions of the indefinite loan, none of them very stringent. The gallery would consult the Jesuits on all matters concerning the painting, such as loans to other museums, which would require the Jesuits' approval. The society would also derive income from licensing the rights to the painting's reproduction on cards and posters. And finally, the gallery would provide a full-sized, high-quality reproduction, complete with frame, to hang on the empty wall in the parlor of the Lower Leeson Street residence.

PART IV

❦

THE
PARTY

It was November 1993, a day of dull gray skies and intermittent rain in London. At Gatwick Airport, Francesca and Luciano sat in plastic chairs at a departure gate, waiting to board a flight to Dublin. The National Gallery of Ireland had planned several days of ceremonies for the public unveiling of *The Taking of Christ*. Benedetti had asked Francesca to give a speech, along with Sir Denis Mahon and eight other Caravaggio scholars. He had extended an invitation to Laura Testa as well, but she had declined to come. She didn't speak English and, even more to the point, she had not liked Benedetti when they'd met at the Hertziana.

Francesca held in her lap the speech she had written, ten typed pages, which Luciano had translated into English. She had never given a speech in English before. She had rehearsed it time and again, but the prospect of addressing an English-speaking audience of several hundred people still made her fingers flutter with anxiety. Luciano told her not to worry. "You won't be scared," he said, "you'll be unconscious."

On the plane to Dublin, Francesca heard a voice speaking in Italian. Several rows ahead of her, across the aisle, Francesca saw the freshly coiffed gray hair of a small, elderly woman. It was Mina Gregori, the Caravaggio scholar from Florence. Francesca had met her once, but she didn't expect that Mina Gregori would remember.

When the plane landed in Dublin, Francesca watched Mina Gregori and her companion, also an elderly woman, start out first in one direction and then turn abruptly in another. They clutched their handbags, stared at a sign overhead, conferred, and looked agitated and uncertain. Francesca decided to introduce herself. Mina Gregori's hand fluttered to her chest in relief and gratitude. Yes, of course she remembered Francesca, she said, and introduced the other woman as her sister. Francesca steered them to the baggage claim. When the suitcases came into view, to cries of relief from the sisters, she had Luciano lift them from the conveyor and wheel them out to a taxi.

They were all staying in the same place, a small, elegantly appointed pensione near the National Gallery, where Benedetti had reserved rooms for those speaking at the unveiling. After settling in the room, Francesca went out for a walk to clear her head and see Dublin for the first time. She strolled around Merrion Square in the direction of the National Gallery. It was late afternoon. The ceremonies weren't scheduled to begin until the next day, but Benedetti had told her to come over to see the painting when she arrived.

At the gallery entrance, she asked for Benedetti, and a few moments later he came down to greet her. She hadn't seen him in several months. He had dark circles of fatigue under his eyes

and his face looked heavy and weary. He told Francesca he had been through endless rounds of interviews and television appearances, in addition to the long hours arranging all the details for the conference. He invited her upstairs to the exhibition room, where several other scholars were looking at *The Taking of Christ.*

The room, the biggest in the gallery, was dark as twilight. Among the shadows a few members of the Working Party were setting up the last long rows of folding chairs to accommodate hundreds of visitors. At the far end of the room hung *The Taking of Christ,* dimly lit by one of the lights high in the ceiling. Three or four people had gathered in front of the painting. Francesca recognized the tall, angular silhouette of Claudio Strinati, the superintendent of arts and culture in Rome. Another, shorter and heavier, was the German scholar Herwarth Rottgen.

Francesca knew the painting intimately, first from her imagination, and then from the photographs and slides that Benedetti had shown her at the Hertziana. And yet, seeing it for the first time, she had the eerie, vertiginous sensation of recognizing something familiar in all its details and yet much different than she had imagined. The painting looked bigger than she'd thought, even though she'd known its precise measurements. The reflected light glinting from the soldier's armor was more sharply brilliant, the colors more deeply luminous, than she had expected. The light—it was always the light in Caravaggio's paintings that astonished her.

She came close to see the details, the self-portrait of Caravaggio holding the lantern, the powerful, veined hand of Judas grasping the shoulder of Christ. She looked for the pentimenti

that Benedetti had pointed out to her in the photos, the ear of Judas and the belt of the first soldier. Close up she could see individual brushstrokes and the texture of the canvas, the fragile reality of the painting. In the dark background she noticed things not readily visible in the photos—the bole of a tree and the leaves in the shadows, the eyes of the third soldier behind Caravaggio. She felt herself drawn into the drama of the scene, spellbound the way she'd been as a young girl seeing for the first time *The Calling of St. Matthew* in the church of San Luigi dei Francesi. She forgot, for a moment, that she was looking at a painting.

And then she was brought back to reality by the voices of the others around her. She didn't like looking at paintings in the company of other scholars. She felt the obligation to say something intelligent and profound when all she wanted was to absorb the work. The others were making observations, pointing out details here and there. Except for Benedetti, who stood to the side, leaning against the wall and holding a glass of what looked like whiskey. He seemed uninterested in the painting, but then, she reasoned, he had spent the past three years alone with it.

She heard Claudio Strinati say to Benedetti, "Well, Sergio, I'd say this is a very fine painting by Giovanni di Attili."

Francesca laughed aloud at this reference to the unknown artist who had been paid twelve scudi by Asdrubale Mattei to make a copy of the *Taking*.

Benedetti was not amused. At another time he might have smiled, but he took everything regarding his discovery of this painting with the utmost seriousness. He had refused, for ex-

ample, to invite Maurizio Calvesi to the conference. He had taken offense when the professor had written in a journal that Benedetti had found the painting because of the archival work of Francesca and Laura Testa. He wrote an irate rebuttal to Calvesi asserting that the professor was completely wrong, that the discovery of the painting had occurred solely because of his own extensive knowledge of Caravaggio's work.

THAT NIGHT FRANCESCA AND LUCIANO WENT OUT TO A RESTAU-rant recommended by Benedetti. Others in the Italian contingent had taken his recommendation, too—they encountered Claudio Strinati and Fabio Isman, as well as the scholar Maurizio Marini and his young wife. It was, Francesca remarked to Luciano, like being in the Piazza Navona on a Saturday night.

Marini had wanted to speak at the conference, but Benedetti wouldn't permit it, for fear of offending Denis Mahon. Marini and Sir Denis had been feuding recently about the authenticity of two nearly identical versions an early Caravaggio painting, *Boy Peeling Fruit*.

Marini had come anyway, if only just to see the painting. His recent book, an enormous volume called *Caravaggio: Michelangelo Merisi da Caravaggio "pictor praestantissimus,"* was the result of a lifelong obsession. He was the only Western scholar who had traveled to Odessa to see the other *Taking of Christ,* the copy probably painted by Giovanni di Attili. Francesca liked Marini, who was fat and ribald and spoke with a thick Roman accent. He was, to her mind, a case study of someone afflicted, unabashedly, with

the Caravaggio disease. She heard that he had mounted a scaffold in the church of Sant'Agostino while restorers were working on Caravaggio's *Madonna of Loreto.* He'd leaned over, trying to kiss the face of the Madonna—Lena, of the Piazza Navona—and had nearly fallen into the painting. The restorers told her that they'd grabbed him by the shirt and pulled him back just in time.

Over wine and dinner, the group of Italians exchanged gossip. Francesca heard Strinati advise Marini to make up with Sir Denis. The Englishman was too powerful in the world of Caravaggio to have as an enemy. But Marini would not hear of it. He merely laughed. He respected Sir Denis; he just thought he was wrong about *Boy Peeling Fruit,* which Mahon had affirmed on behalf of a wealthy Japanese client. And Marini, who had a financial interest of his own in the other version, wasn't about to concede anything.

⟨✤⟩

AT THE GALLERY THE NEXT AFTERNOON, FRANCESCA CAUGHT sight of Sir Denis amid an admiring crowd. She went over to the group. He noticed her and smiled broadly. "Ah, Francesca, che piacere!" he said, shuffling toward her.

She hadn't seen him in half a year, and without thinking, she embraced him warmly, as she would any friend, both arms around his shoulders. She knew instantly that she'd made a mistake. In her delight at seeing him, she'd forgotten how he disliked being embraced. She felt him go rigid and she quickly took herself away. He staggered back a few steps, raising his arms and bringing his cane aloft as he did so. Later, when Francesca told

this story to Luciano, she said that she'd thought for a moment Sir Denis might strike her with his cane. She felt her face flush with embarrassment, but Sir Denis quickly regained his composure and acted as if nothing untoward had happened.

Sir Denis, standing to one side of *The Taking of Christ,* gave the opening address to an overflow crowd that included many citizens of Dublin as well as reporters and television cameras. Looking up at the painting, gleaming under its fresh coat of varnish, Sir Denis said: "*Habent sua fata picturae*—that's a fancy way of saying that pictures have their vicissitudes." He gave an account of those vicissitudes and of Benedetti's serendipitous discovery, mentioning along the way the archival work that Francesca and Laura Testa had done, and noting that the Russian scholar Victoria Markova was also present in Dublin to confirm that the Odessa version was "a careful and accurate copy," but merely a copy.

Afterward Francesca moved among the crowd with Luciano, stopping now and then to chat with someone she knew. She didn't have to give her speech until the next day. She watched Victoria Markova approach Sir Denis with arms opened in greeting, and she knew intuitively what would happen next. The Englishman began to recoil, but Victoria Markova grappled with him anyway. When she finally released him, his face was white and his glasses sat cockeyed. Thereafter, Francesca noticed, Sir Denis thrust his right hand out in peremptory greeting well in advance of every woman who approached him.

Francesca kept telling herself that she was the youngest scholar there—she had just turned twenty-nine—that no one would pay too much attention to her, and that even if they did,

they would forgive her errors. She found Benedetti and confided her anxiety about speaking in English. Benedetti listened sympathetically. "The most important thing is that you are here," he told her. Meanwhile, he had other problems to deal with. Mina Gregori had just decided that she wanted his help in translating her fifty-page speech into English. And Herwarth Rottgen had lost the slides to accompany his speech and appeared on the verge of nervous collapse.

The festivities continued for three days. Luciano had to return to Oxford to teach, so he didn't hear Francesca give her speech about the Mattei collection. She had no real memory of giving it. She was, as Luciano had predicted, all but unconscious with stage fright. Afterward, both Denis Mahon and Claudio Strinati complimented her. She suspected they were just being polite, but she began to enjoy herself at last, at one round of dinner parties after another, always in the company of other scholars, always talking about art.

⟡

SEVERAL WEEKS AFTER THE CEREMONIES, BENEDETTI WAS ON HIS way to lunch when a woman stopped him on the sidewalk and asked for his autograph. He gave it with a smile and a flourish. He carried himself in a new way. His name, now forever linked with Caravaggio, would appear alongside those of Roberto Longhi and Denis Mahon in bibliographies and indexes of the artist. He had made his name in the world of art history, he had achieved immortality on a small scale.

He was invited twice to give lectures at the Bibliotheca

Hertziana. The Longhi Foundation in Florence, directed by Mina Gregori, asked him to speak, an honor akin, Benedetti observed, to conducting Mass at St. Peter's Basilica. Irish television made a documentary about his discovery of the painting. The gallery's board of governors agreed to make him curator of Italian art. He no longer worked as a restorer. *The Taking of Christ* traveled to exhibitions in London, Rome, and America. He went with it.

He would like to find another Caravaggio. Many are still lost. Caravaggio's painting of St. Sebastian, apparently owned only briefly by Asdrubale Mattei, was reported by Bellori three hundred years ago to have been taken to somewhere in France. It has never been found.

FRANCESCA AND LUCIANO GOT MARRIED THE FOLLOWING YEAR. The ceremony took place in the fifth-century basilica in the Piazza San Lorenzo in Lucina, the same piazza where the Tomassoni clan had once lived, and only a short distance from the Via dei Condotti, where Francesca had spent her earliest years.

Francesca wore a white dress and veil. The wedding, ceremonial and formal, was, Francesca later said, "the mistake of the mistake." Luciano returned to Oxford, Francesca stayed in Rome. They commuted back and forth and talked daily on the telephone. But Francesca did not want to move to England, and Luciano did not want to return to Italy. "I have more bacon and eggs in my blood now than cappuccino and cornetti," he said. After three years of marriage, they separated. In time, Luciano remarried, and so did Francesca, to a lawyer. She has a three-year-old son

named Tommaso. Luciano teaches philosophy and logic at Oxford; Francesca teaches art history at the University of Ferrara.

<center>⌾</center>

DENIS MAHON IS NINETY-FIVE YEARS OLD. HE TRAVELS REGULARLY and is often asked to render his opinions on paintings. He still appears at conferences on Caravaggio, although, as Francesca points out, his stories have begun to repeat themselves. The seventy-three paintings that once filled his house in Cadogan Square have taken up residence at the British National Gallery.

<center>⌾</center>

FOR A TIME, THE NATIONAL GALLERY OF IRELAND WAS BESIEGED with people carrying in old works of art, hoping they had found a lost masterpiece. Many of the hopeful were priests from small parish churches and religious houses around the country.

The Taking of Christ became the gallery's biggest draw, attracting thousands of visitors a year. One of those visitors, gazing at the painting on a warm day in April 1997, happened to notice a tiny dark brown speck on the inner edge of the gilt frame. It would not have caught the visitor's attention had the speck not started to move in erratic circles, and then suddenly take wing.

The visitor debated whether this was an event worth reporting to the gallery attendant. It seemed trivial. But in the end, she did mention it, offhandedly, to the attendant, who gravely said that he would have the matter looked into.

That evening, after the gallery had closed, Andrew O'Connor

came down to look at the painting. He saw nothing amiss, but he asked the Working Party to bring it up to the restoration studio so that he might take a closer look.

O'Connor removed the metal clips that held the painting in the frame. As he lifted the stretcher, dozens of small dead insects, reddish brown in color, with beetle-like carapaces, dropped onto the table. Along the tacking edges at the top and bottom of the picture, O'Connor saw a dense network of silky white filaments, the cocoons in which the larvae had grown. And the larvae themselves, hundreds of small white grubs, were writhing among the warp and weft of the canvas. They had eaten away patches of the relining along the tacking edges. O'Connor measured one section of the relining, four centimeters by eleven, that had been devoured in its entirety by the bugs. He had never before encountered anything like it.

An entomologist from the Natural History Museum, one block away, came over and examined the dead specimens. He quickly identified it as *Stegobium paniceum,* more commonly known as the biscuit beetle. The entomologist presented his findings, along with an animated disquisition on the beetle's life cycle, in a meeting with Raymond Keaveney and O'Connor. The entomologist seemed quite delighted to have his expertise engaged in a case of such significance. Keaveney, looking grim, didn't share his enthusiasm.

The biscuit beetle, according to the entomologist, thrived on starch—flour, bread, rice, pasta—hence its name. Its life span ranged between three and seven months. The adult beetles, which measured an eighth of an inch long and could fly, lived only three to four weeks. They did not eat, but they were prodi-

gious breeders, generating four broods during warm months. It was the larvae, which fed for many months, that did the damage.

The source of the insects' food was immediately evident to O'Connor. It was the glue—the colla pasta, with its large quantity of flour—that Benedetti had used in relining.

As senior restorer, O'Connor assumed the task of tackling the problem. He had all the paintings in the Italian room of the gallery taken down. He inspected each in turn for sign of infestation, but found none. *The Taking of Christ* was the sole painting afflicted by the biscuit beetle.

O'Connor examined the entire painting carefully. He found, to his great relief, that the seventeenth-century Italian canvas, Caravaggio's original canvas, had not been damaged. The beetles had gotten only as far as the tacking edges of the new canvas.

O'Connor considered relining the entire painting, but decided against it in the end. He opted not to subject the picture to the additional stress of relining. But he had to replace the tacking edges. With a scalpel he cut away the infested parts of the relining and glued on new tacking edges, a process called strip lining. He did not use the old colla pasta method. He used a modern adhesive, a synthetic resin called Beva 371.

As Denis Mahon might have said, *"Habent sua fata picturae."* Pictures have their vicissitudes.

ACKNOWLEDGMENTS

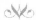

I owe a debt of gratitude to many people in Italy who helped me in ways large and small. Among them are Teresa Notegen, owner of the Bar Notegen on Via del Babuino; Gianni Amodeo, my first teacher in Italian; Jessica Young, the kindest landlady I've ever met; the poet and raconteur Vito Riviello and his talented daughter Lidia Riviello; the painter Ettore de Conciliis, for his friendship and introduction to Maurizio Marini; the art historian Stephen Pepper, whose sudden death two years ago affected many people; the painter Tiziana Monti, who helped to arrange an interview with Mario Masè, former owner of Mario's trattoria; my friend Arnulf Herbst; the beautiful Esther Baird; at *Il Messaggero,* the journalist Riccardo De Palo, who arranged for me to meet Fabio Isman; Emanuela Noci, a friend and journalist who read an early draft of the book, and her husband, the artist Steven Meek; the restorer Maurizio Cruciani; my friend Mayo Purnell; Francesca's husband, Gottardo Pallastrelli di Celleri; and Katya Leonovich, who read this in many versions and endured me at my worst. My thanks also to those at the Ameri-

can Academy, particularly the former director Lester Little, and to the Bibliotheca Hertziana.

I could not have written this book without the consent of those people whose names appear in the narrative. I am deeply appreciative for the time they sacrificed in repeated interviews. This is especially true in the case of Francesca Cappelletti, who tolerated with wonderful good humor my endless requests for details. It applies as well to Denis Mahon, Laura Testa, Giampaolo Correale, Luciano Floridi, Paola Sannucci, Maurizio Calvesi, Stefano Aluffi, Fabio Isman, Caterina Volpi, and Roberto Pesenti. In Dublin, my thanks to Raymond Keaveney, Brian Kennedy, Sergio Benedetti, Andrew O'Connor, Father Noel Barber, and Michael Olohan. In London, thanks to Hugh Brigstocke, Ashok Roy, and Larry Keith.

My friend Tracy Kidder read many versions of the manuscript and took pen in hand occasionally when I got too tangled up. I turned to several other trusted friends for advice, among them Richard Todd, Craig Nova, and Bill Newman, and I'm grateful for their comments. Andrew Wylie was always encouraging when I felt dispirited. At Random House, I was saved countless embarrassments by marvelous copy editors Jolanta Benal and Vincent La Scala.

To Bob Loomis, my editor and friend, the wisest person I know—I don't know how to thank you properly, except to say that I am proud of your confidence and friendship.

And of course, to Diane, who sustained me sweetly throughout, as always.

A NOTE ON SOURCES

This book grew out of a visit of several months to the American Academy in Rome in early 2000. Six years earlier, I had written an article for *The New York Times Magazine* about the discovery of *The Taking of Christ*. I'd thought back then that I might expand the article into a book, but I let the idea lie fallow while I pursued other projects. When Lester Little, then the director of the American Academy, extended an invitation to come to Rome, I was required (if only for the sake of formality) to have a project in mind. I decided to resurrect the idea of the lost painting and see if I could turn it into a book.

The project has taken longer than I anticipated. My first task was to learn to speak Italian with some degree of fluency, since many of the people I wanted to interview in Rome spoke little or no English, and I did not want to use interpreters. Francesca Cappelletti was the notable exception; her English is good, although she much prefers to speak in Italian, and I tried to oblige her.

I have not changed any of the names of the people I've written about. This account is based on interviews with the partici-

pants that I conducted in Rome, Dublin, and London. My focus in writing this book was deliberately narrow. Readers who are interested in knowing more about Caravaggio's life and works, and the history of the early Baroque, can avail themselves of several biographies of the artist. Three were published in 1998. I found *Caravaggio: A Life,* by Helen Langdon (Farrar, Straus & Giroux), to be particularly helpful. The other two, *M,* by Peter Robb (Henry Holt and Company), and *Caravaggio,* by Catherine Puglisi (Phaidon Press in London), are each meritorious in their own very different ways.

The books that I made most use of, however, are landmarks in their own rights. The first of those is Walter Friedlander's seminal work *Caravaggio Studies,* published in 1955 by the Princeton University Press. It is now unfortunately out of print, but the clarity of Friedlander's writing, the depth of his observations on the artist's work, and the large appendix of documents concerning Caravaggio's life and work, in both original language and translation, make the book invaluable. Howard Hibbard's biography, *Caravaggio* (Harper & Row, 1983), has many of the same merits.

But the most remarkable, exhaustively detailed, and fully thumbed volumes in my possession are the second and third editions of Maurizio Marini's *Caravaggio: Michelangelo Merisi da Caravaggio, "pictor praestantissimus,"* published in Rome in 1989 and 2001, respectively. I thank Maurizio also for his friendship, hospitality, and discussions about Caravaggio.

The following books, articles, and monographs were all useful to me. This list does not represent a complete bibliography of works on Caravaggio, nor all the works that I consulted. For a complete bibliography, one should turn to Marini's third edition.

Askew, Pamela. *Caravaggio's Death of the Virgin*. Princeton, N.J.: Princeton
 University Press, 1990.

Benedetti, Sergio. *Caravaggio and His Followers at the National Gallery of Ireland*.
 Exhibition catalogue. Dublin: National Gallery of Ireland, 1992.

———. "Caravaggio's 'Taking of Christ': A Masterpiece Rediscovered," in
 The Burlington Magazine, CXXV, November 1993.

———. *Caravaggio: The Master Revealed*. Exhibition catalogue. Dublin: Na-
 tional Gallery of Ireland, 1993.

———. "Gli Acquisiti Romani di William Hamilton Nisbet," in *Paragone*,
 September 1995.

Bernardini, Marie, Silvia Danesi Squazina, and Claudio Strinati, eds. *Studi
 di storia dell'arte in onore di Denis Mahon*. Milan: Electa, 2000.

Black, Jeremy. *The Grand Tour in the 18th Century*. London: Sandpiper Books,
 1992.

Blunt, Anthony. *Artistic Theory in Italy 1450–1600*. London: Oxford University
 Press, 1973 edition.

Brigstocke, Hugh. *William Buchanan and the 19th Century Art Trade*. Privately
 published by the Paul Mellon Centre for Studies in British Art, Lon-
 don, 1982.

Calvesi, Maurizio. *Le Realtà del Caravaggio*. Turin: Einaudi, 1990.

Cappelletti, Francesca. "The Documentary Evidence of the Early History
 of Caravaggio's 'Taking of Christ,'" in *The Burlington Magazine*, CXXV,
 November 1993.

Cappelletti, Francesca, and Laura Testa. "Caravaggio: Nuovi dati per i
 dipinti Mattei," in *Art e Dossier*, February 1990.

———. *Il Trattenimento di Virtuosi: Le collezione secentsche di quadri nei Palazzi Mattei
 di Roma*. Rome: Argos Edizioni, 1994.

———. "I quadri di Caravaggio nella collezione Mattei. I nouvi documenti
 e i riscontri con le fonti," in *Storia dell'Arte*, May–August 1990.

Cinotti, Mia. *Michelangelo Merisi detto il Caravaggio: Tutte le Opere.* Bergamo: Poligrafiche Bolis, 1983.

Cohen, Elizabeth S. "Honor and Gender in the Streets of Early Modern Rome," in *Journal of Interdisciplinary History,* XXII, Spring 1992.

Correale, Giampaolo, ed. *Identificazione di un Caravaggio.* Venice: Marsilio Editori, 1990.

Corridini, Sandro. *Caravaggio: Materiali per un processo.* Rome: Monografie Romane, 1993.

Corridini, Sandro, and Maurizio Marini. "The Earliest Account of Caravaggio in Rome," in *The Burlington Magazine,* vol. 140, 1998.

De Courcy, Catherine. *The Foundation of the National Gallery of Ireland.* Dublin: National Gallery of Ireland, 1985.

Finaldi, Gabriele, and Michael Kitson. *Discovering the Italian Baroque: The Denis Mahon Collection.* London: National Gallery Publications, 1997.

Floridi, Luciano. In *Cervelli in Fuga.* Rome: Avverbi, 2001.

Frommel, Christoph L. "Caravaggios Fruwerk und der Kardinal Francesco Maria Del Monte," in *Storia dell'Arte,* vol. 9–10, 1971.

Gash, John. *Caravaggio.* London: Bloomsbury Books, 1988.

Gilbert, Creighton E. *Caravaggio and His Two Cardinals.* University Park, Penn.: Pennsylvania State University Press, 1995.

Gregori, Mina, ed. *Come dipingeva il Caravaggio.* Milan: Electa, 1996.

Judson, J. Richard, and Rudolph E. O. Ekkart. *Honthorst.* Doornspijk, Netherlands: Davaco Publishers, 1999.

Keith, Larry. "Three Paintings by Caravaggio," in *National Gallery Technical Bulletin,* vol. 19. London: National Gallery Publications, 1998.

Kirwin, W. Chandler. "Addendum to Cardinal Francesco Maria Del Monte's Inventory," in *Storia dell'Arte,* vol. 9–10, 1971.

Kitson, Michael. *The Complete Paintings of Caravaggio.* London: Wiedenfeld & Nicholson, 1969.

Longhi, Roberto. "Appunti: 'Giovanni della Voltolina' a Palazzo Mattei," in *Paragone,* 1969.

———. "Ultimi studi sul Caravaggio e la sua cerchia," in *Propozione I,* 1943.

———. "Un originale del Caravaggio a Rouen e il problema delle copie Caravaggesche," in *Paragone,* 1961.

Macioce, Stefania, ed. *Caravaggio: La Vita e le Opere Attraverso i Documenti.* Rome: Logart Press, 1995.

Macrae, Desmond. "Observations of the Sword in Caravaggio," in *The Burlington Magazine,* CVI, 1964.

Magnuson, Torgil. *Rome in the Age of Bernini, Vol. I.* Uppsala, Sweden: Almqvist & Wiksell, 1992.

Mahon, Denis. "A Late Caravaggio Rediscovered," in *The Burlington Magazine,* XCVIII, 1956.

———. "Addenda to Caravaggio," in *The Burlington Magazine,* XCIV, 1952.

———. "Caravaggio's Chronology Again," in *The Burlington Magazine,* XCIII, 1951b.

———. "Caravaggio, Michelangelo Merisi: 'Nude Youth with a Ram,' " in *Artists in 17th Century Rome.* Exhibition catalogue. London: Wildenstein & Co., 1955.

———. "Contrasts in Art-historical Method: Two Recent Approaches," in *The Burlington Magazine,* XCV, 1953a.

———. "Egregius in Urbe Pictor: Caravaggio Revised," in *The Burlington Magazine,* XCIII, 1951a.

———. "Fresh Light on Caravaggio's Earliest Period: His 'Cardsharps' Recovered," in *The Burlington Magazine,* CXXXII, 1990.

———. *Studies in Seicento Art.* London: Warburg Institute, 1947.

Martin, John Rupert. *Baroque.* New York: Harper & Row, 1977.

Moir, Alfred. *Caravaggio and His Copyists.* New York: New York University Press for the College Art Association of America, 1976.

———. "Did Caravaggio Draw?" in *The Art Quarterly,* XXXII, 1969.

———. *The Italian Followers of Caravaggio.* Cambridge, Mass.: Harvard University Press, 1967.

Mormando, Franco, ed. *Saints and Sinners: Caravaggio and the Baroque Image.* Exhibition catalogue. Boston: McMullen Museum of Art, Boston College, 2000.

Nicolaus, Knut. *The Restoration of Paintings.* Cologne: Koneman, 1999.

O'Neil, Maryvelma Smith. *Giovanni Baglione: Artistic Reputation in Rome.* Cambridge: Cambridge University Press, 2002.

Pacelli, Vincenzo. "New Documents Concerning Caravaggio in Naples," in *The Burlington Magazine,* vol. 119, 1977.

Panofsky, Erwin. *Idea: A Concept in Art Theory,* 1968 edition. New York: Harper & Row.

———. *Meaning in the Visual Arts.* Chicago: University of Chicago Press, 1955.

Panofsky-Soergel, Gerda. "Zur Geschichte Des Palazzo Mattei Di Giove," in *Romisches Jahrbuch fur Kunstgeschichte.* Vienna-Munich: Anton Schroll & Co., 1967–68.

Podro, Michael. *The Critical Historians of Art.* New Haven: Yale University Press, 1982.

Roskill, Mark. *What Is Art History?* 2nd edition. Amherst, Mass.: University of Massachusetts Press, 1989.

Sherman, John. *Mannerism.* London: Penguin Books, Ltd., 1967.

Spear, Richard E. *Caravaggio and His Followers.* New York: Harper & Row, 1975.

Strinati, Claudio, and Rossella Vodret, eds. *Caravaggio e il Genio di Roma.* Exhibition catalogue. Milan: RCS Libri, 2001.

Thompson, Colin, Hugh Brigstocke, and Duncan Thomson. *Pictures for Scotland: The National Gallery of Scotland and Its Collection.* Edinburgh: Trustees of the National Gallery of Scotland, 1972.

Various authors. *Caravaggio e la collezione Mattei.* Milan: Electa, 1995.

Wittkower, Rudolf. *Art & Architecture in Italy, 1600–1750,* 1982 edition. New Haven: Yale University Press.

Wolfflin, Heinrich. *Principles of Art History,* 1950 edition. New York: Dover Publications, Inc.

ABOUT THE AUTHOR

JONATHAN HARR lives in Northampton, Massachusetts, and Rome. He is the author of *A Civil Action,* which was awarded the 1995 National Book Critics Circle Award.

This book was set in Requiem, a typeface designed by the Hoefler Type Foundry. It is a modern typeface inspired by inscriptional capitals in Ludovico Vicentino degli Arrighi's 1523 writing manual, *Il modo de temperare le penne*. An original lowercase, a set of figures, and an italic in the "chancery" style that Arrighi helped popularize were created to make this adaptation of a classical design into a complete font family.

Church of the
Small Things

Other Books by Melanie Shankle

Sparkly Green Earrings

The Antelope in the Living Room

Nobody's Cuter than You

Church of the Small Things

The million little pieces that make up a life

Melanie Shankle

ZONDERVAN

Church of the Small Things
Copyright © 2017 by Melanie Marino Shankle

This title is also available as a Zondervan ebook.

This title is also available as a Zondervan audio book.

Requests for information should be addressed to:
Zondervan, *3900 Sparks Dr. SE, Grand Rapids, Michigan 49546*

Library of Congress Cataloging-in-Publication Data

ISBN 978-0-310-34887-0

Cover design: Curt Diepenhorst
Cover illustration: Heather Gauthier
Interior design: Kait Lamphere

First printing August 2017 / Printed in the United States of America

To my dad:

This book is for you because you taught me what it
means to love family and the importance of being faithful
in all the small things that make life worth living. I am
grateful for many things and at the top of that list is that
you're my dad. I love you more than I can say and have
always been so proud to be Charles Marino's daughter.

Contents

Foreword

I met Melanie Shankle on the internet. I laugh as I write that, but it's true. She and I began blogging around the same time many years ago, and fortunately for me, we eventually crossed paths in real life. I felt an immediate connection to Melanie, not just because we were both tackling the brave new world of social media at the same time, but because her unmistakable, irresistibly dry-but-warm humor simply drew me in. One has no choice; just a short conversation and you become an instant Melanie fan.

So Melanie and I are friends. But she also happens to be one of my very favorite writers. Having inhaled her blog and devoured her books for years, I can still plop down, start reading, and find myself laughing within the first five minutes. Melanie has this consistent ability to pull you in with hilarious recollections (usually rich in pop culture references), self-deprecating observations (so, so funny), and family anecdotes that are vividly relatable and real.

But here's the kicker—and the truly magical thing about Melanie: Just when you think the girl is 24/7 funny, she'll throw you a major curveball with a poignant moment. A tender reflection. A spiritual contemplation. A painful memory. And then you

have tears in your eyes. The next thing you know, you're crying. (Related note: Have a box of Kleenexes handy as you read certain passages in this book. Consider yourself warned.) But then . . . you guessed it! A classic Melanie one-liner that makes you laugh out loud through the tears. Dolly Parton's character in *Steel Magnolias* had it right: Laughter through tears really *is* the best emotion.

Melanie's previous books have covered motherhood, marriage, and friendship in beautiful detail. But *Church of the Small Things* is, I think, my favorite. With her signature wit and wisdom, Melanie shows us that life is about the small moments, the small memories, the small achievements. We all have them. And when we learn to embrace them, we will see that it really is the small things that make up this beautiful thing called life. As I was reading the manuscript for this book, I sent Melanie a text along the lines of "My gosh, I love this book so much."

It's a good one, friends. I know you'll love it as much as I did.

Ree

Introduction

I've spent my whole life listening to the story in the Bible where Jesus feeds five thousand people with five small loaves of bread and two fish. (Thank goodness that crowd didn't know about being gluten free.) I've seen it depicted on flannel boards in Sunday school, watched it brought to life in movies about Jesus, and heard it taught from various pulpits a million times. Whenever and however the story is told, the focus is always on one of three things: (1) the disciples who didn't have faith in what Jesus could do, (2) the miracle of turning a sack lunch into enough food to feed five thousand people, or (3) the admirable character of the little boy who willingly offered his meager lunch. But you know who never gets a shout-out? The mom who packed that lunch in the first place.

Maybe she was in a hurry; maybe she just threw in those five small loaves and two fish and shooed her boy out the door, glad to get him out from under her feet for the day. If she was like me, she probably hadn't been to the store recently and even gave the fish a quick sniff, worried it might not be any good. Maybe she gave the bread a quick once-over for signs of mold, because how embarrassing would it be to have your kid pull out some moldy

bread for lunch? No matter what was involved in packing that lunch on that particular morning, I'm willing to bet she wasn't really concerned or even thinking about how God might choose to use her boy's lunch that day. I bet she didn't wring her hands over whether or not that lunch might matter in the larger scheme of God's plans or wish she could do something on a larger stage in front of an audience of people cheering her on as she tucked that fish and those loaves into a basket, and she definitely didn't do an Instagram story about it. The bottom line is, she didn't do the glamorous thing; she did the faithful thing. She packed a lunch for her boy just like she'd probably done a million times before, and God used her small act of faithfulness to feed five thousand people. He also used her son, whom she'd probably admonished daily to "be kind and share with others," wondering if it was falling on deaf ears. She got tangible proof that day that her boy had actually been paying attention. If you're a mom, then you know that this, in and of itself, can feel like a miracle.

So maybe you can see where I'm headed with this mom and the lunch bag story. Sometimes the biggest things God does start out in the smallest, most ordinary acts of daily faithfulness. The things we do so often and with so little fanfare that we don't even think about them anymore. We can spend so much time wondering and worrying if we're fulfilling God's primary will for our lives. Yet, ultimately, God's will isn't about the things we achieve; it's about the people we become. Life is more about how he uses us to make a difference to the people who cross our paths, even while we are just going about our normal, sometimes boring, lives. He is a God who used twelve men to change an entire world. He is a God who clearly finds value where we tend to look and see nothing special. God's primary will for our lives

isn't about a particular job or a circumstance. It's not about the city we live in or whether we're married or single. We are in God's will when we wake up with a willingness to go wherever he leads that day, to seek him in the ordinary, and to love and influence the people around us. Sometimes that can look a whole lot like packing a lunch.

Life is what is happening all around us while we're waiting for the thing we hope will give us some sort of inner peace, contentment, or joy. The problem is that when and if that thing happens, we usually enjoy it for all of three-and-a-half minutes before realizing nothing in us has fundamentally changed. Our hair still doesn't look like Connie Britton's and we're still not as funny as Tina Fey, and so we decide that maybe it's the *next* big moment that will finally make us truly happy. Meanwhile, we're ignoring the fact that we woke up that morning with air in our lungs, had a cup of hot coffee, and laughed on the phone with a friend. I once heard a teenage boy say as he worked at the concession stand at our neighborhood pool, "It's Saturday night and I've got a new pair of shoes—the possibilities are endless." I thought, *Yes! Let's embrace the wonder hidden in the ordinary—whatever the new pair of shoes might be—because these are the moments that are full of possibility and promise.*

Sometimes it happens when we're right in the middle of the daily grind—driving car pool, going to the grocery store, attending class, working in a cubicle, wiping sticky jelly fingerprints off our countertops, tucking in the kids, and packing lunches. One of those normally ungrateful children will hug us extra-tight and whisper, "You're the best mom ever." Or a friend texts to say, "I've been thinking about you." Or we crack up because our insane dog is jumping up repeatedly on the other side of the kitchen window.

When we start to pay attention, we realize life is full of small wonders that can make all the difference in a day, an hour, or a lifetime. And those small moments are no less holy than the big ones. In fact, maybe they are more holy because it is the million little pieces of our lives that really shape the people we become.

In J.R.R. Tolkien's novel *The Hobbit*, the wizard Gandalf says, "Some believe it is only great power that can hold evil in check, but that is not what I've found. It is the small everyday deeds of ordinary folk that keep the darkness at bay." The true joy of life is found in the everyday. It's the moments that don't necessarily take our breath away at the time that often become the ones that matter most. When we look back on our days, we realize such moments are the very threads that make up the tapestry of a life. Taken together, these seemingly ordinary threads of joy, sadness, conflict, and laughter make something extraordinary. With every small thread, God is carefully and thoughtfully weaving a masterpiece.

We live in a culture that celebrates the big accomplishment: the touchdown, the Nobel Peace Prize, the student body president and the homecoming queen. But what if we made it a habit to embrace and celebrate the small? The meal delivered to a sick friend, our kids being kind to the new kid at school, volunteering a few hours a week at a nursing home, or helping someone in need? Savoring a lazy Saturday morning in pajamas, listening to the sound of your children actually getting along, piña coladas and getting caught in the rain?

I've lived long enough to know that often, the most memorable moments in life are the ones that sneak up on you because they weren't planned or orchestrated but are just the simple moments we'll eventually look back on and think of as golden. They are

the things of love and parenting and laundry and marriage and what to cook for dinner—just life in all its messy, magical, mundane and marvelous glory. These are the holy moments that are Exhibit A in why I'm a believer in the church of the small things.

These are the stories that, on the surface, may seem like nothing big. Some are silly and some less so, but they are all about the little moments that together leave a legacy and light the way to show us what really matters. A life isn't made from one thing, one big moment, or one huge success. It's created moment by moment, often with pieces that don't look like anything beautiful on their own but are the very fabric of who God meant for us to become as we pack lunches, raise kids, love our neighbors, and simply be who he created us to be—nothing more, nothing less.

Give Me a Casual Corner Suit and Get Out of My Way

Enjoy the little things, for one day you may look back
and realize they were the big things.

Robert Brault, *Round Up the Usual Subjects*

It dawned on me the other day that I've lived in San Antonio, Texas, for over twenty years and that I am forty-five years old. For those of you doing the math at home, that means I've lived here almost half my life. Speaking of math, I read the other day that there are three types of people in the world: those who are good at math and those who aren't.

Give yourself a minute to think about that.

The reality is, I have now lived here longer than I ever lived anywhere else, so I guess San Antonio should officially be my hometown. But when people ask where I'm from, I still say Beaumont, which is funny considering I only lived there for six years and have been gone for the last twenty-five. But I guess

the city where you went to high school stays a part of your story forever—unlike your grades in high school, for which I am eternally grateful.

I ended up in San Antonio after I graduated from Texas A&M in the spring of 1994. I spent the summer living with my parents in Houston while I went on job interview after job interview, wondering who would be lucky enough to hire a young girl who'd graduated by the very skin of her teeth with a degree in Speech Communications and had a long list of accomplishments on her résumé such as:

September 1992—October 1992: Salesgirl at Limited Express
Assisted customers in choosing outfits for special occasions. In charge of folding and hanging new inventory. (Not mentioned: Basically just stood around and danced to Sir Mix-A-Lot songs.)

July 1993—August 1993: Lifeguard
Responsible for the safety of patrons at the neighborhood swimming pool. Trained in CPR. Also taught swimming lessons to toddlers. (Not mentioned: Basically just sat in the sun and danced to Tony! Toni! Toné! songs.)

While I could sell myself pretty well in an interview setting—thanks to the aforementioned Speech Communications degree—I knew I was dead in the water if they asked to see my college transcript. (Warning to any college students reading this: your college transcript does tend to follow you around, so maybe you should put this book down and go study for that Physics 201 exam.) Anyone who figures out a way to fail Kinesiology 101 isn't exactly a star student, but in my defense, that golf class was

dumb and held on way too many days that were better suited to lying by the pool.

I eventually found a job in San Antonio. I credit this to three things: (1) my ability to make myself sound competent, (2) my stellar Casual Corner business suit that screamed "professional career woman" because it was double-breasted, and (3) the fact that the manager who hired me was twenty-seven years old. At the time, I thought she was so mature and wise, but now I know people in their twenties are essentially infants and know almost nothing except what they've learned watching episodes of *Real World* on MTV. I realize *Real World* is no longer a thing, so I guess today's version of it is *Keeping Up with the Kardashians*, and while I'd like to mock this choice, I can't help but feel that my generation started us down the slippery slope of reality television to begin with, and I was one of the first to hop on that train.

Anyway, my first job was working as a contract employee at a local hospital, helping employees figure out how to invest their retirement benefits. Let me stop right here for a minute and ask you to please close this book and look at my picture on the back cover. If I look like someone who gave you financial advice between September 1994 and February 1996, I suggest you immediately have your investment portfolio scrutinized by a certified professional—and I offer my deepest apologies.

Here's what I remember most about that job. My salary was $9,500 a year plus commissions. You would think that the "plus commissions" part would have motivated me to spend more time working as opposed to going back to my apartment for long lunches spent watching the O.J. Simpson murder trial, but you would be wrong.

Side note: When FX aired *American Crime Story: The People v. O.J. Simpson*, I was hooked. It was completely fascinating to watch a movie based on events you vividly remember, which validated for me that those lunch hours spent watching the real trial were totally worth it. Not to overstate it, but it's like I inadvertently made an investment in my future. John Travolta plays Robert Shapiro. Connie Britton plays Faye Resnick. You're welcome.

This also feels like an appropriate time to mention that my best friend, Gulley, was telling her husband, Jon, about a bird she saw in their backyard a few days ago. She correctly identified it as a "red-capped cardinal" and declared herself to be "an orenthalogist." Jon corrected her that she meant "ornithologist," which is the proper term for someone who studies birds, but told her she is indeed also an "orenthalogist" because that describes someone who has spent hours of her life watching a TV series about the murder trial of Orenthal James Simpson. And so, yes, Gulley and I are officially "orenthalogists," and if that is wrong then we don't want to be right.

But back to the story at hand. The problem with $9,500 a year plus the occasional commission check is that it doesn't go far. Especially not for someone who likes the finer things in life, like paying the telephone bill and buying groceries. Not to mention the realization that maybe someone who made a D in Personal Finance 201, was constantly overdrawn on her checking account, and felt like she was playing the lottery anytime she went to the ATM machine (Come on, big money!), didn't need to be in the business of offering financial advice to people who had actual money to invest. So I began looking for a better job in greener pastures like Dallas and Houston. This is probably the first time in history anyone has ever referenced greener pastures

in the same sentence as Dallas and Houston because, while they are a lot of things, green isn't one that typically comes to mind. But while I was plotting and planning a job change and a move, something happened. In the words of Elvin Bishop, I fooled around and fell in love.

I met my future husband, Perry, several months before I graduated from Texas A&M. (You can read the whole story in *The Antelope in the Living Room.* Just look for a copy at your local garage sale.) I didn't realize he was also in San Antonio until a mutual friend mentioned it. Perry and I began spending time together mainly because each of us was the only other person our age that we knew in San Antonio, but then it slowly turned into more when neither of us was paying attention. All of a sudden, my master plan to move to another city didn't look quite as compelling. I still knew I wanted to make a job change, though, which is why when my manager pulled me into her office to offer me a promotion, I brilliantly chose to quit my job instead. This is what most career-guidance books and my dad would call a really dumb move. Consider this next sentence the after-school special portion of this book: "Never quit a decent job unless you have another one already lined up, kids."

In what should have come as no surprise, companies were not lining up around the block to hire me. My grade point average ensured that I was shunned like a leper in the twelfth century, and so I ended up with a temporary position in the human resources department at QVC. That's right. QVC, as in the home shopping network. My job was to call people on the phone who'd submitted an application and prescreen them to see if they were qualified enough to bring to the corporate office for an interview. This led to conversations in which I answered

questions such as, "Is it a problem that I smoke a lot of weed?" or "I turned in the application for my brother. He gets out of prison on Monday; can he call you back then?" I wish I were joking. The only real upside to working at QVC (or "The Q," as we insiders liked to call it) was the in-house store where employees could shop for deeply discounted items that had been returned by customers. But even that eventually lost its novelty, because a single girl in her twenties doesn't have a great need for dolls from the Marie Osmond Collection or jewelry from Joan Rivers Classics, a fact I'd tend to forget when every time I got carried away thanks to all the low, low prices. (It was kind of like the feeling you get on an airplane when you are desperate and end up looking through the SkyMall catalog because you didn't properly estimate how many *People* and *US* magazines you'd need to get you through the whole flight. That's when your mind tricks you into wondering how you ever survived without an illuminated beverage cooler or a space-saving floor-to-ceiling shoe rack.)

Anyway, my stint at QVC led to job search desperation, and I sent out résumés everywhere and to everyone, but I knew my goal was to stay in San Antonio because LOVE. So I finally resorted to signing up with a corporate headhunter named Sasa Johnson in hopes that she might have better luck finding me a job. I went to her office for my first visit in my most professional Casual Corner suit. She was a petite woman with lots of nervous energy, and I immediately felt like I was in over my head. She scanned my résumé quickly, drumming her fingers on the desk the entire time, and then gave me a steely glance as she looked up and said, "I'm looking at your résumé. I see almost no job experience, no qualifications, and that you graduated from college with

barely a 2.0 grade point average. I have to ask, what the hell have you been doing with your life?"

In all fairness, as much as it stung, it was a valid question.

It made me ask myself the same thing as I walked out of her office. It also made me decide to use a different corporate recruiter since it was fairly obvious that Sasa didn't necessarily believe in my potential. Ultimately, I found a job working for a local company that manufactured doors (SNOOZE), but a year at that job gave me much-needed experience and led to a job opportunity in pharmaceutical sales, which is where I spent the next eleven years of my life.

Let's talk for a minute about pharmaceutical sales. I had a love/hate relationship with it. The free car, the nice salary and bonuses, and the incredible health insurance were all huge perks. The days of hauling in lunches from Great China Inn, pretending to be an extrovert in hopes that the nurses would like me, and the constant worry over market share for my products? Not so much. To this day if I find myself sitting in a doctor's office waiting room, I can start to suffer from post-traumatic stress and feel like maybe I was supposed to show up with lunch for thirty from the Olive Garden as I wrack my brain trying to remember the difference between LDL and HDL cholesterol.

But as much as I joke about it, working my way up to a job in pharmaceutical sales was one of the first real goals I set for myself. People tried to tell me it was a hard industry to get into, and I should have majored in Biology (as if), and they only hire people who graduate from college with a 3.5 grade point average or higher. But I didn't let that deter me, because at that time in my life, I saw it as my own little cough and cold promised land. When I got the call from the hiring manager offering me the job,

I realized for the first time what it meant to shoot for something that seems impossible and achieve it. As an added bonus, Perry proposed to me two days later. In the words of Charlie Sheen, I was #winning.

God used that feeling to remind me to trust his voice when, eleven years later, I felt him calling me to walk away from pharmaceutical sales and take a chance on trying to write full time. It seemed like an insane risk at that point in my life, but if you're reading this book then—SPOILER ALERT—it turned out okay.

The point I'm trying to make in this long, fairly uninteresting history of my career trajectory is this: For a long time, I really had no idea what I wanted to do with my life, so I spent years making decisions based on fear rather than taking a leap of faith to figure out what I really wanted to do or who I wanted to be when I grew up. It's what so many of us do, because society has ingrained that kind of thinking into us. We're supposed to go to college, get a degree in business, keep dating the same person, get married, have three kids, buy a house and a minivan, and call it good. It's the American Dream. Except who decided the dream is one size fits all? Especially the part about the minivan. I know they have those automatic doors that slide open, but nevertheless, NO THANK YOU.

Sometimes we get caught up in thinking that the thing God has for us is something huge but hidden, and we either have to work really hard to figure it all out or wait until he drops that thing in our laps like manna from heaven. I absolutely believe God has a plan and a purpose for our lives, otherwise we wouldn't be here. But he has also given all of us unique gifts—time, resources, money, hearts for service, athletic ability, intellect,

music, or the dedication to watch all six seasons of *Parenthood* in just a few sittings—which means not one of our lives will look like anyone else's life.

I spent many years wringing my hands over God's will for me and worrying that I was going to miss the whole thing while I was selling doors for a door company or cholesterol drugs for a pharmaceutical corporation. What I realize now is that God used every one of those experiences to build my character, to teach me perseverance and dedication, to help me figure out my strengths and weaknesses, and to shape my perception of the world. He used those jobs to get me to San Antonio, which is where I learned to hear his voice when I was all alone, met my husband, figured out I loved to write, and am now raising my family. I thought it was all about finding a job and being a productive member of society, but ultimately it was God's way of leading me to a home and a purpose.

Nothing is wasted when we view it through the lens of what God has for us in whatever life brings our way. It's all a part of who we are and who he is making us to be. For some, that may be a public role on a big stage, but for the vast majority of us, it's about being faithful in the small stuff: going to the grocery store, volunteering in our kid's classroom, befriending the new girl, coaching a Little League team, showing up for work every day, being kind to our neighbors.

We need to look for God in the ordinary, everyday things, to pursue our dreams and live our lives and be faithful in the small things, because those are the moments that prepare us for the next thing. Pay no mind to the critics who want to point out how and where we might be falling short in the process. I've always loved this quote from Teddy Roosevelt:

It is not the critic who counts . . . the credit belongs to the man who is actually in the arena, whose face is marred by dust and sweat and blood . . .

Or as Taylor Swift taught us, haters gonna hate, hate, hate, but I'm just gonna shake, shake, shake it off.

Or as Sasa Johnson so eloquently asked me twenty years ago, "What the hell are you doing with your life?" Because now I realize what she was really asking—in a not-so-delicate or tactful way—was, "Are you going to waste this one imperfect, yet precious life you've been given?"

Small Things

Things I Wish I'd Known in College

"I was really going to be somebody by the time I was 23."

Lelaina Pierce, *Reality Bites*

Every fall on Facebook, I see pictures of my friends dropping their kids off at college, and it always makes me want to curl up in the fetal position and bawl my eyes out. It also makes me speculate what it will be like someday when Caroline leaves for college, and I think it's probably best summed up in two words: HOT MESS. I have this mental image of her dragging me across the ground as I hold on to her ankles and cry, "Don't leave your mother!" Although the sane part of me knows she has to leave because otherwise, we might become like Big and Little

Edie living with fifty stray cats in *Grey Gardens*, and that's not good for anyone. Maybe especially the cats.

1. It's really never a good idea to drink beer from a funnel.
2. I know Whataburger taquitos are delicious, but perhaps eating them every day at 1:30 a.m. isn't the kindest thing to do to your pants.
3. Those boys who seem like they could have real potential if you could just change a few things about them aren't going to change.
4. On a similar note, not one boy in the history of the world has ever quit calling because he's "scared by how much he cares for you." That's a lie sold by Meg Ryan and romantic comedies in general.
5. Contrary to your belief, you do need to learn how to use a computer, and email is going to take off as a viable form of communication.
6. You will never regret all the late nights you spent hanging out laughing with your roommates.
7. That bodysuit that snaps at the crotch that you insist on wearing with high-waisted jeans and a Brighton belt is a mistake.
8. Maybe you should actually attend class every now and then since that's technically what your parents are paying for every semester.
9. Choosing the right major really doesn't matter as much as just doing enough to graduate.
10. These four years (or five or six) (no judgment here) will teach you more about yourself and life than you ever could have imagined. And give you friends and memories that will still be some of your favorites long after it's over.

How Walmart and a
Frito Pie Made All
the Difference

I wish there was a way to know you're in the good old
days before you've actually left them.

Andy Bernard, *The Office*

I was born in Houston, Texas, in August of 1971. I'm not sure
how familiar you are with Houston, but I will tell you that
August isn't one of its finer months—unless you are a person
who enjoys breathing air that is so hot and damp it makes you
feel like you need to wring out your lungs like a wet sponge.

The story goes that my parents were with the neighbors watching a preseason game between the Houston Oilers and the Dallas
Cowboys when my mom realized she was in labor. My dad has
always been a fan of football and especially of the Houston Oilers,
back when they still existed (Luv ya, Blue!), so I can only imagine
the levels of grief he experienced when he realized he was going
to have to miss the fourth quarter to get my mom to the hospital.

In what was an early indicator of my night owl ways, I arrived in the world a little after 2 a.m. This was back in the days when the medical profession still treated childbirth with the respect and awe it deserves, considering something the size of a watermelon has just been pushed through something the size of a garden hose, so I assume my mom was knocked out for most of the excitement and I was whisked off to an incubator somewhere for my first few hours in the world. A few days later, it was time for our little family of three to go home from the hospital. My dad brought me a life-size Raggedy Ann doll that I still own to this day, and we made our way home to a one-story brown house complete with wall-to-wall luxurious green shag carpet where I would smile my first smile, take my first steps, and begin to figure out what life is all about.

My parents met in college in the late '60s and married in July of 1969. It seems appropriate that their wedding took place just days after Neil Armstrong set foot on the moon and took "one small step for man, one giant leap for mankind," because my mom and dad truly came from two completely different worlds. In fact, family legend has it that when they first started dating, my mom told her parents my dad's name was Charles Brown. Why? Because the fact that his last name was really Marino would reveal that he was Italian and Catholic, both of which proved to be scandalous to my mom's small-town West Texas family. One could argue here that perhaps Charlie Brown wasn't the most well-thought-out fake moniker, but it just proves that some realities are better than anything you can fabricate in an attempt to write a good story.

Anyway, because the 1960s were an optimistic time, and my parents were both very attractive, I guess they thought all their

differences wouldn't matter in the long run. I have no idea about all the ins and outs of their marriage and what went wrong, because those aren't the kind of things you pay attention to when you're a kid. Especially not when you're busy making up scenarios in which your Barbies travel cross-country in a Winnebago, stopping at various destinations to lip-synch Olivia Newton-John songs before returning home to their luxurious townhouse complete with an elevator and an inflatable hot pink couch.

Now that I've been married for almost twenty years myself, I know that every marriage is more complicated than it appears to be on the surface. It can be a delicate dance of romance, hurt feelings, love, driving carpool, cooking dinner, dreams, and a lot of work. It's hard to know why some marriages survive and others don't, other than by some combination of pure stubbornness, grit, and a lot of prayer. A wise, older friend once told me that sometimes the best part of staying married is being glad later that you did, and I think that's about the best marriage advice I've ever heard.

I was eight years old when my parents sat me and my sister down one night and explained that my dad was moving out. It was one of those moments in life that doesn't seem all that significant at the time, but you realize years later that the shockwaves continue to reverberate in countless ways.

Also, when you find you're suddenly one of the few kids with divorced parents in an idyllic suburban neighborhood with tree-lined sidewalks and cul-de-sacs, you quickly realize life is complicated. You learn to be the funny kid to deflect attention away from the fact that you're also the kid who has to have weekly meetings with the guidance counselor because you have some "anger issues." Granted, some of my anger issues were attributed

to the fact that I tended to "mouth off" in class with sarcastic comments. As it turns out, that's just my personality.

The next few years were tumultuous. My parents attempted reconciliation at one point, then my mom ended up in an ill-advised second marriage that ended badly and resulted in our moving to Beaumont to be closer to her parents, my Nanny and Big Bob. To this day, Nanny and Big Bob serve as proof to me that sometimes, two complete opposites find each other and figure out how to build a life together.

Big Bob was the youngest child in a family of all girls. His daddy passed away when he was six months old, so Big Bob was raised by his mother and older sisters. I feel certain this was God's way of preparing him for his future, because he married my Nanny and had two daughters, four granddaughters, four great-granddaughters, and one grandson. He spent his life surrounded by women, so he obviously had a high tolerance for pain, lots of talking, and manufactured drama.

He and Nanny were in the same class at Lockney High School. Big Bob was a star football player and sure of himself in that way only a male who's been surrounded by adoring females all his life can be. One night when they were dating, Nanny was waiting for him to pick her up, and he never showed. The next day, she asked him why he stood her up, and he replied, "Oh, I showed up but I saw through the window that you were wearing those pants I don't like, so I left." But for all of his bravado, he couldn't stay away from her. He went off to the University of Texas but missed home and Nanny so much that he came back a semester later.

She had a date with another boy the night he returned but instead, she ran off and eloped with Big Bob. He took her back to his house afterward, and the next morning his mother (who by

all accounts was more than a little intimidating) found them in bed together and said, "Well, you've ruined your life."

Big Bob was part of the greatest generation. He served in the Navy during World War II. He left his wife and his little girl to go fight for our freedom. While he was gone, Nanny had the neighbor girls take pinup-style pictures of her in a green bathing suit to send to him. He never talked much about those days, but Nanny said she'll never forget looking outside and seeing him coming up the front walk in his sailor uniform the day he got home. Not surprisingly (especially considering the sailor uniform), my mother was born the next year.

Big Bob worked as an appliance repairman for years. He could fix anything. None of the women in my family ever had to buy a new appliance. He'd just find old ones someone had thrown out, fix them up, and you had yourself a new washing machine.

At any given time, he owned at least three different station wagons. Two were usually Pintos. (I don't think they make them anymore. Mainly because the majority of people don't want a car named after a bean, no matter how tasty.) The other was a huge, full-sized wagon perfect for loading up stray appliances. They all smelled of grease, sweat, and Sir Walter Raleigh pipe tobacco. It's one of the defining smells of my childhood.

My little sister went to a private school, and when Big Bob went to pick her up one day, instead of just stopping at the curb like the other parents, he drove his huge white wagon all the way up the ramp to the front door. Turns out it was raining, and he didn't want her to get wet. She was so embarrassed at his carpool line faux pas that she dove headfirst into the front seat like she had just robbed the place and yelled, "DRIVE, DRIVE, DRIVE!"

In contrast to Big Bob, Nanny had style and always drove

a Cadillac. In high school I would run down the street to her house to borrow her clothes and jewelry because she always had the latest fashions and a collection of twist-a-bead necklaces that would make you weep. I believe the term "bedazzled" was almost exclusively invented to describe her style. Big Bob's fashion sense hovered somewhere in the realm between auto mechanic and Goodwill chic. He was a big fan of the one-piece, zip-front jumpsuit, and on especially cold days he paired it with a large fur hat with earflaps. Also, I never saw him without a pipe in his mouth unless he was filling it back up and relighting it.

Most evenings at their house involved Nanny and whichever of her girls happened to be visiting sitting around the kitchen talking while Big Bob sat in his recliner in the living room. He was always quiet, and we thought he was just watching *Walker, Texas Ranger*, but later on he could tell you every word the girls had said. One time, when I was fresh out of college, I was crying to Nanny about how I didn't have any money and felt so overwhelmed. Big Bob was in the other room, but before I left the next day, he handed me $100 without saying a word. He just silently and faithfully took care of the people around him. Looking back, I see that while Nanny often got all the praise because she was right in the middle of everything, Big Bob was always quietly present in the background, navigating the family ship through life like a quiet, steady rudder.

When I was about nine years old, Nanny and Big Bob bought a lake house in Colmesneil, Texas, population 318. Our family wasn't necessarily (and by necessarily, I mean not at all) what you would describe as "outdoorsy" and had never really dreamed of owning any sort of lakefront property until Nanny, who had started selling real estate later in life due to her love of Cadillacs

and jewelry, stumbled upon the house when her company listed it for sale. None of us knew the first thing about boats or docks or fishing poles other than what we'd seen in *On Golden Pond.* (And, let's be honest, Katharine Hepburn and Henry Fonda can make anything look dreamy. "The loons, Norman! Look at the loons!")

To our credit, we all jumped in with both feet. Nanny took us up to Granny Graham's Get It and Go, the oldest grocery store I have ever been in, with an equally old Granny Graham sitting behind the counter. (We would always describe her as "even her wrinkles have wrinkles.") Nanny bought us Styrofoam tubs full of night crawlers so we could bait the hooks of our little Zebco poles. We'd sit on the dock for hours with the sun adding to the freckles on our noses while we put worms on our hooks by ourselves, and catch 104 perch in one afternoon. But with every catch we'd yell, "BIG BOB, come get this fish!" And Big Bob would stop whatever he was doing to come take our fish off the line for us and throw them back in the water so we could inevitably catch them again.

We spent weeks there during the summer, floating on inner tubes, going for boat rides, fishing, roasting hot dogs and marshmallows over the campfire, and taking exploratory walks down the long dirt road that led to the highway. One summer my cousin, Todd, built a floating dock that we christened the S.S. Nanny. We'd take it out to the middle of the lake and spend the whole day floating and swimming. Everyone would take turns making runs back to the house to get drinks, pimiento cheese sandwiches, and other assorted snacks. I thought my older cousins were so glamorous and sophisticated as they applied baby oil to their skin while cigarettes dangled from their lips, which were lacquered with a fresh coat of Maybelline, while a jam-box played Waylon and Willie songs in the background.

Some days, Nanny would drive us down the road to Lake Tejas, which was basically the greatest place ever. It was a neighboring lake that had been turned into a real swimming hole. You could rent a tube for a dollar and hang out all day. They had huge slides and the highest high dive I had ever seen. Every summer I had to work up my courage to jump off that high dive, but I always had a fondness for impressing the small town boys, so I'd eventually take a deep breath, make sure my super-cool OP swimsuit was securely in place, and jump. We would spend all day floating and jumping until our fingers were pruney, and then we'd eat Frito pies right out of the Fritos bag before heading home.

Nights at the lake were spent visiting, sitting around on the faux leather couches that stuck to our sunburned legs, and staying up late to watch *The Tonight Show* with Johnny Carson. Most nights, my sister and I could talk Nanny into playing Skip-Bo with us until the wee hours of the morning. The air smelled of the aloe vera and Solarcaine everyone slathered on their sunburned skin, and the face cream Nanny meticulously applied as part of her evening beauty ritual. We were a family full of women, so the house often felt like an offbeat sorority consisting of girls of all different ages. Someone was always crying about something, because at any given time there was someone going through menopause, pregnancy, or puberty. Big Bob always went to bed early, partly because he was an early bird and, I suspect, partly to avoid all the drama.

On days when we'd all had enough of the water and the sun, we drove to Woodville to go to the Walmart. (That's how you know you're in a small town: "the" Walmart, "the" Dairy Queen, "the" Sonic.) We'd load up on essentials like new makeup, a bathing suit, floats, fishing poles, and toys. This was back in the

days when Walmart was found only in small towns, so it was a total novelty to city girls. It was also long before I'd experienced the phenomenon now known as "Target Shopping," wherein you walk into a store to buy a bottle of Coppertone and walk out $100 poorer with a cart full of stuff you didn't even know you wanted. We spent hours at the Walmart and were always rewarded with a freshly squeezed lemonade and a corn dog apiece from the stand set up outside the store. Then we'd head home and take a quick swim in the lake before the sun went down. On those nights, we skipped the shower and went to bed with our hair damp from the lake water, warm in our new pajamas from Walmart as the window unit air-conditioning blasted frigid air into the bunk room where we slept on foam mattresses.

Nanny and Big Bob sold the lake house several years before they passed away, but they are both buried in the little cemetery in Colmesneil because the lake house was so much more to our family than just a place to fish or ride a boat. It was a piecemeal house with an odd layout, because rooms were added to make room for more people as my cousins began having families of their own, but it's where real life happened. There were fights in that house; there was always drama; there was the Thanksgiving Big Bob got so tired of all of us that he drank a little more vodka than was reasonable and passed out at the lunch table. It was real, messy, raw life full of love, disappointments, celebrations, anger, laughter, and tears. As a kid who was struggling with what family was supposed to look like, I found it in the waters of that lake and in the walls of that little house.

A few years before Big Bob died, he began to lose his memory. Nanny said she first noticed it when they were at a wedding, and he walked up to her eating a piece of chocolate cake. She asked

where he had gotten it, and he said, "Well, it's over there on that table. I just went and cut myself a piece." She said she wanted to crawl under the table when she realized he had been the first one to cut the groom's cake.

During those years, Nanny really needed a break from taking care of him, so my best friend, Gulley, and I drove to Beaumont to stay with Big Bob for the weekend while Nanny drove to Houston to relax with my mom. Around 6 p.m. that first evening, we were sitting with him in the living room when he asked, "Y'all think Nanny's ever going to get out of the bed this morning?" At the end of the weekend when Nanny got home, he told her he'd missed her. She asked, "Where do you think I've been?" and he replied, "Well, I guess you've just been at the Walmart." Which just serves to prove how much time we actually spent at the Walmart in Woodville. Except if she'd really been at the Walmart, she would have brought him some lemonade and a corn dog.

Anytime I spent the night with Nanny and Big Bob, Nanny would kiss me goodnight as she said, "Parting is such sweet sorrow, but we will meet again on the morrow." She and Shakespeare were right; parting is such sweet sorrow. It's weird that you usually don't know life is going to change until it's already happened. I didn't know our last day at the lake would be our last; I didn't know a day would come when we wouldn't go back to the Walmart; and my mind couldn't comprehend that one day Nanny and Big Bob would be gone. Yet here we are.

Their lives and the time I spent with them stand out to me as a shining example that a happy childhood is made up of the small, simple things: a Frito pie, a day spent floating in a tube, a trip to Walmart, and being tucked in at night knowing you are loved.

Small Things

Things I Wish I'd Known When I Was a Kid

"Are you there, God? It's me, Margaret. I just told my mother I want a bra. Please help me grow, God. You know where."

Judy Blume, *Are You There God? It's Me Margaret*

Early on in my tenure as a mother, I realized one of the joys of having a child is that it allows you to revisit things from your own childhood. The problem with your own childhood is that you have absolutely no bandwidth for realizing life won't always be so simple. It's just one long, endless stream of school days, summer vacations, curling up in a bunk bed next to your best friend while you debate whether you should marry Shaun Cassidy or Donny Osmond, and concluding that eight-track tapes are a technological wonder which will never be improved upon.

Here are a few things I wish I'd known when I was a kid:

1. It's kind of weird that Bert and Ernie live together.
2. Donny Osmond couldn't actually see me through the TV set.
3. When your mom asks, "Who broke this vase?" it's not a real question because she already knows.
4. Enjoy how great you feel wearing a swimsuit, because it's short-lived.
5. Eat more popsicles.

6. There isn't an actual monster living under your bed, and if there were, running and jumping into bed at night isn't really going to help you.

7. If your biggest dream is riding the mechanical bull at Gilley's, then perhaps you should find a bigger dream.

8. On that same note, steakhouses called Tumbleweeds, where they advertise that they'll cut off your tie if you dare to wear one in their restaurant, are just a weird response to the entire *Urban Cowboy* phenomenon and will be a brief fad.

9. Santa Claus will never really just bring a lump of coal.

10. All those choreographed roller skating routines you and your friends create on the driveway will never come to fruition and certainly won't get you a part in *Xanadu II*. And not just because there will never be a *Xanadu II*.

11. Letting your grandmother give you a perm is a bad idea.

12. Cutting off all your hair to sport the "Dorothy Hamill" haircut is also a bad idea. That's a very specific cut for a very specific kind of person, namely an Olympic figure skater or a cartoon character named Buster Brown.

13. Your grandparents won't be around forever. Enjoy the time you have with them and how much they adore you.

14. Baloney sandwiches on white bread with Miracle Whip and crushed Doritos in the middle are gross and will one day be a socially unacceptable thing to eat.

15. There are few joys in life as simple as spending the night with your best friend and staying up late to watch *Grease* for the one-hundred-and-seventy-fourth time.

16. I know you can't wait for your period to start because you've read *Are You There God? It's Me, Margaret* a thousand times,

but once that sucker shows up, it's going to stick around for a long, long time.

17. Don't be in such a hurry to grow up. Childhood is magical and wonderful and the last time you'll ever feel so completely carefree.

18. Someday you will have your own puppy, but you will never have a jukebox in your living room, and it turns out that's probably for the best.

19. Bonne Bell Lip Smackers are still one of the greatest things ever.

20. Your eyes won't really stay like that forever just because you keep crossing them.

Yes, Virginia, There Is Such a Thing as a Naugahyde Sofa

> That house was a perfect house, whether you like
> food or sleep or story-telling or singing, or just sitting
> and thinking best, or a pleasant mixture of them all.
> Merely to be there was a cure for weariness, fear,
> and sadness.
>
> J.R.R. Tolkien, *The Fellowship of the Ring*

We are a soccer family. We spend our weekends at soccer tournaments, we shuttle a car full of junior high girls back and forth to practices three or four times a week, and heaven help us, we record soccer games on the DVR to watch them later. This wasn't something my husband, Perry, and I envisioned for ourselves in our pre-kid days, but let's not even begin to count all the ways parenthood redefines what is important to you. You know what else I never envisioned? That I would know what it's like to catch throw-up in my hands or spend sleepless nights

worrying about a twelve-year-old going off to college when it's still six years away.

My career as a soccer mom (because make no mistake about it, this is a second job) began when my daughter, Caroline, was in kindergarten. Her first foray into the world of extracurricular activities involved a short stint in dance classes that caused her to tell us she was "sadder than a pickle that had been eaten," so we decided to make athletics our next stop. The first sport we tried was T-ball, and it quickly became evident that there was way too much sitting on the bench involved for a kid who makes a Tasmanian devil seem lethargic. That's when we found ourselves signing her up for soccer.

What we didn't factor in was that the soccer team was in need of a coach and thus, Perry and I became coaches of a group of five-year-old girls who named their team Rainbow Magic, because everyone knows that there is no more ferocious magic than Rainbow Magic. What they lacked in skill, they more than made up for in candy consumption and overall enthusiasm to move in a huddle down the field as they all vied for a chance to kick the ball. Yet somewhere during that first season, a love of the game was deeply planted in Caroline, and here we are seven years later, consumed by all things soccer.

I tell you this because it explains why we were all gathered around the TV to watch Abby Wambach play her last game on December 16, 2015. She is arguably the greatest women's soccer player of all time, and her accomplishments on the field changed the game forever and fostered a whole generation of little girls who dream of playing soccer at the highest level.

During her last game with the US Women's National Team, Gatorade aired a farewell commercial as a tribute to all Abby

Wambach has meant to women's soccer. It features her cleaning out her locker as she says these words in the background, "Forget me. Forget my number, forget my name, forget I ever existed. Forget the medals won, the records broken, and the sacrifices made. I want to leave a legacy where the ball keeps rolling forward, where the next generation accomplishes things so great that I am no longer remembered."

I love this commercial. In fact, I cried when I saw it for the first time because there is something so powerful about seeing success mixed with true humility and the heart of someone willing to be forgotten so that those coming behind her can achieve even more.

Abby's words have stayed with me, but over time I've decided it's not really possible to forget the great ones whose lives have played out before us. When you have lived life to the fullest, when you've *carpe diem*ed the heck out of who and what God has created you to be, you leave an indelible mark on the people around you and on those who will come long after you're gone.

The summer after my freshman year in college, I lived with my Me–Ma and Pa–Pa. My mom had moved to Oklahoma a few months earlier, my daddy lived in Houston, and I wanted to spend the summer in Beaumont because that's where my friends were. Most importantly, my high school boyfriend, the one I'd been dating for the last two and a half years, was in Beaumont.

It wasn't a good relationship, and in truth, I knew it was on its last legs, but I was eighteen, insecure, and desperate to hang on to anything familiar as everything else in my world changed.

No one really thought I should stay in Beaumont, but Me-Ma and Pa-Pa agreed to let me spend the summer with them on two conditions: I had to go to summer school, and I had to be in by 10:30 every night.

Think about that. I had just finished an entire year with all the freedom college offers, and I was going to spend the summer with a 10:30 curfew, living with my grandparents. Even on the weekends. That is what you call a tight ship. But desperation makes you agree to things you normally wouldn't even consider, and I respected their wishes. And at a time in my life when I certainly wasn't afraid to rebel against authority, I didn't dare break their rules. Back then, I wasn't really sure why I agreed to it, but looking at it now, there is no doubt it's because they were my grandparents, and they adored me and thought the best of me even when I didn't deserve it. I didn't want to disappoint them. They felt like the last bastion of people who truly believed I could do no wrong.

I thought I was staying with them and enduring a 10:30 curfew as a last resort, but I now consider that summer one of the greatest gifts of my life. I'd spent a lot of time with Me-Ma and Pa-Pa ever since we moved to Beaumont when I was twelve, because my daddy drove in from Houston every other weekend and we always spent the weekend at their house, but that summer I got to know them in that way that can only happen when your daily lives are intertwined.

While I'd always felt safe and loved at their house, I saw it through new eyes. Me-Ma and Pa-Pa's house was the unofficial meeting place for all the extended family members, and they came and went all day long almost every day, dropping by without calling first or worrying if it might be a bad time.

Me-Ma never worried about whether or not the house was clean or if she had on makeup. She welcomed everyone with a hug, offered them something to eat, and made them feel so incredibly welcome. She showed me what real hospitality is and that it doesn't involve waiting to have people over until you finally buy a new couch or remodel the bathroom. And, maybe most of all, she showed me that a simple life that revolves around loving your family doesn't equate to a small life.

I had an 8:00 class every morning. I think it was a political science class, but I honestly can't remember because for me, college wasn't so much about the actual classroom experience as it was about the extracurricular activities. Still, I seem to remember some talk of various branches of the government. I'd wake up in the morning and stumble into the kitchen, even though I'd had plenty of sleep the night before, thanks to my 10:30 curfew.

Me-Ma and Pa-Pa would be sitting at the kitchen table, drinking coffee and reading the newspaper. They'd discuss what they needed from Market Basket that day, because heaven knows not a day would pass without at least one trip to the Market Basket since it was the cornerstone of their daily activity.

I'd head off to school and arrive back home around lunchtime. By then Pa-Pa had spent the morning watching *The Price is Right* and making the first trip of the day to Market Basket. They were gearing up for *General Hospital*, which started at 2:00. The sound of the ambulance in the opening credits of *General Hospital* will always take me back to those afternoons, sitting on one of their Naugahyde sofas, getting caught up in a bad soap opera plot where invariably some girl fell in love with her kidnapper, only to find out he was her long lost brother.

Pa-Pa was a master of various culinary delights. Early on

in my childhood, he introduced me to the artery clogger known as a baloney sandwich on white bread with Miracle Whip and a slice of processed Kraft American cheese. It makes me gag a little thinking about it now. But his real specialty was sausage and potatoes. I'd walk in from class and there he would be, standing over a skillet on the stove, getting it all ready for me. "BIG MEL!" he'd boom. "The cook has your sausage and potatoes going!" I've spent the last twenty years trying to make them like he did and have never even come close. You can replicate a recipe, but there is no substitute for all the love that goes into someone making something for you just because they know it's your favorite and believe you are so perfect that they don't even notice you've gained ten pounds over the course of a few weeks.

That summer ended up being a defining summer for me. I finally broke up with the high school boyfriend, decided to go back to Texas A&M in the fall, and managed to keep my weight at a decent level in spite of all the sausage and potatoes. I watched a lot of *General Hospital* and cried a lot of tears on my Me-Ma's lap.

And I was home by 10:30 every night.

But I think the greatest gift I received that summer was spending every day with two people who thought I'd hung the moon and stars. They built me up and loved me unconditionally when my self-confidence was at an all-time low. They gave me a safe place to land that took me back to childhood for a little while. It was a chance to catch my breath and make some good decisions for the first time in a long time, which gave me the confidence I needed to embrace the future. For that, and for the sausage and potatoes, I will be forever grateful.

As I've thought about Me-Ma and Pa-Pa and how they shaped my life, I realize I can still close my eyes and recall every detail of their home, where I spent so many weekends as a child. It's hard to imagine that a place so familiar, even all these years later, is gone forever.

I remember Sunday afternoon naps on the Naugahyde sofas and, yes, they were as attractive as they sound. I'd fall asleep listening to the sounds of the Houston Oilers playing on TV and wake up with my hair plastered to my face, because let me tell you, that kind of upholstery doesn't breathe well.

I remember the yellow rotary phone that hung on the wall in the kitchen and the plastic fruit that sat in a bowl on a shelf nearby. I used to love to break off the fake grapes and chew on them, which is really kind of gross now that I think about it.

I remember the formal living room that was sectioned off from the rest of the house by a pocket door. That room was never used as much more than a storage facility for a secret stash of premium snack items in the china cabinet. Me-Ma would pull you aside like a Keebler drug dealer and say, "Psst . . . come see what Me-Ma has in here for you," as she pulled out the Nutter Butters or Little Debbie snack cakes.

I remember playing the bubble game in the middle bedroom with my sister. We could entertain ourselves for hours by fanning a huge, king-size sheet up in the air like a parachute and then pouncing down on the big bed to pop the "bubble," while Jesus in Gethsemane looked down on us from an oil painting that hung on the wall. He may have also actually been looking down on us from heaven, but that oil painting made it seem like he was tangibly in the room, which as a kid was a mix of both comforting and creepy.

At night, I slept with Me-Ma in her pink bedroom. (I'm sure at some point she and Pa-Pa shared a room, but those days were long gone by the time I arrived on the scene.) It was the most beautiful room I had ever seen, with its pink walls, pink fluffy bedspread, and gorgeous mahogany four-poster bed. I loved getting out of the bath in the pink bathroom, dusting myself with Me-Ma's pink powder puff, and then climbing into that fancy, pink bed knowing that Me-Ma was going to sleep next to me and would let me stay up late while she read me stories.

I can picture the way the insides of the closets looked; I can see the hallway with its array of family pictures; I can see the garage with Pa-Pa's poker table and picture of dogs playing poker hanging on the wall; and I can see the back patio with its multi-colored tiles, wrought iron table, and statue of Mary looking down on me as I played with my Barbie pool. No doubt the Virgin Mary was probably a little scandalized at all the skin Barbie showed in her yellow bikini.

In her younger days, Me-Ma was a real beauty. I have her wedding portrait hanging in my hallway, and she is so thin, young, and beautiful. By the time I knew Me-Ma, she was obviously older, though I realize now she wasn't as old as I thought at the time. She was plump, had graying hair that she kept dyed black, and wore a lot of polyester pantsuits. She'd raised three boys and lived a lot of life, so she wasn't necessarily thin and fashionable, but man, she was comfortable in her own skin.

I can't think of her without remembering the way she would come hurrying to the door to greet you. She'd have on her turquoise

pants, a brightly striped polyester shirt, and some brown SAS orthopedic shoes. She would wipe her hands on her pants because she was always in the middle of cooking something for lunch or dinner. She made the best spaghetti in the whole world, and if I had one more day with her, I'd make her write down the recipe instead of just letting her vaguely talk me through what she put in her sauce. When you left her house, she would stand in the driveway to blow you kisses and give you hand signals like a flight crew to help you navigate as you backed into the street. In spite of the fact that she never learned how to drive, she considered herself an expert at directing traffic.

Me-Ma and Pa-Pa were both first-generation Americans. Their parents immigrated to the United States from Sicily when they were young in search of a better life and landed in Louisiana. They eventually settled in Beaumont, Texas. My dad and step-mom took us to Sicily several years ago, and I can't imagine how depressing it must have been to end up in Beaumont after living somewhere so breathtakingly beautiful, a place that had acres of vineyards as opposed to oil refineries.

Me-Ma married Pa-Pa against her parents' wishes. She was a high school graduate, and he was a sixth grade dropout. She was raised to be a good Catholic girl, and he was a wild bootleg-ger who gambled and ran moonshine back and forth across the Texas-Louisiana border. Her younger sister, Josephina (Fina for short), was scared of Pa-Pa until the day he died. If he answered the phone, she would just hang up and he'd yell to Me-Ma, "That was your dang sister again."

Pa-Pa was a character in every sense of the word. My dad likes to tell us how Pa-Pa would take him to the pool hall while they were supposed to be at Mass. He loved to have a good time.

Despite his limited education, he used his drive and street smarts to provide a nice life for his wife and three sons. And every Friday night, he hosted a poker game in his garage. I remember helping Me-Ma get ready for all of his poker buddies. The garage would be thick with cigar smoke, and I always wondered what went on in there because I was never allowed in. He played poker with the same group of men for as long as I can remember, and the poker games kept going until most of the group passed away and he'd say, "Big Mel, all my poker buddies up and died."

Saturdays and Sundays were always about sports. This was back in the days before picture-in-picture was invented, so my uncles would set up two TVs with rabbit ears balanced precariously on top to get the best picture. A football-watching marathon would ensue, along with phone calls to bookies to make bets. To this day, I take my best Sunday afternoon naps with the sound of a football game in the background.

They had a huge backyard, and Pa-Pa set up two swing sets for the grandkids. We spent more hours than I can recall back there playing baseball using the big oak trees for bases. Pa-Pa would sit and smoke his cigar and watch us play. Every now and then he'd yell, "You kids, don't ruin Pa-Pa's barbecue pit!" or "You kids, don't mess up Pa-Pa's garage!" or "Don't make Pa-Pa go get his strap!" He loved to act put out with us, but I know the truth is he loved every minute of it.

For most of my life, Pa-Pa drove a huge, old baby blue Fleetwood Cadillac. It had an eight-track player that at some point got a Kenny Rogers tape stuck in it, so as you flew down Avenue A at twelve miles per hour, you were always listening to "Ruby, don't take your love to town . . ." And he loved to tell stories. He would sit and tell stories for hours about different

things he'd done, and his favorite part was luring us into the story like this: "Do you remember that time we went on that trip with the Modica boy and his dad? How old were you?" My dad would reply, "I think I was ten," and Papa would say, "No, you were twelve." It was like a game show.

Speaking of game shows, Me-Ma and Pa-Pa watched all of them. My love of *The Price is Right* came from them. And I can't tell you how many Friday nights we watched *Dallas* at their house. True quality programming for the entire family. That's how I learned to throw a drink in someone's face after pouring it from a crystal decanter and that just because you think your husband is dead doesn't mean it won't all turn out to be a dream and you might find him in the shower.

As Pa-Pa got older, he got a little forgetful. A few weeks before I got married, I called to see if they thought they'd make it to the wedding. He answered the phone and we talked, and he assured me he would be there and wouldn't miss it for the world. Then he said, "Let me let you talk to the cook," and as he handed the phone to Me-Ma, I heard her ask, "Who is it?" and he replied "Hell if I know."

Pa-Pa did make it to my wedding, then passed away a month later. One of my biggest regrets is that I didn't make one last trip to Beaumont to see him before he died, but I guess I was busy getting settled into my new life as a married woman. I also believe there was a part of me that was in denial that he was going to die. I'd never lost anyone close to me at that point, and I must have believed he was going to be okay. Especially since he'd spent every Christmas of my life gathering all of us around to announce, "This might be Pa-Pa's last Christmas with y'all." It was a family joke for twenty-five years.

But then he really was gone.

Me-Ma slipped away from us unexpectedly. She had a stroke that just changed something in her. She was okay physically, but something shifted inside and she was never quite the same. She lived four more years and had good days and bad days, but it was like part of her left and never really came back.

Family was everything to them. They were surrounded by the people they loved and who loved them for their entire lives. They knew what was truly important, and their home reflected it. It was very rare that there weren't at least twenty people in their house at any given time. They were always there to laugh at a good joke or old story, to cook a great meal, or read a book to a grandbaby. They loved nothing more than to be right in the middle of all their people, and there was never a day that didn't see Me-Ma wiping her eyes with the corner of her apron as she laughed so hard she started to cry.

What I don't know is why I thought it would never end. I thought we'd always walk up their driveway and Pa-Pa would swivel around in his chair to open the door while Me-Ma hurried toward us from the kitchen, wiping her hands on her clothes, ready to wrap you up in a hug. I know that sounds silly, but when you're young, you take it for granted that things and people will just always be there. You don't realize the richness of a life well-lived and don't question how it all happened.

I've always thought I would love to have one more day with them to ask about their hopes, their dreams, their heartbreaks and disappointments, but I think what I've realized as I've grown older is they probably didn't think much about those things. Life, for the most part, just was what it was . . . good and bad. They lived their lives with a faithfulness and commitment to the small,

important things we tend to overlook in the quest to do something grand with our lives, somehow missing the fact that the small things are ultimately the biggest things.

Me-Ma and Pa-Pa left a legacy of love and steadfastness. Every day they lived out this command written by the apostle Paul: "Take your everyday, ordinary life—your sleeping, eating, going-to-work, and walking-around life—and place it before God as an offering" (Romans 12:1–2 MSG).

Which brings me back to Abby Wambach's words about leaving a legacy. Me-Ma and Pa-Pa definitely left a legacy that has kept the ball rolling forward. The generations that have followed them have done things our great-great-great-grandparents in Sicily could have never imagined. (And I don't just mean watching Bravo and being able to have take-out food and groceries delivered right to your door.) But when you've left a legacy that strong, you can never be forgotten. You shouldn't be forgotten. Because every moment in what some might consider a small life was a moment painted with great love.

There is something about grandparents that change and shape a child's life. Your parents have to work hard and discipline you to make sure you turn out to be an upstanding member of society, while your grandparents can relax and let you stay up late and have that second or eighth ice cream cone. Once you're good and spoiled rotten, they pack you off you home to let your parents deal with you. This is called "getting revenge." I can see so much of my childhood spent with them in my mind and in my heart, and it makes me a little sad to know that it's all gone, all part of a bygone era, a piece of time that shaped me and taught me how to live and love well.

Yet their impact will never be forgotten. Caroline has their

bedroom furniture. My sister has their living room furniture. We all have bits and pieces of the things that belonged to them. And more than that, we have the lessons they taught us, the memories they gave us, the stories they told, and the way they loved their family, day in and day out. These are the things they handed down to us when we didn't even know we were paying attention.

Se Habla Van Halen?

The best way to find yourself is to lose yourself in the service of others.

Mahatma Gandhi

I was totally robbed of my First Communion. It's true. I spent the early years of childhood being raised Catholic and going to CCE classes and enjoying all the perks of Catholicism, including but not limited to going to church where they had kneelers you could stand on and pretend to be taller than you actually were. First Communion was something I'd long looked forward to, not because I really understood the holiness of the sacrament, but because it was a significant rite of passage. My Me-Ma used to let my sister and me walk forward with her at her beloved Our Lady of Assumption while she took Communion, until the day my sister blurted out, "ME-MA! THAT MAN DIDN'T GIVE ME ANY OF THAT CANDY!" as we walked the long center aisle back to our seats—and that was the end of that. All of that to say, I had long awaited my chance to walk down that aisle again. But my parents divorced when I was nine, and my mom, who had never converted to Catholicism, began taking my sister and

me to a Protestant church. And not just any Protestant church, because all of a sudden we were a hair shy of being arm-waving, speaking-in-tongues Pentecostals. If you want to give a child some serious religious whiplash, this is an excellent way to do it.

So instead of First Communion being a formal affair complete with white patent leather shoes and a frilly white dress from Weiner's and consisting of walking down a long aisle back to a wooden pew while incense filled the air, mine consisted of half a cracker and some grape juice in a thimble-sized, disposable plastic cup while I sat in what was basically a chair from someone's yard because the Protestants lack a little of the pomp and circumstance of the Catholics. And by a little, I mean that our new church met in a double-wide trailer with faux wood paneling and an oscillating fan as opposed to a hallowed cathedral with majestic stained glass windows. Also, instead of First Communion, they called it "The Lord's Supper," which, honestly, sounds like you're about to pull up to a table of meatloaf and mashed potatoes while Jesus calls from the kitchen, "Y'all need anything else?"

But I learned a lot about Jesus within the walls of that double-wide. I learned about the beauty of potluck dinners and that it's always a good bet to avoid a gelatin mold salad, even if the colors are festive. I look back now and think there was maybe a tad bit of misguided teaching going down, but there were also a lot of Sunday school lessons taught on flannel boards that gave me a pretty good foundation of faith to build on.

We stayed at that church until we moved to Beaumont at the end of my sixth-grade year, and after visiting several congregations, we wound up at a church called Cathedral in the Pines. I immediately felt as though I belonged with the youth group

there and loved the constant activities. For the first time, church became something I really looked forward to, and I was there every Sunday morning, Sunday night, and Wednesday night. I'm not sure whether my faithful attendance was about an enthusiasm for Jesus as much as it was about all the social opportunities, including cute boys, but there are far worse places for a seventh-grade girl to be than at church, even if her intentions aren't completely pure. God uses mysterious ways to draw us to him, and sometimes that involves a high school boy with gorgeous brown eyes who plays guitar in the youth praise band.

Over the next several years, I did everything with that youth group. Every Sunday night after church, we went to Mazzio's Pizza. To this day the smell of a pizza buffet takes me right back to eating a slice of pepperoni while watching the boys play the Punch-Out!! video game in the arcade. The scenes of my first crushes played out between trips to refill my Dr. Pepper and visits to the bathroom to make sure the enormous lace bow (Shout out to Madonna! As in *Desperately Seeking Susan*, not the mother of Jesus) was still perfectly in place in my hair.

On Sunday mornings, Pastor Dabney used his big, booming voice to preach eloquent sermons from the pulpit as the entire youth group gathered strategically in the last three rows of the sanctuary. We'd pass notes back and forth and, I'm mortified to say, got called out for being disruptive more than a few times. This resulted in threats from our parents that we'd have to sit with them next week instead of our friends, which was, honestly, a horrific fate and enough to ensure our best behavior for a few Sunday mornings thereafter. But eventually, we'd revert back to our note-passing ways—and these weren't just any notes, but elaborate missives in which we actually used countries as code

names on the church bulletins we wrote on in case we acciden-
tally left them behind on the church pew. All anyone would know
if our notes were discovered was that, "Switzerland is still an ally
of the United States, but Russia is looking to cause problems,
which is why Germany needs to be at the movies with us on
Friday night and no one needs to tell the Romanian spies." We
were a United Nations of big church nerds.

During the summer, we went to summer camp, where at
least 85 percent of us would rededicate our lives to Jesus. Again.
Especially after feeling guilty about making out with a blond-
haired boy from another church right before the evening service.
(I'm talking about a friend. Fine. I'm talking about myself. Myself
is the friend.) And then there was always a spring break trip to
a place called Sky Ranch, where we spent three days hurtling
our bodies down water slides, doing our best to tip our canoes
in the lake, and engaging in drama over everything from boys
to friendships. The last night at Sky Ranch always culminated
in a gathering around a big bonfire. This was our opportunity
to stand up and share deep things with the group. There were
always lots of tears and confessions and, ultimately, a whole lot
more rededications to Jesus because our rededication the previous
summer had worn off. Especially when you consider that some
of the stuff we were being taught made us all fear the Rapture
was imminent and there was a good chance we'd be left behind
if Jesus came right after we'd snuck out of our cabins to engage
in shenanigans.

If you didn't grow up in a charismatic, evangelical church,
then I don't think you can truly appreciate how much the Rapture
was a real part of my teenage nightmares and fears. I just knew
it was only a matter of time until I woke up one morning only

to discover that Jesus had returned and taken everyone I knew to heaven with him, and I'd been left behind. You'd think rededicating my life to him upwards of fifty-six times between 1983 and 1989 would have given me a little bit of reassurance, but apparently I hadn't quite gotten ahold of concepts like mercy and grace back then. This wasn't helped by reading Christian teen fiction in which a girl could just think about having sex and end up pregnant. Not to mention all the various dramatic skits enacted by the youth group drama team, wherein someone loudly repeated, "TICK TOCK TICK TOCK," in the background as the teens onstage acted out drinking alcohol at a party as a way to remind us that Jesus was coming soon. None of this really helped ease my mind about the whole thing.

Anyway, maybe it was partly fear of not being good enough to be truly saved or fear of missing out on fun (this is most likely), but something caused me to sign up for the youth group mission trip to Reynosa, Mexico, the summer after my freshman year. At that point in my life, I'd never been on any sort of mission trip and probably thought I actually qualified as the less fortunate because I owned only two pair of Guess jeans.

This was back when it still felt fairly safe to travel to Mexican border towns. I mean, sure, there was a good chance you'd see someone selling a goat's head on the side of the road and be bombarded by small children selling Chiclet gum, but that was about the extent of it. So my parents put me in a big blue van and sent me to Mexico. That last sentence sounds like the makings of a fantastic Lifetime movie.

Despite the fact that Texas shares a border with Mexico, it takes approximately nine hours to drive from Beaumont to Reynosa because you are literally traveling all the way across the

state of Texas. I'm sure a Texan has never told you this, but we have a big state. We also like to own a lot of things in the shape of our state, but it's not our fault God made Texas in a shape that makes a nice waffle.

Our van caravan was driven by brave, tireless youth workers with a high tolerance for tomfoolery. This was long before the days of cell phones, so our road trip entertainment consisted of occasional stops for fast food and marathon rounds of the alphabet game and Truth or Dare (although there are only so many truths or dares that can happen within the confines of an Econoline van). Several of us also had our Sony Walkmans so we could listen to music. We'd been told that we could only listen to Christian music since this was a church sponsored trip and we were on our way to do the Lord's work, which apparently didn't include listening to Lisa Lisa and Cult Jam. Our musical selections were supposed to consist of artists like Michael W. Smith, Petra, Amy Grant and, for the real Christian rock music pioneers, Rez Band.

However, someone may have slipped in a cassette of Van Halen's *5150* album and caused us all to gather around two ear-buds in the back of the van as we listened to "Dreams" over and over again. No offense to any of the Christian artists previously mentioned, but it's hard to compete with an impassioned Sammy Hagar telling you to "dry your eyes, save all the tears you've cried, because that's what dreams are made of." We made our way to Mexico as Sammy Hagar encouraged us to "reach for the golden ring, reach for the sky." That song, along with "Glory of Love" from the *Karate Kid II* soundtrack, were the anthems of my summer of 1986.

When we finally arrived in Reynosa, the temperature was

approximately 158 degrees. I can't remember where we stayed except that it resembled a large dormitory with several rooms of bunk beds and a shared bathroom where we all quickly discovered there was no hot water. Also, there was no air conditioning to speak of, unless you consider two small oscillating fans to be air conditioning, which I personally do not.

Sleep came easy that first night because we were all exhausted from the long trip. We woke up bright and early the next morning, ready to begin our first day of mission work, which was going to involve visiting an orphanage and passing out rice and beans to families in a remote area of town. The girls had been told to wear skirts and dresses, so I put on my cotton Esprit dress with a pair of scrunchy socks and Keds because I wanted to look extra special as I began my first foray into the world of being a missionary.

Nothing could have prepared my fourteen-year-old mind and heart for everything we saw that day. Here was a whole world I didn't know existed apart from the occasional Save the Children commercials narrated by Sally Struthers. I'd never really known what it was to think outside of myself and my little world until this moment. It was both humbling and sobering to spend time with orphans who needed homes, who craved love and attention so much that they congregated around us like we were rock stars even though we were complete strangers.

We spent the next several days painting churches, feeding the hungry, and sharing the love of Jesus with the help of our translators. The thing that amazed me most was how much the people we met wanted Jesus. They were desperate for him in a way that we rarely experience. How desperate can you be if you already have everything you need? The people we encountered

that week knew what it really meant when we told them that Jesus was the bread of life because they understood what it meant to be truly hungry, both spiritually and physically.

However, there was one evening when the language barrier caused a little confusion. One of the youth workers spoke to the local church crowd in Spanish, telling them that God was their heavenly father, but instead of using the masculine *el papa*, he said *la papa*. Essentially, he shared a heartfelt message about how our heavenly potato sent his son to save us from our sins. Don't get me wrong, I have had some heavenly potatoes in my time, and not one of them has saved me from my sins. But I still hope they have potatoes in heaven, and frankly, I can't imagine that they don't.

As I've gotten older, I've heard criticisms of short-term mission trips. People question how much good you can do in a few days and whether or not the local people even need their church to be painted or to have a bunch of overly enthusiastic American teenagers teaching their children all the hand motions to *Father Abraham*. (Not to be confused with Abraham the Potato.) And I get it. Sometimes we barge into situations with the best of intentions but don't know how to make the most of our efforts. A short-term mission trip reminds me of that episode of *Friends* when Joey challenges Phoebe to do a good deed that doesn't somehow make her feel better about herself, and she discovers it's impossible to do good for someone else without getting joy from it. Ultimately, she lets a bee sting her, because she forgets that just means the bee will die. Sidenote: There aren't too many situations in life, if any, that I can't relate back to a *Friends* episode. Which just proves that when they sang, "I'll be there for you," they weren't kidding.

Anyway, that trip to Mexico was the first time I understood what it meant to live out these words of Jesus:

> "'For I was hungry and you gave me something to eat, I was thirsty and you gave me something to drink, I was a stranger and you invited me in, I needed clothes and you clothed me, I was sick and you looked after me, I was in prison and you came to visit me.'
>
> Then the righteous will answer him, 'Lord, when did we see you hungry and feed you, or thirsty and give you something to drink? When did we see you a stranger and invite you in, or needing clothes and clothe you? When did we see you sick or in prison and go to visit you?'
>
> The King will reply, 'Truly I tell you, whatever you did for one of the least of these brothers and sisters of mine, you did for me.'" (Matthew 25:35–40)

Sure, I spent a lot of time that week flirting with boys, listening to Van Halen, shopping for cute Mexican embroidered tops in the local market, drinking Big Red, and giggling with my girlfriends late at night, but something also shifted in my heart. Now I could put faces and names with real children who didn't have a home or family. I knew real families who were unbelievably grateful to receive a few bags of rice and beans because it meant the difference in whether or not they'd eat that week. I met local pastors who worked tirelessly to spread the words of Jesus to their congregations, not for money or to build a big building, but purely for the sake of the gospel.

On that trip to Reynosa, my self-absorbed fourteen-year-old heart turned its gaze outward and grew ten sizes. I returned

home with a greater appreciation for what I had, including but not limited to air conditioning. That one week laid the groundwork for trips I'd take as an adult to places like the Dominican Republic and Ecuador to serve the people there, to play a game of soccer with kids desperate for love and attention, and to pray with families who have nothing this world says is valuable but do have an unshakable faith that humbles me—especially when they ask how they can pray for us because they have all they need. It made my eyes quicker to see the needs around me and motivated me to figure out how I could help. It gave me a much wider view of the world, one that was very different from what I saw on the streets of my suburban neighborhood.

A few years ago, someone posted this plea on a neighborhood Facebook message board: "Help! Looking for a place to take my kids to feed some homeless people but don't want to have to go all the way downtown!" It made me laugh because, first of all, our neighborhood is five minutes from downtown. Second, I saw myself in that comment because sometimes I want to help, but I just don't want to leave my comfort zone.

Maybe sometimes the point of a mission trip is God changing our hearts and our eyes to see what he sees more than about an orphanage needing us to sing some songs and put on some plays. If our purpose is to become more like Christ, then I think we take the first step on that path when we begin to see things outside of ourselves, no matter how small or insignificant that may sometimes seem. And sometimes we have to leave the comfort of home to get that perspective.

God doesn't call all of us to live our lives on a foreign mission field, but we are all called to help when we can and to love at all times. One week in a small Mexican border town was the

beginning of that for me. It created an understanding that there are people in need all around us every day if we ask God to give us his eyes to see them. That week also taught me the words to every song on Van Halen's *5150* album, but, sadly, didn't do much to diminish my fear of the Rapture. Most importantly, that week showed me there can be big implications to small sacrifices of time and resources, whether in a foreign country or in our own communities, and that sometimes the best way to be a light in the world is to shine where you can, when you can, wherever God has placed you.

Small Things

Things I Wish I'd Known about God When I Was Younger

> You can safely assume you've created God in your own image when it turns out that God hates all the same people you do.
>
> Anne Lamott

1. He's not as angry as some preachers make him out to be.
2. He may or may not look like George Burns, but chances are weighted heavily on the no side of that.
3. He loves us more than we can comprehend.
4. He probably isn't concerned with denominations, the color of carpet in the sanctuary, or whether you have pews or folding chairs.

5. Sometimes he probably looks down here and wishes we'd all quit arguing over stupid stuff that isn't going to matter in light of eternity.

6. He probably thought that bumper sticker that reads "My boss is a Jewish carpenter" was funny the first time he saw it, too.

7. He cares about even the smallest details of our lives.

8. I bet he reads *The Chronicles of Narnia* and thinks "Wow, that's amazing."

9. His mercy and grace are so much deeper than any of us can conceive.

10. His love for me isn't based on my performance, and thank you very much for that, because otherwise I'm sunk.

Why a Trans Am
Might Be Overrated

Listen to your life. See it for the fathomless mystery
that it is. In the boredom and pain of it no less than in
the excitement and gladness: touch, taste, smell your
way to the holy and hidden heart of it because in the
last analysis all moments are key moments, and life
itself is grace.

Frederick Buechner, *Now and Then*

Several years ago, in a burst of productivity, I decided to completely rearrange my kitchen cabinets. Now that I think about it, this may have happened while I was writing my first book, because I will find any excuse to procrastinate while writing, as evidenced by the fact that I scheduled an appointment to get a mammogram next week. (Yes, there are days when getting your boobs manhandled by a complete stranger and squashed in a hard plastic vise is preferable to trying to put words on a page. Don't ask me to explain this logic because I cannot.)

At the time, I hadn't cleaned out my kitchen cabinets or

changed the way things were arranged in almost ten years, and eventually I realized there had to be a better way to use all that space. There was one huge corner cabinet that held nothing but our wedding china and stemware, which had been used approximately three times in eighteen years of marriage, so I decided I should move all that stuff my mother-in-law said I'd be happy to have someday to the cabinets above my oven, which is totally out of normal reach and a much better location for crystal goblets that might still have price tags on the bottom of them.

So up went all the Lenox china, and I never really thought about it except on the occasions I'd open that cabinet to pull out a terracotta chip and dip tray that was a wedding present I actually use because CHIPS AND DIP. But then last week I went to pull out the chip and dip tray because it was the Super Bowl (I mean the Super Bowl as in the one where they play professional football, although the chip and dip tray is very much its own super bowl in a matter of speaking), and I noticed it was filled with broken pieces of crystal stemware. On further inspection, I realized the cabinet had completely shifted, causing the back shelf to crash down and break several goblets. As I surveyed the mess, I was much sadder about having to spend time cleaning up the broken pieces of glass than I was about the actual glasses, because you know what? My twenty-five-year-old self picked out those pieces of Waterford and fine china for some idea of what I thought real adult married life would look like. That idea was largely based on the fact that I spent a lot of my formative years watching *Dallas, Dynasty,* and *Falcon Crest,* all shows in which there was never any shortage of people pouring scotch from crystal decanters into fancy glassware.

It made me think about all the ways pop culture in the 1970s

and early 1980s influenced my thinking about exactly what my adult life might look like. Most of it has turned out to be completely inaccurate. Let's take a closer look.

1. *Grease* (the musical, not the laundry stain)

I have seen this movie upwards of 473 times. I owned the soundtrack on both eight-track cassette and a double record album with bonus photos inside. I dressed as Bad Sandy for at least three Halloweens and can't guarantee I won't do it again in the future, except that my time of looking remotely appealing in black spandex is quickly diminishing.

There was a time when I came up with a master plan to be the good girl and wear skirts all year long and then show up on the last day of school wearing some Jordache jeans and my Nike tennis shoes and shock the entire third grade class at Bammel Elementary School. Which, granted, is not exactly as cool as showing up in black leather pants and red Candies, but I was a realist. I knew my mom would never buy me black leather pants because—hello—inappropriate. But that didn't keep me from cutting up some black leotards and tights and wearing them with my mom's Candies to reenact that last scene over and over again. And really, is there anything more appealing than a seven-year-old pretending to put out a cigarette with the toe of her high-heeled shoe while saying, "Tell me about it, Stud"?

(Note to self: Do not allow Caroline to watch *Grease* until college.)

Grease was the reason I believed I'd meet my true love in high school, he'd wear a leather jacket and be part of a cool gang,

and, after a festive carnival to celebrate the end of our senior year—during which I totally changed to be what he wanted me to be—we would drive off together and inevitably live happily ever after. What could possibly go wrong?

2. *Coal Miner's Daughter*

Do not try to convince me that this isn't one of the greatest movies ever made. I will sit and watch the entire thing anytime it's on TV. What other movie has even come close to offering such classic lines as, "Hey, Doolittle Lynn, who's that sow you got wallowin' in your Jeep?"

For many years I wanted to travel the country in a car with my husband as we looked for radio stations and asked them to play my album. Ultimately I'd end up singing at the Grand Ole Opry and wear long, ruffled dresses. I'm sure the only thing that kept all of this from actually happening is the little detail concerning my lack of a singing voice.

3. *Urban Cowboy*

Nothing is more romantic than getting in fights at honky-tonks and riding mechanical bulls, right? For years after I saw this movie, I dreamed about my wedding day and just knew I'd have the band play "Could I Have This Dance?" by Anne Murray.

I'd wear white cowboy boots with my wedding dress before we moved into our brand-new double-wide trailer, and we'd spend our days training for mechanical bull riding contests. To my

credit, I had no desire to repeat the part about hooking up with an ex-convict who stole money from Gilley's and wore shirts made out of fishing net—I had standards, after all.

4. *Smokey and the Bandit*

I don't know what I loved more, Burt Reynolds or that black Trans Am he drove. I do remember that my sister had a crush on Jerry Reed, and we'd argue about who was cuter, Bandit or Snowman. Also, it made me want a CB radio in our car more than anything in the world. Oh, the elusive glamour of being known on the interstate by a super classy handle like "Hot Pants."

As I look at the common thread running through most of these movies, it appears I essentially wanted to grow up to be a redneck who traveled the country in some form in "hot pursuit" of something. But you have to realize no good can really come of running out on your wedding day and hopping into a black Trans Am driven by a lawless cowboy running beer across state lines in a race to win a bet with a father/son duo known as Big and Little Enos.

5. *The Electric Horseman*

This movie was pivotal, if for no other reason than how good Jane Fonda looked wearing her jeans tucked into her boots. It inspired my fashion sense at an age when my wardrobe consisted largely of Luv-It jeans with embroidered roller skates on the back pocket. It also made me think that maybe one day, I might run

off with a rodeo cowboy trying to save a racehorse from a life of drugs and being paraded on a stage lit up with Christmas lights. We'd end up in a canyon in Montana watching wild mustangs run while Willie Nelson sang in the background, "My Heroes Have Always Been Cowboys."

Perhaps I'm saddest that this particular version of adulthood never transpired because that sounds fairly dreamy even as I sit here watching my daughter's soccer practice and reminiscing about it. So I guess the lesson here is that rodeo cowboys who wear light-up suits trump mechanical bull riders and Trans Am drivers every time.

No. Sorry. I don't think that's really the lesson here.

Well. Maybe a little, but not the one I'm looking for at this particular juncture.

The point is, when I was younger, I pieced together all these fantasy versions of what I imagined real life would be like, and decided it looked a lot like being a secretary who rides mechanical bulls, disco dancing in flowy dresses with a man wearing a white suit, and singing at the Grand Ole Opry before riding off into the sunset in a black Trans Am to set a horse free in a canyon in Montana. And listen, if any of those describe your life, then let me be the first to say WELL DONE. I applaud you and the fantastic choices you have made. Clearly.

The truth is, I sit here at forty-five years old, and my life, for better or for worse, bears no resemblance to any of the aforementioned scenarios. I can still hope that maybe singing onstage at the Grand Ole Opry is in my future, but chances are it's not going to happen and not just because I have no discernible singing talent. My days consist largely of waking up to an alarm at way too early o'clock, starting a load of laundry I meant to start the night

before, deciding what kind of meat to thaw for dinner, cooking a bowl of oatmeal, packing a lunch, and driving a teenager who may or may not be having the worst morning ever to school before I return home to clean up the kitchen, make a grocery list, and convince myself that maybe I should actually go work out since I'm wearing workout clothes for the seventeenth day in a row. Some days I feel like I'm doing a pretty good job at being a wife, mother, daughter, and friend; and some days I feel like I want to run away from home because I am an idiot who is just screwing everything up.

Perry and I were watching beach volleyball during the Summer Olympics awhile back, and the announcers were talking about Kerri Walsh Jennings and her incredible career as a beach volleyball champion. They aired a voice-over of her saying that she strives to be the best at everything she does: the best wife, the best mother, the best athlete. Perry turned to me and said, "I bet it wouldn't be very fun to be married to her." (It's a smart man who knows to say that to his wife while watching a gorgeous blonde with zero percent body fat in two strips of fabric play volleyball.) But I was curious about his thought process and asked why he'd said that. He replied, "It sounds like a lot of trying. I bet it gets exhausting." I turned to him, grabbed his hand, and whispered softly, "Here is my promise to you. I will NEVER try to be the best wife."

The truth is that real life is messier than the movies, and sometimes the harder we try to make everything look a certain way, the more frustrated we find ourselves. There isn't always a happy ending, the boy doesn't always get the girl, the marriage doesn't always work out, the kids don't always learn their lesson, and Prince Charming may never come riding up in a light-up suit

on a rodeo horse. So I guess the question becomes, *Is my real life better than what I imagined it might be back in 1981 based on what I saw on a movie screen?*

The honest answer is *yes* on most days. I love my family. I love my friends. I love this life I've been given, and I don't take it for granted. But occasionally, when Caroline is having a level-ten reaction over Algebra homework and I have to think of a new way to cook chicken for dinner and the dog has just thrown up on the rug, I look out the kitchen window longingly, wondering what it would be like if Burt Reynolds showed up in a black Trans Am.

6

The Dirty Truth
of a White Couch

It does not do to dwell on dreams and forget to live.

Albus Dumbledore, *Harry Potter
and the Sorcerer's Stone*

It starts when we are little girls. We see Cinderella find her Prince Charming, Sleeping Beauty awakened by true love's kiss, and best of all, Snow White living with seven dwarves who whistle while they work, and we think to ourselves, "How can I have that?" Eventually we graduate to more sophisticated and complicated love stories that play out on our movie and TV screens, and we wonder why not one man has ever barged into girls' night at our house and declared, "You complete me."

The truth is, real life doesn't usually resemble what we see on any kind of screen, especially the big screen. There are dishes to be washed, beds to be made, and laundry to be done, and no one wants to see a movie about that. Also, can we talk for just a minute about the laundry? It never ends. I didn't understand for a long time that the real reason I only had one child was because God knew I

couldn't handle the laundry for any more than that, but I know it now without a doubt. The laundry will cause your soul to shrivel up and die because it's a battle you can't win. Are you sitting on your couch right now feeling smug because you believe you've actually washed and put away all your family's clothes? Then let me ask you a question. Are you wearing clothes right now? Did you send your kids off to school wearing clothes? I hate to be the bearer of bad news, but all those things are now dirty laundry. It never ends.

Whether you are married or single, have kids or are childless, work from home or in an office, volunteer for the PTO or just watch a lot of Netflix on your couch, life has its ups and downs. It's messy and hard and beautiful and wonderful, sometimes all within one hour. If I could sit down across from you (and I so wish we could make this happen), I would share that perhaps the thing I've learned the most over the last several years is that we all have a tendency to compare our lives to others' and think everyone is living a better story than we are. With social media, it's never been easier to get a glimpse into strangers' lives and decide their marriage is better, their house is cleaner, their kids are better behaved, while we are just a step away from living in a van down by the river and we don't even care because our children are so ill-behaved that it would seem like a vacation.

I've read so many articles about what porn does to a man and why it's so damaging, but as women we deal in some form of what might be called "emotional pornography" all the time—often without even realizing it. We fantasize about how life would be so perfect *if only* we had that new couch from Pottery Barn, *if only* our kids wore smocked dresses instead of that same old Gap T-shirt with the stain on the front, or *if only* we could finally lose that last ten (okay, fifteen) pounds of baby weight and fit back into our skinny jeans.

About three years ago, I made a mistake of epic proportions and let an interior designer friend talk me into buying a white couch. I really can't put the sole blame for this purchase on her, though, because the truth is I'd been pinning white couches on Pinterest for months along with doing Google searches like "How hard is it to clean a white couch?" "Am I crazy for wanting a white couch?" and "White couch: friend or foe?"

Every blog post I read by someone who'd made the decision to buy a white slipcovered couch raved about how it was just so easy to maintain. Sure it gets dirty, but you just take those slipcovers off, throw them in the washing machine with some bleach, toss them in the dryer, and your couch is as good as new! As good as new! In fact, it's even better because you have the smug satisfaction of knowing your couch is cleaner than your neighbor's couch because who knows what horrors lie within that dark taupe fabric that the eye can't see.

So I drank the Kool-Aid and bought a white couch. Ironically, I could never drink actual Kool-Aid on the white couch, because there are some stains that cut too deep—specifically stains from powdered drink mixes that can also be used to dye hair.

The day the white couch was delivered was perhaps second only to the day my daughter was born on the scale of best days ever. My living room looked like it was ripped straight from the pins of Pinterest. (If it weren't for Pinterest, none of us would know that there is actually a decorating style called "Vintage Industrial Train Station," so basically Pinterest was created for the purpose of making women everywhere feel like we aren't living up to our potential.) And for that one glorious day—let's be honest, it was more like two hours—I defied every teacher I'd had throughout school who wrote, "Does not work to full potential"

on my report cards because I was—as Whitney Houston sang—
EVERY WOMAN. It was all in me.

I strategically placed my multi-colored throw pillows on that
white couch and then took a slew of pictures to post on my blog,
Instagram, and Pinterest, because if an awesome white couch
falls in the forest and no one is there to see it, does it really exist?

Then life happened. Perry came home from a long day of
landscaping work and innocently sat on the couch to try it out,
leaving behind a bottom imprint made of dust and grime. "OH
NO! THE COUCH!" I cried as I wiped my hand across the cush-
ion furiously, trying to erase the dirty mark. Perry glanced at
me with a look of pity as he remarked, "Well, this couch is going
to work out beautifully. Totally worth the money because who
needs a couch you can actually sit on? That's for regular people."

I realized I'd made a tactical wife error so I immediately
switched into a more laid-back mode. "Well, the beauty of this is
it's all slipcovered! It's a wash-and-wear couch! It doesn't matter
if it gets dirty because I'll just wash it with bleach and it will
be brand-new again! This is the best money we've ever spent!
I promise! It's all fine! Everything is fine!" A week later, I had
some girlfriends over for a wine night, and one of them acciden-
tally spilled almost an entire glass of Cabernet on the center
cushion. I played the role of gracious hostess as I explained, "It's
no big deal because BLEACH!"

The next morning, I stripped all the slipcovers off, washed
and bleached them for the first time, threw them in the dryer
and then began putting them all back on the cushions. That's
when I discovered all those white couch evangelists are either
gluttons for punishment or in much better physical shape than I
am because people have finished triathlons with less sweat and

exertion than it took me to get those slipcovers back on the cushions. There was profanity involved. I tore my clothes and covered myself in sackcloth and ashes when it was all over. What fresh hell hath Pinterest and my pride wrought?

I couldn't admit to Perry that I'd made a costly, tactical error. Even as he occasionally declared, "Babe, we aren't white couch people," I insisted we were. We are clean. We shower. And look how good that couch looks for all of thirty-eight seconds once every three months when I muster the inner fortitude to wash, dry, and repeat.

Then we brought home two new puppies, Piper and Mabel, who developed a penchant for flying through our back door and making a running leap onto the white couch, muddy paw prints be hanged. This was the final straw that proved to be the tipping point of my delicate grasp on sanity, which resulted in a tearful confession to Perry: "I can't do this. I cannot live like this. BABE, we ARE NOT WHITE COUCH PEOPLE! ERRBODY BE SO TIRED OF THIS WHITE COUCH!"

He hugged me, and I'm sure there were all manner of "I told you so" comments raging inside his head, but he is a smart man and just said, "Why don't we look into getting a new couch?" And with that, I ordered a new brown leather couch so fast it would make your head spin. Brown. I wanted all brown. I am a brown-couch-that-can-be-wiped-clean-with-some-leather-cleaner kind of person. It's not nearly as Pinterest-worthy but it helped me quit walking around like a woman in need of a lot of medication, although I continued to be a little disappointed that I wasn't up to the white couch challenge. Maybe those teachers were right after all, and I'm not living up to my potential.

But you know what I was doing with all my visions of what life should be, could be, and ought to be based on Pinterest and

bad movies from the '70s and '80s? You know what we all do when we sit around thinking about our Fantasy Someday?

We miss the holiness of this moment we're living right now.

There will never be another one like it. And even if that makes you think "THANK GOD, BECAUSE MY LIFE CURRENTLY STINKS," there are still lessons to be learned, character to be built, and stories that will be told about where you are right now. God takes all of it—the mundane and the ugly, the clean couch and the wine spills, the ordinary and the occasional extraordinary—and when we allow him to add his grace, his mercy, and his outrageous love, he adds a brushstroke there and some color here and so paints it all into one glorious work of art, one that only he can achieve through us where we are right in that moment—in our homes, in our neighborhoods, in our classrooms, in our communities and world. No one else can live our story. So maybe it's time to embrace all that is uniquely ours and realize that is exactly what makes it special.

Small Things

Things I Wish I'd Known in High School

You see us as you want to see us—in the simplest terms, in the most convenient definitions. But what we found out is that each one of us is a brain . . . and an athlete . . . and a basket case . . . a princess . . . and a criminal. Does that answer your question?

The Breakfast Club

A few years back, I received an email about plans for my twentieth high school reunion. My first thought was, bless their hearts, it hasn't been twenty years since we graduated from high school because that would mean we're old and all drive minivans and wear sensible loafers. Then I did the math and realized that yes, as a graduate of the class of 1989, it had been twenty years since I teased the crap out of my bangs in hopes that they would be higher than my mortarboard cap when I walked across the stage to receive my diploma and hugged all my classmates while a cassette tape of Whitney Houston belted out "One Moment in Time" over a mediocre sound system.

Then I looked in the mirror and found two new gray hairs.

And then I cried.

One of the things the reunion planners asked was that we send in any old pictures we had from our high school days. As I looked through my high school photo album full of memories, I reflected on all the things I'd learned over the last twenty years. Deep life lessons. The wisdom that only comes with age and the realization that Guess overalls can't bring lasting happiness, even though they were totally awesome when I wore them with my Esprit booties.

Here are twenty other lessons I've learned over the last two decades.

1. Tweezers are your friend. For heaven's sake, if your eyebrows cover half your eyelids and often impede your vision, don't be afraid to get rid of a few of them.
2. It may seem cool to get a car with only two seats, but it will prove to be impractical even though it has a sweet Alpine stereo system with a radio that requires you to turn the knob to change stations.
3. Nautical-themed attire is best reserved for toddlers and sailors.

4. Four perms a year is four perms too many.

5. Later in life you may experience some guilt related to your direct role in destroying the ozone layer due to excessive use of Rave aerosol hairspray.

6. Tucking your jeans into your socks just makes you look like an ice cream cone. An ice cream cone with a big, crispy perm on top.

7. Blue mascara. No.

8. Lying out in the sun using only the SPF contained in baby oil is a bad idea. (Why did it never occur to me that I was literally frying myself?)

9. It's possible to wear too much Lauren by Ralph Lauren perfume, especially if you carry it around in your purse to touch up your scent between classes.

10. Just because you can get shoes dyed to match your peach lamé prom dress doesn't mean you should. And really, peach lamé is a regretful choice.

11. Peplums don't work for everyone.

12. Same goes for shoulder pads.

13. Contrary to your belief, Erasure will not prove to be the best band ever. Ditto for Duran Duran and Whitesnake. However, Run DMC and The Beastie Boys totally stand the test of time.

14. While satisfying and delicious, a lunch comprised of Cool Ranch Doritos and Reese's Peanut Butter Cups probably isn't the best choice.

15. As it turns out, breaking up with a boyfriend doesn't mean it's the end of the world, although it does push the limits of how many times you can fast-forward a mix tape to Sinead O'Connor singing "Nothing Compares 2 U" or listen to the entire *Chicago 17* album.

16. There is such a thing as hair that's too big. A sure sign is when it extends past the perimeter of your graduation cap or requires you to use a whole bottle of Aussie Sprunch Spray and a set of fifty-two hot rollers to achieve the desired width-to-height ratio. Sometimes less is more.
17. Same goes for bows—on dresses and in your hair. Also, a puffed sleeve should be used in moderation.
18. The banana clip was an unfortunate hair accessory made more unfortunate by the fact that you owned one in every color.
19. You were never more right than when you informed your geometry teacher that geometry was a waste of time because you'd never use it in real life. EVER.
20. Twenty years go by in the blink of an eye, and while each one has its share of challenges, life just gets better.

Out of curiosity and interest in the male perspective, I asked Perry what he's learned since high school and he said, "You reap what you sow." I was thinking more along the lines of, does he regret having a mullet during his junior year of high school? So I guess the other life lesson is, it's a good idea to marry someone who tends to be a little more philosophical and introspective about life, although I think it's safe to say, in retrospect, the mullet was a bad call.

Forty Is Not the New Thirty

Life is amazing. And then it's awful. And then it's amazing again. And in between the amazing and the awful, it's ordinary and mundane and routine. Breathe in the amazing, hold on through the awful, and relax and exhale during the ordinary. That's just living, heartbreaking, soul-healing, amazing, awful, ordinary life. And it's breathtakingly beautiful.

L.R. Knost

or

It's hell to get old.

Emiel Marino, also known as my Pa-Pa

I just spent a few minutes reading an online article about twenty-five celebrities who haven't aged well. Of course, using the term "article" is a generous assessment of what was essentially a slideshow of photos that showed various celebrities as their youngest, best selves contrasted with a more recent photo taken when

they were most likely unaware of the camera's presence, weren't wearing a stitch of makeup, and had decided it was a good day to breathe through their mouths. But this is the kind of "article" that sucks me right in because I am all about some serious, hard-hitting journalism regarding plastic surgery gone wrong.

Make no mistake, we have become a people who believe in some cosmetic overhauls. Aging naturally is for suckers. I think I first realized it was an epidemic when I watched *Real Housewives of Orange County*. They all had to drink their cocktails through straws because not a one of them could trust that their lips had enough feeling left in them to support the whole notion of actually drinking from a glass. At first glance, I found myself thinking, "Well, that is a lovely forty-year-old woman without any wrinkles," but then realized it was actually a twenty-nine-year-old with Botox who just looked like a well-preserved older woman because her face didn't make expressions anymore, and between the bleached blonde hair and the enhancements, it's hard to tell a thirty-year-old from a sixty-year-old.

And I'm not even saying I'm against the Botox or the Restylane or whatever else is out there that serves as a proverbial fountain of youth. In fact, there have been times I've considered it myself. Like the time Caroline examined my forehead closely one morning and rubbed it with her little fingers before exclaiming, "Mom! I can see your brains on your forehead!" Really? Because I can see me dropping you off at a fire station to see if you can be adopted.

My bathroom cabinet is now full of products that all make varying promises to give me a youthful glow and reduce fine lines, deep lines, and hyperpigmentation. They guarantee that after four weeks, I will see a reduction in sagginess, wrinkles, and depression when I look in the mirror. They will lift, tuck,

refresh, and restore my face to some version of what it used to be. I have never used more products on my face than I do at this stage of life, and it all seems a little bit like trying to build a sand castle right where the tide is rushing in. You can pile and shovel and scoop on everything you want, but it's just a matter of time before nature wins out and that whole thing collapses.

Also, you don't even want to know the font size I'm typing this in just so I can read my words on the screen. The other night I had to use my new readers *and* the flashlight on my iPhone to see the words in the book I was reading, and all I could think about was how I used to make fun of my grandmother for asking waiters at restaurants if they could turn up the lights or bring over a flashlight so she could read the menu. Now I am that person.

People want to tell you that forty is the new thirty. You are young, you are vibrant, you are better than ever! And I do believe that might be true mentally, but I can assure you it doesn't apply to your physical state, particularly and maybe most assuredly to your metabolism. My face is decidedly not better than ever with the ramifications of my ill-spent youth in the sun dotted all over my complexion. And my ankles pop every morning when I hit the floor. I really can't even talk about my knees. They don't look or feel the way they did five years ago. I'd like to say I look in the mirror and see my grandmother's knees, but the truth is I think I see Snuffleupagus's knees. Except I shave mine.

Not to mention all the pressure to celebrate the big 4–0 milestone with a huge party. As soon as I turned thirty-nine, everyone began to ask what I was doing for my fortieth birthday. I didn't know. Maybe staying home in my pajamas and reading *People* magazine before I turn on Netflix and have two glasses of wine because it's my special day? Some of us introverted types

like to party like rock stars. Rock stars who don't actually party as much as just hole up in fancy hotel rooms and watch TV. Can't you just leave us alone and let us commemorate the day without any social pressure? We're happy with that. I promise. We really are. Because the mere thought of turning up at a surprise party for myself filled with all manner of my friends from different stages of life is enough to cause me to breathe into a paper bag. That's the kind of thing that needs some advance warning. I realize there are those who love nothing more than a huge celebration, and I dearly love some of those very people, and I'm happy to celebrate with them as long as *they* are the center of attention. I just don't know why there's all this pressure to celebrate the end of the thirties with a huge middle-age palooza when some of us are just lame enough to spend it reading a good book.

I recently spoke to a group of college students at Texas A&M University (my beloved alma mater). I always enjoy college-aged kids because they are what I like to call "amateur grown-ups". They have some responsibility in life; they have to get themselves to class and buy their own groceries and pay their bills, albeit for most of them it's with money their parents have put in their bank accounts. But then they have this whole other side of life where they can stay out until 2 a.m. on a Wednesday night and eat Taco Bell every day and go watch a baseball game with all their friends on a Tuesday afternoon. For me, college was one of the best times of my life. It's a good thing none of us know how great we really have it during those years or we would never graduate, and then who would pay for all the fun? Plus, who wants a bunch of forty-year-olds in their sorority?

I kept telling them all how cute they were, which is such an old-person thing to say. I was one step away from pinching their

cheeks when I said it. But I couldn't help it. They were so cute and so fun and so full of life.

The other speakers at the event were a Stage 4 colon cancer patient who finished the Ironman World Championship after being diagnosed and a man who owns a hugely successful public relations firm in Washington, D.C., and whose life changed dramatically after he almost drowned in the Persian Gulf.

And then there was me. One time I had to pay full price at Gap and my dry-cleaning wasn't ready when I went to pick it up. There was also that time I forgot to charge my Clarisonic skin brush and had to wash my face with my hands. We have all had our personal struggles. I think it was mainly my job to let the students know that you can score a thirteen on a college exam and it isn't the end of the world. Ask me how I know.

As I looked around that room and spoke to many of the students afterward, I just wanted to wrap them all in a big hug and tell them the next five to ten years might be a little rough, but they should hang in there. And wear sunscreen. The truth is, it can be easy to idealize what those years were like because there was much fun to be had, but I wouldn't go back to my twenties for anything unless you could send me back with the knowledge I have now. Kind of like Michael J. Fox in *Back to the Future* but without the puffy vest. Or maybe with the puffy vest, because I do enjoy a vest on occasion.

For most of us, the twenties are all about figuring out what life is about separate from our parents. What kind of career do we want? Where do we want to live? Who do we want to marry? Sure, we have great skin and toned legs, but we're too filled with angst to enjoy it most of the time because we're learning that adulting can be serious business with good and bad consequences.

By the time most of us deal with the decisions of our twenties, they are over.

The thirties for me were all about settling into married life, becoming a mother, learning how to get the smell of a rotten sippy cup filled with old milk out of my car, and trading in corporate life to be a homeroom mom. They were about finding my way and getting used to being called "ma'am" and realizing it took more than giving up chocolate ice cream for two days to lose five pounds.

Those were the years that sometimes seemed endless, with a toddler who wouldn't nap, finances that always seemed to be an issue, and marital struggles that became more real as the shiny newness of our wedding rings faded and we had to figure out bigger things than what we were going to have for dinner that night.

And now here I am, smack-dab in my mid-forties. I vividly remember thinking people in their forties were old and probably spent a lot of time watching episodes of *Murder, She Wrote* after eating dinner at Golden Corral. I thought a lot about turning forty before I got here, and then an older friend of mine encouraged me that the forties are a kind of crossing over for a woman, a new beginning of sorts. I totally get that now.

Just last week my friend Jen, who has Stage 4 breast cancer, celebrated her forty-fourth birthday, and it was such a milestone because I'm not sure any of us knew she would get there. When you come face-to-face with mortality and how fleeting all of this really is, there is such an overwhelming sense of gratitude for every single moment, an appreciation for the gift of picking up your kids from car pool, having friends at work that you enjoy, sipping the perfect cup of coffee by the fire on a cold winter day.

By the time you're in your forties, you have experienced a lot of the best and worst life will throw your way, and that takes the sting out of having a few more "laugh lines" and knees that sometimes choose to do their own thing when you get out of bed in the morning.

So far, my forties are about helping Caroline through her pre-teen and teenage years, following where God leads, buying a lot of wrinkle cream with Retinol, taking multiple vitamin supplements in an attempt to hold back the hands of time, making sure I exercise on occasion so I can still move in ten years, and just generally being so much more comfortable in my own skin. I don't worry as much about what people think, or who they want me to be, or what everyone else is doing. There's an ease to life as I sit back and go, "Okay, so this is what I've got to work with." I've figured out how to make peace with what isn't optimal and embrace the parts that make me so grateful.

I read a quote by Max Lucado a while back that says, "The difference between mercy and grace? Mercy gave the prodigal son a second chance. Grace gave him a feast." I feel like when I turned twenty, and later thirty, I'd accepted God's mercy and was so thankful that he'd saved me from myself and a steady stream of bad decisions. But it was in the next decade, my forties, when God showed me what grace really looks like. Because when I look at life, even with all the ups and downs and good and bad and things that haven't turned out the way I wanted, I realize he has blessed me with so much more than I could have imagined. My friends, my family, Perry, and my baby girl. He has given me a feast. So maybe these next decades are about the feast.

Best of all, it's the kind you can enjoy in spite of a declining metabolism.

8

Bangs, Bangs, You're Dead

A woman who cuts her hair is about to change her life.

Coco Chanel

Several years ago, I had "the talk" with Caroline. I wasn't really ready for it, but she asked, and I have always done my best to answer her questions honestly and sincerely. And by "the talk," I'm assuming you realize I mean she asked me if I thought she should get bangs.

As a mother, you're never really prepared for these moments.

It was right before the end of the school year, and I explained to her that summer is a bad time to get bangs because we're at the pool almost every day, and also, we live in Texas. No one lives in Texas because they believe the hot and humid summers are great for their hairstyling regimen. We endure the summers because of the Mexican food. The end. I told her that even Kate Middleton regretted cutting bangs, and she has hair that was clearly handwoven by fairies.

Yet Caroline was skeptical about my reasoning and seemed

more than a little unsympathetic to my own horror stories of bangs gone wrong, so I did what a good mother who values her sanity should do and took matters into my own hands by texting my hairdresser the morning of Caroline's appointment to beg her to talk Caroline out of bangs.

We left the stylist later that day with what I felt was a compromise I could live with: long bangs that could be swept to the side and easily pinned back into a ponytail. Caroline complained about them all summer long. And you know what I complained about? My ears. Because they were so tired of listening to her complaining about what I'd begged her not to do. After all that drama and the whole growing-out process that followed, I naively assumed that the matter of bangs had been forever put to rest.

As with many things concerning parenting a pre-teen, I could not have been more wrong.

At the end of the summer, I scheduled a back-to-school haircut for Caroline. All the chlorine and a general lack of hairbrush use had left her hair with a look that most closely resembled a coiffure favored by yetis and reggae singers everywhere. As soon as I told her she had a hair appointment, she immediately launched into stating all the pros and cons of bangs but leaning heavily toward the pro side.

The way Caroline saw it, her previous side bangs really fulfilled no real bang function. They were merely a nuisance that added nothing to her overall look. I kind of wanted to tell her that it was largely due to any lack of styling technique or hairdryer use on her part, but decided against it. It was time to let her take ownership of her hair victories and/or mistakes. It's a rite of passage for all girls. And I say this as a woman who thought it was a good idea in ninth grade to have the right side

of my hair cut significantly shorter than the left side to create a swooping effect that found its way back to the permed hair at the back of my head. I have tasted the bitter fruit of hair regret, and it smells a lot like the aforementioned Aussie Sprunch Spray and Final Net. (I wish I could show you the photo documentation of that particular hairstyle captured forever in some fine Olan Mills portraiture. I'm just a girl with a popped collar and a sassy Esprit sweater lounging casually on an enormous wicker chair. As one does.)

As we walked into the beauty salon that day, Caroline was still going back and forth. She wanted my opinion because it always helps her to know what I think so she can ignore it or do the opposite, but I wasn't biting. I told her she would be beautiful no matter what she decided and that bangs can always grow out. There is no hair decision that can't eventually be undone with tears, patience, and hard work. Says the girl who once had a mullet.

She sat in the chair and informed our hair stylist that she wanted bangs. Real bangs. Straight-across bangs that fell across her forehead. Thirty minutes later that's exactly what she had. She spent the rest of the afternoon admiring those bangs, and I don't know that she's ever loved herself more.

Until the next morning when she realized, as most women have, that bangs require some effort. And so she undertook the time-honored ritual of women everywhere and began growing out her brand-new bangs that very day.

I bought her plenty of bobby pins and hair clips and taught her all the tricks for bang transition because I have been there myself countless times. There is a picture of me at about three years old, and I have long hair and the best bangs you've ever

seen. I blame this photo of myself and Reese Witherspoon circa 2010 for my eternal bang optimism. I repeatedly forget that I developed a cowlick at some point in my life that really rules out my ability to be my best bang self, yet this still didn't keep me from getting bangs cut the week before I married Perry. To this day he contends he hardly recognized the girl with bangs walking toward him down the aisle because I hadn't had bangs ever in our two years of dating. As much as I ended up regretting that decision, it hasn't kept me from repeating it countless times since then. I eventually made my beloved hairdresser vow that she would never cut my bangs again no matter how much I might plead, or how many pictures of Reese Witherspoon I show her, or whatever hormonal state I am currently in. As sad as I was for Duchess Kate when she had to awkwardly and publicly grow out the bangs she cut shortly after having Princess Charlotte, it validated the fact that truly, no woman is immune from an irrational hair moment where the bangs and grass appear to be greener on the other side. I'd like to think Kate was in the throes of postpartum hormones and grabbed a pair of scissors herself, thinking, "I'll just trim them a bit!" but even though *US Weekly* reminds us often that "Stars, They're Just Like Us!" I'm not sure it completely applies to royalty, who can probably just summon in the royal hairdresser to do as they say. "Give me bangs or off with your head!"

The bangs aren't my only beauty mistake. Years ago I decided to make a lifelong dream come true and purchase a laser hair removal package. I did some research in the form of asking Deidre, a former coworker, about the process. She is an authority on all beauty-type issues, and I knew she had laser hair removal done a few years prior. I called Deidre's laser girl (not

the technical term), purchased a hair removal package over the phone because it was ON SALE, and then scheduled the first of my five appointments, which is how many times it takes to completely shock all your hair follicles out of existence.

The day of my first session, I drove to the doctor's office full of excitement at all the possibilities of a life that doesn't require shaving my underarms. I was almost there when Deidre called to check on me. I asked her the question that, in my infinite foolishness, I had neglected to ask earlier: "Does it hurt?" She answered, "Not really. I mean you've had a baby, so you can handle it." Which is never exactly the point on the pain spectrum that I find preferable. I prefer to always be closer to the hangnail end of the spectrum because, yes, I have experienced childbirth, but please note that I only have one child. While it was an incredible experience, it's not one that I'm looking to repeat with any frequency. Plus, I was pretty sure the cost of laser hair removal didn't include an epidural or even a martini.

I went in and signed a stack of paperwork that basically said I could experience a myriad of unpleasant side effects, including the darkening and/or lightening of the skin on my upper lip, neither of which sounds optimal. The dermatologist came in for a consultation, looked at my lip, and stated the obvious "You have dark hair," and then pronounced me a fit candidate for the procedure. Then, Laser Girl walked in and I asked her if it was going to hurt. She nonchalantly replied, "Oh, yeah. It will hurt," and then repeated Deidre's comparison. "But you've had a baby."
Great.

I am an idiot who doesn't ask the right questions far enough in advance. Maybe while I was feeling so giddy about my 20 percent discount for scheduling all five sessions up front, I should

have asked about the pain. But oh no, it was much more impor-
tant that I was getting a good deal. Laser Girl applied some type
of gel to my lip and an ice pack and went to work. Ironically,
the laser was called the Cool Touch 1000, which is the biggest
oxymoron of all time. The Cool Touch 1000 burned like the
heat of 10,000 white hot suns surrounding a planet of volcanoes
filled with molten lava that has been set on fire. At one point,
Laser Girl stopped before moving on to my underarms, and I
asked her if someone had burned some popcorn in the office. She
replied, "Oh no, that burning smell is your skin and your hair."
Well, what a relief. It was just like childbirth but with the smell
of burning hair. All I really know about torture is what I learned
from *Alias*, but make no mistake about it, this laser hair removal
stuff ranks up there for sure. It would make Jack Bauer talk.
However, for the following few weeks, I marveled over the fact
that I didn't have to shave my underarms or wax my upper lip,
and I decided it was all worth it. Like childbirth, the end product
is so great that you forget what you endured to get to that point.
Unfortunately, unlike childbirth, I was supposed to go back for
four more sessions before the process was completely finished.

I decided to be proactive and ask if there was anything I
could use to numb the pain before my next session. The nurse
told me she could sell me a topical anesthetic that would numb
the areas where they would be using the laser. This sounded like
an optimal solution, so I slathered that anesthetic both under
my arms and on my upper lip. But something in my brain forgot
to remember that perhaps I shouldn't lick my lips while there
is a thick layer of anesthetic on them. And that's how the pain
relief cream did not do one thing to ease the torture under my
arms, but left my mouth and throat completely numb for the next

twelve hours. So you can jump to the safe conclusion that I still have to shave my underarms and wax my upper lip because I never dared to go back for the remaining three sessions, proving that, for me, pain trumps vanity and convenience.

And that's why I decided the best beauty solution is to just embrace the natural version of yourself.

I'm sorry. I can't even go down that trail like I'm serious. What I've actually concluded is that I prefer my beauty to not involve bangs or laser hair removal, both of which can leave scars, whether they be physical or emotional.

Here's what I do believe in: some good hair products.

Caroline's favorite lazy activity these days is to look around on Pinterest. I know this because many of our school mornings are now like an exam at a beauty school where she rushes into the kitchen three minutes before we need to walk out the door and asks, "Mom, can you do my hair in a messy triple Dutch braid like this one on Pinterest?" as she shows me a braid that would make Princess Elsa claw her eyes out in jealousy and never be able to let it go.

Right. Like if I had that kind of hair styling ability, I would be walking around with this bun on top of my head 99 percent of the time.

I have some hair skills. I can curl or straighten hair like it's my job. I can do a simple French braid. I can do a ponytail and even tease the crown to give it some body. But I am not a magician. I cannot turn fine hair that's been slept on wet and treated to absolutely zero products into a Dutch-braided masterpiece. Not even (insert famous Dutch person here) could do that.

I told Caroline exactly that one day after she asked me to do something "cool" with her hair. I explained it would be really

hard to do and she asked, "Why?" and I replied, "Because you have no product in your hair."

She looked right at me and implored, "WHY DOES IT ALWAYS COME BACK TO PRODUCT WITH YOU?"

To which I replied, "Because it always comes back to product."

And that in itself is a valuable lesson. Life always comes back to the right hair products. And not cutting your bangs on a whim.

And never getting laser hair removal.

Unless it includes an epidural.

So You Think You Can Parent

Finish each day and be done with it. You have done
what you could. Some blunders and absurdities crept
in; forget them as soon as you can. Tomorrow is a new
day; begin it well and serenely and with too high a spirit
to be encumbered with your old nonsense.

Ralph Waldo Emerson, *Inspiration and Wisdom
from the Pen of Ralph Waldo Emerson*

Let's be honest. Most of us have no clue what we're doing when
it comes to parenting our kids; otherwise, why would there
be so many articles on Facebook telling us all the ways we are
doing it wrong?

I was so much wiser about parenting before I actually had
a child, and now most days feel a little like, "Um, I think this is
right?" We want to be great at it and have all the right answers
and give our kids all the things they need to ensure they don't
end up living in a van down by the river, but we don't always
know what those things are, and—here's the tricky part—every

new stage requires a new set of skills. Just when you think you are really amazing because you taught a small human how to use the toilet, the game changes and the potty-training portion of parenting is just a distant memory with some lingering PTSD.

I currently find myself in the parenting stage of having an adolescent. Anyone else spend their own years as an adolescent reading James Dobson's book *Preparing for Adolescence* because your mom handed it to you and said it would help with any questions you had? I don't remember getting much out of it back then, but now I'm wondering if I should re-read it to help me navigate the world of social politics in junior high for the second time. As if it wasn't painful enough the first time, you have to do it again with a person you love even more than you love yourself. This can lead to fantasizing about yanking a thirteen-year-old girl by the ponytail and telling her to straighten up and act right.

Sometimes that girl is your own child.

Just a few nights ago, Caroline and I were sitting together on the couch when I saw a roach run across the living room floor. I immediately jumped up and began scrambling to kill it with my shoe. This is absolutely the grossest thing ever but far preferable to having a live roach in your house. So I dashed around the living room until I finally got it and then realized Caroline had never even looked up from her iPad.

I asked, "Did you not see me trying to kill that roach?" and she replied, "Oh, is that what you were doing? I just thought you were dancing around the living room acting weird." This basically sums up the daily humiliation of having a teenager. You lose all semblance of coolness and just become someone (in their minds) who's likely to decide to "dance around and act weird" in your living room at midnight.

As a parent, I have made mistakes and will continue to make mistakes. I've been too strict and I've been too lenient. I've yelled too much and I haven't yelled enough. I've second-guessed decisions Perry and I have made, and ultimately find myself on my knees asking God to cover the places where we are going to get it wrong. Parenting is like a pop quiz some days and— SURPRISE!—there's an essay portion at the end.

It's mentally exhausting to navigate all the emotions and the line between being sympathetic and telling them to buck up and quit feeling sorry for themselves. It's determining the line between appropriate amounts of social media and being a Quaker. Or is it the Amish? Who doesn't use computers? I can't remember because I used all my brain power today trying to explain to a thirteen-year-old why it's important to take Spanish as an elective as opposed to being an Office Aide.

For a long time, Caroline was the only kid on the planet who didn't have her own phone. (It's totally true. Just ask her.) EVERYONE had a phone except for her because we are actively looking for ways to ruin her life. We kept telling her she did have a phone; it's called a "home phone" that people can call and talk to her whenever they want. But apparently we've raised a generation of kids who don't get the concept of using a phone to actually talk on it. For them, a phone's primary purpose is to send seventy-four emojis in a row and maybe a selfie that looks like you have a rainbow coming out of your mouth. It's all super similar to how the Greatest Generation stormed the beaches of Normandy during World War II.

Anyway, I decided that since Caroline now had her own phone, we might as well use that power for good, so I installed an app called Locate 360. This app connects her phone to my

phone, and I can basically find her location at any given time. At this current phase, it's not all that necessary because either Perry or I drive her just about everywhere she goes, but my thought is that it's like putting a frog in boiling water. We'll condition her now so that, as she has more freedom, she'll be totally used to the fact that we can and will monitor her whereabouts.

You need to know that I was inordinately pleased with myself for installing this app and putting in various alerts to let me know when she arrives at school or when she leaves school or when she walks in our back door. Well, at least until I had a text exchange with her while she was at school that went like this:

Caroline: Mom, did you install something called Locate 360 on my phone?

Me: Yes, I did! Love you!

Caroline: Okay, because it alerted me to tell me you left the house and went to get a pedicure. I can totally stalk you during the day now!

So. Um. That's not really how it was supposed to go down. Mainly because it blows my whole elaborate scheme that I work really hard all day long while she's at school. Pop quiz FAIL for the day.

The thing is, I don't know that any other generation of parents has worried about their kids the way we do. I think it's partly because social media has made us so aware of every little thing that can go wrong. All it takes is a quick scan of your Facebook newsfeed to find a story about a kid who drowned hours after leaving the pool, or a teenager who was in a car wreck because he was texting and driving, or that we need to cherish every moment

with our kids and never tell them to hurry up, or that we can't make our kids the center of our universe because they will become narcissists who can't function in society. If we're not overwhelmed by all the things that can go wrong, we will be by all the ways we're falling short. All it takes is one quick look at Instagram to see all the moms who are doing it better. They do things like play board games and have hot chocolate bars waiting for their kids when they get home from school and pack healthy lunches in Bento boxes with sandwiches cut in the shape of R2-D2. Or maybe they just take pictures to make it look that way. We'll never know for sure. But the pressure to do it all perfectly is stifling, and honestly, I don't think it's doing us—or our kids—any favors. We can't prepare them for the real world if we're constantly protecting them from the real world. We can't teach them to be brave if all they see from us is that we are scared. They'll never learn that having sandwiches that look like Star Wars characters isn't really a thing if we keep carving those light sabers out of cauliflower.

The bottom line is, life is going to come with hard times, disappointments, challenges, and all those other things that we all know deep down are the very things that end up shaping our character.

A few months ago, a high school student in our community committed suicide after being continually bullied by a group of fellow students. From what I know, the majority of this took place over various social media channels, and I won't even pretend I know all the ways there are these days to harass someone online. I thought I was so tech savvy because I know kids create Finstagram accounts (that's a fake Instagram) and use Snapchat, but in the days that followed this tragedy, I read about so many other apps that make cyber-bullying easier than ever.

I watched our community grapple with what should have been done differently, what could have been done differently, and what we need to do to keep our kids from being bullied or being a bully. Spoiler alert: I don't know all the answers to these questions. In fact, at one of my speaking events last year, someone introduced me as "a comedian and a parenting expert," and I cringed because I'm not a comedian (as evidenced by the fact that no one has ever followed something I've said with a ba-da-bum on the drums) and I am certainly no parenting expert, seeing as how I'm only twelve-and-a-half years into this job.

But here are a few things I do know. I know the darkness wants to come for our kids. I know that evil is everywhere and looking for a chance to whisper to them that they are less than, that they're inadequate, that they'll never be enough, and that their lives don't matter. I know that bullying has gone on from the beginning of time and has never been easier now that we can hide behind a keyboard and show our rear ends without showing our faces. I know that many people are more fragile than they appear, and we need to treat our fellow human beings with kindness and respect even and perhaps especially when they are different from us and we don't agree with them. And I know our kids are looking to us to model appropriate behavior. They may not act like it or acknowledge it, but they know better than anyone if who we are in public is the same as who we are in private.

What if we teach our kids that their true identity and security is found in the fact that they "are God's handiwork, created in Christ Jesus to do good works, which God prepared in advance for [them] to do" (Ephesians 2:10)? Each of us is fearfully and wonderfully made, and God has put us in our families, schools, communities, and the world in this time and in this generation

for a very specific and unique reason. And instead of finding power or making ourselves feel better by making someone else feel small and insignificant, we will never feel more empowered or confident than when we run our own race to discover the purpose for which God created us.

What if we showed our kids what kindness and compassion look like? There is never any weakness in showing mercy and grace, because those characteristics are the very heartbeat of God. Let's live in a way that teaches our children the importance of loving our neighbors and that peers aren't our competition. When we begin to see our own value, we realize that no one else's successes or accomplishments diminish our own but rather we see that God has a unique path for each of us. Sometimes a closed door is the very thing that leads us to our calling. We can walk our road without worrying if someone else's road looks better. The comparison trap is an endless vortex of nothingness that serves only to make us feel insecure and discontented because we are measuring our insides against someone else's outside.

What if we instill in our kids the words of the apostle Paul to young Timothy, "For God has not given us a spirit of fear, but of power and of love and of a sound mind" (2 Timothy 1:7 NKJV)? God doesn't want us to live in fear. We can call on his power and love to stand up to the bullies in this world and, maybe even more importantly, to speak up for those who are too broken and have been hurt too badly to defend themselves. A famous quote by philosopher Edmund Burke says, "The only thing necessary for the triumph of evil is for good men to do nothing." Let's raise good men and women who aren't afraid to speak up or do something when they see wrong.

There is so much emphasis on paying attention to what our

kids see online, what apps they use on their phones, who they hang out with at school and in their free time—and all those things are important. I absolutely check Caroline's phone on a regular basis and will continue to as long as I'm paying for it. And I will flat out take it away from her if I ever see that she's not using it like a responsible member of society. Our mantra here is "Social media is a privilege, not a right," and I plan to say it over and over again, and any eye rolling will only make me say it more, maybe even have a T-shirt made and turn it into a quote with a flowery border that I post on Instagram.

But I think I'm realizing the most important thing to teach her is to be true to herself and who we are raising her to be— even when we're not looking, even when she's not at school, and even when no one will know what she did—because one of these days she'll be on her own and will need to decide these things for herself. In the meantime, we monitor, we discuss, and we discipline if something seems amiss.

The Bible says, "Point your kids in the right direction—when they're old they won't be lost" (Proverbs 22:6 MSG), which means it's our job to give them what is basically a road map for life. It takes work and perseverance and dedication to raise our kids. It takes sacrifice and commitment and dying to self as we spend eighteen short—let's be honest LIGHTNING FAST—years pouring into them and equipping them to be responsible, productive, kind, and ideally, employed adults. And make no mistake; our kids will model what they see much more than what we say.

The thought that keeps running through my mind and heart since that precious young man took his own life is that we are called to be the light of the world, a city on a hill. In the days when Jesus spoke those words, a city lit up on a hill would have

been a haven for weary travelers, a welcome sight and an indication that they were nearing a good meal and a warm bed to sustain them for the rest of their journey. I want our kids to be a city on a hill, a safe harbor for those who need refuge in the midst of life's storms. The only way I know to accomplish that is to allow the love of Christ to take hold of our hearts and the hearts of our children so that we can show each other how to find a way home when we are lost, to hold out hope when we see someone is hurting, and to celebrate how our differences enable each of us to shine our own unique ray of light in the midst of a dark night.

Small Things

Things I Wish I'd Known When I Became a Mom

And should she choose to be a Mother one day, be my eyes, Lord, that I may see her, lying on a blanket on the floor at 4:50 a.m., all-at-once exhausted, bored, and in love with the little creature whose poop is leaking up its back.

"My mother did this for me once," she will realize as she cleans feces off her baby's neck. "My mother did this for me." And the delayed gratitude will wash over her as it does each generation and she will make a Mental Note to call me. And she will forget. But I'll know, because I peeped it with Your God eyes.

Tina Fey, *Bossypants*

For about the first six weeks of Caroline's life, I was convinced that motherhood was all part of a vast conspiracy by women everywhere, who were already mothers, to make the rest of us as sleep deprived as they were. It wasn't that I didn't love her more than I ever knew I could love anything, but nothing prepares you for how hard it is and how ill-prepared you are for the following eighteen or so years that they'll live under your roof.

If I could go back in time, here are a few things I'd tell my new-mom self.

1. I know you're freaked out because the hospital just let you walk out of there with a baby and you're an idiot. But riding in the backseat to monitor every single movement she makes on the way home isn't really necessary.
2. Don't throw away that gigantic pacifier the hospital sent home with you, because it turns out that's the only one she'll like for the first six months of her life.
3. Breastfeeding is great when it works, but nobody is going to end up in long-term therapy just because they drank formula from a bottle.
4. At some point, you will be able to watch a movie that has more violence or tragedy than *Little Women* without feeling like you need to wrap your entire home in bubble wrap to protect you and your child from the cold, cruel world.
5. It's okay that all you accomplished today was brushing your teeth. Embrace the victory. In fact, celebrate it with a glass of wine or a pint of ice cream.
6. The stains newborn yellow poop leaves behind aren't ever going to come out, so go rock your baby and quit wasting your time attempting the impossible.

7. Kids all reach their milestones in their own time. Trying to force your two-week-old to hold a rattle isn't going to increase her chances of participating in the Olympics someday. Although it may increase the odds that she'll need therapy.

8. Toddlers can be the worst. Don't take it personally. It's them, not you.

9. Potty training is terrible for everyone. Don't listen to your friend who tells you her child couldn't wait to poop on the potty. She's a liar. Kids think their poop is part of their soul and hate to flush it away.

10. You will be so grateful you didn't listen to the woman who advised you to shave your child's head when she was a year old because it allegedly ensures she will have thick hair as she gets older.

11. Never underestimate the power of a well-timed bribe. It's okay because everyone does it. A bag of M&Ms can be a powerful tool if used wisely.

12. Someday, many years later, you will still, oddly enough, remember every word of the theme song to *Mickey Mouse Clubhouse* even though you wrote a check yesterday and started to write the year with 19 before you realized, *Oh, right, it's been a new century for almost two decades.*

13. On a similar note, you won't believe you devoted so much time to *The Wiggles*, particularly Captain Feathersword. I mean, what the heck?

14. It's okay to lock yourself in the bathroom for a few minutes. Sometimes even mommies need a time out.

15. There will come a day when you will not have to chase that chubby toddler around the pool while you're wearing a swimsuit. In fact, you'll be able to sit poolside and read a magazine while they swim.

16. But the truth is, you'll be a little sad that those days are gone, so try to enjoy them while they last. Even when you have to make the walk of shame with a child wearing a swim diaper that has gone awry due to an overflow of feces, thanks to the effects of your kid ingesting too much chlorine and flimsy elastic at the legs.

17. Don't kill yourself taking the kid to the zoo. Why does everyone assume kids want to see animals stand around in the hot sun all the time? I have a theory it's just propaganda developed by zoo investors.

18. Once school starts, your child will grow up like a freight train going down the tracks. It is wonderful and magical and heartbreaking and exhilarating and nerve-wracking and like one big punch in the gut all at the same time.

19. Volunteer in the classroom as much as you can during elementary school because they will want you to make yourself scarce in their school environment by junior high.

20. I know it doesn't feel like it when you're exhausted and drained and just had to chase a toddler through the grocery store, but it goes by in a blink. A BLINK. Try to enjoy it as much as you can, and drink a glass of wine on the days you just can't even.

10

Fish, Frogs, Crabs, and a Farm of Lies

We are never owning another fish.

Melanie Shankle

My mother-in-law stopped by the other day to bring Caroline a little Easter basket she'd put together for her. It was about three days before Easter, but this is the kind of woman my mother-in-law is. She invariably shows up—sometimes at least a week early—for any life occasion with a thoughtful gift that she no doubt purchased several months prior. She routinely gifts things that are monogrammed because she is a person who plans far enough in advance to actually have time to get things monogrammed without having to pay a $20 rush fee to get it finished in time. She also emails me no later than early September every year to see what Caroline might like for Christmas.

This is who I want to be.

In reality, I am a person who only remembers major holidays because everyone else in the world is celebrating them on the same day. And even with all the seasonal aisles at Target

screaming at me to be a better person, my daughter knows what it's like to trick-or-treat carrying a plastic grocery bag from HEB or to have a decorative basket I use around the house suddenly be confiscated by the Easter Bunny to fill with eggs and chocolate bunnies. I always vow to be better next time. Next year will be the year we make those hollow rolls I see on Pinterest so we can totally comprehend the resurrection of Christ using baked goods! This Christmas will be the time our Elf on the Shelf finally quits being a slacker and learns to zip line on dental floss with all the Barbie dolls and ride in a Jeep with G.I. Joe and take a bath in marshmallows!

As for birthdays, I need you to know that my inability to remember your birthday is no indication of my love for you. Facebook and iPhones have helped me immensely with this, yet I still manage to end up buying a gift or card on the day of the event. Or—let's be honest—the day after. To my shame and horror, I've managed to forget my mother-in-law's birthday two years in a row. Even worse, she couldn't be sweeter or more understanding about it. She even gives me an out by saying I'm an artist and it's just not the way my brain works. And she's right. I *am* an artist, provided your definition of an artist is some-one who sits around trying to type words on a computer while looking more like someone who is recovering from a prolonged illness, has no access to a hairbrush, and has been left with only a pair of cropped sweatpants and a T-shirt that reads "Aggie Baseball 1994." Because why update my T-shirt collection to the current century?

Anyway, back to my mother-in-law delivering the Easter basket, which was never even the real point of this story (I'm off in the weeds looking for a squirrel). She stayed to visit for a

while, and we sat out in the backyard while Caroline juggled her soccer ball before deciding to catch a lizard that was climbing up the side of our house. My mother-in-law told her to turn it over and stroke its belly, because apparently she is a woman of many talents and knows that lizards like that. I personally wouldn't know what lizards like because I believe they are just snakes with legs and avoid them at all costs, maybe while also screaming, "GET IT AWAY! GET IT AWAY!"

The stomach rubbing must have worked, because the lizard decided it liked Caroline and just stayed on her arm even after she let it go. This caused my mother-in-law to remember that when she was a girl, you used to be able to buy a lizard with a collar and a chain that you could attach to your shirt at the county fair. This is really more than I can process and brings up so, so many questions. Who catches the lizards? How do you get a collar on them? Where was PETA when this whole thing was going down? Even Caroline agreed, because she told Perry about it later at dinner that night and said, "That just kind of seems like animal cruelty." Which I felt was supremely ironic coming from someone who once took three weeks to notice her pet goldfish had died and been flushed away to the big aquarium in the sky. Or the sewer. Depending on your beliefs concerning the viability of a fish afterlife.

In fact, it was her particular lack of concern for fish life that led me to issue my ultimatum before each ensuing school carnival that Caroline was under no circumstances to play a game wherein a goldfish in a plastic bag was the prize. I don't know what genius originally decided that giving elementary-school-aged children a fish in a plastic baggie sealed with a rubber band was a good idea, but I now have my suspicions that they were a descendant

of whomever put those collars on lizards. In my experience, the goldfish prize is a losing proposition either way. You either end up with an overly tired and dramatic child mourning the loss of her beloved pet of one hour, an hour she spent jostling said pet in a hostile environment that included a round of musical chairs, a cakewalk, and a trip on a bounce castle. Or you have yourself a "free" pet goldfish who will require a bowl, a plastic treasure chest full of fake treasure, colored rocks, and fish flakes. Because make no mistake, pets that come into your home are going to be your responsibility no matter how many promises a child makes to the contrary. Children are filthy liars at worst and con artists at best.

My precious child outsmarted me, though, because the year after my no goldfish stance, she obeyed me and played a carnival game where she won a hermit crab. A hermit crab she christened Phillip. Which seemed like an incredibly regal name for something with antennae that eats freeze-dried shrimp.

Perry and I tried to make a temporary habitat for Phillip. Or as people in the crab business call it, a CRABITAT. He spent the night in one of my glass mixing bowls (which went in the trash immediately afterwards) with the lid of a spice jar as a water dish and only a layer of sand and the memories of his time at the pet shop with his old crab friends to keep him warm. We went to bed that night with the satisfaction that only comes with the knowledge you now own a hermit crab, and the next day we went to the pet store, where we spent forty American dollars gathering everything we needed to keep our FREE hermit crab in the style to which he apparently had grown accustomed.

Oh, and Caroline also talked me into buying a friend for Phillip. She named her Clementine. A month after that, we

decided the more the merrier in our little crabitat and added Big Daddy. Which means you can just call me sucker.

Six months later, I decided it was time to get rid of Caroline's hermit crabs and their accompanying crabitat. Normally, I might have felt guilty about this, but Phillip had died almost three months prior and it took her every bit of two and a half months to even notice. However, we were left with Big Daddy and Clementine, and I wasn't sure what you do with unwanted crabs (all of a sudden this sounds like an unfortunate late-night infomercial) and didn't feel like I could just throw them away. The truth is they were stinking up my house with all their freeze-dried shrimp food, and it was time to bid them adieu. So I did what I do in all complicated situations: I set the crabitat with the crabs outside on the back porch and told Perry to handle it.

For some reason, he decided to put Clementine and Big Daddy in the dog's water bucket to let them have one last swim or something. I don't know. Then his phone rang, and he forgot about them and left for his family's ranch. All I know is I looked outside hours later and noticed the dog was acting weird about drinking water. When I went to investigate, there were Big Daddy and Clementine swimming happily in the water dish. Heaven knows it's probably the only water they'd had in weeks, since Caroline had proven to be the crab-version of Dr. Kevorkian.

As I was removing the crabs from the dog's water dish, Caroline started to walk outside. I didn't want her to see the crabs and be reminded of their existence, so I hurriedly set them down behind it and went inside. When I finally remembered what I'd done hours later, I discovered they were nowhere to be found. They made a mass crab exodus. If you consider two crabs to constitute a mass exodus. I do, because in any economy, two

crabs are really two crabs too many to have roaming freely in your backyard. I like to think maybe they packed their teeny tiny crab bags and left our house for good; that they were like little crab Joads in search of a better life. Either that or they were eaten by the dog.

A few years later Caroline began junior high, and I breathed a sigh of relief that the fish-and-crab-winning days of elementary school were behind us forever. But I went out of town one weekend and something developed while I was away.

I knew Perry and Caroline had plans to go to the ranch after I left town, but nothing prepared me for what she told me when I called home to check on them late Saturday night. I asked, "Did you have a great day? How was the ranch?" and she excitedly replied, "Yes! We had a great time! Dad let me bring home five hundred tadpoles!"

Umm.

When did my husband decide to see how many tadpoles it takes before I check myself into a home?

The answer to that word problem is that five hundred tadpoles are significantly more than the number of tadpoles I am equipped to handle, which is zero. What little I understand about basic biology was enough for me to know our backyard was about to look like a plague from the days of Moses and Pharaoh. Which meant I'd have to move.

Caroline wanted to show me her new "pets" first thing when I got back home, and there they were swimming around in what used to be a container for food storage and therefore caused me to reject all plastic storage apparatuses for the rest of eternity. I put a picture of all the tadpoles swimming around a big piece of wood on Instagram later that day and someone commented

that they thought it was meat I had marinating for dinner, and that is why I am now a vegetarian.

(I'm not really a vegetarian. But I could be. Except for the hamburgers. And the chicken fried steak.)

I immediately noticed that some of the tadpoles, much like Bruce Jenner in 2015, had begun to transition into something else. I may even have seen what I believed to be tiny hopping motions, but I couldn't process that any further or FOR SALE SIGN IN MY FRONT YARD. Caroline explained she was hoping to sell some of them to her classmates in a business proposition I can only assume was making me extremely popular among my fellow mothers. But she didn't have many takers. I think she said about three people were interested. Which left us at about four hundred and ninety-seven tadpoles that were going to need to be relocated to a neighborhood that wasn't my backyard. So the rest of that week was spent monitoring the real, live biology lab happening on our back porch while attempting to convince Caroline that if you love something, you need to set it free. Sting told us that years ago, and he is rarely wrong. He also told us De Do Do Do, De Da Da Da, but that didn't really apply to the situation at hand, so I stuck with free, free, set them free. I just happened to know the perfect creek nearby, where we could show the tadpoles how much we loved them. They didn't come back, so clearly they weren't really ours to begin with.

You'd think that would be the definitive end of our taking in any pet that wasn't a dog, but you are giving me way too much credit. It continued at Christmas when Gulley and her boys, Will and Jackson, gave Caroline an ant farm. I agreed to this gift because it was one of those green gel ant farms that allegedly required nothing of you except being bored enough to watch

ants dig tunnels. I was also powerless to tell Gulley not to buy Caroline an ant farm since I'd recently helped Gulley's youngest son, Will, convince her to buy him a bearded dragon and had maybe even used the phrase, "It's the Golden Retriever of the lizard world!"

We went online a few days later to order our supply of ants because the alternative was to find our own out in the yard or something, and let me just say AS IF. The confirmation email let us know that our ants would arrive in approximately two to three weeks depending on the weather in our area, because it can't be too hot or too cold or the ants might die in transport. Apparently being in transit with the US Postal Service is harsher than living out in nature.

However, I found myself on the horns of a dilemma when the ants arrived because the package said the ants needed to be placed in their new home IMMEDIATELY and Caroline was at the ranch for the day with Perry. I knew they wouldn't be home until much later that night. So the sole burden of placing the ants fell squarely on my shoulders. I later learned I could have waited and IMMEDIATELY didn't so much mean IMMEDIATELY as it meant just sometime in the next twelve or so hours. But it's too late now. (Dear Ant Suppliers, please don't use the word IMMEDIATELY if you don't mean it. It's very alarming.)

I carefully read all the instructions to make sure I did every-thing the way it was supposed to be done to ensure our ants' safe arrival in their new home. The first step was to poke three holes in the gel farm, which I guess helps them get started in their new environment. The second step was to place the test tube full of ants into the refrigerator for fifteen minutes so they'd be lethargic when I dumped them in and thus not as likely to try to

escape from gel Alcatraz, so I finished folding some laundry and straightening up the house while the ants chilled in the fridge. I mean that literally. Although maybe they found the Pinot Grigio I keep on hand and chilled both literally and figuratively. I don't know an ant's life.

After fifteen or maybe thirty minutes (I lost track of time. Get off my back.), I opened the top of the ant farm and dumped all the ants into their new home with fear and trembling. And, well, the scene was exactly what you'd expect. Ants everywhere. Ants milling and crawling and trying desperately to find a way to escape their new gel-filled enclosure.

I spent the rest of the afternoon checking on the ants' progress, and I was afraid I'd basically killed a bunch of ants because they weren't doing much of anything. Maybe they were stunned. Or maybe it's because they'd been in the fridge longer than necessary. In all fairness, if someone put me in a tube, mailed me, stuck me in an igloo and then dumped me out on a beach somewhere, I'd be a little shell-shocked too. It might take me a day or two to find the will or courage to make a sand castle or to quit rocking back and forth in the fetal position.

But by the time Caroline got home later that night, the ants had begun to dig some tunnels. They'd piled their dead ant friends in a corner (They didn't all make it. Tragic, I know.) and were working furiously in some type of assembly line formation.

It was what I saw the next morning that stopped me in my tracks. It's about to get all *Charlotte's Web* up in here in case you're wondering when this whole drawn-out story about some ants is going to come together, and also when I might quote a DMX song. Because the ants had worked furiously to tunnel out a message in the green gel of the ant farm that clearly spelled out:

LIE

I know. What could it all mean? Did they think I was lying? Were *they* lying? Was their whole life a lie now that they'd been subjected to a life of hard labor on an ant farm? Did the people at Uncle Milton and the US Postal Service tell them they were going to a place with green pastures to roam around and cows to milk while wearing jaunty straw hats and perhaps tiny pairs of overalls?

Then, as if that wasn't enough, I settled in on the couch to go through my email and was immediately greeted by an email in my inbox that began "SALUTATIONS!"

Are you getting this? Do you see that the email said SALUTATIONS? That is exactly how Charlotte greeted Wilbur in *Charlotte's Web*. It was her fancy way of saying hello.

What were the odds that on the same morning the ants wrote LIE, I'd get an email sending "salutations"? And it wasn't a real email. It was a spam email from an unknown address. I can't say for sure, but I think the ants sent it. How else do you explain it?

All I knew was that if I woke up the next morning to find the word RADIANT spelled out in the ant farm, I was either throwing them away or taking them to the county fair.

While I was out running errands several days later, I received a distressing text from Perry. It read, "Caroline's ants are out. Just nuked half of them."

Well. That wasn't good.

I called him and asked, "What do you mean the ants are out? How did that happen? Did you squash them?" He replied, "I'm not sure how they got out, but it looks like the lid wasn't on good and some of them escaped. I sprayed them with Windex."

The good news (if this can be considered good news) was

that only some of them escaped, and Perry and his Windex came to the rescue at just the right time. It was bound to happen. I mean they'd already let me know they felt they were living a lie.

Plus, I think they had changed "LIE" to "LIB" the night before, which I felt might be a political declaration, and if that was the case, then it was no wonder they felt the need to move on from our conservative household, especially considering they might be in need of Obamacare after the Windex incident.

Needless to say, we didn't mention the ant mutiny to Caroline when she got home from school. I wasn't too worried that she'd notice half her ants were missing when you consider that her hermit crabs escaped in our backyard and she never even realized they were gone.

The lesson here is that it's better to stick with dogs if you want pets.

Or maybe even a lizard on a chain.

Also, we should all be more like my mother-in-law and buy thoughtful, meaningful gifts and deliver them in a timely manner.

 Small Things

Things I Wish I'd Known Before Getting a Hermit Crab as a Pet

1. DON'T.

True Tales of Canine Delinquents

> Dogs are minor angels, and I don't mean that face-
> tiously. They love unconditionally, forgive immediately,
> are the truest of friends, willing to do anything that
> makes us happy . . . If we attributed some of those
> qualities to a person we would say they are special.
> If they had ALL of them, we would call them angelic.
>
> Jonathan Carroll from *Teaching the Dog to Read*

Several years ago, Caroline and I spent an afternoon watching the movie, *My Dog Skip*. Have you ever seen this movie? It's like the kid version of *Marley & Me* and guaranteed to put you straight in the bed with a full-on ugly cry, particularly if you watch it during a bout of PMS. Ask me how I know.

As we watched it, my mind became overwhelmed with several thoughts. First, I felt that we needed to get Caroline her own puppy immediately. Then I became worried about how sad that hypothetical puppy would be someday when she left for college, and that led me down a road of wondering how I'm going to

survive when she leaves for college, because apparently I like to worry about things a decade in advance. But most of all, it made me remember how much I always wanted a dog when I was a kid.

I never had a dog growing up. My mom let us have cats, but a dog was never on the table. While cats have their own charm, kind of like a cross between a cactus and a Care Bear, provided you don't mind being completely ignored by an animal that would rather lick its own rear end repeatedly than pay attention to you, they never fulfilled my dream of having a puppy.

When Perry and I were newlyweds, we decided we were ready to take the next step in our lives as real adults and get a dog. Perry really wanted a Blue Heeler (also known as an Australian Cattle Dog) and I just wanted a puppy! Any puppy! All the puppies are so cute! And so we began to look at litters of puppies. Our search was over as soon as we saw our Scout.

He didn't look like a typical Heeler. His face was much darker, and whereas most Heelers are high-energy and protective, Scout preferred a lap and welcomed everyone into our backyard with a wagging tail. He never acted like a dog. In fact, Perry remarked after a few days of owning him that he'd never had a dog that acted less like a dog than Scout. Of course, it probably didn't help that we bought him from a woman who lived in a trailer home in Hondo, Texas, and she informed us as we were walking out the door with him that he really enjoyed sleeping on her couch and watching "the color TV."

Scout was my first dog, my first experience with something that loved me totally and completely and greeted me with unmatched enthusiasm even if I'd only been gone five minutes. I was crazy about him in that way you are before you have kids, when your dog is your baby. I hated to leave him when I had to go

to work in the morning. I rushed home at lunch to see him. I took him to Sonic to get ice cream. Let's put it this way: I SANG HIM LULLABIES while rocking him on my lap. I was besotted.

When he was about three months old, our vet discovered he had a hole in his heart that needed to be closed up or he wouldn't live more than a year. At the time, it was a surgery that could only be done at Texas A&M and wasn't inexpensive, but he was my baby so Perry and I drove him to College Station to have heart surgery that would save his life.

Boy, did we get our money's worth. Scout turned out to be an adrenaline junkie who never stopped. We had to build a higher fence in our backyard because he would get so excited he'd just jump over it. Perry and I would stand at either end of the backyard and take turns calling him. He'd come barreling at us as fast as he could and leap into our arms. Heaven help the raccoons he managed to chase down at the ranch, because they weren't long for this world.

Scout never met a stranger, and we always said he'd totally sell us out for a hamburger. Turns out, at night he really did like to watch "the color TV." He'd growl at the deer on Perry's hunting shows and then fall asleep while he dreamed of chasing them down, evidenced by the way his paws moved constantly as he slept.

During those first few years, Scout was my original road trip partner. Gulley lived in Austin at the time, and I'd go visit her on weekends when Perry was hunting. I always brought Scout with me. He loved being at Gulley's because he loved her dog, Annie. Plus, we fed him some expensive, healthy food, and Gulley fed Annie something called Dinnertime from HEB. Scout would scarf that food down like a kid at McDonald's and have the worst

gas all the way back home to San Antonio. But he and Annie would play non-stop, and Gulley and I declared them to be best friends. They were our first generation of best friends.

A year after we got Scout, we brought home another Heeler we named Jem. Jem couldn't have been more different from Scout and preferred to spend his time outdoors, growling and barking at anyone who came within a twenty-foot radius of our backyard. But both dogs became my constant shadows when I was pregnant with Caroline. Jem even went so far to share my morning sickness (Who am I kidding? It was all-day sickness.) and would throw up any time I threw up. It was one of the hottest summers ever in San Antonio during the last months of my pregnancy, and the three of us would pile up on the couch in the air-conditioning and watch endless episodes of *Alias*. This was in the days before the DVR, so I'm talking about popping in VHS tape after VHS tape in the VCR just like I was a pioneer.

When we brought Caroline home from the hospital, we didn't have to worry about Scout or Jem because they immediately knew she was a part of our pack. They seemed to accept that they had moved down a rung in our family hierarchy but took it in stride. Sadly, Jem had an accident down at the ranch when Caroline was about five months old, and we had to put him to sleep. I can still remember dropping Caroline off at my mother-in-law's house so I could go be with Jem to say good-bye. Scout was the first dog I'd ever owned, but Jem was the first dog I ever lost, and the pain of losing him made me feel like I couldn't breathe. Losing a beloved dog and postpartum hormones are a dreadful cocktail.

About two weeks after that, we got another Heeler named Bruiser. I don't remember one thing about Bruiser's puppy days. I was still in the fog of losing Jem and having a newborn, so

basically sheer survival mode. I can't even tell you why we thought it was a good idea to add a puppy to that mix, except that I decided Scout might be lonely without a buddy.

When Scout was a puppy, I came just shy of burping him after he ate and still credit him as being part of what gave me the courage to become a mom to an actual human. But poor Bruiser just had to make do. There were no lullabies. I never rocked him in my lap. I had a baby and spent Bruiser's puppyhood barely treading water. But he was a good dog, loyal to his marrow and always so gentle with Caroline, even as she unwittingly taunted him while she toddled around the backyard holding all manner of animal crackers loosely in her sticky toddler hands.

(I am giving you this illustrious history of "Dogs We Have Owned" because I feel you need to know our dog ownership background. You can reference this section in your two-star review of this book on Amazon and write, "I don't know why she thinks anyone cares about her dogs or wants to hear about them for an entire chapter.")

Anyway, by the time Caroline became old enough to enjoy having a dog and emotionally astute enough to sob her way through the ending of *My Dog Skip*, Scout and Bruiser were old dogs, so she began the time-honored tradition of begging us to buy her a puppy. But we figured it was only a matter of time before Scout or Bruiser passed away, and then we could think about a new puppy because you know how many dogs is too many dogs? More than two.

In fact, Scout had a health scare two years earlier, and the vet told us then that he only had about three to six months left at best. Let me know if that math doesn't add up for you either. Then Bruiser was diagnosed with a degenerative spine and could

barely get around anymore. In short, we were running a geriatric facility for dogs in our backyard. Apparently we were doing a heck of a job, because they continued to beat the odds.

So we became more serious about finding a puppy for Caroline, because at the rate Scout and Bruiser were continuing to defy all canine odds, she might be leaving for college before they actually left this world.

Perry found out about a litter of puppies that would be ready soon, but then there was some sort of miscommunication, and we found out they'd already committed all the puppies to other homes, which I just realized makes it sound like they ended up in some type of asylum situation. This was not the case. I'm sure they were loving homes full of Puppy Chow and plenty of stuffed toys to tear up like it's their job.

Anyway, the guy with the first litter put us in touch with a friend of his who also had puppies and GUESS WHAT? They were eight-and-a-half weeks old and ready to go to new homes immediately. We had less than twenty-four hours to get our house puppy-ready. As if that's a real thing. No house can truly be puppy-ready unless it's covered in floor-to-ceiling Teflon and has a closet full of sedatives.

I picked up Caroline from school, we drove to the pet supply store to pick up all the various accouterments a puppy requires, and then we met Perry to go get our puppy. But something unexpected happened when we went to get our girl. She had a sister. Dang those puppy eyes and that puppy breath. It turns even the hardest hearted into someone who baby talks. One minute we were picking up a single puppy, and then we were saying, "So do you want to come up with us, too? Do you want to come live with your sister, precious punkin baby girl? Are you the sweetest

girl ever who needs a home?" And that's how we ended up with two Blue Lacys named Piper and Mabel. Little-known fact about Blue Lacys: they are the official state dog of Texas and are often mistaken for small Weimaraners with their blue-gray coat and light eyes. In other words, they were irresistible to me.

Oh, sure. They looked innocent enough. That was part of their master plan. But the first night they were home, they shredded both the lining of my shower curtain and the sea grass rug in our living room. They were two little maniacs who trained us more than we trained them, as evidenced by the fact that we only lasted a week before they were no longer sleeping in their kennels but right next to us in the bedroom. Also, the lush, green grass in our backyard became a distant memory as they dug holes and chased each other all over the place.

But I loved them. I loved their puppy breath and Piper's pretty eyes and the way Mabel put her front paws in the water dish when she drank. I loved the way their ears constantly flopped backward like little superhero capes and how they ran across the yard to meet us at the gate when we pulled up in the driveway. They were precious. Those things are what helped me survive their puppy months and kept me from listing them for sale on Craigslist.

Because there were moments I thought we must have been out of our minds to bring home two creatures with an energy level resembling my KitchenAid mixer's highest setting—well, that is if my mixer also occasionally liked to pee on the rug and chew up flip-flops while racing at full speed around the kitchen.

Here we had finally reached the point where we had a child who could make her own sandwiches and appreciate the fine art of sleeping late, and then we added two poop machines who liked

to wake up barking at the crack of dawn. What were they barking at, you ask? Each other, Scout, Bruiser, a dog walking by, a leaf falling from a tree, an ant crawling on the sidewalk, the very air.

And so the daily routine that summer after we first brought home Piper and Mabel was this: I woke up to the dogs barking as soon as Perry leaves for work. They were barking because he had left; they were barking because it's morning; they were barking because they were alive. I'd lie in bed for a few minutes to see if the barking would stop. When it inevitably didn't, I stumbled outside and greeted the puppies, who were jumping up and down like they were on bungee cords hovering over a canyon, with a warm, loving question along the lines of "Why are y'all so dumb?" which was my way of saying, "I love you so much but you are driving me to a point that is a hair shy of a mental institution."

But they had me where they wanted me, which meant I was helpless to resist their little puppy charms and let them in to sit with me while I drank my coffee at a much earlier hour than I really prefer in the summertime. Or ever. They'd curl up near me and take a little morning nap while I did my Bible study and checked Twitter or whatever, and I'd get lulled into thinking they're precious. It reminded me of that episode of *Friends* where Phoebe's brother looks at his sleeping triplets and says, "I really treasure these moments. Because pretty soon they're going to wake up again."

It was usually around that time that one of them would jump down and attack the fireplace tools because the fireplace tools exist and are very menacing sitting there lifelessly on the hearth. Then they'd begin to race around the house, sliding and skidding on the wood floors like kids at a roller rink for the first time,

until I opened the back door and called their names, which is when they would go flying outside to annoy Scout and Bruiser. It made me feel like we might as well have brought home two Tasmanian devils.

One of Piper and Mabel's favorite activities is what I like to call "Your Bone Looks Better than Mine." They each have their own bone. They are exactly the same. And they are happy with their respective bones for 1.3 seconds before each feels her bone must be inadequate compared to her sister's bone. If you ever doubt that all living creatures have something innate that makes them feel like someone else might have something better, the puppies were living proof it's true. They'd growl and chase to get each other's bones and then were completely dissatisfied and wanted their original bones back two seconds later.

It was as fun for me as you're imagining. I'd hear myself saying things like "Don't be mean to your sister!" and "Why would you do that to your sister?" and "Sisters don't fight! Sisters love!"

What I'm saying is, I didn't even know who I was anymore.

Then, to add insult to injury, Scout peed on the rug. Scout. Our sixteen-year-old dog who has been house-trained for fifteen-and-a-half years. He just stood there and let it go. Just like Elsa in *Frozen* except he didn't freeze anything; he just urinated. On my antique rug.

So I used my dog psychology skills and asked him, "WHY DID YOU DO THAT? WHY? WHAT IS HAPPENING?" as I escorted him out of the house. Because it's one thing when a baby pees on your rug, but it's an entirely different kettle of fish when Grandpa does it. We can just start with sheer volume and go on from there.

Truth be told, I'd been telling Perry for months that I thought

Scout had dementia, and I felt this incident confirmed it. He was losing his mind.

Which, on the bright side, meant that I wasn't alone.

Several months later, we took Piper and Mabel to get spayed, and the vet called me to let me know they were non-compliant patients and I should probably come pick them up earlier than planned. I chalked up their nervousness to the fact that they'd each basically had a surprise hysterectomy, and wouldn't we all be a little out of sorts if someone surprised us that way? As it is, we have our whole lives to prepare for menopause, and a hysterectomy doesn't seem to make that process go any smoother from what I can gather.

Also, they had never been at the vet for an overnight stay other than that time Mabel decided to chase down a pack of wild javelinas, overestimating her size in an ill-advised pursuit.

It did begin to occur to me that we needed an option for boarding the sisters when we take vacations and such. So I spent a month or so doing some research to see what options might be available. Several people, including our vet, recommended a certain doggy day care/boarding facility, and I scheduled us for a trial visit.

We had an interview/orientation and I had HIGH hopes about how well the girls would act. A new dog park had opened in our neighborhood about two weeks prior, and I had been pleasantly surprised at how well they played and interacted with their fellow canines each time we visited, so I—FOOLISHLY—thought this would translate into their being awarded STAR CAMPER at the doggy camp.

Things went awry from the very beginning. Caroline and I had one heck of a time wrangling them out of the back of my

car and into camp. Piper somehow wrapped her leash around my legs, and I fell. On the concrete. Fell. As in I skinned my knees, my hand, and an elbow. It was at this point that I began praying the camp counselors couldn't see what was proving to be a very inauspicious beginning to Piper and Mabel's camp experience.

We eventually got the girls through the door and into the check-in area. They verified all our paperwork, asked a few questions about their behavior, which I answered very optimistically, and then told us the girls were welcome to stay all day. They would take it from there. "No news is good news!" chirped the camp counselor as I limped toward the exit, nursing both my skinned knee and my pride. "But we'll call if there are any problems!"

Caroline and I drove back home, I poured myself a cup of coffee, and not even ten minutes later my phone rang. It was the camp counselor. "Um. Mrs. Shankle, Piper and Mabel are not really responding well to the camp environment. They are very stressed out, and we haven't even been able to work with them to the point of introducing them to their fellow campers."

"So should I come get them?" I asked. "Do we give it more time? I'm happy to do what you think is best."

"I think it's best if you come get them now," she replied firmly.

So that's how my girls got expelled from camp.

I made the drive back to the camp to pick them up, and I swear Mabel was smiling at me as she trotted into the check-out area. Mabel and Piper 1, camp counselor 0.

They didn't appear to be traumatized at all, although when I got them back home, they did exhibit some signs of shame. Piper kept giving me the side eye, and Mabel curled up in her bed and wouldn't even look at me. Of course, later I discovered she'd been busy writing some haikus in her journal.

Camp could not be worse
I have no need to make friends
Didn't even get s'mores
Billed as summer fun
Lying liars telling lies
Pack my bags, I'm out

But in a sign that this camp experience brought out her creative side, Mabel also changed the lyrics to the classic "Hello Muddah, Hello Faddah" and composed her own version.

Hello muddah, hello faddah
Here I am at Camp Bow Wowdah
Camp is very, very draining
And I would rather be in my own backyard even
* if it's raining*
I went hiking with a terrier
Wished to bite him in the derriere
You remember I hate shepherds
There's one here that thinks he's faster than a
* spotted leopard*
All the counselors smell like biscuits
And the kitchen has no triscuits
And the head coach has a shih tzu
So he thinks we should all just do what he do
Take me home, oh muddah, faddah
Take me home I hate Bow Wowdah
Don't leave me here with just my sister
I even miss Scout and he's not my favorite mister
Take me home, I promise I will not make noise

Or mess the house with all my toys
Oh please you hold the power
And I managed to get kicked out within an hour

While I appreciated her ability to write some catchy lyrics, it still didn't solve the problem of where the sisters could stay while we were on vacation. As it happened, we ended up boarding them at the vet. It wasn't my first choice, but when you're a canine delinquent, you find your options are limited. They were kicked out of two more doggy day camps (presumably for trying to sneak in cigarettes and sharing them with the other dogs while wearing black leather jackets), and then we briefly visited a fourth option, but I left before even attempting to board them there because the whole place felt too much like a maximum security prison. Ironically, that probably would have been the place that actually worked.

The good news is, we knew they were safe at the vet, and it was familiar to them. We thought about having someone stay at our house, but it takes the girls a long time to warm up to people they don't know, and they can be so wild that it's not a task for the weak. So basically, we need to make a strong, new friend who can come to our house on a regular basis and feed Piper and Mabel loads of treats. Or maybe just invest in a case of doggy Valium.

While we were at the beach, our sweet Scout passed away. Bruiser had died about a year earlier, but Scout was still hanging on, although he spent most of his time sleeping and passing what can only be described as the most horrendous gas known to man. And dog. He outlived two of his doggy companions, Jem and Bruiser, and he was a good grandpa to Piper and Mabel

when they came along. He took them in stride and never minded that they jumped all over him and were constantly in his space. He was such a sweet boy, and I can cry now just thinking about him. He was my first baby. He loved us unconditionally in that way dogs do and never wanted anything in return other than the occasional belly rub. He was a good boy, and if it's true that all dogs go to heaven, then Scout will be one of the first in line.

I'd like to tell you Piper and Mabel came home from the vet after our beach trip and noticed Scout was no longer with us. A story about how they cried actual doggy tears and moped around for days. But that would be a lie. If they noticed he was gone, they showed no signs of grief. I knew Mabel wouldn't, but Piper seemed to enjoy having Grandpa around on the rare occasion when he wasn't sleeping, so I was surprised she never looked for him at all.

Mabel did write several haikus after our vacation and her stay at the vet:

All day in this place
they want me to be their friend
I bow to no one
Dogs on my last nerve
How long, O Lord, will I wait?
Need my house, my bed
Sister is so dumb
Making friends to get more treats
I will not be bribed

And I guess Piper got bored enough to write a poem of her own:

I like food. Food is good. Please give me more of that food.
Where is my food? Food, food, food. I'd like more food.

These days, I take them to the dog park every day, which has become my saving grace for getting rid of some of their energy. As soon as they hit the gate, they take off running as fast as they can. Eventually, Piper slows down and just mills around and smells things like a normal dog. But Mabel never stops. She runs at full speed, constantly looking for a new dog to chase.

In fact, I looked at her the other day after we'd been there for a while, and her face was kind of sunken in from all the exertion and her tongue was hanging way out, but she was still frantically scanning the park to see if she was missing anything fun. I thought to myself, she's like the super-hyper kid on the playground you think is fun at first, but then want to avoid because she looks more than a little nuts and is scaring all the other children. That's when it dawned on me. Mabel is like the kid in the *Saturday Night Live* skit where Mike Myers plays a hypo-hyper kid who actually pulls a jungle gym out of the ground and runs down the street dragging it behind him after eating a Snickers bar and drinking a Coke. On the upside, if my car ever stalls at the dog park, I can give Mabel a Snickers bar and a can of Coke and have faith that she can tow me home.

I can't even imagine why Mabel and Piper got expelled from a place where normal dogs go and manage to act like they're not insane, but it does explain why they curl up in a ball around seven every night and barely move for twelve hours.

No amount of *My Dog Skip* prepared me for life with Piper and Mabel. Although it did show me how a dog can split your heart wide open in ways you never imagined. How can you love

something so much when it simultaneously drives you crazy and prefers to eat your shoes instead of a fifty-dollar bag of gourmet dog food? How can you look at it one minute and wish it would quit barking and then the next minute rub its little head while using your schmoopiest Harlan Pepper voice to ask, "Who's the best dog ever?" and then answer for it, "I'm the best dog! I'm the best dog!"

It's one of life's great mysteries. And I wouldn't trade it for anything in the world. Not even a pair of flip-flops without teeth marks.

The Glamorous
Life of a Writer

Being a writer is 1 percent inspiration, 50 percent
perspiration, and 49 percent explaining you're not a
millionaire like J.K. Rowling.

Gabrielle Tozer

These days it seems like it's a rare weeknight when we all
sit down and eat dinner together as a family. Caroline
has soccer practice three nights a week because this is the new
American sports-obsessed way—apparently all of our children
are going to grow up to get athletic college scholarships and be
Olympic athletes. When you combine this with my schedule and
Perry's schedule, it all converges to create a lot of weeks where a
traditional family dinner is going to be the exception and not the
rule. On the upside, it has allowed me to drastically downscale
my dinner preparation game, and I basically end the week feeling
like Martha Stewart if I manage to cook just two meals, one of
which is always guaranteed to be tacos because Old El Paso just
makes it too easy with their Super Stuffer taco shells.

Anyway, it was during one of these family meals a few weeks ago that the conversation turned to famous people. Caroline told us that one of her friends at school discovered her family was distantly related to the Wright brothers. Or maybe it was Sir Isaac Newton. I can't remember that particular detail, and I'm not sure why my brain has decided it was either the Wright brothers or Isaac Newton. Maybe because one takes you up, and the other proves everything must come down. I'm probably not even right about either of those names and it's somebody like Amelia Earhart. I know there's some elaborate joke in here somewhere, but I'll spare us all by not trying to come up with it.

So Caroline was telling us about this friend being related to either the Wright brothers or Isaac Newton and finished it by saying, "I wish we were related to someone famous. Are we related to anyone famous?"

Perry pointed at me with his fork and said, "Mom." Caroline turned to me excitedly and asked, "Who are you related to that's famous?"

Here's the thing. I totally don't think I'm famous. At all. But I have written three books that all somehow ended up on *The New York Times* bestseller list, so some people might consider that an accomplishment. An accomplishment, by the way, that has clearly left my child less than impressed. In her mind, fame isn't something anyone has truly achieved until they're featured on Taylor Swift's Instagram with a #Squad.

I always tell people I never thought I'd actually get to write for a living, even though it was something I always loved to do. "Writer" just seemed like a fancy way of saying "I still live with my parents" or "I only wear sweatpants." (Based on how hard it has been for me to get a company to refinance our mortgage, this

is a widely held belief.) So I did all the things you're supposed to do to become a self-sustaining adult: graduated from high school, went to college, got my degree, and then found a job I didn't really love just so I could pay the bills. Or at least most of the bills. I have always had a weakness for shopping, so I think there were several times in my first years out of college when I still needed my dad to bail me out every now and then. I have no doubt he was thrilled about this. Let's just say I was doing my personal, somewhat adequate best to be a grown-up.

It wasn't until after marriage, a child, and ten years of working in pharmaceutical sales that I started a blog on a whim late one night in July 2006. It was like my Hail Mary pass in the hopes of finding a creative outlet because I felt like that part of myself was dying. I had no idea what God was going to do with it or if I'd even stick with it for longer than a month, but over ten years later, that Hail Mary pass has proven to be more than I ever could have imagined.

For me, the dream of being a writer was born sometime in elementary school. I had a love of books that makes the phrase "voracious reader" seem not quite accurate enough. My first loves were books by Beatrix Potter, then Laura Ingalls Wilder, Beverly Cleary, and Judy Blume. These women all wrote words that meant something to me, and I got lost in their stories time and time again. I remember reading Erma Bombeck's syndicated column in the newspaper each morning and checking the Sunday paper to see what books were on *The New York Times* bestseller list. Somewhere inside of me was a little voice telling me that I could write a book someday.

Here's the thing: God puts dreams, both big and small, in our hearts for a reason. And it's no coincidence that our dreams

most often line up with the gifts he has given us. Now, let me say that sometimes, as children, we can have other dreams that are just our imagination running wild, because I also had a dream of being Olivia Newton-John, but all those practice sessions of *Let's Get Physical* in the mirror while wearing a ballet leotard and leg warmers weren't ever going to make that dream a reality. And I'm eternally grateful for that.

What I'm talking about are those deep down, scared-to-even-voice-them-out-loud, heart-beating-out-of-your-chest dreams. The things that seem like they could be a reality if we can just get past our fear of failure and exposure and critics because all those elements are a real part of anything we are going to achieve in life.

J.K. Rowling was a single mom on welfare who dreamed that the name Harry Potter would one day be known by children everywhere yet had a manuscript rejected twelve times. Steven Spielberg was a kid with an idea about a large shark that terrorized a beach yet was turned down multiple times by the USC School of Cinematic Arts. Thomas Edison was told by teachers he was "too stupid to learn anything," and he invented the lightbulb, an invention with which you may be familiar. Walt Disney was fired for lacking imagination and informed that he had no good ideas. How stupid did that person feel later on, when a mouse in pants took over the world? The thing all of these one-time failures have in common is that none of them knew exactly how their leap of faith would turn out.

So many of us choose our path out of fear disguised as practicality: *I'll major in business; I'll get a sensible job; I'll keep dating this person because it's less risky than finding someone new.* I believe God wants us to walk out on the waters of our faith and calls us

to things that are greater and deeper than any of our fears. And when we realize that failure at some point in life is inevitable—whether we're doing what we want or not—we might as well take a stab at doing something we love. We might as well go with the dream.

It makes me think of one of my favorite passages in *The Lion, the Witch and the Wardrobe*, when Mr. Beaver tells the Pevensie children about Aslan.

Lucy asks, "Is he—quite safe? I shall feel rather nervous about meeting a lion."

Mr. Beaver replies, "Safe? . . . Who said anything about safe? 'Course he isn't safe. But he's good. He's the King, I tell you."

When we open ourselves up to the life God has for us, it probably isn't going to look like what we had planned, and it isn't always going to feel safe, but it will be infinitely better because it's a life filled with purpose. And isn't that what everyone is searching for? Significance? A reason why we're here?

I transitioned from writing a blog to writing books almost by accident. I began blogging in July 2006 and spent the next two years writing for nothing but zero dollars and my love of telling stories. I didn't even necessarily have a huge "platform," as the marketing folks call it, but this was back in ye olden days of 2008, and the Internet was a different thing at that time because there was no Twitter, no Instagram, and not even much Facebook. Just blogs. #YeOldenDays. We barely even had iPhones. Just phones that flipped open and required you to text by pressing a number until it coincided with the letter of the alphabet you needed. It was essentially an updated version of hieroglyphics, and it's a wonder more of us aren't suffering from carpal tunnel syndrome. It also explains why I never texted anyone with anything other

than a capital "A" which was my way of letting them know I'd received the text but wouldn't be responding to them with actual words or sentences unless I was on fire.

But it was in 2008 that I was asked to teach a workshop about blogging at the Proverbs 31 She Speaks Conference, even though all I could really add to the discussion is, "Hey, you can write things on the Internet, and people might read them." Lysa TerKeurst, the head of Proverbs 31, mentioned there would be agents and publishers there and encouraged me to put together a book proposal. So I went to Office Depot and bought a very professional plastic binder and then googled, "How Do You Write a Book Proposal?" It was all very sad.

While I was at the conference, I met with two publishers, both of whom told me no one would be interested in reading the memoir of a non-famous person. (I have refrained from sending them letters saying "I TOLD YOU SO!" because I am a bigger person than that. Well, not in my head but at least in actual actions.) But I did meet a great literary agent who saw potential in what I had put together, even though it more closely resembled a sixth grade book report than a book proposal, and called me six months later when I had given up all hope that I would actually ever write a book. The only problem was the publishing industry had kind of bottomed out with the rest of the economy, and no one was taking a chance on an unknown author at that time, so unless I changed my name to John Grisham or Danielle Steel, I essentially had no publishing options other than maybe going to Kinko's, paying them to print out what I had written, and putting it in one of their plastic binders. I also decided around that time that writing a book sounded really hard and wasn't something I wanted to do at all. Except for the little voice inside

telling me otherwise. But then three things happened over the next two years:

1. The publishing industry rebounded.
2. Ann Voskamp showed the publishing world that a blogger could sell a lot of books, like half a million and counting. (This is very rare. It's like a unicorn sighting in the literary world, but it happened.)
3. I kept waking up every morning in a panic that there was something I was forgetting to do, and I knew in my heart that it was God not allowing me to let go of writing a book. It sounded a lot like, "Write that stupid book," because apparently God and I have similar personalities in my mind.

Ultimately, I threw caution, along with my pride and fear, to the wind and emailed the literary agent I'd had a few conversations with a few years earlier, and asked if he remembered me. He did. And he spent the next few months helping me figure out how to put together a book proposal for what became my first book, *Sparkly Green Earrings*. We received offers from several publishers, and like the most overused phrase ever from *The Bachelor*, my journey began. So whenever someone emails me and asks, "How do you write a book?" my answer usually is something along the lines of "You just have to write. And cry a lot. And hate most of what you write before you ever come up with something you can actually tolerate. And then read things written by other people that are so brilliant you want to die and never type another sentence. Also, sweatpants help."

For several months before my third book came out, people

kept asking if I was excited. And I was. Let me say that before I say anything else. Writing books had been a dream that was so deep inside me for so long that I don't know if I can even articulate what it means for it to come true. I still look at those book covers with my name on them, and it all seems like I'm playing an elaborate game of pretend.

I think being on the verge of having your third book release must feel a little bit like having your third child. You're not as naive. You know all the work that goes into it and that you're going to have some sleepless nights worrying about things beyond your control. You're trying to navigate that line between hoping people will buy your book and not being an annoying self-promoter. You know now that people can be mean and leave reviews that will hurt, even though you try to pretend you're totally cool with the fact that they just called your baby an ugly troll. Or maybe they just said you're a bad writer. Whatever. Same difference.

Maybe that's why I felt so overwhelmed. There were a few days when I thought to myself, "Well, I have officially begun my descent into full-blown agoraphobia," because I didn't really want to leave my house and I certainly didn't want to think about speaking events I'd already committed to or whether or not I'd commit to more. Because here's my little secret: I still feel so inadequate. Off the top of my head, I can think of at least 4,052 people who are better than I am. And that's on a good day.

That's what kept running through my mind. *I can't do this. I can't balance my time between work and family. I have no wisdom to share. I'm not enough. I'm not good enough, I'm not smart enough and, doggone it, I don't even know if people like me.* Stuart Smalley was a dirty liar.

Then one day I was driving to meet some friends for lunch and secretly wishing I'd get the flu so I would have an excuse to continue to be a social recluse (I'm envisioning you second-guessing your assumptions that we'd be friends in real life because now you're overcome with the realization that I'm so weird and introverted. Nothing makes me happier than when plans get cancelled.) when the song "Oceans" came on.

> *Spirit lead me where my trust is without borders*
> *Let me walk upon the waters*
> *Wherever You would call me*

As I listened—really listened—I felt God say to me, "You feel like this is too much because you're trying to figure out how to do it in your own power, and none of this is about you." It took everything in me not to just pull the car over and cry, because that's exactly it. I try so hard to be graceful and compassionate and kind and wise and discerning and loving, but I'm putting myself in charge of the production of all those attributes. And then my selfishness and pride and insecurity all rise to the top instead, and I freak out because I know how lacking I am in basically every category, and then I just want to sit on my couch in my pajamas and watch old episodes of *Friday Night Lights* because it feels safe.

Here's the thing. It's easier to sit on your couch than to risk failing. It's easier to sit on your couch than to be out in the world where you're vulnerable and open to being hurt or disappointed. But you know what happens while you sit on your couch in your pajamas playing Candy Crush and watching Tami Taylor? Real pants with buttons and zippers. Also, *life*. Beautiful, gorgeous,

fragile, heartbreaking, mind-blowing life. God has a script written for each and every one of us, no matter who we are or what we've done or how ill-equipped for the adventure we feel.

We are all climbing our own versions of Mount Everest and have no idea if our oxygen will last or if an avalanche will come, but God does. We can never underestimate the grace and the strength he will give us for whatever he is calling us to do and whatever challenges we'll face. What he has planned for us is higher and deeper than anything we could ever hope to achieve on our own.

It's too much. It's too much for us to do in our own strength because we will mess it up, but he knows that and uses us anyway. It's never about creating or doing or being something that's perfect. It's not about having all the right answers. It's about being his. It's knowing that he who has called us is faithful.

I've always loved this verse: "He is before all things, and in him all things hold together" (Colossians 1:17). Notice how clear it is that we're *not* the ones who are supposed to hold everything together? God is holding it all. He is before it all. He uses the sinners and the weak and the ordinary things that this world views as broken and hopeless. But in him all those things come together and enable us to do things we never dreamed possible.

There was a time when I thought being a published writer would be a game-changer, that I would suddenly have an office that smelled of mahogany and own many leather-bound books. I will never forget the day my beloved editor texted me to let me know my book had made *The New York Times* bestseller list. I ran outside to tell Perry, and we hugged and I cried. We popped a bottle of champagne that night to celebrate. And you know what I did the next day? Scrubbed my own toilets and cleaned the tile

in the shower. I tried to tell Perry that maybe I didn't have to go to the grocery store anymore since I was a *New York Times* bestselling author and he replied, "Um, I think you better get your *New York Times* rear end to the grocery store, because we're out of milk." Except he didn't say rear end. I did get to have my first television appearance on a local morning show, and Caroline encouraged me as only a preteen can, with "Bye, Mom! Please try to not act weird!"

Perfect.

The truth is, we can spend our lives waiting for the big thing to happen, the dream to come true, the thing that will change everything. And then it happens and it's nice, but guess what? No matter where we go, there we are.

The world tells us that true success is a certain amount in your bank account, a certain number of cars in your driveway, maybe that all kinds of people know your name and you write a book that inspires an entire theme park and a line of collectible figurines. But true success and prosperity comes when you are right where God wants you to be, doing what he has called you to do.

Or eating dinner as a family while your kid reminds you that in no universe are you famous. #NotSquad

To Exercise or Not to Exercise? That's Not a Real Question.

My favorite exercise is a cross between a lunge and a crunch. I call it "lunch."

Author Unknown (but beloved and understood in the deepest part of my soul)

In what is a true slice of irony, I'm sitting down to write this chapter on the day of the Boston Marathon. A friend of mine from high school is actually running it and has been documenting her experience on Facebook. Yesterday was carb-loading day. I can totally get on board with that. Carb-loading day is what I like to call "Wednesday." The part of a marathon that truly troubles me is the running continuously for four hours part. Four hours. And that's considered a pretty decent finish time. There are some poor saps out there that will be running for closer to six hours, or if they're like me, two days later as they try to finish twenty-six miles.

The thing is, I absolutely believe in the importance of being physically fit. I've read all the magazine articles. I know it can lead to a longer life, better quality of life, and the ability to wear a swimsuit without wondering why a bunch of dumb-dumbs let swim bloomers quit being a thing back in the 1920s. But when it comes to exercise, I'm kind of like this guy, John, at church. Someone brought in a couple of dozen doughnuts and set them on the same table as the coffee urn to share with everyone, and John remarked to me later, "I went to go refill my coffee and accidentally ate two doughnuts before I remembered I'm supposed to be gluten-free." In that moment, I wanted to embrace him in a side-hug and whisper, "You, good sir, are my spirit animal." Because I would totally love to run a marathon someday and put one of those 26.2 bumper stickers on my car, except I keep forgetting that I don't like to run. Thus I don't ever want to run twenty-six miles at one time. Or over the course of two years.

Way back in 2008, two evil pandemics swept the country: the swine flu and Jillian Michaels' *30 Day Shred*. I don't know much about the swine flu, other than the fact that I believe pigs everywhere were being slandered for reasons that were beyond their control, and we are all going to turn into Howard Hughes if the media doesn't quit their fearmongering in an attempt to divert our attention from the real issues at hand, such as if there is really going to be a *Friday Night Lights* movie. I'm not talking about the one that already exists with Billy Bob Thornton. I'm talking about the one of my dreams starring Kyle Chandler and Connie Britton.

Here's a new topic for the media: Why won't Anthropologie send me even just one dish towel when I link to their site constantly? Is it some sort of fashionista prejudice because I am a

forty-something mom and not their desired demographic? I believe the answer is yes, and that, my friends, is fashion profiling.

Anyway, unlike the swine flu, I did fall victim to the *30 Day Shred.* I can't remember when I first heard someone mention it, but I remember thinking they were kind of overly dramatic about the whole thing. And if there is one thing I cannot tolerate, other than reruns of *Golden Girls* and water chestnuts, it's someone being too dramatic. It makes me WANT TO PULL OUT ALL MY HAIR AND SET IT ON FIRE.

In fact, I vaguely recall thinking that I had mastered my *Fat Burning Pilates* DVD and had even reached a point where I could easily keep up with smug girl in the green sports bra (as I so affectionately referred to her), so what could the *30 Day Shred* possibly have to offer me? What new challenge could the *Shred* throw my way that could top *Fat Burning Pilates?*

I vividly remember a friend telling me she was on day eleven of the *Shred* when her teenage son walked in and mentioned that she had developed real, live ab muscles. I was impressed by this, because you know what teenage boys usually notice about their moms? Absolutely nothing. I personally hadn't seen my ab muscles since the second month of my pregnancy with Caroline. I figured the *30 Day Shred* might actually be worth looking into.

But then I just felt too tired to order the DVD from Amazon. Not to mention all the effort it would take to actually open up all the cellophane packaging and place it in my DVD player, because remember this was 2008. DVD players were still a thing, along with predictive texting, gluten, and Tom Cruise and Katie Holmes, better known as TomKat.

However, Jillian and I had a date with destiny, because as I

innocently walked the aisles of Target one day, I happened upon the exercise equipment aisle, where I saw her staring me down, perhaps even daring me. I had no recourse but to buy the *30 Day Shred* and some lime green hand weights in the two-pound size because I am a risk-taker at heart.

I decided to wait until Monday to start my new workout regimen because I am a firm believer in procrastination, especially when it comes to anything regarding physical exertion. Why sweat today when you can sweat tomorrow? Also, it's always a good idea to plan to start something new on a Monday because even if the right Monday never actually comes along, you can keep believing that the following Monday holds the key to unlocking all your hidden potential.

But Monday came and I knew it was time to shred because I'd spent a whopping $15.99 on that DVD and couldn't let it go to waste. I believe I even told Gulley that I was starting it that morning as soon as we got off the phone and then laughed as I said, "It's ONLY TWENTY MINUTES! How hard can it be?"

I got off the phone and turned on the DVD. There was Jillian going on and on about how pain is fear leaving your body and blah, blah, blah, fast-forward to the real thing. She suggested that everyone start at Level 1. I decided I'd start at Level 1 to appease Jillian and her cut-off sweatpants, but figured I was really way past that since I'd been fairly consistent with my *Fat Burning Pilates* and elliptical workouts. And by fairly consistent, I mean I'd done them four or two times each.

Level 1 was an experiment in PURE HATE. I can't confirm this, but I am fairly certain it is something akin to what the CIA uses to get terrorists to talk. The static lunges with bicep curl combo was enough to get me to admit to anything I've ever done

wrong in my life, including the time I stole a Brach's peppermint candy when I was four years old.

To add insult to total muscular injury, Caroline stood by as my alleged cheerleader, although she was actually more like a heckler in the audience at a comedy club. Do you know what's more aggravating than some muscular girl from a TV show taunting you with the fact that a four-hundred-and-fifty-pound person can do more jumping jacks than you? A five-year-old girl you gave birth to asking, "DO YOU FEEL THE BURNING, MAMA?" over a hundred times in three seconds. When I finished, I collapsed in a big heap on the couch, and in the words of Fred Sanford yelled out, "I'm comin' Elizabeth. This is the big one."

But I survived and felt compelled to do Day 2. In fact, I was determined to complete all thirty days of the *Shred* even if it left me completely incapable of standing upright or reaching for a bag of Cheetos. However, around Day 15 I began to pray I'd get the swine flu so I wouldn't have to work out with Jillian anymore. I figured if anything was going to kill me, my money was on Jillian Michaels and not some lame pig virus.

So I fell off the exercise wagon for a while. Or six months. But then I decided to try out this new sprint interval workout I saw on Pinterest. Mainly because it was a diet/exercise plan that featured a picture of Carrie Underwood's legs. And I don't know if you've ever seen her legs, but I would be happy to have a tenth of that muscle tone.

Who am I kidding? I'd be happy with less than a tenth.

Okay. I'd be happy with muscle tone. Period.

Anyway, this whole article on fitness said the key was not just to jog but to shock your body with sprint intervals and a lot of lunges and squats and other things that will make you want to

cry. So I began a regimen of walking/jogging/sprinting through my neighborhood every morning, and when it was all said and done, I'm pretty sure my neighbors thought Phoebe Buffay had moved in. Because in my mind, I think I look as graceful as Beyoncé dancing when I run, but in reality it is much closer to a hippo stampede. And honestly, that's kind of an insult to hippos.

Apparently I'm not afraid of a little humiliation in the name of being physically fit, but you can imagine my disappointment when I looked in the mirror two days later and discovered my legs had yet to look like Carrie Underwood's, especially considering the last time I'd had that much of a cardio workout was running to get the dog off the carpet before he threw up. But I persevered and ate a small slice of ham for dinner with a side of steamed spinach. Then I texted Gulley and told her I felt like I was eating in prison, and that in no civilized setting is a hard-boiled egg considered an actual snack food. Not to mention that my body was going to need some time to adjust to all this fiber and protein and food people refer to as "fruits" and "vegetables."

That's all I'm going to say about that.

I also discovered that I think Greek yogurt is disgusting. The Greeks do many things well. Take, for example, the Olympics and the gyro, but yogurt is not one of them. I'm not sure all the reasons that it's supposed to be better for you than regular old Yoplait, but yuck. I bought a tub that was allegedly flavored like vanilla but tasted like thick cheese. While I like cheese in the form of chips and queso, I don't want anything vaguely cheese-flavored with that kind of density and texture mixed with berries and granola. I also don't want to eat like the cavemen ate because they would have totally eaten Hostess cupcakes if they'd had them, and last I checked, no one is pining for the days that you

ate a meal consisting of wooly mammoth and some foliage that didn't even have the benefit of lemon pepper seasoning. As for eating gluten-free? I'll take all of the gluten that the rest of the world has given up. I'd like to open a bakery and name it Glutes and have an ad slogan that declares "All Gluten, All the Time."

Still, I pinned all these healthy eating sites on Pinterest because I decided I needed to learn to make more things that didn't contain cream of mushroom soup and cheese and pasta. I found some decent offerings, but some of the recipes were things like Roasted Beet Soup with Garlic. Yes, that is a diet food because no one would actually eat that. You'd roast those beets, puree them, pour them in a bowl, and then throw the whole thing in the trash when you realized it tasted like feet. No calories.

I just felt as though maybe my body needed a few weeks of shock and awe to remind itself that Oreos aren't a side dish, and six cookies after each meal might be considered excessive. Then I would plan to reintroduce a few of my favorite food groups back into my diet slowly, like chips and queso and guacamole and Gummies Sours Life Savers. Meanwhile, I'd continue to tear through the neighborhood with my arms flailing wildly to burn it all off and to have legs that looked like Carrie Underwood's. Oh, and to keep my heart healthy.

Because that's important too.

Although I have yet to see anyone putting up pictures of Carrie Underwood's heart on Pinterest.

Eventually, my search for the perfect exercise routine led me to something called Smart Barre. There is some variation of this in just about any city in America at this point, and the studios have various names that employ the word "Barre," always with an "E" on the end lest you not realize how superior you are if you

do this variation of yoga/Pilates/ballet. A bunch of my friends had been raving about it, and there is nothing like peer pressure to make you try something new. This is how I discovered Bartles & Jaymes berry-flavored wine coolers in high school. But I'd also begun trying on sleeveless shirts in preparation for the upcoming summer months, and there is little that will serve to make you fully aware of your need for more exercise than carrying in a bunch of groceries and typing on the computer, which had essentially been my regimen for the last six months, than looking at your bare arms in the mirror. Be on the lookout for my new exercise video coming out soon entitled, *Here Are a Bunch of Groceries I Bought at HEB.*

Anyway, I wrongly assumed that since it was just a combination of ballet, yoga, and Pilates it certainly couldn't be that difficult. Isn't it just some stretching or something?

Yes. If they have stretching in hell.

I forgot that time I watched a documentary on PBS about ballerinas and the entire discussion of how much ballet requires of your body. You know how sometimes you work out, and you can feel your muscles start to shake in the middle of something? That was me. There was a point when I had to lift three-pound weights (I don't mean to brag about my impressive strength) until my triceps (I just googled "What are the muscles on the backs of your arms called?") were about to charley horse. I really thought I was about to shame my family name by dropping to my mat and writhing in pain and agony while singing out "Swing Low, Sweet Chariot."

If you've read anything I've written for, let's say, four or five minutes, you might know that I have a small tendency to exaggerate. But not this time. Even as I type this, the memory is

causing my triceps to try to cramp up, and I had no idea typing even required the use of triceps.

But it wasn't just my arms. We worked our glutes and our quads and our abs. I thought a lot of bad words in my head when I had to semi-recline on a rubber ball and work some muscle in my stomach that I had never even been acquainted with prior to that point. Before I left that day, I signed up for the whole month because I knew it would make me feel like I'd have to keep my commitment—and I knew that otherwise I would never walk through those doors again. Partly because I wasn't sure my legs would ever work properly again. I was certainly aware that my triceps weren't going to help me propel myself off the couch. I couldn't even go to the grocery store because how was I supposed to carry all those bags with the things formerly known as my arms? At least that's what I told Perry that night when I informed him we were picking up Mexican food for dinner. After all, I'd burned all those calories at Smart Barre.

A few weeks later, as I drove to my 9:45 a.m. class, I finally pinpointed my real issue with working out.

You have to keep doing it to get and maintain results.

You know who I blame for this?

Jane Fonda.

That's right.

Some people are still angry about her stance on the Vietnam War, but that happened before I was born. All I know is that until she donned those black leg warmers for her workout VHS tape and then filmed *On Golden Pond* looking all tanned and toned and doing a backflip off a diving board in cutoff shorts and a bikini top, exercise wasn't really a thing. I mean, sure, some people did it, but it wasn't so much an aerobic workout or

a social thing as much as it was maybe jogging around the block or standing on one of those jiggly machine things with a large band around you that was supposed to shake off your extra fat.

Now there's all this pressure to be "in shape" and "work on your cardio" and "quit eating ice cream for dinner." Pinterest is full of motivational quotes about working out like, "You don't get the bottom you want by sitting on it," and "Sore today, Strong tomorrow," and "Put Down the Doughnut, Loser." And then there's the whole CrossFit phenomenon in which people aren't content to just do their "Workout of the Day" or "WOD" as they call it, but also need to post videos of themselves doing it on Facebook. It's like Amway and Mary Kay had a love child who branched into the exercise business. You do you, CrossFit devotees, but with every video you post I'm only motivated to unfriend you instead of challenging myself to a series of workouts that seems likely to cause a serious knee injury.

All this pressure is why over the last several years, I've attempted everything from the *Couch to Almost, But Not Quite 5K* (that's my own personal version) to *Body by Bethenny*. There have even been a few days when I pulled out my Elle Macpherson workout video from college, although it's on VHS so it's safe that those days were circa 2002. I even went through a spell when I thought I could just work out at home and follow all the different workouts I pin on Pinterest. But then I discovered that pinning them doesn't count. You have to actually do them. Which is significantly harder to achieve.

All this to say that I'm really not sure why it just dawned on me, at forty-five years old, that exercise requires an actual lifestyle change, and sadly, is not like doing your income taxes, which only involves a few painful days and then it's all over for

another year. You have to keep doing it on a regular basis, and if you quit for even a week, then you have to motivate yourself to start again. And eat carrots and whatnot.

So in the midst of all this self-actualization, here's what I have admitted to myself: I am not going to work out twelve months a year and eat healthy every day. Judge me if you want, but I'm just being honest about myself and my limited capacity to achieve long-term goals. I hate to waste my exercise energy on months like January and February when we can wear big sweaters and puffy coats and layers upon layers of clothing, plus I'm not caving in to the concept of New Year's resolutions because they only serve to give me an actual benchmark of how long it took me to fail. I believe January and February are prime Netflix months, and that's why God made them so cold. Plus, it's not like all those episodes of *The Unbreakable Kimmy Schmidt* are going to watch themselves.

So I've recently adopted an exercise philosophy I like to call, "Oops, it's about to be hot, and I'll have to wear shorts" (trademark pending). The theory behind this is to wait until sometime around late March (this could even translate to mid-May for you northern girls) and then completely panic when the weekly forecast shows temps that will be in the mid-80s for the foreseeable future, and rush to sign up for the exercise class of your choosing.

As for my exercise of choice these days, I'm giving spin classes a whirl. Get it? Spin? A whirl?

This decision didn't so much come about as a result of my love for cycling so much as some friends of ours recently opened a new cycling place. My friend Debbi invited me to go with her for about two weeks until I finally ran out of excuses and went through the seven stages of summertime grief and said yes.

When I finally tried my first class, all I could think about was that old saying about how you never forget how to ride a bike. LIES. ALL LIES. Because even though it's a stationary bike, I felt a little bit like a cat who has accidentally found itself in a tap-dancing competition.

Debbi had promised me the whole thing was a no-pressure deal and I could ride at my own pace, but it turns out my own pace is "leisurely ride down the sidewalk," and we had an instructor who believed our pace should be "you are single-handedly responsible for pedaling hard enough to supply the entire city with electricity." At one point he walked to the back of the room where we were (Yes, I was in the back of the room. Hoping against hope to achieve invisibility.), and he got in our faces and yelled, "GO! GO! GO!" I'm not sure exactly what motivates me, but it is not that. Well, I take that back. It motivates me to kill someone with my bare hands but not to pedal a bike harder.

But I picked up speed and increased my resistance because I am just competitive enough to be a danger to myself, and long story short, I think I smelled popcorn burning before it was all over, which is one of the ten signs you're about to have a stroke. I read it on BuzzFeed.

However, when the class was over, I looked at my stats and realized I'd ridden almost fifteen miles and burned over five hundred calories. For those of you doing the wine math, that's two glasses. Not to mention I had tons of energy and felt super accomplished and basically had levels of excitement that most people reserve for accomplishments way more complicated than riding a stationary bike in an air-conditioned room while music plays and a disco ball lights everything up—you know, real accomplishments like running the Boston Marathon.

I'd like to believe that this time the exercise lifestyle will stick, and that I'm in it for the long haul. I'd like to say that exercise makes me feel levels of achievement I'll never feel after watching a Netflix marathon.

But I know none of that is true because history and Kimmy Schmidt have taught me otherwise.

Autocorrect Is the Devil

I know there's a proverb which that says "To err is human," but a human error is nothing to what a computer can do if it tries.

Agatha Christie, *Hallowe'en Party*

L isten. Once upon a time there was a thing known as a home telephone. It was a communication device people had in their homes, usually in the kitchen or another common area, and friends and acquaintances could call you and you would have conversations about boys or school or plans for the weekend. This usually led to stretching the coiled cord as far as it could possibly go in an attempt to reach your bedroom closet or the kitchen pantry in the hopes of having a semi-private conversation. Of course, this still didn't guarantee that another family member might not pick up the phone in another room causing you to have to sigh deeply and say, "I'M ON THE PHONE. HANG UP!" Because 1980s teenage struggles were real.

I spent a large portion of my high school years trying to convince my parents that I needed my own phone line. If only I had my own line and my own transparent neon phone, I could

be just like Mallory Keaton on *Family Ties*. My kingdom full of scrunchies, Benetton apparel, and Final Net for a neon phone and a personal number.

If only I knew then that one day I would live in a world where we all have our own personal phones with our own unique numbers. With no cords. That allow you to talk to anyone at any time. And type messages back and forth while simultaneously watching videos of a cat wearing a shark costume and riding on a Roomba. Who are we, the Jetsons?

But here's what our past selves couldn't have warned our future selves about. All this technology, as wonderful as it may be, also has a tendency to make you look like an idiot at best and completely callous at worst. As if I don't have enough ways to make myself look stupid and sometimes incompetent, now I have my phone to help me, because there is nothing like the humiliation that comes when you text a friend who is going through a hard time in an attempt to say, "I'm so sorry," and the phone decides of its own free will to change your heartfelt sentiment to "I'm so sporty."

Sure. Because what I really wanted my friend to know during her time of grief and sorrow is that I have a lot of Lululemon leggings in my closet, and I occasionally wear them to do physical activity because I'm so sporty.

(I actually tend to wear them to go to the grocery store much more often than I use them for their intended purpose because the truth is, I'm not that sporty even if my phone says otherwise.)

I can't even talk about the time my best friend, Gulley, attempted to write a Facebook post on Thanksgiving Day to convey that she had "many things to be thankful for" and autocorrect decided what she really meant to say was that she had "many thongs to be thankful for." Yes, on this day commemorating that

the Pilgrims and Indians shared food together in celebration of their new land, I want you all to know I am especially thankful for my skimpy underwear.

I remember when iPhones first introduced us to the concept of Siri. I couldn't wait to essentially have my very own personal assistant, so I drank the Apple Kool-Aid and immediately bought a new phone. As I was leaving the store, I asked Siri to text Perry on his cell to let him know I got my new phone. And she did it. I got a text from him a few minutes later that asked, "Is this you or Siri?" I told Siri to text "Siri." And she did it. Then he asked if the dishes in the dishwasher were clean or dirty and I told Siri to text that they were dirty. Except she texted "They're DARTY."

Oh, that Siri. Making fun of my accent and we've only known each other a few minutes. What a kidder! But that should've been my first clue.

When I picked Caroline up from school later that same day, she was thrilled to learn about Siri. I explained that you can ask Siri questions like "How is the weather?" and she'd answer. And so Caroline spent the next few hours SCREAMING things into my phone at poor Siri like "HOW DO MONKEYS WIPE THEIR BOTTOMS?" And Siri would say, "I don't understand."

Neither do I, Siri. Neither do I.

Siri did her best to answer Caroline. She'd pull up Google and search for "monkey's bottoms," but even Google has its limits. Then I read that Siri gets used to the sounds and intonations of her owner's voice over time and begins to understand requests better. And I lamented to Gulley that I was concerned Caroline had screwed up Siri forever with all that screaming and bizarre line of questioning because Siri and I seemed to have increasing difficulty communicating.

I'd ask questions that had been weighing on me such as, "Siri, why are the Kardashians famous?"

And she'd say, "I do not understand Kardashian."

"Me either, Siri. What's the deal?"

"I do not understand the deal."

Then came the day when I said, "Siri, call Gulley on her cell."

She responded, "I do not see a Deli in your listings."

"NO, SIRI. CALL GULLEY CELL."

"Okay. Calling P.F. Chang's."

What the heck, Siri? What kind of mind game are you playing? So this is how it's going to be.

P.F. Chang's isn't even a deli. And I wasn't even trying to call a deli. I don't even really like sandwiches.

Then one of my friends on Facebook posted a cute exchange she had with her Siri. She told Siri, "Thank you," and Siri said, "No problem, Mary. It's my pleasure." This caused me to develop a complex that maybe the problems between Siri and me were because I neglected to tell her thank you. Maybe other people's Siris liked them better than mine liked me. Maybe Siri thought I was rude and ungrateful. And because I am neurotic, I actually conveyed this concern to Gulley, who replied, "There are enough problems in the world without people worrying about telling their phone, 'Thank you.' That's what's wrong with the world. People are worried about making their phone feel appreciated."

Yes.

People like her best friend.

I tried to thank Siri the next time she texted something to Perry for me, and she responded with "I don't know THANK YOU." Really, she was lucky I thanked her in the first place because her spelling was atrocious and she only understood half

my words, and then I had to call Perry anyway to explain that we were having chili for dinner and not "jelly." I felt a little better when I read a story about someone who'd asked Siri to "Call me an ambulance," and she came back with, "From now on, I'll call you 'An Ambulance,' okay?"

Meanwhile, Gulley thought all of this was hilarious and loved to kid me about my concern that Caroline had been a bad influence on Siri and corrupted her from the very beginning, or that Siri's feelings were hurt because I didn't appreciate her. But that all changed on Christmas morning when Gulley opened up a brand new iPhone of her own. She set the whole thing up, synced all her information and then, eager to try out Siri for herself, said, "Siri, call my mom." Siri replied, "I don't know you and I don't know your mom."

Yes. Exactly my point.

Maybe she should have said, "Please."

A few weeks later, Gulley and I were at lunch with our friend, Donna. Her oldest daughter had just found out she'd gotten a really great summer internship. Donna laughed and told us that Avery had received a congratulatory text from Pop, her grandfather. But Pop sends all his text messages using Siri. So instead of sending his granddaughter a sweet, heartfelt message, Pop's text instead said something along the lines of "That's great about those mumbo jumbo hookers." Which isn't really a phrase you expect or want to hear from your grandfather.

Because Gulley and I have the sense of humor of two twelve-year-old boys, we decided it would be hilarious to just use Siri as our primary means of communication with each other over the next few days as an experiment in how wrong it could go.

I'll tell you what happened. Total and complete nonsense.

We sent each other things like, "I'm satisfied we can't go to lunch tomorrow at Alamo Café I was really happened we get data. I'll be satisfactory."

And, "You me and sister Garrett Allyn at half-right leaning Steve can't wait to talk to you."

For the record, I was not satisfied that we couldn't go to lunch at Alamo Café. I was sad. And I didn't really need any data. And hopefully it all worked out and I was satisfactory. I'm also sure that Sister Garret Allyn is a lovely person, and I can't wait to see her at half right-leaning Steve. Even though it's a shame Steve only leans half right. Was that a political statement by Siri? Who knows.

Finally, after several days of our fun at Siri's expense, we realized we needed to go back to normal texting. Mainly because we each had no idea what the other was trying to say. But Gulley texted me later and was concerned that one of her eyes was swollen and sent me a selfie so that I could see if she was imagining it.

(By the way, I'm absolutely sure this is exactly how Steve Jobs envisioned his technology being used. Well, this and being able to watch a hedgehog take a bath on your phone while you're in line at the grocery store. God rest his soul.)

So I looked at the picture and assured her the eye situation was her imagination. And then I decided to revert back to Siri, who took it upon herself to say, "You look beautiful. It's just that Bajando know how to capture Sarah Fossett."

I have always, ALWAYS, believed that Bajando know how to capture Sarah Fossett.

Now if I just knew exactly what that meant.

Other than the fact that Siri and I have a failure to communicate. And I don't think manners are really the problem.

The Leader of the Band

My life has been a poor attempt to imitate the man.
I'm just a living legacy to the leader of the band.

Dan Fogelberg

I just hung up the phone after a conversation with my dad. He called, as he usually does these days, to recap Caroline's soccer game the day before and to add his insights and thoughts about her performance. I always say his boundless excitement regarding Caroline's athletic ability is the reason God didn't give him an athletic child. His enthusiasm needed to be tempered with the love and adoration that grandparents produce in spades. It's as if that generational gap feeds the flames of what it truly means to love someone with your entire being and believe that they are capable of doing no wrong.

He likes to take credit for the fact that Caroline is so fast, saying it came from all those times he chased her around the yard as a toddler, causing her to squeal and laugh with pure joy. And the truth is, while I don't think it was necessarily the chasing that made her fast, her athletic skill does have a lot to do with the DNA she gets directly from him. She looked just like

him the day she was born, causing Perry to declare, "She looks EXACTLY like your dad!" And while I don't know that it's a compliment to say your precious baby girl looks like an older Italian man, I loved that she looked like him, and I will say that as the years have gone by, she has kept the features that are to her benefit and lost the ones that might make her look like she could be part of the Mafia. She has my dad's long legs, his quick smile, and olive skin that causes her to turn golden brown as soon as the sun hits her. She'd also tell you, in a phrase she coined when she was little, that she and her Bops, as she calls him, share "a family resemblance for violence" because they both have a tendency to get irritated by all manner of small annoyances. I always say they are the true definition of a mutual admiration society.

Caroline has played soccer since she was in first grade, but this past year was the first year she was old enough to try out for the school track team. My dad talked about it endlessly and couldn't wait to see her run. Then she ended up getting sick for several days and was unable to try out for the team. I picked her up from school that day and asked if she was disappointed that she wasn't going to be able to run track this year. She assured me she was fine with it and maybe even a little relieved because we weren't sure how it was going to fit into our already busy schedule, but then she ended by saying, "I'm just worried about how Bops is going to take the news. He was so excited to see me run track, and you know, I'm his whole heart and soul."

I wanted to die at the sweetness. Because she couldn't be more right. She is his whole heart and soul. She has been since the moment he first laid eyes on her. He and Mimi drove all night from Houston after finding out I was in labor while they were at a Patsy Cline musical, and I don't know that he's ever

loved anyone more. And what a gift to go through life with the certainty that you are someone's whole heart and soul. If she had been a boy, Perry and I would have named her Charles after him, but instead she turned out to be his beautiful little female mini-me, and I think he was more pleased about that than having a namesake.

The truth is, my dad has a way of making everyone around him feel like they're his heart and soul. He was the firstborn son of my grandparents, who were themselves the children of Italian immigrants. His family didn't have much, and he spent the first twelve years of his life living in what was essentially a one-room house. One of the stories he loves to tell about growing up was the time he was at his grandparent's house watching the chickens they let roam around the yard, when all of a sudden a huge rat came out of nowhere, grabbed one of those chickens, and dragged it down a hole in the yard. I realize this story doesn't mean his childhood was as rough as, say, growing up in a gang on the streets of Compton, but tell that to the chicken. What his family lacked in material possessions and chicken safety, though, they more than made up for in love. You have never met a group of people who would be as quick to take you in, feed you a meal, or hug you and kiss you right on the mouth before you leave. My dad carries their spirit of laughter, love, and the importance of family with him to this day, and it overflows to everyone he meets.

When my parents divorced in 1980, I didn't really know what it meant other than my dad wouldn't live in our house anymore. He rented an apartment less than a mile away, and my sister and I spent every Wednesday night and every other weekend at his house. He still attended all our school functions, and most importantly, called us on the phone every single night to see

how our days had been and to tell us goodnight. I took all of it for granted. This was in the days before I knew that sometimes after a divorce, dads leave and start new lives and never call or visit. I didn't know he could have opted to just send a check every month and be done with it.

Instead, he eventually bought a house not too far away and took us shopping for twin beds and new bedding so we could decorate our second bedroom. He took us to Shipley's for donuts on Thursday mornings before he dropped us off at school and planned fun things for our weekends together, things like picnics and cookouts and taking us to Willowbrook Mall to shop. He stayed up late playing Donkey Kong with us on the ColecoVision he bought us for Christmas (You can have your Atari. Everyone knows ColecoVision was THE BEST and had amazing graphics that would make kids today be like, "Were these the video games cavemen played?") and watched *Smokey and the Bandit* with us for the four-hundred-and-fiftieth time. He was always open to letting us invite a friend over to spend the night, and I can't tell you how many times he must have cringed as he heard a bunch of little girls turning a game of Blind Man's Bluff into a full-scale pillow fight in the next room, but the beauty of a single, divorced dad's house is that he didn't have much in the way of breakable items. The only downside to our time at his house was that he never mastered the art of grocery shopping. All he kept in the way of snacks were raisins and nuts, both of which were beyond gross to us, so my sister and I often made our own snack out of dry spaghetti noodles dipped in peanut butter. How is that better than a raisin? I'm not sure.

Eventually, my mom moved my sister and me to Beaumont, which was about two hours away. Even then, he'd drive over

to see us every other weekend or have my Me-Ma and Pa-Pa put us on a Greyhound bus to make the trek to Houston so he could have his time with us. (This was a simpler time, before the Internet, when people didn't know that maybe you shouldn't put your child on a Greyhound bus unless you wanted to end up as a cautionary tale on *Dateline*.) During those years, he still called every night to check on us. The truth is, I think I talked to my dad on the phone every night until I was married, and even now, we talk just about every single day. I think the upside to the divorce (if there's ever an upside) is that it forced us to forge our own relationship as father and daughter because we weren't able to rely on the mom to forge all the emotional connections.

When I was in college, I would often call him and ask him if I could take a road trip with some friends or something else that would require extra money and he'd always say, "Well, maybe I could sell a few of my suits." It became a huge joke with all of my friends, and we'd always refer to things by how many suits Charles Marino was going to have to sell to fund my latest adventure or mishap. For example, my wedding probably cost him his entire fall and spring wardrobe. He would send me a check enclosed in a note on his company letterhead, on which he'd written, "To keep you in the style to which you've grown accustomed. Love, Dad." Somehow he managed to walk the delicate parental line of giving me just enough but not too much along with setting expectations that were high yet attainable. And the truth is that while some people may struggle with seeing the graciousness and unconditional love of God as a heavenly father due to their earthly father, that aspect of faith has never been hard for me to grasp because of my dad. He never made me feel anything other than confident (perhaps a little overconfident) in my abilities

while still showing me that anything worth having requires hard work and dedication.

After I met Perry and it was clear our relationship was heading toward marriage, Perry remarked that he felt like I still had some unresolved issues regarding my parents' divorce.

Really? Do you think so? But look how emotionally stable I am except for the times when I completely overreact to the smallest little feeling of abandonment!

Here's the thing: so much of what I had been told as a child wasn't that cut and dry in the bright light of adulthood, and the stability of marriage was at the top of that list. I asked my dad if he could come to town so we could talk about a few things that had been on my mind. We sat at Luby's Cafeteria just a couple of days later (which is really the best place to revisit any scars from your childhood because you can eat Jell-O afterward), and I asked him all the questions that had been piling up in my mind over the past fifteen years. He patiently and lovingly answered each one to the best of his ability, and while the details aren't something I feel I can share, I will say that while I had already spent my entire life up to that point being so proud to be Charles Marino's daughter, I never felt it more so than that day. He is a man of impeccable character and the utmost integrity, and he lived out what it means to take the high road even when the easiest thing in the moment might be to throw blame around. He put my sister and me before his need to be right, and now that I'm a parent myself, I can appreciate the fact that there isn't any act of love greater than sacrificing yourself to protect your child.

About a year later, my dad and I stood in the vestibule of Alamo Heights United Methodist Church, me in my wedding dress and he in his tuxedo. As the organist started to play

Pachelbel's *Canon in D* and my bridesmaids began to walk down the aisle, there were no words either of us trusted ourselves to say without releasing the floodgates of twenty-six years of love. He had loved me richly, protected me fiercely, and taught me everything that had brought me to that moment. I was leaving his care to walk toward the man who would take over where he was leaving off. Of all the good-byes I said as I left my wedding reception to begin my new life, the one I couldn't audibly say to him was the hardest. I just hugged him as hard as I could, whispered a teary thank-you, and ran toward the waiting car with Perry by my side. How do you thank someone for making you everything you are and showing you all that you hope to be? I think we both knew that even though that moment felt a little bit like the end of an era, it was also a whole new beginning. The thing about fathers and daughters is that little girls never forget their first hero, the first man who made them feel like they were the entire world wrapped up in a parade of Barbie dolls, dance recitals, freckled noses, bouncy ponytails, skinned knees, broken hearts, and high-pitched giggles.

My dad retired several years ago after spending almost forty years with the same company. They held a big retirement party for him to celebrate and invited all the people he'd worked with over the years, along with his family. I sat there that night and watched grown men get up with tears in their eyes and toast my dad, saying what he meant to them. I mean, he worked in the payroll industry; this wasn't a touchy-feely group of people. But he had given so many of them a chance to prove themselves, had mentored them, encouraged them, and made everyone laugh because he's never afraid to laugh at himself.

One of them told a story I'd never heard about a time my

dad shared with them that I had told my first-grade class my dad worked in "a jungle" because I'd heard him come home so many nights and say, "It's a jungle out there." And he was right. The world can be a jungle. There are always scary things waiting for you, the unknown lurking around the corner, things that go bump in the night; but what I saw that night was the way my dad had impacted his world and made it feel like a much better, safer place for everyone he encountered along the way.

One of my biggest regrets is that I didn't stand up and make a toast to my dad that night. I just couldn't. Some moments are so tender and take root so deeply inside you that you almost can't bear them, and that night was one of those times for me. It's one thing to know your dad is your hero, but to hear a room full of people echo the same sentiments will send you straight to the ugliest of all the crying.

But if I could go back, this is what I'd say. People talk so much about what it means to live an important life. What my dad taught me is that it's not about how much money you make, the car you drive, or any titles you achieve. He taught me by example that life is about showing up, living in the moment, and being true to who you are and what you believe, even when it's not the easiest path. Life is about your family, your friends, and your faith. It's about loving big, laughing hard, and enjoying a nice glass of wine. His love wrote the first chapters of my life and is the reason I never had to wonder if I was adored. He taught me what it means to be the same person at home that you are out in the world, and that you can never go wrong by making someone feel they are your whole heart and soul.

He is my hero, my leader of the band. The music of my life has been so much sweeter because of him.

Baby Sister

There were once two sisters who were not afraid of
the dark because the dark was full of the other's voice
across the room.

Jandy Nelson, *The Sky Is Everywhere*

My first real memory is of the day we brought my sister, Amy, home from the hospital. Actually, my first real memory is of the time I stubbed my toe while riding my tricycle, but that's the extent of that memory, and it only serves to explain my lifelong fear of sustaining toe injuries.

I barely recall my mom being pregnant since I wasn't even four years old at the time, but I do remember sitting on the emergency brake of my dad's beige Toyota Celica as my mom got in the car with my new baby sister. This was back in the days when people still believed kids should be allowed to roam freely in cars and that a center-console armrest was a perfect seat for a small child. You know, to allow them to see the road better. Or to get hurled out of the front windshield at top velocity. Either way.

I know I'm not the only child of the '70s who spent countless hours trying to sleep on the floorboards or in the back window of

a Buick LeSabre. Obviously, God had a plan for my life, because between my daddy's road rage and the lack of any type of safety restraint, it is a wonder I did not have an untimely demise.

Amy was a colicky baby. She spit up a lot and had to be on a variety of special formulas due to some stomach issues. Thanks to modern medicine, we now realize that some of those intestinal issues could have been due to the vodka and Sprite my mom frequently drank throughout her pregnancy as part of her doctor's plan to ease her nausea. Of course, if you drink enough vodka, you eventually don't care if your stomach is calm or not. Considering the '70s were a simpler time, I guess we're just fortunate the doctor didn't suggest a good, old-fashioned bleeding complete with leeches and a pack of Marlboros to take the edge off. Good parenting in 1976 was essentially all about remembering to crack the car window so the smoke from your cigarette didn't suffocate the family while you blazed down the road listening to a Rita Coolidge eight-track tape. We've come a long way, baby.

Sisters can either be best friends or sworn enemies, depending on the day and sometimes the hour. It must be the combination of shared DNA and a shared bedroom that can cause you to love someone with everything in you one minute and be completely annoyed by the way they sound when they're breathing the next. There's a cassette recording my mom made on a little handheld recorder back when you had to push play and record at the same time. It captured me tormenting Amy at a young age. She's crying and whining as my mom is feeding her some of the few foods her stomach could tolerate while I sing-song in the background like only an annoying big sister can, "Amy! Amy! Look what Sissy's got! Rice! Potatoes! Ta-da! Ta-da! Ta-da!" and you can hear Amy begin to wail even louder as I lovingly point out that I have not

one, but two starches for dinner that evening. Years later, we would listen to that recording and laugh while my mom merely wondered why she'd served both rice and potatoes for dinner one night.

When we were little, one of my favorite games to play with Amy was The Wizard of Oz. I loved to be Dorothy, and I could always count on my baby sister to be my faithful little Toto. She crawled after me everywhere I went anyway, so I figured I might as well make the best of it. I'd spread out my mom's old yellow comforter on the living room floor and travel down the yellow brick road as my little "Toto" crawled behind me and I commanded her to "bark louder!" Every now and then, I'd find a scrap of something on the floor that I'd feed her as a treat, because shag carpeting can reveal a lot of mystery items lost during previous TV tray meals eaten while sitting on the couch.

As we got a little older, I discovered the book *Freaky Friday* and thought it was the utmost in cleverness that the main character, Annabel Andrews, called her little brother "Ape Face." I quickly decided that imitation is the sincerest form of flattery, especially when it comes to insulting names for a younger sibling, and began to refer to Amy as Ape Face while encouraging all my elementary school friends to do the same.

I know. I was the worst.

However, in my defense, Amy did have quite the reputation on our street. She was known to make grown kids show up in tears at our front door to ask our mom if she would please make Amy give back their Big Wheels because she had commandeered it and wouldn't let it go without a fight. She was known to bite anyone and anything that didn't respond the way she wanted. I remember watching *Tom and Jerry* cartoons one afternoon when she snuck up behind me and bit me as hard as she could on my

shoulder because she was so mad I was watching TV as opposed to playing whatever game she wanted to play. Everyone was a little bit scared of her in spite of how innocent she looked with her wrinkled-up pug nose, sweet smile, and Buster Brown haircut.

She got me back for making her play Toto and for the whole Ape Face thing the summer before I began fifth grade. My mom had gone back to work as a real estate agent, and my friends and I had some boys ride their bikes over to my house while the babysitter was there. This was strictly forbidden, but I didn't care because full-fledged boy craziness found me at a young age. (I blame this on both the movie *Grease* and all the Air Supply songs that were always on the radio.) Amy took blackmail to a whole new level and used this information against me for years. It cost me more nights of scratching her back until she went to sleep than I can count and many nights when I had to let her have the bigger cookie for dessert. Finally, around seventh grade, I decided the statute of limitations had surely worn out on this offense and told her to go ahead and tell on me. It was a relief like I had never known before, and my mom's non-response when Amy aired the story made me wish I'd come clean years earlier, because the entire sordid tale consisted of nothing more than a bunch of ten-year-old boys loitering out in front of our house on their bicycles while we giggled at everything they said.

One of our fights is so legendary that to this day, we refer to it as:

The Black Sock Debacle of 1988

It was the fall of my senior year of high school, and I was truly a pleasure to be around. Like most seventeen-year-olds, I had the world completely figured out and certainly didn't need

anyone telling me how to live my life, much less breathing air in my presence. I was so cool in my own mind that I sincerely believed the only reason Simon Le Bon from Duran Duran wasn't dating me was because he hadn't met me yet. Amy was in eighth grade and attended a private Christian school which required her to wear a uniform every day, except on the one day a month deemed "Free Dress Day."

Since I attended public school, my wardrobe was significantly larger than Amy's, not to mention full of sophisticated items like Reebok high-tops, a Guess miniskirt, and Girbaud jeans, along with a lot of shirts with shoulder pads and various bedazzled treatments. This resulted in Amy usually borrowing something of mine to wear on Free Dress Day because if you only have one day a month to express your style, you want to make it count. Anyway, on this particular Free Dress Day, she wanted to borrow my black socks.

Now, we could spend a few hours discussing why I even had black socks, much less socks in every color of the rainbow, but that's beside the point. And honestly, I have no explanation other than to say that the late '80s were an unfortunate time in fashion, and all the misfortune included therein can basically be summed up with the words "acid-washed."

I told her no. The black socks were off-limits.

What was I? Some sort of teenaged Anna Wintour? The devil wears black socks? Why on earth was I so stingy with my black socks? It confirms my suspicions that I may have not been living as my best self in 1988. Lo and behold, Amy believed strongly enough that her outfit couldn't be all it was intended to be without the black socks so had the audacity to sneak into my room, take them, and wear them in spite of my denial. I was

infuriated. I was enraged. I threw a fit about the thievery of my black socks and perhaps even went so far as to launch into a tirade about a lack of moral character, which was really gutsy and hypocritical, considering I'd spent the weekend before hosting a secret "get-together" for some friends while my mom was out of town that involved one of them drinking until she threw up in my sister's bed. And while I am sure my mom thought this whole black sock situation was one of the dumbest incidents she had ever dealt with, she was forced to punish my sister for taking something that didn't belong to her, even if that something was a cheap pair of black socks.

Amy got grounded for wearing my black socks.

And I was glad.

I would like to publicly acknowledge right now that perhaps I pushed the sock incident too far. Maybe I should have been a little more forgiving and understanding about how a thirteen-year-old girl, forced to wear a hunter green plaid skirt and matching vest on a daily basis, could have been driven to steal a pair of black socks, because when you think about the unspoken freedoms a pair of black socks can convey, it's totally understandable.

That was our relationship in those younger years. Amy was the baby sister always sizing me up, competing in everything, including brushing her teeth faster, making better grades, and making better decisions. Once I got my driver's license, there were days I had to pick her up from school. I'd pull up with the sunroof open and the music blaring, then drive way too fast on the way home while she yelled at me to "SLOW DOWN OR I'M GOING TO TELL MOM!" She was the good one, the studious one, the responsible one. Maybe that's why I got so much satisfaction out of getting her in trouble for taking my socks.

Having a sister can be one of those things in life you take for granted. After all, it happens with basically no say-so from you, and it's a built-in relationship that is as much a part of you as an arm or leg. You don't get to choose whether you want it; it's just part of who you are. There were times when the almost four years between us seemed immense, and times when that age difference didn't matter at all. We have each alternately thought the other was dumb, bossy, wonderful, maddening, amazing, someone we couldn't live without, and a total pain in the rear end.

When we were little girls, there were days we would get totally immersed in our relationship and play Barbies forever, have dance parties, build forts, and curl up in bed together at night whispering secrets and dreams and fears. There were times when our childhood looked scary, and we were there to reassure each other that it was all going to be okay. And then there were times when we'd get so mad, we'd shut each other out with silence and slammed doors. But at the heart of it all, Amy is the only person in the world who shares my entire life story. Our relationship has a shorthand unique to sisters because we each know what the other means even when it's a one-word exchange. In so many ways, we survived not just with each other, but because of each other.

Little did I know that the same annoying sister who ill-advisedly took my black socks would be the same person who would help me keep my sanity after Caroline was born. At that point, Amy didn't have children of her own yet and was more than happy to come over on a daily basis and hold Caroline for hours while I did such novel things as shower, cry, and brush my hair. She'd sit on the couch with me and hold Caroline while I sat in my purple, spit-up-stained chenille robe and cried (a combination

of sleeplessness, feeling overwhelmed, and a potent cocktail of postpartum hormones). I am forever grateful for the afternoons she spent on my couch when she could have been doing so many things that were more fun than watching your big sister have a meltdown, like going to the dentist. Watching her hold my baby girl and seeing how much she loved her, just because she was mine, made me realize even more that there is no gift like a sister.

Sometimes you're fortunate enough to have one of your best friends born right into your family. You know each other's stories, you feel each other's pain, you rock each other's babies, and you hold each other's hands as you go through life. You forgive the bad, remember the good, and are forever grateful that there is someone in the world who knows you so well and loves you anyway. Even when you used to refer to her as Ape Face.

Dodging a Bullet

It was a million to one shot, Doc. Million to one.

Frank Costanza, *Seinfeld*

S ome of you may remember several years ago when then-Governor of Texas Rick Perry shot and killed a coyote during his morning run. It made national news because the rest of the United States was all like, "What madness is this?" while most people in Texas were like, "We call it a Tuesday."

I identified with the story because we have had an infiltration of coyotes in our neighborhood over the years. We live right on the edge of a wooded basin that tends to flood at least once every few years, causing all the wildlife that normally live there to head for higher ground. Unfortunately, this higher ground is also called "my backyard." There was a time about ten years ago when we trapped over twenty-seven raccoons, sixteen possums, and seven skunks, otherwise known as trash cats, night rats, and stink squirrels, in our backyard over a six-month period. It's like we inadvertently put up a billboard advertising our backyard as the hot new wildlife club in town. Thursday night is Lady Opossum Night, and trash is free until 10 p.m.!

With this infiltration of rabble-rousers, who skitter and skritch and search through your trash like they're trying to steal your identity, came the coyotes. There used to be a couple of chickens who lived at the end of our block, and every now and then, we would drive by in time to see one of them crossing the road, causing Perry or me to predictably ask, "Why did the chicken cross the road?" because we are never ones to pass up that kind of golden opportunity. But after the coyotes made themselves at home in the neighborhood, the chickens were suddenly never seen again. I think we all know what happened. The chickens opted to move to a nice, big farm in the country where they could roam free and raise their babies without the worries that come with big-city life, such as chicken gang violence and rooster drug dealers. I will not discuss the alternative scenario.

However, it wasn't just the chickens. All of a sudden there were signs everywhere that read, "Have you seen this cat?" or "Help! My Chihuahua is missing!" and I hate to be heartless, but we've all seen *The Lion King* and know that the animal kingdom can be cold and cruel, no matter how many animal videos you've watched on YouTube that try to prove otherwise. For every elephant that cuddles up with a puppy, there's a hippo that will tip a canoe and chomp some villagers with his giant teeth that look like marshmallows but are decidedly not made of sugar.

One morning when Caroline was still small enough to be pushed in a jogging stroller, Perry and I were taking a walk with her and our dogs when we spied a coyote staring at us from about thirty yards away. He was particularly intent on Caroline; she must have looked like a bite-size treat with a bonus cup of Cheerios thrown in. Perry used his cell phone to call our neighborhood police department and report the coyote sighting as we hurriedly

185

put distance between ourselves and Wile E. We stopped to watch as a police officer showed up on the scene and pulled a .22 rifle out of the trunk of his car, aimed at the coyote, and proceeded to miss him three times before the coyote finally turned and made his way back through the woods whence he came. I guess if you want a coyote shot properly, then you better hope the governor is around and not just the local police force.

Anyway, I tell you all of this to make the point that sometimes things are a little different in Texas than they are in the rest of the United States, and lo, the world. We are a state that was founded by outlaws and immigrants in search of land and adventure, and much of that spirit still remains. It should really come as no surprise that there is an actual training program in Texas whereby you can become certified to shoot wild hogs from a helicopter. This is officially called "Aerial Wildlife Management." I realize if you live in New York or somewhere of that nature, this may sound absurd, but wild hogs are an actual problem in Texas and tend to destroy everything in their path. Not to mention that they reproduce at a rate that would make rabbits and the Duggars jealous. It is a constant battle to keep their numbers in check.

Perry participated in several helicopter hog hunts as an observer but decided a couple of years ago that he would like to become certified to shoot them himself. Maybe you're already doing the math in your head and realize this requires both shooting a gun and flying in a helicopter. What could possibly go wrong?

The morning of the certification process, he drove to the appointed testing location. I didn't hear from him for several hours. I had no idea how long it takes to prove you can bring home the bacon from a helicopter, so I wasn't necessarily concerned

until he called me and said, "Hey, I'm on my way home now, and everything is okay, but there was a little bit of an incident."

"What kind of an incident?" I asked.

"I kind of shot myself in the head," he replied.

Well. This is very normal. Let me tell you a story about a wife who hears that her husband has shot himself in the head and begins to freak out. It's called RIGHT NOW.

He assured me he was fine, then said, "I'll tell you the whole story when I get home, but I just want to concentrate on driving because I have a little bit of a headache."

I would think so.

When he walked through the back door an hour later, I wasn't prepared for the enormous bandage on his forehead, not to mention the dried blood covering his face, his neck, and the front of his shirt. Hey, next time maybe bring a change of clothes in case you accidentally shoot yourself. Fortunately he seemed to be okay, and the actual wound was much smaller than I originally thought based on the enormous gauze bandage and all the blood. It seems your head bleeds profusely at the least little thing.

Perry explained that they were up in the helicopter, and he was firing shots at the various targets when one of the bullets ricocheted off the metal and grazed his forehead. He was most proud of the fact that he never quit firing, in spite of the blood running down his face and clothes.

He said, "The instructors couldn't believe it happened. They've never heard of it happening to anyone, ever. We all agreed it was a one-in-a-million shot!" Then, he added with a flourish, "Best of all, I found out that I not only qualified as a licensed shooter but received an EXPERT rating, which less than 5 percent of all people achieve!"

Yes, that is the best of all. That and the fact that you are still ALIVE.

You know what you never think about when you meet the person you want to spend the rest of your life with and you're coming up with clever hashtags like #MelAndPerryGetMarried or #PerryAndMelWeddingBells or #GoingToTheChapelAnd-GoingToGetPerry'd? (I know. Perry'd. I'm inordinately pleased with myself right now.) You don't think that one day maybe your beloved is going to accidentally shoot himself in the head while flying in a helicopter and then believe the most noteworthy thing from the day is that he qualified as an expert shooter. You have hopes and dreams and plans, but not one of them includes that scenario. In fact, there are many things that are going to happen over the course of a life together which you can never anticipate, no matter how many cute engagement pictures you take while holding a chalkboard with "I DO" lettered artfully across it.

I used to love buying copies of *Brides* magazine way before I was even anywhere close to becoming a bride. Maybe part of it was growing up in a home where my parents were divorced, or maybe it was all the times I watched *Cinderella* or—even more so—Danny and Sandy from *Grease* ride off into their happily ever after, but marriage was what I wanted more than anything. The problem is, we can get so focused on the big moment—the proposal, the wedding, the honeymoon in the Bahamas—that we have no idea about the reality of what happens next.

And what is that, you ask? Well. It gets complicated. There are births and deaths, love and loss, tears and fighting, laughter and joy. There are bank accounts that never seem full, kids who interrupt you constantly, car pools to drive, groceries to buy, and dinner to cook. It's a constant push and pull of what you want

versus what he wants, and ultimately, the compromises you're willing to make. It's never knowing you could love someone so much one minute and then be yelling at them the next minute for something as dumb as not throwing away their Band-Aid wrappers.

It's realizing that the things that define a successful marriage have nothing to do with the wedding dress you choose or whether you decide on the Italian cream wedding cake or opt for plain white icing or find the perfect song for your first dance. It's not the big moments that make a marriage work but all the little things that remind the other person how much they matter. Reaching for a hand, saving the last cookie, driving soccer car pool, stopping at the grocery store for milk, letting it go when the other person says something stupid, and taking the time to look each other in the eyes. Little things that help you remember that before all this chaos you've created together, there were two people in love. And that the whole thing can be so fragile because you never know where life is going to take you next, especially when one of you likes to shoot hogs out of helicopters.

And that maybe this life you've made together is the ultimate one-in-a-million shot.

Small Things

Things That Keep Me Up at Night

"I'm tired of overthinking every single thing, you know?"

Tim Riggins, *Friday Night Lights*

Almost every weekday, I pick up Caroline from school. This requires sitting in a line of cars for anywhere between ten and twenty minutes, depending on how early I arrive and how long it takes my girl to pack up all her stuff and make her way out to my car. On most days I use this time to do very important things like check Twitter or Instagram, send funny Snapchat photos to Gulley, or return all the texts I've neglected to send earlier in the day. But sometimes I just listen to the radio, and that's what I was doing the other day when all of a sudden, an ad came on with a deep, authoritative male voice that asked, "Does your teenager have yellow toenails? Have you noticed that your teenager's toenails seem thicker than normal?"

My first thought was "EEW." I love my child, but I do not really want to think about her feet. My second thought immediately followed, and it was a level-ten reaction along the lines of, "WHAT DOES IT MEAN IF MY TEENAGER HAS YELLOW TOENAILS? IS IT A SIGN THEY'RE USING DRUGS? DOES IT MEAN THEY HAVE AN EATING DISORDER? IS IT A WARNING THAT THEY HAVE A HEART CONDITION?" As it turns out, yellow toenails in your teen are nothing except a sign they might have a toenail fungus. Which means my initial response of "EEW" was the appropriate one.

This is the hell our Facebook culture hath wrought. Everything is something to worry about. I never knew a child could drown hours after leaving the pool, but I know it now, thanks to a Facebook article. I didn't know you could be electrocuted jumping into the water off a boat dock, but I know it now. I didn't know there is an amoeba that lives in certain lakes, and if you swallow it, you could die. Or that if you see a pair of shoes hanging on an electrical line near your home, it means someone is selling drugs nearby. Thanks, social media, for taking fear and anxiety to an entirely new stratosphere. You are the best. One quick question: where can we send the bill for the medication we have to take every

night in the hopes of turning off our brains long enough to get some sleep without worrying about all the ways we and our loved ones could possibly die?

Here are the things that keep me awake or can ruin a perfectly good day when my mind goes to the dark place. (Disclaimer: This is by no means a comprehensive list but rather a random sampling. Because one of my fears is that if I were to show you all my crazy, then you might put this book down and never pick it up again.)

1. Did I remember to blow out the candles I lit earlier to get rid of the fried fish smell in the house?
2. What's that noise? Is there something outside my window? Is it a raccoon, or worse, a clown?
3. Did I overpluck my eyebrows again?
4. How do I balance keeping Caroline off the worst of social media but still let her engage with her friends?
5. What if something happens to Perry on a hunting trip?
6. Is that a lump I feel? What if I have cancer? What if Perry gets cancer? What if Caroline gets cancer?
7. Did Caroline finish her homework? Should I remind her to finish her homework, or should I let her deal with the consequences?
8. What am I going to cook for dinner and/or pack for school lunch tomorrow?
9. Should I keep those new shoes I ordered? Do I really like them or just kind of like them?
10. What am I going to do when Caroline leaves for college in five years?
11. What if everything Fox News tells us might happen really happens?

12. Will we be able to afford college and still retire before we're eighty-five?

13. What if an alligator rings my doorbell? (This actually happened to someone. I saw it on CNN.)

14. Should I turn off my phone? Are the wireless signals from our phones going to give us all cancer?

15. What if I turn off my phone and there's an emergency?

16. Did I remember to set the DVR to record *The Bachelor*?

17. Will Piper and Mabel suffer from depression when we have to board them while we're on vacation?

18. Should I quit eating gluten? Should I try the Whole30 diet? Do I need to exercise more? Are we out of Sour Patch Kids?

19. Do I need to clean my oven? Is it true that the self-clean feature can cause your oven to break, or worse, burn your whole house down?

20. Am I supposed to be this worried about things? Am I worrying too much? Should I worry more? Are there things I should be afraid of that I don't even know about?

I once heard someone say that the best way to combat your greatest fears is to speak them out loud. It causes them to lose a little bit of their power. And if that's the case, let's hope this does the trick so that I didn't reveal the deepest and sometimes dumbest parts of myself in vain.

When Life Is a Mixture
of Sweet and Sad

Where you used to be, there is a hole in the world,
which I find myself constantly walking around in the
daytime, and falling in at night. I miss you like
hell.

Edna St. Vincent Millay

I have known since junior high that there is really no angst
like junior high angst. Those years are rife with unfortunate
haircuts, hormonal acne, and questionable fashion choices. That
those things also coincide with an awakening that maybe boys
aren't such a bad thing after all is a recipe for a lot of feelings.
And by a lot of feelings I mean a junior high girl can completely
suck all the emotional oxygen right out of any room.

A friend of mine, who shall remain anonymous to protect
the innocent, told me years ago about her then-junior-high-aged
daughter and how she made graphics to post on Instagram that
said things like, "I'm in love with a person I've never met and

a city I've never been to," or a list of her favorites that included "listening to old record albums while burning candles in my room." My friend told me, "We don't even own a record player, and she's not allowed to burn candles in her room!" But junior high girls aren't ones to deal in reality when the drama they can create is infinitely more satisfactory and tumultuous.

At the time, Caroline was still in elementary school, so I hadn't experienced any of this from a mother's perspective, but we have now arrived at that juncture. Thus, I was thrilled when her seventh grade English teacher invited us to the class poetry reading. Sure enough, there were poems written by the girls about things like transparency, heartbreak, and wearing a mask, while the boys stuck to familiar ground such as fishing and football. But I cannot judge, seeing as I am the one who once wrote these words in my own junior high poetry book entitled *Except for One*:

> *All my friends were sympathetic*
> *Except for one*
> *Because she was his someone else*

That particular piece was penned late one night after a dance at the local YMCA where I'd had immediate regrets about breaking up with my eighth-grade boyfriend hours earlier. So much drama, so little sense.

Fortunately, Caroline is much more level-headed than her mother has ever been, and so her poetry is actually about real things as opposed to manufactured romantic intrigue. She had to write a book of five poems for her seventh-grade English final, and as I was reading through her words, I was struck by one line

in particular: "some people stand out more than others, like neon posters on a beige wall."

I wondered if she sees herself as the beige wall or the neon poster, because she is nothing if not a neon poster kind of girl. But the junior high years can cause you to question everything from the way you look to what you believe as you and your friends grow and change at such a rapid pace.

The following weekend, I was at the pool with Caroline and one of her best friends, Maddy. As I watched the two of them jump off the edge of the pool and laugh until they cried and talk endlessly as they baked in the sun, it dawned on me that this kind of friendship is what helps you be a neon poster. It's the knowledge that you have people who know you and love you and encourage you, who help you be the best and brightest version of yourself. So I thought it was fitting that Caroline ended her poem with a line about how sometimes you may not notice the beige wall, but it is the thing that holds up the neon poster. The beige wall allows the neon poster to shine bright.

One of the reasons I'm so fascinated by having a daughter who falls closer to the neon poster end of the spectrum is because I spent years seeing myself as more of a beige wall. It's true. I wanted to be the girl who dances without feeling self-conscious or tells the funny stories that make everyone laugh and believe the party wouldn't be half as much fun without you. But as I've gotten older, I've realized the truth is that we should all have a little bit of neon poster and a little bit of beige wall in ourselves.

Sometimes our role is to be brighter than the sun, and sometimes our role is to sit back and cheer on our friends as their gifts are on display. My friend Jamie's mom once told her, "Every relationship has a peacock and a grouse." I think that's true.

When I look at my closest friends, I can totally see a pattern. I am drawn to peacocks. I love being surrounded by funny, witty, bright, strong-willed women who aren't afraid to take charge of almost any situation. I tend to approach social situations—and life—a little more cautiously, and the friends I have chosen along the way have taught me the joy of jumping in with both feet, embracing a challenge, and not being afraid to love with your whole heart. We all love each other fiercely. They are my cheer-leaders, my first call, my sanity, and a big chunk of my heart.

This is why it was so devastating when, five years ago, one of us found a lump in her breast. Jen is one of my closest friends and was my college roommate. She is also one of the funniest and warmest people you could ever hope to meet, a neon poster if there ever was one. She was just shy of her fortieth birthday and still nursing her seven-month-old son when she realized she had a lump that wasn't going away, which made her decide it might be more than a clogged milk duct. Sure enough, a biopsy confirmed her fears, and it started us all on a journey that none of us ever wanted to take. That first round of cancer involved chemother-apy, a lumpectomy, and radiation. It was a hard road for Jen and a hard one for us to watch her travel, especially as she balanced being a wife and mom on top of all of it. But she made it through and got the all-clear from her doctors almost a year from the day she was first diagnosed. We all breathed a deep sigh of relief and said prayers of gratitude that we had gotten our miracle.

When I was writing my book *Nobody's Cuter than You* (It's all about friendship, in case you haven't read it, and is available at bookstores everywhere. Pardon the shameless promotion, but I just thought two of you might be interested.), Jen was about six months into her new, cancer-free status, but as I wrote the book,

I texted her to clarify a few details about her diagnosis, because I wanted to make sure I was getting the timeline right. It was in the midst of a flurry of text messages back and forth that Jen texted, "Truthfully, I don't believe it's the end of my cancer story. But I can be thankful for now that there's 'no evidence of disease,' as they say. And I'm not scared of the future either, which is such a gift!"

When I read that text from her, I got chills down my spine because the cancer felt like Lord Voldemort and was He Who Must Not Be Named. Plus, I had naively assumed that the all-clear meant all-clear forever, and we had fought that battle and come out on the other side. But Jen sent that text on October 2, 2014, and on December 6, 2014, we found out that her cancer was back with a vengeance.

Gulley and I always reserve the first weekend of December for our Christmas shopping weekend. We start on Friday morning and use the entire weekend to finish all our Christmas shopping and even get all our presents wrapped. The fact that we find time in between all of this to drink wine and go out to dinner and sleep in late is just a bonus. So we were out shopping on Saturday, December 6.

We'd made our way out of the house late that morning and hit a few stores on our list. We were beyond pleased with our progress, because we were breaking all manner of Christmas shopping weekend records. We even made it to The Container Store to pick up wrapping paper while it was still light outside. This turned out to be fortunate because it allowed Gulley to fully appreciate a man parked next to us who was wearing a red T-shirt with a white Santa beard down the front while drinking a can of Budweiser through a straw. He rolled down his window

and said to Gulley, "I'm gonna tell you like I told that woman in there, you ever seen me and Santa in a room together?"

Well. No.

No we haven't. Also, I don't believe we asked.

We pondered our thoughts on this man as we made our way to our neighborhood Target. It was, by the way, our third Target visit of the weekend but served to confirm that our Target is the best of all the area Targets. While we were there, we both heard our phones ding with an incoming text and checked them, only to discover our friend Jamie was texting us to let us know that she had been at the hospital all day with Jen, and that the doctors had said Jen's cancer was back. Which is how Gulley and I found ourselves crying in the gift wrap aisle at Target at 5:38 p.m. on a Saturday evening.

I spent those weeks before Christmas in a little bit of a haze. The holidays are always so busy anyway, and Jen's cancer was like a bruise you forget about for a minute until you bump it again and remember it still hurts. One night, a few days after that initial text from Jamie, I was in the middle of helping Caroline finish a science project (this is squarely not in my set of skills or life goals) when I received a text update from Jen to several close friends that basically let us know her hard news had just gotten harder because a follow-up appointment to the doctor discovered the cancer had spread to her lower back, ribs, lungs, and more lymph nodes as well as more spots on her liver than they had originally thought.

Honestly, as I read her text, I didn't even let myself process it because I knew I couldn't without falling apart. I still had to help Caroline finish making videos showing the difference between physical and chemical changes, cook dinner, and get everyone

settled in for the night. So I felt tears in my eyes and then quickly compartmentalized it into "Things to Think about Tomorrow," which I learned from Scarlett O'Hara.

The following day, I woke up and discovered Jen had posted the news on her blog along with an update that she was headed to Houston to see some specialists there on Friday. Since my parents, Mimi and Bops, have a house in Houston, I texted her and asked if she had a place to stay. She said they were planning to get a hotel room, but I told her Mimi and Bops would love for her to stay at their house. I just needed to overnight her a key since they weren't there. She loved this plan, and I loved that I was able to do something tangible, because it's hard living five hours away and feeling like there's not much you can do to help.

So I got the key to the Houston house from Mimi and Bops, and then drove to the mail store where I paid not a small amount of money to get guaranteed delivery by 10:30 a.m. the next day. And I was none too happy when Jen texted me at noon the following day to let me know the key still hadn't arrived, and they needed to get on the road in the next hour. I immediately drove to the mail store to track down the key and knew I was in trouble when the girl behind the counter typed in the tracking number and said, "I'm going to go get the lady who helped you yesterday." This is normally not a harbinger of glad tidings.

The lady who helped me the day before explained that the package hadn't been scanned again since it left her store the day before, and there was no way to know its current location. That's when all my pent-up feelings from the last forty-eight hours decided to rise to the top and make a fool out of me. I fell apart crying, right there in the mail store among all the people happily mailing their Christmas packages, as I explained the

package contained a key for one of my best friends who has cancer. As Gulley said later, I literally went postal at the post office.

It was so bad that the sweet lady in the store wrapped me up in a hug as I cried. She apologized, even though it wasn't her fault, promising me that I could get my money back as soon as the package was located. I called Jen as soon as I got back to the car and started crying again as I told her the key was missing. But then, like we always do, we found the humor in the whole situation. One of my favorite things about Jen has always been that she is quick to find the funny, so I hung up the phone with tears from laughing instead of crying. But then I decided that the delivery company was responsible and should pay for Jen's hotel room in Houston for the night since it was their fault the key was missing and she didn't have a place to stay. I spent the rest of the afternoon emailing back and forth with their customer service department until they agreed to cover the cost of her hotel for the night. Then I made a hotel reservation right in the medical center and texted her the information since she and her husband, Scott, were on their way to Houston at that very moment.

I'm telling you this whole story because as I drove to pick up pizza for dinner later that night, I found myself praying for Jen, thanking God that the delivery company had agreed to cover the cost of her hotel room and asking for the doctors to have wisdom about the best treatments going forward. Then I turned up the radio and heard a Christmas song that includes the words we all know so well: "Do not be afraid, a Savior is born to you this day."

I don't even know what song it was—I had never heard it before—but in that moment, I was hit with the full realization of what Christmas is about. Yes, it's about a baby born to a virgin and laid in a manger. But those words by the angels to those

shepherds that night hold the weight of it all: "Do not be afraid, a Savior is born." I've always read those words and just thought of them in terms of the angels reassuring the shepherds there was nothing to fear as they saw a heavenly host in the night sky, which admittedly might cause a person to freak out.

But through the angle of the lens of watching my friend fight this battle with cancer, I saw it as more of a life promise. "Do not be afraid, a Savior is born." Because that's what God gave us when his son Jesus was born that night so long ago: the assurance that we no longer need to be afraid because we have a Savior. We don't need to be afraid of death or the future or the present or all those other fear-mongering rabbit trails our minds go to in the middle of the night when we can't sleep, because we have a God who loves us so much that he sent his son wrapped in the soft skin of a newborn, and what sounded like a baby's cry was actually a holy roar letting darkness know the light will always triumph in the end.

As the weeks went on, Jen saw doctors and had test after test that confirmed she had Stage 4 metastatic breast cancer. We were told she might live anywhere from eighteen to twenty-six months. If there is any silver lining to a cancer diagnosis, it's that it puts what really matters in life into sharp focus. Gulley and I drove from San Antonio to Dallas to be with Jen as she went through the first of many experimental chemotherapy trials. We went to dinner the night before with a whole group of friends who have stuck together in the twenty-plus years since we graduated from Texas A&M, and we laughed and caught up on life until we realized it was almost 10 p.m. and remembered the real reason we were in town was because we had to be at the hospital early the next morning for Jen's treatment.

The days at the hospital were long due to the battery of tests they perform throughout the day. So Jamie met Gulley and me at Starbucks, and then we drove to the hospital to meet Jen. She was getting an initial blood draw, but they eventually moved us into what her nurse referred to as our own private "party room." This seriously oversold what was basically a small patient room, but we were just thankful to have our own little place to set up camp with all our snacks and drinks where we could spend the day together.

And that's what we did. We laughed and told stories and solved problems and had ourselves a complete therapy session before the day was over. We analyzed our marriages, our in-laws, our parents, our clothing choices, and our children. There were moments I almost forgot why we were there until the nurse came in to do a blood draw or Jen's oncologist came in and handed her a "Cancer Sucks" pin to wear. That part? The part where we were all sitting in an oncology ward in a hospital? It still does not compute.

But the thing about being with dear friends is that you can have fun just about anywhere. This was never more evident than when Jen's nurse had to come in and tell us we all needed to be a little quieter because we were laughing and talking too loudly. It just goes to show some things don't change, even when one of you has cancer.

Over the course of the day, different friends stopped by to check on Jen and even brought us lunch. Then Jen's friend Cynthia brought Jen's little boy, Lincoln, up to visit his mama. And he got us all so tickled when he informed us he didn't like Jesus because Jesus has bad hair. Gulley suggested that maybe Jen needed to find a better picture of Jesus to show him in the future, since it's clear the one he's seen might present a Jesus in need of a hairbrush.

It was a short trip, but we packed it full of so many sweet memories and good laughs and the reminder that perhaps nothing makes you realize what's truly important in life more than being with friends you've known and loved for decades. To our great sorrow, none of us had the power to change Jen's circumstances or make the cancer disappear, but we did what we could: loved hard, laughed loud, and hugged like it might be the last time.

At this point, we are now eighteen months into this journey into the unknown. There was a time a few months ago when Jen was in the hospital due to extreme pain and nausea. Gulley and I drove up to visit her and ended up spending that night in the hospital with her just to be close. If I'm honest, I think after we arrived and saw how frail she appeared, we were both afraid it might really be our last time with her. We all tried to act as normal as possible and talked about everything but the fact that Jen was dying of cancer. We discussed school sports, good restaurants, and at one point, what was on sale at Lululemon.

I told Jen about some hot pink workout pants I'd bought on sale for 50 percent off, and she was so intrigued that she had us bring her phone to her so she could see about ordering a pair for herself. As she looked at them online, she said, "Are you sure these are hot pink? Or are they magenta? They look more magenta to me!" I assured her I thought they were more hot pink, so she placed her order, causing Gulley and me to laugh at how a person can be so sick and yet so fundamentally themselves because only Jen would order workout pants from a hospital bed in between waves of pain and nausea.

When it came time for us to drive back to San Antonio, Gulley and I hugged Jen as hard as we could without hurting her, and we all cried our eyes out. I think we all realized this could be

our last good-bye, our last moment to say all the things none of us could actually verbalize, except "I love you, I love you, I love you," while the tears became full sobs. But Jen rebounded because she has the strongest will of any person I know, and about ten days later, I received a text from her that said simply, "Got the Lulu pants. THEY COULD NOT BE MORE MAGENTA!" I wanted to tell her I might have known that from the outset but didn't know at the time that she would even live to see them and just knew she'd get some joy from a good bargain.

A few months later, Jen had to travel back to Houston because she had an opportunity to meet with one of the foremost breast cancer doctors in the world. Her cancer has been a medical anomaly in many ways since the very beginning, so it's been difficult to figure out the best treatment options. Gulley and I drove to Houston to meet her there, and we all ended up spending the night at my parents' house, just like we did when we were in college. Jen was actually feeling pretty good, so we were able to go out to dinner and stay up late talking, just like we used to back in the golden days. The next day, after her doctor's appointment was over, we were even able to go shopping at Anthropologie together, and it was hard to even remember she was sick by the way she shopped with us and found cute things for us to try on. We laughed in the dressing room over bad fashion and old memories, and for one brief, shining moment it was like we got the gift of being our twenty-year-old selves again with not a care in the world except finding a good pair of jeans. Then, not even twelve hours later, I became heartbreakingly aware of what a gift that time was. Shortly after they returned home to Dallas, Jen's husband had to rush her to the hospital because she was in such extreme pain. It was another difficult reminder that life can

change so quickly and that we need to enjoy each other while we can. I wouldn't trade those hours when God smiled on us and gave us something immeasurable for anything.

Jen is still fighting and has more bad days than good right now. But she's been able to watch her little boy turn five, travel to a few more places, move into a new home, and continually tells everyone how much she trusts in the faithfulness and goodness of God in spite of her circumstances. It has been incredible to see the way her community has supported her family. There have been huge gifts of time, service, and all-expenses paid vacations, but one of the most tangible examples I've seen of absolute love in action is the way our friend Jamie has shown up for Jen during this battle. Jamie and Jen met in junior high and have been best friends ever since. They have that bond you can only have with someone who has known you since the days of braces and bad hair and awkward poetry writing.

While we have all done what we can to help Jen, it's what Jamie has done that stands out to me. There are no grand gestures, just an almost daily faithfulness. Jamie is at every chemo appointment, every late night emergency room visit, and takes care of Jen's little boy, Lincoln, on the days when Jen is fighting too much pain or nausea to take care of him herself. Jamie has sacrificed her time and her own agenda to serve Jen with a million small kindnesses that aren't glamorous, but scream love and devotion in a big way. It's been a reminder that the best thing we can do when someone we love is hurting is show up. Most times there are no right words, no one thing that will make it all better, and nothing we can actually do to change the circumstances.

But we can be the beige wall holding up the neon poster. And make all the difference simply by being there.

After a long, hard battle with cancer, Jen passed away peacefully in her sleep on August 9, 2016. There are no words for how much she impacted everyone who came in contact with her and how much she will be missed. I was able to say one last good-bye before she died, and we both knew it wasn't a forever good-bye as much as an "I'll see you later," but that didn't make it any less painful. I have no doubt she is in heaven with the Savior she loves so dearly. And maybe even offering him some unsolicited advice.

In what is proof to me that God cares about even the smallest details, Jen's beloved ninety-seven-year-old grandmother passed away the Thursday morning after Jen's funeral. The two of them were kindred spirits and ate lunch together every Thursday. I believe God knew Grandma Vonie needed to keep her lunch date with Jen.

19

Beyond Measure

God has not been trying an experiment on my faith
or love in order to find out their quality. He knew it
already. It was I who didn't. In this trial He makes us
occupy the dock, the witness box, and the bench all
at once. He always knew that my temple was a house
of cards. His only way of making me realize the fact
was to knock it down.

C.S. Lewis

In one form or another, I grew up in the church. Some of my
earliest memories are sitting in a pew while squinting my eyes
to purposely distort all the stained glass images for my own
amusement. I've always been a little bit aware that church, or
"the church," as people like to call it, is a flawed institution at
best, which only makes sense given that it is essentially a human
execution of what God had in mind.

I have laughed at preachers who slam their Bibles on the
pulpit as they promise "hellfire and destruction" in a dramatic
fashion, I have cried over hypocrisy among church members,
I have imitated bad youth group skits where the best looking

boy in the group always plays Jesus and is always so sad at the portrayal of someone at a keg party, I have wrestled with guilt over my lack of desire to serve in children's ministry, and I have wondered endlessly why we sometimes just repeat the same chorus over and over again during worship. But at the heart of it all, I love church. With all its failings and shortcomings and inadequacies, I love the hearts of the people who jump in and do their best to serve and love and follow the heart of God.

Until a year and a half ago, Perry and I attended the same church since Caroline was less than a year old. It was a church we'd had ties to long before that, and it was a great place for us for all those years. We were involved with different ministry groups, learned so much, made new friends. There was a time when I couldn't imagine we'd ever leave to go anywhere else.

But then something began to shift. At first I thought it was just my own issues, but then one night Perry and I talked about it and realized we were feeling the same things. I can't even tell you what the exact feeling was other than just a little bit of restlessness regarding church that we hadn't experienced in a long time. So we began to pray about it and agreed to see what happened next. What happened was that Caroline moved up to the junior high youth group and began to enjoy church more than she ever had during the days of elementary Sunday school. We agreed that was the most important thing and decided it meant we should stay put.

Then, a few weeks later, the youth director sent out an email informing parents that the youth group would no longer meet on Sunday mornings and would meet on Wednesday nights instead. That schedule wasn't going to work for us because the church is about a thirty-minute drive from our house on a Sunday morning

and takes even longer when you factor in weekday traffic. Then Caroline admitted that she never really got to know the other kids because none of them were from our neighborhood or attended her school, and what she really wanted was to go to church closer to home.

I remember hearing Priscilla Shirer tell how a mother eagle begins to shake her nest when it's time for her babies to start flying, and I believe that's what was happening to us. Our familiar little nest was being shaken because God was calling us out of our comfort zone. It was one of those times when you're either going to allow God to help you fly, or you're going to fall flat on your face. I have chosen the latter more times than I care to admit.

As we talked about it one night over dinner, what became clear was that all three of us had a desire to attend church in our neighborhood, with the people we go to school with and grocery shop with and see every day. We live in a small community in the middle of San Antonio, and it tends to feel like a small town. We had no doubt God was calling us to be a part of something right here and not thirty minutes away. Our hearts were increasingly drawn close to home. The problem was, we weren't sure there was a church that would be the right fit for us.

Then, one night, as we were discussing it for the twenty-third time, Caroline declared, "Maybe we should start a church!"

What?

No. Just no.

I am not a church plant kind of person. I am not organized. I am not overly spiritual. I have never won a Bible drill contest. I have never even sung in the choir, unless you count my brief stint in Mixed Choir in seventh grade, which sounds much more

impressive when I tell you that we sang "Human Nature" by Michael Jackson, complete with extensive hand motion choreography.

So I did the supportive mom thing by essentially patting Caroline on the head and saying, "Aw, that's a sweet idea," while everything inside me was screaming, "PLEASE GOD DON'T MAKE US START A CHURCH! I DON'T WANT TO START A CHURCH!" I knew Perry was thinking exactly the same thing by the way he looked at me across the table.

But it was one of those small things—you know, *those things*—that just burned a hole in my heart and I knew—I KNEW—even though I ignored it, that there was something to it. Out of the mouths of babes and junior high kids and all that.

We spent the next six months after Caroline's declaration visiting different churches in our neighborhood, but none of them seemed right for us. The majority were very traditional, and we just aren't traditional church people. Here's the thing: church preference is such a personal decision. I mean, Gulley and I have never gone to the same church, and she's my best friend and we basically agree on everything, so that's how personal and unique church is to each person. I don't see the fact that we didn't find a good fit as a reflection on any of the churches in our neighborhood as much as the fact that God wanted to create a new, different space. I knew he would eventually wear us down, because Perry and I are ultimately suckers for what God calls us to do, even when we resist at first.

At the same time that this was going on at our house, some acquaintances of ours, August and John, who happen to be immensely talented worship leaders, were feeling called to something new too. August was at another church at the time, and Perry and I just happened to decide to attend that church on

Easter Sunday, specifically because we knew the music would be great. August saw us across the room that morning and came over to say hello. She mentioned that she was feeling restless and believed God was calling her to something new. I stared a hole into the side of Perry's head as August said those words, and I knew at that moment that God was about to do something. I was excited and scared and wonder-filled and nauseous all at the same time. Here's the thing: I have never identified more with Moses when he says, "Oh, my Lord, please send someone else" (Exodus 4:13 ESV).

Perry and I began to watch all the pieces fall into place. Pieces we'd always cited as the reason we could never start a church. Where would we find a good worship leader? Where would we meet? What about the fact that neither of us wanted ministry to be our full-time job? Would anyone even want to come to a new church? What about how I like to sleep in on rainy Sunday mornings? All those things just seemed insurmountable.

I realize now that all of this sounds ridiculous because, well, GOD. It turns out he means it when he says he will do more than we could ask or imagine (Ephesians 3:20). That's why it's more than you can imagine.

Because you can't imagine it.

We met with August and John about a week after Easter and discussed the logistics of what it would take to start a simple Sunday morning worship service. We all agreed that none of us were looking at this as a vocation but rather as creating an organic gathering of people who wanted to come together for worship and teaching with their families each Sunday morning, right in our neighborhood. Kind of like the first churches in Acts, we wanted it to be about the people and not the place. Over

the course of the previous year, I'd felt strongly that God was reminding me that the way to change your world is to start in your own community and invest in the lives of the people around you—and that's what we wanted to do. We all gathered in my living room to pray and agreed we would give it thirty days. The thirty-day church experiment.

As I write this, we just celebrated our first year as a church community.

The past year has caused me to question my sanity, my selfishness, my spirituality, and God. I will confess to at least one or six Sunday mornings when I said out loud to God, "I HATE THIS. I wish you never would have called us to do this" and then ended up in tears an hour later when I looked at the group of people who believe in what we are doing and show up to help us make coffee and set up chairs and greet people as they come through the door. Starting this church or worship service or whatever we call it on any given day has been the greatest and hardest and best and worst thing I have ever done, sometimes all within one five-minute span of time. It has stretched my faith in ways I never imagined and ultimately leaves me feeling so grateful that we have a God who uses us in spite of ourselves.

Several years before any of this happened, I found myself spending a lot of time feeling kind of left out. It seemed as though a lot of people I knew were being used by God to do various things, and I felt like I was a little bit adrift. It was enough to make me feel like I was in fourth grade again and the last one picked for the kickball team. Even though this was different, because it had been years since I'd kicked a big, red rubber ball straight back to the pitcher, making myself what is known as an easy out. Which only actually happened twice, by the way. But

fourth graders are an unforgiving bunch with a long memory where kickball is concerned.

The thing about feeling left out is it turns into some sort of quicksand of self-doubt. What's wrong with me? Am I not a likable person? Is it because I'm socially awkward? Am I not good enough? Is it because I admit to watching every season of *The Bachelor*? Do people think I'm shallow?

Then I would catch a glimpse of myself in the mirror and lose my train of thought because I'd notice a new gray hair, which inevitably led to a full evaluation of the state of my eyebrows.

No way anyone thinks I'm shallow.

So basically, I was struggling with all these feelings of being inadequate and questioning why things happen the way they do and wondering why I wasn't good enough for this or that.

One night I climbed into bed, and my mind was racing with all these things I'd perceived as slights, and I began to get all worked up. All my doubts and fears came flying to the surface until I felt like I wanted to cry.

At that moment, I felt God speak to my heart, saying, "You need to quit asking 'Why?' and start asking me 'Where?'" I knew immediately it was God because I wouldn't have come up with anything that profound. And I certainly wouldn't have come up with anything that succinct.

I realized I'd fallen into a cycle of asking, "Why not me?" or "Why me?" or "Why is this so hard?" and now it was time for me to ask, "Where would you have me go? Where would you have me serve? Where are you leading me?"

Don't get me wrong. I think there is a time to ask why. I have friends who are facing hard circumstances, the kinds of things that can only lead them to question why. I think God understands

our need to ask why at times, even if he doesn't always give us the answer. He isn't afraid of our questions.

But my "Why?" had become a question that was causing me to spiral into a vat of self-pity, which is even more gross than a vat of tartar sauce. It's hard to admit, because even now I'd like to think I'm better than that.

Asking "Where?" changes things. It takes the focus off me and what I perceive as my failures and shortcomings and all the ways I don't measure up and puts the focus where it belongs. On God. The One who has plans and purposes for us, in spite of all our failures and fears.

Then you realize the why doesn't really matter as much as the where. The where is the question that asks, "What am I supposed to be doing?" instead of the why that always seems to ask, "What am I doing wrong?"

The world tells us we have to do it all, be it all, and achieve it all. We need to do big, important things to leave a legacy. All while looking fabulous and being a size four and raising kids who are fluent in at least two languages and in gifted classes. Our houses have to be straight out of Pinterest, our dinners need to be clean and healthy, and our Instagram accounts should to be full of beautifully filtered photos that catch every single moment of our kids' lives or they'll end up in therapy wondering why they don't have an Instagram book like all the other kids.

We are a generation of women who have never worked harder to have it all, yet go to bed most nights worrying that we aren't enough. We are constantly asking "Why?" We are constantly measuring. It doesn't matter if you're single, if you're married, if you're rich, poor, old, young, in college, or out of college. Every human heart struggles with this. We are always looking around

to see how we measure up to everyone around us and usually focusing on all the ways we fall short.

I believe our struggle with wondering if we are enough goes back primarily to how much we trust God. We aren't struggling because of the specifics of our circumstances as much as we are struggling because we fail to trust God to give us what we need, to show us where we are supposed to go and what we are supposed to do. That's why discontentment surfaces in our lives in all the ways it does.

Deep down, we struggle to believe God is going to lead us to what is best for us. It's our internal voice that whispers we will never be enough, so we work and worry and feel like we must do something big, something huge to prove our worth and to make sure our life matters. We have to host a conference, start a movement, adopt fifteen kids, or fight human trafficking to really matter. Which are all great things, but thinking this way can cause us to lose sight of the small things that can also change a life: bringing dinner to a sick neighbor, smiling at a waitress who's having a bad day, reading to your kids before bed, and simply praying for someone going through a rough time.

If you're like me, you can spend a lot of time looking around at what everyone else has or is doing or all the ways they appear better. We measure. We measure our insides by other people's outsides—and that's never a fair assessment. We don't know what they're going through, how they have been hurt, or the struggles they face. We see their social-media best selves and assume everybody is winning at life. We are constantly seeing the "Everything's great!" version of other people's lives while living the reality of our own lives, which may often feel a little mundane and purposeless.

A few weeks ago, as I was reading my Bible, I ran across some verses that leapt out at me. I can't even explain how I found myself in Zechariah, because sometimes I can't remember if it's a real book of the Bible or one I made up in my head because Zechariah *sounds* like a name that would be a book of the Bible. I read:

> And I lifted my eyes and saw, and behold, a man with a measuring line in his hand! Then I said, "Where are you going?" And he said to me, "To measure Jerusalem, to see what is its width and what is its length." And behold, the angel who talked with me came forward, and another angel came forward to meet him and said to him, "Run, say to that young man, 'Jerusalem shall be inhabited as villages without walls, because of the multitude of people and live-stock in it. And I will be to her a wall of fire all around, declares the Lord, and I will be the glory in her midst.'" (Zechariah 2:1–5 ESV)

It hit me that this is what we spend so much time doing. We are constantly measuring our city—is it big enough? Does it need more? How does it compare to other cities? Does my city have the kitchen that looks most likely to get pinned on Pinterest? Do people like my city?

I wonder what might happen if we could quit building walls around ourselves and let others see who we really are. To see where we are broken and where we are hurting and where we feel like we aren't enough. Sometimes when we speak those things out loud, they lose their power, but when we keep them hidden, they grow stronger because we are almost always our own worst critics.

What if we lived as though we truly believed God has given us a life without walls, that he has plans for us that go beyond anything we can measure or imagine and promises to be the glory in our midst?

I believe God wants to make our city—our lives—so big that walls can't contain it. His idea of big is so different from ours. A God who promises us that not even a sparrow falls to the ground without him knowing is a God who values even the smallest things. He wants us to have peace and contentment that won't require us to put up walls of protection and spend our lives afraid of being vulnerable and real as we stop compulsively trying to measure the width and depth of our lives. He will be our protection. He will be the wall of fire all around. He will be the glory in our midst and whisper to us that our lives, no matter how small they may seem to us, are enough because he is enough.

I used to be a member of the Church of Big Moments. I lived for the major life events, the magnanimous gestures, and the idea that the best marriage proposals surely happen on the fifty-yard line at halftime during a football game. Because what says happily ever after more than fifteen seconds of fame on a Jumbotron? Unless, of course, it's Tom Cruise busting into a room full of women and declaring, "You complete me."

In that funny way life has of teaching you as you go, I learned over the years that it's usually not the big moments that make up a life as much as it is the small ones. It's not going to college and setting up a dorm room that makes you an adult but the discipline of showing up for class, studying for tests, and learning that perhaps Jell-O shots are a bad idea. It's not the wedding ceremony that makes you a married couple, but the daily commitment to stay in love even when someone is seemingly incapable

of throwing away the wrappers from the York Peppermint Patties he eats every night and asks every year if Valentine's Day is the second Tuesday in February. It's not giving birth or signing adoption papers that makes you a mom, but braiding hair and kissing scraped knees and walking the floor at night with a feverish baby in your arms as you whisper a silent prayer, or listening to someone sound out the word "cat" until you want to gnaw your arm off to make it stop. I've learned that the best way to live is to look for God in the church of small things. The church of small things is where God does his best work. The church of small things is where the majority of us live every single day.

Vincent van Gogh said, "Man, I really wish I hadn't cut my ear off" (probably) but he also said, "Great things are done by a series of small things brought together." That's it. Or in the equally profound lyrics of the classic TV show *One Day at a Time*, "This is it, this is life, the one you get, so go and have a ball."

Acknowledgments

Writing a book is a funny thing because it can be such a lonely process to have to live inside your own head for months on end, but at the same time you have a whole support system who is cheering you on and praying for you every step of the way. They remind you to breathe, to keep engaging in life, and to shower. They assure you the book you're working on won't be the worst thing ever written and always seem to say the right thing just when you feel like you're on the edge. At some point in the middle of writing each book I've written, I wonder why I do this to myself. Why do I subject myself to this crazy-making endeavor? The following people are the reason why.

Perry: You are the calm in my storm. When I think everything might be terrible, you remind me that life always has a way of working out and that I need to fight for what I believe in. You never fail to support everything I do, even when it means a lot of takeout dinners and being down to our last roll of toilet paper. You are home to me, and I love you more now than I did twenty years ago.

Caroline: You are all my dreams come true. I didn't even know what I hoped my daughter would be, but you have surpassed anything I could have imagined. I am so proud of you and can't wait to see what God continues to do in your life. You have a heart for him that inspires me every day.

Mimi and Bops: There aren't even words for the love and support you have given me over the years. You have both cheered me on and supported this crazy dream every step of the way. I wouldn't be who I am without the two of you. I love you both so much.

Lisa Jackson: I trusted you with my writing career from the very beginning, first as a publisher and now as an agent, and you have never let me down. You encourage me, challenge me, and make me laugh every step of the way. Thank you for reminding me to always trust my instincts. You are more than an agent; you are a dear friend, and I am so grateful for you.

The Zondervan Team: I am not a girl who enjoys change, and I was a little afraid of what it would be like to work with a new publishing group. But from the moment I arrived in Grand Rapids and saw that Jesus was wearing a Texas A&M shirt, I knew you were my people. I cannot thank you enough for all the ways you have embraced this project and worked hard to make it more than I could have hoped for. I love that every time I said, "Maybe we could . . .", you were always up for the challenge and figured out a way to make it happen.

Amy: I'm so thankful that I was given both a sister and a friend in one package. Thanks for loving me, encouraging me and making me laugh.

Gulley: Thanks for all the money you have saved me on therapy bills. You always know whether a crisis of faith or identity or parenting calls for chocolate chip cookies or wine or, most likely, both. Nobody's cuter than you.

Jamie: Watching the way you loved and cared for Jen made me want to be a better version of myself. I'm forever thankful you're in my top five. (Or four. Sorry, Trevor.)

Sophie: No one can help me edit, outline or think about a better way to write something than you. It's so handy to have a former English teacher as one of your dearest friends and I am so grateful for all the ways you help and encourage me and make me feel less crazy.

Beth Moore: I don't know that I ever would have written one word if not for your influence in my life. The fact that God used your Bible studies to change me forever and then actually put you in my life as a real-life mentor is one of his most outrageous blessings to me.

Ree Drummond: Thank you for your encouragement and advice and for taking the time to write the foreword for this book. You are always so faithful to support me, and I appreciate it so much.

My blog readers: The fact that you have faithfully shown up in my little corner of the world wide web for over eleven years now is just crazy. Thank you for reading my words, loving my family, and reminding me that sometimes what we all need is a good laugh. I am eternally grateful for each and every one of you.

And, most of all, God: You gave me a gift for writing words, and I will use it forever to bring glory to your name. You are the great love of my life. My prayer is that I will use every bit of every small thing you've put in my path to point back to your great love and faithfulness.

Hello, Barnes & Noble readers!

I am so excited for you to have this special edition of *Church of the Small Things*. I spent a year of my life writing this book because I believe so strongly that life really is richer and better when we don't lose sight of all the small daily gifts in our lives and, if nothing else, writing that book made me believe it even more. (It also helped me get my baseboards the cleanest they've ever been and finally finish watching *The West Wing* on Netflix because procrastination is my friend.)

Sometimes it's a good idea to look around at all the little things in your life that bring you joy. And you can even make a list if you feel so inclined. I have always been a fan of making lists. I like to make lists of books I want to read and places I'd like to go and, true story, I often make to-do lists for the week and add things that I've already done just to help myself feel productive because sometimes happiness is found in being able to cross something out with a Sharpie. And so it felt like a natural choice to share some lists of various things I love in this special edition.

The majority of the things on these lists are not life-changing in any way—they are just some of the small things in life that make me happy. They are things that have caused me to laugh out loud or wipe away a few tears or to reflect on memories I thought I had forgotten years ago. In a way, they are

what make me me. As Pam Beesly from *The Office* says, "There's a lot of beauty in ordinary things. Isn't that the point?" I believe the small, ordinary things in our life are the building bricks to the cathedral that becomes our legacy.

I encourage you to use the journaling pages at the end of the book to make your own lists. Or just write down your thoughts. Or draw really cool stick figures … whatever works for you. That space is for you to reflect on your own small things and small moments that make up your life. It's amazing what we discover when we take the time to count up all those little bits of good we take for granted every day.

Wishing you so much love and joy!

—Melanie

Small Things That Make Life Worth Living List

Sometimes it's in the nothing special that we find the best parts of life.

Ten Small Things That Make Me Happy

1. Summer nights staying up way too late with my daughter, Caroline, watching a movie or just lying on opposite ends of the couch reading our respective books.
2. A venti non-fat latte with one raw sugar. Or when I'm feeling really wild, an iced caramel macchiato.
3. A thunderstorm that rolls through in the middle of the night.
4. A wine night with my girlfriends.
5. New pajamas.
6. Date night with Perry.
7. Cold nights and a fire in the fireplace.
8. Getting a reflexology massage at this neighborhood place. I don't know if I actually believe in the science of it but it feels amazing.
9. Reading a great book. Preferably a well-written memoir, something about royalty or anything set in World War II.
10. Piña coladas and getting caught in the rain. (Someone should write a song about that.)

Pop Culture Lists

Never underestimate the power of a great movie quote or a TV show to turn your day around.

My List of Guilty-Pleasure Movies

The other day there was a John Hughes' movie marathon on TV, and now I refer to that day as the best day ever. I thought about how almost every single one of his movies fall into the category of movies I will stop and watch every time they're on. *Breakfast Club, Pretty in Pink, Sixteen Candles,* and *Ferris Bueller's Day Off* were the movies of my teen years, and I spent countless dollars going to see them at the dollar movie theater around the corner from my house.

And then I started thinking of other movies I will stop and watch every time they're on TV and came up with this list that is definitely not comprehensive, but rather an adequate representation of my taste in cinema. This may be the reason that I've never been asked to be a member of the Academy. Well, this list and the fact that no one in Hollywood has a clue that I exist.

1. *The Philadelphia Story* - The version with Katherine Hepburn and Cary Grant is one of my favorites of all time. It's so witty and makes me feel all swoony inside.
2. *Gone with the Wind* - Of course. Rhett and Scarlett were my

#goals until I was old enough to realize their relationship wasn't actually necessarily healthy.

3. *Rocky I, II, III, IV* - I have no explanation, but it's true. I pity the fool who doesn't appreciate Sylvester Stallone as Rocky Balboa. That being said, I have no need to see Rocky V ever again.

4. *Sweet Home Alabama* - I love Reese Witherspoon in this movie and I just find the whole thing so charmingly romantic and sweet.

5. *Coalminer's Daughter* - I can recite every line from memory.

6. *Little Women* - The Winona Ryder version. If it's cold and rainy outside, I will hunt this movie down and watch it.

7. *Grease 1 and Grease 2* - I should be ashamed to own up to 2, but Michelle Pfeiffer singing "Cool Rider" redeems Grease 2, and Grease 1 is just a classic.

8. *Bridget Jones' Diary* - Colin Firth as Mr. Darcy. The end.

9. *Best in Show* - So many levels of genius in one movie.

10. *Lonesome Dove* - Technically it's a miniseries, but it's pure greatness. And the reason I have a large crush on Robert Duvall.

My Favorite TV Shows of All Time

I love a good TV show, especially now that Netflix is a thing and you can watch just about any show you want at any time. This is much different from the days of my childhood when I had to meticulously set the VCR to record *Days of Our Lives* while I was at school. Yes, I watched *Days of Our Lives* as a junior high kid and spent my formative years thinking Bo and Hope were the ideal couple except for the part where one of them kept getting kidnapped by Stefano DiMera. This basically proves my working theory that the 70s and 80s were a weird time to be a kid. But at least we knew the struggle of having to watch commercials. Anyway, here are my favorite TV shows of all time, the ones I have watched over and over again and still love as much as I did the first time around.

1. *Friday Night Lights* - I live in Texas. I love football. The end. Yet this show is so much more. I contend that Eric and Tami Taylor have one of the most real marriages depicted on TV, and every character on this show has a piece of my heart. Except for Season 2 which was sketchy.

2. *The Office* - I just re-watched this entire series over the last couple of months and I think I loved it even more. Jim and Pam are the greatest. Also, I cried like a baby watching the series finale.

3. *Parenthood* - This show makes me wish I was part of a big

family that regularly gathered to eat under twinkle lights in our parents' backyard.

4. *Parks and Recreation* - This show is the perfect blend of comedy and heart. It's one of those where you laugh at all the bizarre characters and then realize you have completely and totally become invested in their imaginary lives.

5. *Seinfeld* - If there is one show I still quote to this day, it's Seinfeld. There really isn't a situation that will arise in life that can't circle back to a Seinfeld episode.

6. *Friends* - I became an adult along with Monica, Rachel, Phoebe, Ross, Chandler, and Joey. They got me through figuring out how to be a career girl, meeting Perry, and having Caroline. In short, they were there for me.

7. *Gilmore Girls* - Lorelai Gilmore was the kind of mom I hoped to be long before I knew I'd be a mom of an only daughter. The witty banter and the quirky characters make this show.

8. *Little House on the Prairie* - I realize this seems random, but this is an all-time list. I remember vividly waiting anxiously on Monday nights for this to come on and to see Laura Ingalls run down that hill in the opening credits. To this day, I will stop and watch if I happen to be flipping through the channels and see that's it one of the episodes where Laura and Almanzo fall in love.

9. *Beverly Hills 90210* - Yes. I admit it. It's so bad that it's good. But I have such great memories of watching it with my college roommates that I have to list it as a favorite. Donna Martin graduates!

10. *Mad Men* - This show had so many dark moments, but it also seemed hopeful at times. It's smart, brilliantly written and the wardrobe and sets were to die for.

My Top 10 Workout Songs

Before I share this list with you, I need to confess that my musical taste hasn't changed much since I was in fifth grade and "Kiss On My List" by Hall and Oates was my favorite song. My preferred genre of workout music falls somewhere between 1980's Roller Skate Disc Jockey and Cheesy Pop Songs in General. I know it. I own it. I have no shame.

Well I have some shame, but not enough to change my playlist to something more current and trendy. I've got to go with whatever gets me through 30 minutes of cardio-activity because desperate times.

So I'll quit justifying my choices and share.

1. "Sexyback" by Justin Timberlake - I don't think I need to explain this choice. If this doesn't motivate you to work out, then it's time to hang up your Nikes.

2. "Crazy in Love" by Beyonce - Um. It's Beyonce.

3. "Unwritten" by Natasha Bedingfield - I know it was the theme song to The Hills, but I am a sucker for TV theme songs. Don't even get me started on The Jeffersons theme song because it is a multi-layered lyrical masterpiece.

4. "Since U Been Gone" by Kelly Clarkson - I'm embarrassed, but I'm going for complete honesty.

5. "Walk this Way" by Run D.M.C. - Aerosmith plus rap equals perfection.

6. "PYT" by Michael Jackson - This may be my favorite song on the list. But I will caution you that if you get carried away during your workout and try to do the P Y T hand motions that you used to do at the roller rink, you might lose your balance and fall off the elliptical.

7. "It's Tricky" by Run D.M.C. - See? I am not kidding around with the late 80's rap music.

8. "Wanna be Startin' Somethin'" by Michael Jackson - Oh Michael. Back when you still had your original face you were a musical genius. How else can you explain "Mama se Mama sa Mama ma cu sa"?

9. "Why Can't This Be Love?" by Van Halen - I don't even know what to say about this one. The heart wants what it wants.

10. "Don't Stop Believin'" by Journey - Fifth grade. Magic Skate. Comb in my back pocket and lime green wheels on my roller skates with matching pom-poms. Enough said.

Top 10 Movie Quotes I Use in My Daily Life

I will never forget the first time I saw Steel Magnolias. It was my freshman year at Texas A&M and they were doing a special sneak preview on campus. I went with my new roommate and suite mates because if you're sharing a bathroom with three complete strangers you might as well go see a movie together. And as we sat there, crying and laughing together, it became our first real bond. There are so many great lines and we spent the rest of our freshman year repeating things like "Our ability to accessorize is what separates us from the animals" and "When it comes to suffering she is right up there with Elizabeth Taylor."

The other day it was on TV, and as I watched it I began to think about how many phrases I use from it on a regular basis. Which led me to think about lines from other movies that have worked their way into my subconscious and will randomly pop into my head and come out of my mouth, causing people around me to either laugh in recognition or wonder what's wrong with me.

Here are just a few that have become a part of me in a weird, symbiotic way. And I'm a little embarrassed to admit that this is the short list.

1. "Just keep swimming, just keep swimming." – Dory from *Finding Nemo*

I first watched this movie when my daughter Caroline was about 14 months old. And have now seen it approximately 1,423 times. There are so many lines I repeat on a regular basis, but none more than this little piece of Dory's encouragement.

I find that it gets a guaranteed eye roll and huge sigh every time I use it in relation to math homework.

2. "As God is my witness, I'll never be hungry again." – Scarlett O'Hara from *Gone With the Wind*

This is the short version. There are times when I'm feeling especially dramatic that I like to throw in the whole "if I have to lie, steal, cheat or kill."

But I usually save that for Sundays after church when we're on our way to lunch and I'm pretty certain death is imminent if I don't get a breakfast taco.

3. "Well, um, actually a pretty nice little Saturday, we're going to go to Home Depot. Yeah, buy some wallpaper, maybe get some flooring, stuff like that. Maybe Bed, Bath, & Beyond, I don't know, I don't know if we'll have enough time." – Frank from *Old School*

If ever a quote summed up married life, I think this might be it. My husband and I use this all the time because throw in an early morning soccer game and it conveys the excitement of a typical Saturday at our house.

Oh, and sometimes we pick up Chick-fil-A for lunch.

4. "We have so much in common, we both love soup and snow peas, we love the outdoors, and talking and not talking. We

could not talk or talk forever and still find things to not talk about." – Sherri Ann Cabot from *Best in Show*

I'll be honest. I use this one as a litmus test to whether or not I really want to be someone's friend. If I can mention "We could not talk or talk forever" and see that someone knows what I'm referring to? Friends for life.

5. **"I got off that boat with nothing but my dancers belt and a tube of CHAPSTICK!"** – Corky St. Clair from *Waiting for Guffman*

This one is a fun one to throw out at random moments. Most people have no idea what I'm talking about but I feel like they're immediately impressed.

6. **"I caught you a delicious bass."** – Napoleon Dynamite from *Napoleon Dynamite*

My husband uses this one more than I do, but it's become a regular at our house. He's a fisherman and, though he usually comes home with trout or redfish, it's so much more entertaining to call it a "delicious bass."

7. **"P-p-plenty."** – Mel Tillis from *Cannonball Run*

I know what you're thinking. Yes, I have very sophisticated taste in movies. This is from an early scene where Terry Bradshaw and Mel Tillis are loading beer into the back of their car and are wondering if they have enough. We use "p-p-plenty" at our house in reference to everything from toilet paper to tortilla chips.

8. **"When you are a man, sometimes you wear stretchy pants in your room. It's for fun."** – Nacho Libre from *Nacho Libre*

I usually substitute "woman" for "man." And then I go put on my yoga pants.

9. "You think anybody wants a roundhouse kick to the face while I'm wearing these bad boys?" – Rex from *Napoleon Dynamite*

Possibly one of my favorite movie lines of all time because I am very sophisticated.

10. "I don't know how to put this but I'm kind of a big deal. I'm very important. I have many leather-bound books and my apartment smells of rich mahogany." – Ron Burgundy from *Anchorman*

I don't know that anyone has more quotable lines than Will Ferrell. Really, I should have done a list solely devoted to him and things like "Milk was a bad choice" or "I immediately regret this decision."

But this is one we use frequently because nothing really says you've arrived in life like leather-bound books and rich mahogany. Please make sure you use a strong "h" when saying "mahogany."

Fashion and Beauty Lists

Because a good wrinkle cream is a small thing that can change your life. Or at least your face.

My Top 10 Beauty Products

It's no surprise that I love some beauty products. My bathroom cabinet is overflowing with all manner of things that I believed at one time might change my life. I am a sucker for anything that promises to lift, to hold, or to make me look like an airbrushed version of myself.

Sadly, I have kissed a lot of frogs in my search for various beauty princes, but these ten products continue to do what God and beauty research intended them to do, and I buy them over and over again.

1. Skinceuticals Renew Overnight Dry Moisturizer

My skin is so dry, especially as I've gotten older, and this moisturizer is the best I've found. It is so moisturizing without being greasy and absorbs easily into your skin. I actually use it morning and night and sometimes I mix a little frankincense oil into it because I'm a moderate essential oils fan.

2. IT Your Skin but Better CC Cream

I've tried a bunch of BB and CC creams and this one is my favorite. It's reasonably priced and a tube of it lasts forever. It's the perfect amount of coverage and never feels heavy.

3. Anastasia Brow Wiz Mechanical Eyebrow Pencil

My 1980's self wouldn't believe a day would come when I needed to fill in my brows, but apparently that's what happens as you age. You develop eyebrow bald spots. It's humbling. This fills in my brows and looks natural and never overdone.

4. Hummingbird Farms Lavender Heavy Cream

Back to my dry skin, this lavender cream smells like a dream and manages to moisturize my skin on the driest of winter days. I use it every night when I get out of the shower and on my hands multiple times a day.

5. Neutrogena Moisture Smooth Color Stick

You cannot beat this for the price. It is super moisturizing and so easy to put on.

6. Stila Smudge Stick Waterproof Eyeliner

I don't always wear eyeliner, but when I do, I wear this. It never moves and goes on so smooth.

7. R + Co Badlands Dry Shampoo Paste

I have thick, fine hair and so it can get weighed down, but this paste is unbelievable. It's kind of like a dry shampoo but it's a paste and I rub it in at my roots where I need some volume and it is miraculous.

8. Revitalash Advanced Eyelash Conditioner

There was a time I debated getting eyelash extensions. But then I got a hold of myself and realized I am not a Kardashian. I made myself draw a line at needing to get my eyelashes done every two weeks. But this Revitalash eyelash conditioner is

AMAZING. I use it two to three times a week and it makes my lashes grow long and thick, plus you only need a little so a tube of it lasts a long time.

9. Skinceuticals Physical Fusion Universal Tint UV Defense SPF 50

Here's what I wish my teenage self would have known: There is no beauty product more important than a good sunscreen. I try to restore the years the locust and the sun have eaten by being a faithful sunscreener now. Better late than never and I really don't want to look like the crypt keeper. This one goes on light and it's tinted so on summer days, I usually just wear this and nothing else. I mean, I wear clothes. But nothing else on my face.

10. Kenra Volume Spray #25

The description of this hairspray claims it keeps its hold in 25 mph winds. What else could you possibly want? I don't use it every day, but I use it when I need to know my hair is going to stay in whatever configuration it's in that day and this works like a charm.

My Favorite Fashion Staples

1. A good pair of jeans. Or six.

Never underestimate a great pair of jeans. They can change your life. Or at least your wardrobe. Skinny, bootcut, flare—whatever makes you happiest.

2. Boots

I own a shocking number of boots. I realize I'm a Texas girl so part of it is almost mandatory, but I have a deep and abiding love for a great pair of boots and their ability to transform an outfit.

3. Cotton dresses in the summertime

It was around the time I turned 40 that I discovered the beauty of a cotton dress in the summertime. They are far preferable to their evil cousin, a pair of shorts. The problem with shorts is that you're eventually going to have to sit down.

4. Good foundational undergarments that are up to the task

This is key. Clothes just look better when everything is lifted and tucked and Spanxed.

5. A cute pair of sneakers or running shoes

We live in a miraculous time of athleisure, a time when you can essentially wear workout clothes and sneakers everywhere. We all need to take full advantage of this.

6. Denim jacket

A great denim jacket is a must-have for me. You can wear it over your cotton sundresses in the summer when you go in a restaurant whose thermostat has been set to FREEZE.

7. Little black dress

I know it's a cliché, but a little black dress can totally eliminate your "WHAT DO I WEAR" panic when a nice occasion comes up.

8. A nice neutral handbag

I'm not a fan of switching between multiple bags because I will inevitably forget to move my favorite lipstick or gum from one purse to the other. I stick with one nice bag for the spring and summer and one nice bag for the fall.

9. A plain white T-shirt (I like a V-neck)

I know this sounds boring, but you can wear a good white T-shirt by itself or under so many different outfit combinations. All you need are some great accessories and it's the perfect building block.

10. A good pair of sunglasses

Let me clarify that I do not allow myself to buy expensive sunglasses because I have proven time and time again that I can't be trusted with nice things that are small. But I do let myself buy several inexpensive pairs that I rotate depending on my mood and outfit. Sunglasses are key to helping you not squint into the sun, which helps prevent "laugh lines" around your eyes.

My Top 5 TV Fashion Influences

I love clothes. It's true. I have loved clothes since the fourth grade when my Me-Ma bought me a pair of aqua Gloria Vanderbilt jeans with a matching aqua top with that little swan on it. When I think back on it, that seems like a lot of aqua to rock in one outfit. But, prior to the moment I put that ensemble on, I had no idea an outfit could make you feel that good. And, lo, a clotheshorse was born.

Sadly, I had an unfortunate incident that ended with me getting battery acid on my aqua Gloria Vanderbilts while changing the batteries in my eight-track player. That's the kind of life-altering tragedy a child of today will never have to suffer with all their fancy iPads that don't run on six Duracell "C" batteries. They'll also never know the agony of trying to save their Def Leppard *Pyromania* cassette tape by putting a pencil eraser in those little hole things and winding all the tape back in.

But that's a discussion for another time.

The point is that fashion has been a constant in my life for a long time. I've been influenced by everything from *Seventeen* magazine to *Vogue* over the years. But more than anything else, my fashion tastes have been inspired by characters on my favorite TV shows. In fact, I've been known to watch shows just to see the ensembles the characters wear. Shout out to *Gossip Girl*. Because while I couldn't care less about Serena van der Woodsen and Blair Waldorf, I love to see what they have on. Even though I

can't really copy their style for reasons that include lack of funds and the fact I just turned forty.

But there are five TV characters whose style has influenced the way I've dressed in various seasons of my life.

1. Denise Huxtable

Was there anyone cooler than Denise back in the 80s? She had a sense of style that was completely fearless and managed to take the trends of the time and make them into her own. Before Denise I'd admired the style of Mallory Keaton, but Denise took fashion to a whole new level.

She did hippie/eclectic in a way that hadn't been done as well since Rhoda Morgenstern. Denise made girls everywhere swoon with envy over her wardrobe with all her hats and oversized sweaters and drapey pearl necklaces.

Before Denise Huxtable I stuck to my Levi 501s with various grosgrain ribbon belts paired with Polo shirts. She opened my eyes to a whole new bohemian style that influences my wardrobe choices to this day.

2. Rachel Green

Yes, her hair launched a million layered haircuts, but it was her sense of style that drew me in. *Friends* will always have a special place in my heart because it debuted the fall after I graduated from college and all of a sudden there was this cast of characters in the same stage of life I found myself in. They were my Thursday night refuge after a long week of trying to act like I knew what I was doing as a financial consultant.

(Sidenote: If I helped you set up a 401(k) in the early 90s, please go see a real expert immediately.)

Rachel had a style that was accessible to the average girl on budget. Vintage T-shirts with jeans, short skirts with boots, pencil skirts with tights. I paid attention to everything she wore and did my best to emulate it in real life. She had a way of putting clothes together that looked effortless and totally chic all at the same time.

3. Lorelai Gilmore

Gilmore Girls isn't necessarily a show that makes you think about fashion. It was quirky and funny and the witty dialogue (especially in the early years) made me so happy, especially when I caught all the random references the characters made.

But Lorelai Gilmore had a sense of style that appealed to me. It wasn't flashy or super trendy, it was just an eclectic mix of T-shirts, scarves, hats, and dresses that she wore with flair. She influenced my wardrobe as a mom and helped me navigate that line between practical and boring. Her wardrobe was appropriate for being the mom of a teenage daughter, but never dull.

4. Carrie Bradshaw

Whether you love the show or not, you cannot underestimate the impact Carrie Bradshaw had on the fashion world. Yes, there were times she wore things that were completely whack-a-doo, but she always did it with flair. And then there were the moments she wore things that completely took my breath away at the gorgeousness.

Her style was a combination of haute couture mixed with quirky vintage finds and she wore combinations that were abso-lutely fearless. Carrie wasn't afraid to wear what she wanted to wear and always dressed to fit her mood and the occasion. (As

a girl who once wore a leopard print top to the zoo, I really appreciate this quality.)

Very few of us could totally emulate her style and almost none of us can afford a closet full of Manolo Blahniks, but you can't deny that none of us would have worn flower pins on our lapels or in our hair without her influence. She brought us nameplate necklaces, baguette bags, and newsboy hats. And the fashion world was forever changed.

5. Betty Draper

Betty Draper makes me wish I lived in the 60s. Her style is everything that is good and right. Classic, elegant, and sophisticated. Whether she is cooking breakfast for the kids and dropping cigarette ashes in the eggs or on vacation with Don Draper in Rome, she epitomizes style. There is one scene after she returns home from Italy where she's in the kitchen wearing some sort of Pucci-inspired caftan that made me gasp out loud with love.

I love *Mad Men* for so many reasons, but a big part of it goes back to the fashion. Joan, Betty, and Peggy, in all their different ways, remind us of a time when it was okay to embrace glamour and for a woman to look like a woman. In a world that brought us Britney Spears and her low-rise cut-offs, I find this refreshing.

And so those are my top five fashion influences over the years. I know there are so many more, but those are the women that stand out in my mind.